Public His

Public History

A practical guide

Faye Sayer

Bloomsbury Academic
An imprint of Bloomsbury Publishing Plc

B L O O M S B U R Y
LONDON • NEW DELHI • NEW YORK • SYDNEY

Bloomsbury Academic

An imprint of Bloomsbury Publishing Plc

50 Bedford Square	1385 Broadway
London	New York
WC1B 3DP	NY 10018
UK	USA

www.bloomsbury.com

BLOOMSBURY and the Diana logo are trademarks of Bloomsbury Publishing Plc

First published 2015

© Faye Sayer, 2015

Faye Sayer has asserted her right under the Copyright, Designs and Patents Act, 1988, to be identified as Author of this work.

British Library Cataloguing-in-Publication Data
A catalogue record for this book is available from the British Library.

ISBN:	HB:	978-1-4725-0837-9
	PB:	978-1-4725-1366-3
	ePDF:	978-1-4725-1465-3
	ePub:	978-1-4725-0649-8

Library of Congress Cataloging-in-Publication Data
A catalog record for this book is available from the Library of Congress.

Typeset by RefineCatch Limited, Bungay, Suffolk
Printed and bound in Great Britain

For Rick and Hector

Contents

7 Policy, Politics, and History 185

8 Digital Media 219

Illustrations

Figures

Tables

Case studies

1

Introduction

History Beyond the Classroom

The pursuit of **public history** has become essential to the practice of history. Public history has developed from a separate entity, a sub-discipline, outside of the mainstream of the academic discipline of history, into an integrated and essential element of the subject's research and communication. Consequently, it is now expected that historians employed in both private and public historical institutes understand, embrace, and integrate elements of public history into all components of their work. This introduction of public history into wider historical practice aims to broaden the impact that history has on the wider world and, conversely, the impact that the wider world has on history. The practice of public history and its diverse methods have influenced how historians approach historical research and how, and to

whom, it is communicated. As such, developing a knowledge of public history, understanding its methods and its application in practice are now essential components in graduate and undergraduate history syllabi around the world.

This book explores what public history is, how it has developed, and the mechanisms used for its application in practice. It aims to help the reader consider key questions regarding the nature of public history, and its methodological and practical differences from the academic discipline of history; it has raised issues of interpretation, audience response, and the use and exploitation of history in the "real world." It examines the variety of methods and skills that historians use and require to practice history in the public domain. It discusses how, through various modes of interpretation and presentation, a range of institutions, including museums, archives, government agencies, **community history** societies, and the media, make history accessible to the wider "public" audience. It provides the reader with an overview of the wider world application and communication of history beyond the classroom, through core case studies that include ideas for best practice "in the field," and detail the interplay between public history and public archaeology. This book offers a synopsis of the topic in a way that has not previously been done, in an accessible and engaging format. Public history is a specialist topic that has changed substantially in the past decade. As such, this book will present a comprehensive overview of its practice and provide ideas for future methodological approaches and a reference point for students planning professional development in order to gain future employment in this sector.

Introduction

Public historians are individuals, usually trained historians, who work in either a professional or academic capacity and who engage in the practice of communicating the past to the public. Such individuals collaborate with various publics and communities to research and present their histories. Principally, they aim to facilitate open access of history to the public. Furthermore, public historians facilitate the personal involvement of the public, in a diverse range of projects, ranging from group projects such as museum exhibitions, oral history projects, and community archaeology excavations, to individually-led projects, such as genealogical research, archival research projects, and historical blogs. This range serves to highlight

the breadth of methodological approaches used to communicate history to and with the public, which can include: designing exhibitions in museums; interpreting history with aboriginal descendant communities; undertaking oral history projects based upon memories of World War II; producing material for living museums; working with local history societies to research and excavate former nineteenth-century streets; producing educational learning; and presenting television and radio programs. The central and often deeply personal motivations for this work have been to provide a past that is relevant and accessible to the public in the present.

This book draws on first-hand experience, knowledge, and self-reflection of practitioners of public history in action from around the world, to provide a guide to public history for students, amateurs, and professionals. It aims to give advice and guidance on best practice and the practical application of this in the workplace. Different chapters cover distinct subdivisions of public history, museums, archives and heritage centers, education, community history, politics, media, and **digital media**. In an economic climate where public funding may be uncertain and the graduate employment market is competitive, undergraduate and graduate students are required to understand the broader applications of history beyond university. This book contains the tools and advice needed to enable them to get one step ahead in terms of knowledge, skills, and experience.

Background to public history

Historians have been unable to agree a precise definition of public history. Some historians regard this difficulty as inherent in the subject's nature, asserting that the diversity of media and approaches used by its practitioners serve to hamper agreement of a commonly applicable definition.[1] As such, public history has become a catch-all phrase that can cover any historical activity that is not regarded as academic history (usually individually produced scholarly research on a specific topic aimed at expanding "historical knowledge" within, but rarely beyond, the academic community).[2]

Public history is an intrinsic part of history today. It seeks, like all other forms of history, to broaden our understanding of the past and its contested relationship to the present.[3] However, its future is uncertain. It could be argued that the failure of historians to agree a satisfactory definition of public history risks the future of the profession by jeopardizing both recognition of its value to wider communities and its status as an

academically respectable form of historical research. As such, it is essential to the future practice of public history that it is clearly defined and that the role of the public historian is firmly placed within history's professional framework. This requires professional, academic, and amateur historians to move away from a tradition that has regarded public history as anti-establishment and facilitate the subject's positioning within history's overarching theoretical and methodological frameworks. If public history is to provide evidence of its success in promoting the wider impact of history beyond university, then university departments should assist this process.

The methods developed by public historians have broken down the barriers between history professionals and the public and made history more accessible and relevant to the wider society.[4] As a result, history has become an agent of social change and has played a role in new forms of historical knowledge creation.[5] Public history is active, reactive, and relevant in the present, and, as such, relevant to the wider public, enabling them to connect to the past, present, or future. Properly implemented, public history in action acts to counter the novelist L.P. Hartley's often quoted assertion that "the past is a foreign country"[6] and helps communities to understand their place in modern society and the world around them. It removes the subconscious and conscious distance that "professional historians" have from the public.[7] Public history seeks to dissolve boundaries between professionals and the public and open up the past, enabling the public to play a role in the production and consumption of history.

Public history has been described as "history for the people, by the people, with the people and of the people."[8] This "manifesto" for public history disguises that fact that the idea of "with," "for," "by," and "of" often conflict in practice. The "public" and, as a result, public history in practice, are often geographically defined, politically manipulated, and manifest in various guises. Understanding these complex definitions of the "public", and the value that history offers, enables historians to regain control of the subject and support it in its attempt to flourish among a wider audience. The idea that public history is only the methods and practices used to enable involvement and understanding of history by a specific community disguises the potential for collaboration and cooperation between historians and the public. This is increasingly done without historians' formal input, for example, the public's interest in genealogy and the creation of family trees, and digital media projects created by local history societies.

It is this book's premise that public historians search for patterns in human behavior and provide a link between history and heritage. Where history seeks to explore and explain the past by researching source materials, heritage uses the past in the present, populating and personalizing the past through intangible ideas, such as personal stories, folklore, and traditions. Public history seeks to be both history and heritage, blurring the disciplinary boundaries to make the past relevant in the present. Critically, public history it is not history becoming heritage,[9] but is a merging of the two.[10] As such, public history enables history to be valuable to a broad audience and to have significance in the present, beyond the creation of knowledge, providing broader social, political, and economic value. Subsequently, a crucial part of a public historian's role is decoding history's underlying significance to people outside the profession. To do this, many public historians and those working in sectors of public history, such as the media, listen to stories, and ensure, where possible, that the multiple voices are heard as part of the **narrative** of the past. This leads to new avenues for historical dialog through the understanding that "there is not a single unitary voice on the history of the site."[11] Public historians are not arbiters of the "past," rather they are providers of present past narratives.

Types of public history

Public history's lack of a specific or precise definition has enabled it to develop organically and to use a variety of methods. As such, a diverse range of projects are categorized as public history. These range from school outreach projects, digital media, historical television programs, museum exhibitions, oral history projects, and **re-enactments**. Each of these diverse public history mechanisms has a shared overarching aim: that of communication and engagement of the public in the past. To achieve this, a balance must be struck between education and entertainment but getting that balance right has aroused a debate that will be discussed further in this chapter.[12]

Public history projects adapt to their specific contexts and thus each one tends to have unique properties. Nevertheless, overarching patterns can be found in their application in practice. As such, three distinct, identifiable approaches exist: (1) **grass-roots, bottom-up** projects; (2) institutionally-led projects (**top-down**); and (3) research-led projects (top-down) (Table 1.1). Despite these categorizations, the activities and groups of people

Table 1.1 Public history strands

Type	Description	Example
Grass roots (history from below, bottom-up)	Also known as bottom-up projects, these are run by individuals, local societies, or community groups without being initiated by professionals.	Family history projects Amateur projects, publications and digital media Genealogy
Institutional (top-down)	Public institutions such as museums or historic sites, initiate these projects. They aim to engage the public in history by providing educational or entertaining historical activities. These are also known as top-down projects.	Learning packs Exhibitions Digital media projects (Cybermuseology) Popular media
Research (top-down)	Projects that are initiated by universities, academic and historical researchers. These projects have specific research aims for including community members in historical research.	Oral history projects Community excavation projects

involved in these approaches to public history are often not limited to strict boundaries, for example, grass-roots projects, such as those led by amateurs, often require and seek support and guidance from professional historians, such as in the Muncy Project (Case Study 13). Equally, research projects, those run by professionals, often rely on community members to support their research and assist them in data collection, for example, in digital media projects such as Google's History Pin (Case Study 14) and the September 11 Digital Archive Project (Case Study 29).

Each methodological framework for public history uses a variety of different historical research approaches to investigate the past and differs in the mechanisms used to incorporate the involvement or leadership of the public, such as oral history, **social media**, and archival research. These mechanisms aim to support public collaboration and cooperation in the understanding and uncovering of the past. A vital component of all public history projects is engagement with the public in order to communicate history in a relative and accessible manner. Communication is facilitated through multisensory publicly engaging activities that aim to appeal to a broad public audience, such as storytelling, exhibitions, learning packs, multimedia, **social media, re-enactment**, and **reconstruction**.

Definition of public history

The definition and project descriptions found in public history frequently include phrases such as communication, engagement, cooperation, and collaboration. Public history could be described as "the communication of history to the wider public" or "the engagement of the public in the practice and production of history." These statements place professionals in control of the past, however, as previously indicated, public history is not merely a professional endeavor; in many cases, the public are in control and the aim is to make history become a "democratic" process.

Until recently, too many historians have used the term "public history" to describe the act of historical communication to a specific public, such as interested amateurs, as opposed to involving a broader public. Consequently, for many academic historians, the "public" often referred to those lay people who are not professionals, anyone who has not formally trained as a historian. Today, the definition of public history is broader, yet in some senses still restrictive, often referring to engagement with, and of, a geographically, socially, and politically-determined public, with "their history," for example, the Annapolis Public History Project (Case Study 27). Thus, the term "public history" is highly complex and deeply evocative as it attempts to construct identity.

The word "public" means "a population and community as a whole," acting as an umbrella phrase to deliberately hide or homogenize the numerous publics that can and do exist simultaneously within a territorial space. The word "public" in "public history" usually refers to a geographically constructed public, a group of people linked together in a specific locality, for example, New Yorkers. The phrase can be used to link "groups" of people together who share ideas, beliefs, or values; this can include local historical societies or socially disenfranchised groups of people.

Therefore, the word "public" in the term "public history" has hidden meanings and political contexts, and is often used to create an idea of unification and homogeneity of identity, something that is seen as stable and controlled. For example, the public history project in Annapolis, in the USA, promotes the homogeny of the city's past. This both deliberately and subconsciously hides the multiple publics that exist within the city's districts, many of whom feel disenfranchised from the city's history, and regard history as irrelevant to their pasts, such as the African-American population.[13] This highlights the potential dangers and ethical considerations inherent in using the phrase "public history" and its practice. Public history as a phrase

is highly complex and potentially dangerous and can easily be politically manipulated by individuals or groups of people. As such, policy-makers have drawn upon history and public history to create concepts of national identity.[14]

The creation of national identity through history is illustrated by the case of Russia and the former Soviet states creating or rebuilding often conflicting national identities since the end of the Soviet Union, in the 1990s.[15] Russia has since faced a national identity crisis, with notions of democracy and Western values conflicting with traditional "*sovki*" history and ideology.[16] The fragmentation of ex-Soviet states and their changing geographical boundaries have resulted in confusion over which countries are part of the Russian nation and state. This destabilization of "national" Soviet identity has caused a growing propensity to create "nationhood" through "homeland" myths. These homeland myths, directly driven by intellectuals and politicians, are based on historic tales and myths of origins and continuity of peoples, rather than historical facts. Nationhood serves the interests of the "country," providing economic gain, for example, through oil supplies, and serves to prevent national security threats. The concept and creation of a "national identity" are not stable, and as such have resulted in multiple conflicts, including the Serbian-Albanian conflict (1991), the Russian-Georgian War (2008), and recently, the Russian-Ukraine conflict (2014).[17]

Historians often find themselves confronting conceptions (and misconceptions) about the past, which have been shaped by others, such as politicians, media figures, or even religious leaders. In such cases, they are, therefore, reacting to, rather than initiating, an on-going discussion about history. Indeed, in the case of professional historians, such as those working in museums, the public often refers to those with whom they wish to engage, rather than those who may wish to engage with them. Historians themselves are often motivated by latent, but no less significant, agendas that can affect how they approach projects designed to engage the wider community. For example, public history in museums frequently aims at communicating with a more "diverse audience," beyond the normal visitor demographics, such as ethnic minorities, out of a laudable desire to be inclusive and to encourage in potentially marginalized social groups a sense of ownership of their community's past. As such, when they use the term "public," historians are often referring to one specific group. Yet this definition has fundamental flaws as it conceals the diverse demographics of general populations; the public in reality consists of a diverse range of people of all ages, beliefs, socio-economic backgrounds, sexes, and cultures. Consequently, rather than

historians embracing diversity, the word disguises a lack of engagement with the multiple publics and the divisions in the nature and type of interest of these individuals.

The diversity of the public is highlighted by Merriman's extensive work on the public perceptions and use of museums.[18] This research indicated that many public history organizations, such as museums, make assumptions about the "public" and the subsequent construction of public history.[19] This is unwise, as the public should not be regarded as a single monolithic entity that has a particular understanding of the past. Rather, the public should be seen as a patchwork of individuals, each with their own unique perceptions of history, which are contextually and personally specific. Homogenizing the public hampers historians' ability to engage with the diverse publics that exist.

A history of public history

"Public" involvement in history was present before the formal academic discipline of History and the historical profession were established in the latter half of the nineteenth century. The involvement and engagement of, by, and with the public in history could be regarded as an essential component in the practice of history.

People "have a propensity to want to understand themselves through their pasts and endeavour to search for their origins."[20] History has played a critical role in understanding ourselves and our place in the world. History explores the human dimensions of life by transforming words into stories,[21] it involves looking to the past for answers to existential questions in the present, shedding light on our current and future selves, acting as a form of self-reflection on the human condition. From the earliest historians and chroniclers, including Herodotus, Tacitus, and Bede through to the antiquarians of the nineteenth century, such as Flinders Petrie and Thomas Elgin, the collection of stories, historical items and the writing of history narratives, have determined, to some extent, what history is and how it has been placed in the public domain (Chapter 2).

It could be proposed that from the beginnings of the informal "public" practice of history, individual members of the public have sought to record, collect and research the past for the benefit of not only themselves, but for what was perceived as for the wider public good. History was "saved," collected, stored, cataloged by individuals, in order to obtain new knowledge

about the past and preserve fragments of the past for future generations. By the eighteenth and nineteenth centuries, history could be considered a public, albeit one often conducted in private, endeavor. Public-oriented history continued into the nineteenth century with the amateur historical movement, which predated the formal "historical" profession. It was the public's interest in the past and the search for usable and relevant history that led, in part, to the formal establishment of history as a subject in the late nineteenth century.

During the twentieth century, university-trained academics practicing history sought to separate themselves from these foundational connections to the public through establishing formal qualifications to practice, from undergraduate through to doctoral awards and adopted an approach based solely upon professionally-led research. The academic pursuit of history later developed various separate research strands, sub-disciplines with their own specialist vocabularies and methodologies, such as economic history and political history. This separation of the public from history disguised the original link between the public and the historical discipline, and the public's formative influence on both research and practice.

Public history has only (re-)emerged recently as a sub-discipline in its own right. There persists an arbitrary division of public history from the wider discipline of history, with public history often being regarded as "history practically applied." This has largely prevented the development of a distinct historiographical framework; there is no extensive literature discussing the practice of public history or establishing its credentials as a legitimate endeavor for university-trained historians.[22] This in part results from the failure of professional historians to establish such a historiography of public history or to recognize that history can legitimately be communicated in museums, collections and festivals rather than only journal articles.[23] The starting point for understanding public history, its theories and methods can be found in the formation of museums in the eighteenth century (Chapter 2).

The radical political climate of the 1960s saw the emergence of novel and challenging sub-disciplines of history that had a profound impact on the work of academics. These rejected the conventional practice of writing history as the story of "great men," of politicians, kings, and generals. Instead there was a new emphasis on the history of the poor, of women and of the colonized, and the enslaved. It was the decade that saw the emergence of social, feminist, and black history.[24] History sought to represent the diversity of past communities and the agency (the capacity to control their circumstances) of individuals in the past and present. Social and radical

historians, rejecting academic elitism, also sought to be relevant to the public. This emphasis on "bottom-up history," or history from below, aimed to research informal and hitherto untold history. For example, the unrecorded, lived experiences of working people, wartime soldiers, or grass-roots activists that might otherwise have been lost were preserved as personal stories through mechanisms including oral history. This change in approach to historical research was linked to class conflicts and racial divides, history started playing a role in wider political debates. As a result, history acted as a power negotiator for both individuals and disenfranchised groups. For example, many American historians, such as C. Vann Woodward, were active in the Civil Rights movement of the 1950s and 1960s.[25] This provided a new perspective on historical study, which changed relationships between the public and history, as the public perception and interpretation of the past were viewed as equal to that of professionals. This practice was later referred to as "public history."[26]

The phrase "public history" formally appeared in the USA in the 1970s.[27] Public history continued to be linked to wider socialist movements, aligned to professionals mirroring political liberal ideals, championing more democratic approaches to history.[28] These liberal ideas were represented in the actions of the public, in public politically-oriented movements, such as the workshops movement, which included history workshops and workers education programs organized by trade unions, such as the Workers Educational Association.[29] This period represented the public fighting for a voice beyond that allowed by traditional authority, this applied to the public representation in history. The National Council of Public History (NCPH) was founded in 1979, with the specific aim of promoting the use of history by the public, and this led to the production of the journal, the *Public Historian*.[30] Public history was linked to the political impetus to consider the unified voice of disenfranchised groups, including indigenous rights. In some senses, public history aimed to make the past more consensual, with individuals and organizations showing a range of interests in the unified past and the corporate past.[31]

The sub-discipline of public history and the professionals associated with it are therefore often strongly linked to the social history movement, liberal agendas, and anti-elite stances; this includes topics such as racial debates, feminism, and working-class histories.[32] Historical research in the 1970s combined traditional primary written records and non-written unrecorded sources, such as oral testimonies. The newly emergent practice of oral history aimed to uncover historical details that had been hidden, lost or deliberately

subverted in written records by engaging the public historical discourse.[33] It was this new, two-way dialog through which historians realized the active role the public could play in uncovering hidden and untold stories, that provided a more balanced and comprehensive story of the past. Subsequently, the multiple "publics" started to play a major role in historical research and the "emergence" of community history (see Chapter 5).

The practice of public history expanded in the 1980s, particularly in the USA, Australia, and Canada.[34] Institutions, such as Maryland University and the United States Forest Service, integrated public outreach activities specifically linked to communicating and engaging the public in their past. This included the Annapolis Public History Project, which linked local government agencies and universities together to adopt formal approaches to investigating and communicating the history of the city, including working with marginalized groups (Case Study 27). There was a focus not just on new research methods but also on communicating this new history and perspectives. During this period, the subfield of public history was academically established as a valid part of history. Yet, despite the powerful changes in historical practice in this period, the majority of public history projects in USA and Canada were still expert-led with elements of community involvement.[35]

The 1980s saw the national growth of, and support for, public history in Australia and New Zealand, albeit at a slower pace than in the USA.[36] Professional historians, supported by politicians, started formally to organize public history projects.[37] The definition and methods of history were broadened as public historians developed links with indigenous and aboriginal rights movements; this included the introduction of intangible elements of history, such as folklore and traditions, ideas that were not formally recorded and thus were not conventionally accorded the status of "evidence" (see Chapter 7). This open approach to history and the public was not initially reflected in historians' work in the UK and Europe. To some degree, this was because professional historians in these countries did not have the same political and public impetus, such as the indigenous rights movement. As such, it was the ethical and moral debates that acted as a catalyst to change in both the approaches and mind-sets of historians.

In the UK, in the 1980s, the concept of public history was still an activity principally performed by local history groups, private historians, and individuals, usually within the museum sector.[38] Funding cuts to the humanities sector during this period impacted on the development of public history. These new fiscal pressures required history to justify its wider role in society and, as a profession, to engage with the public.[39] Historians were

required to consider the value of their work and to implement publicly-oriented "humanistic" methodological approaches to their research, and to engage in wider communication.[40] Specifically, professionals were being politically and financially pressurized to undertake research that engaged with the public, "the taxpayers." Subsequently, professionals and academics could no longer engage in research for purely personal motivations. This forced historians to move from a private research endeavor to a public enterprise. Historians began to consider their roles in wider policy debates; including history's ability to predict change and the future in areas of contemporary debate, such as the environment or the economy.

The financial imperative to justify professional output to the public has continued under the current global government austerity drives. History as a profession and a subject has had to justify itself in terms of fiscal and social value.[41] This has led to widespread cuts to museum sectors and public history organizations around the world. In the UK, this has included the closing of government-funded organizations, such as Museums, Libraries and Archives Council, and funding cuts to large national public institutions, including English Heritage.[42]

It was not until the late 1990s, and the election of a Labour government in the UK, that public history adopted a more organized approach. This has been linked to the increasing pressure from the trade unions and the working class of Britain for more focus on the history of the common people. During this period, the governance of a more left-leaning, social-democratic political party impacted upon the approach and focus of the historical profession. It could be suggested that this was spurred by increasingly close political and professional links to the United States, with many historians in the UK adopting approaches to public history that had already been pioneered in North America.[43] In the UK, rather than organizations championing public history through linking it to international debates, public history happened in a more haphazard and less organized manner. This approach had its benefits, enabling it to be flexible and diverse, rising up from the streets and being shaped by amateur historians.[44]

Public history's diverse theories and methods reflect the myriad of social and political contexts in which it has developed. As such, each country has a unique approach to public history. A single definition that crosses all geographic and cultural boundaries therefore remains elusive.[45] However, despite the vast differences in the motivations for, and application of, public history around the world, all aim to widen public awareness and accessibility to the past.

Public history debates

Authenticity

Authenticity is associated with "truth," "fact," and "evidence." The nature of historical evidence is considered to influence its level of truthfulness, reliability, and authenticity.[46] For instance, primary physical documentary evidence, such as census records, are often trusted and believed by historians as "true." Conversely, first-hand accounts of the past, such as oral history testimonies, which are linked to memory and emotions, are believed to be less valid, and are considered subjective and problematic, relying on individual memory.[47] Yet, to the public, it is these personal narrative accounts of history that are often regarded as being the most authentic representations of the past. This demonstrates that authenticity is subjective and constructed at an individual level, drawing on emotions and personal responses.

Creating history and historical stories requires interpretation and linking together various forms of evidence to make suppositions about the past. Public history is about interpreting and communicating historical stories with and for the public. Therefore practitioners use a variety of media to transpose history into representations of the past; this frequently leads to questions about the authenticity of these representations. For example, "living history" displays, such as re-enactments and re-creations, are often at the forefront of the authenticity debate. Conversely, static museum displays and artifact collections are often regarded as authentic and more truthful. If we deconstruct museum displays, these displays involve objects with no narrative context ("zero degree"), objects with explanations based on historical knowledge, and objects with full museum treatment, including with staging and a comprehensive narrative. This "full museum treatment" acts as an authentication device for historical interpretations.[48] As such, museum displays are not autonomously designed; they can be regarded as having ranges of authenticity, which are subjective and based on personal experience.[49] For example, the "Their Past, Your Future" exhibition (Case Study 2) specifically aims to present World War II to the public from the perspective of UK veterans. As such, this specific UK-oriented story of the war has different values and meanings depending on the viewers' personal or family experience. It furthermore authenticates these veteran memories and stories of the war through placing them alongside historical video footage, documents, and items.

Recently, changing research mechanisms, including first-hand accounts and presentations of history, have challenged traditional ideas of authenticity, for example historical films, such as *Schindler's List* (directed by Steven Spielberg, 1993) attempted to create an authentic treatment of the human story of how Jews were treated in Nazi Germany during World War II, by using a mixture of historical facts and first-hand accounts, alongside original locations and black-and-white filming, creating the impression of documentary footage.[50] Similarly, the growth and development of cultural heritage tourism have altered how authenticity is defined, taking into account the multiple perspectives of authenticity and the dynamics of the audiences.[51] As such, the authenticity of public history's interpretation has come to include elements of nostalgia, emotivism, and intangible elements of the past.[52] This has changed the use of interpretative techniques, often through the use of methods common in the entertainment industry, to display the past, through re-enactment and reconstruction, as "frozen," monolithic and simplistic, even sanitized.[53] It relies, perhaps rather dangerously, on nostalgia to authenticate versions of the past. For example, the World War II Living History Association aims to promote, preserve, and respect the spirit and memory of World War II soldiers through using both historical information and personal impressions and memories.[54] It promotes the spirit and memory of World War II through nostalgic period-inspired activities such as dinner dances.

The authenticity in public history is associated with personal experience, emotions, and feelings. Authenticity is thus made problematic; members of the public view and experience the past differently, and, as such, consider authenticity to be attached to different elements, including both tangible and intangible pasts. World War II re-enactors stage mock battles, wearing authentic uniforms, using authentic tactics and fielding authentic equipment, but they do not stage mock genocides or prisoner massacres. In their battles, no-one dies; no-one is maimed; no-one is splattered with the blood and gore of their eviscerated friends. How authentic, then, is their version of the war? Attaining authenticity in the practice of public history is about negotiating the complex juxtaposition between fact and fiction, truth and lies, remembering and forgetting.

Entertainment versus education

Public history has changed the way history is presented and interpreted. It has seen historical communication move away from the nineteenth-century

focus on history as a tool for education, for example, in museum exhibitions created to transmit new historical knowledge and professional theories to the public. Subsequently, the approach in the late twentieth and early twenty-first century increasingly is focused on history as a form of public entertainment. Heritage centers and museums incorporate media and interactive elements to present the past to the public. These elements aim to transport the public back into the past, through creating an atmosphere and an emotional reaction to the past. For example, the Jorvik Viking Centre in York, in the UK, takes the visitor on a time train journey from the present day to the Viking past. The visitor experiences a reconstructed village, with the noises and smells associated with the period in order to be entertained *and* learn about the past. Public history organizations have used entertainment to provide education to a more diverse audience. The concept of history moving beyond education to entertainment is linked to wider debates about commercialization and authenticity.

The concept of history as entertainment is supported by research undertaken to investigate why people visit heritage and historic sites.[55] It concluded that the main reason was entertainment rather than educational aims.[56] *The Popcorn Report* offers further insights into the need of heritage to provide entertainment, escapism, and adventure.[57] This has offered an insight into what the "public" consumer wants in the future, suggesting history needs to move away from the static museum displays of the nineteenth century (or even the twenty-first century), to be more interactive and participatory, something that public history supports. Furthermore, research into community heritage projects has indicated that the majority of people visited and returned to heritage sites, based on their associated entertainment values.[58]

Entertaining the public through the past has been criticized as the **Disneyfication** of the past.[59] Public historians have been accused of using the media and its techniques to sensationalize and romanticize the past in order to create an unrealistic, yet publicly appealing, version of history. These critiques are often associated with the consumerism of the past, with heritage sites in particular being accused of creating "theme parks" and tourist attractions to attract visitors and bring in revenue, with the facts being concealed by clever tricks.

Public history is about finding a balance between providing both educational and entertainment value, meeting the demands of the public for enjoyment and the ethical requirements of the profession to safeguard and communicate the past. Many public history organizations such as museums aim therefore to provide mechanisms for enjoyable learning, both

within and outside the classroom. For example, the International Spy Museum in Washington, DC, aims to entertain and educate its visitors, both schoolchildren and tourists about spy culture through the ages. This is achieved through interactive "James Bond" spy-style training that educates the public about spy technology and historical impacts while fulfilling a commitment to interactive entertainment.

Consumerism

Elements of **consumerism** in the practice of public history have been discussed within the wider debates about entertainment and authenticity. The growth of consumerism directly relates to the changes in how public history organizations and public historians view and engage with the public. The visitors (the "public") and external forces, such as economics and politics influence how public history is communicated and presented. This has led to changes in the relationship between the professional and the public, as public history organizations face pressure to increase visitor numbers and generate more income, in part in order to maintain their institutions and their work.

Initially the core aims of the first public history organizations were preservation and collection, focusing on the objects rather than the public. Recently, budget squeezes have led to shifts in focus from being product-driven to being visitor-driven. As such, the approaches to presenting the past have altered, putting the public, "the consumer," first and therefore drawing on entertainment and media to achieve this. In this consumer-driven economy of heritage, when marketing public history organizations through their uniqueness, this is often expressed as "unique selling points," and has become paramount. Thus, museums host "blockbuster" exhibitions and **World Heritage Sites** represent themselves as unique cultural commodities.

The tourism industry and its growth in recent years have also led to changes in how public history is displayed and presented, with increasing pressure to commercialize public history organizations, providing visitor services, such as toilets, cafés, shops, all of which bring in additional revenue to ticket sales. As such, the heritage tourism industry has become a major player in the Gross National Product (GNP) of a nation.[60] Cultural heritage tourism in the UK makes up 3 percent of GNP.[61] Thus, public history organizations and their staff are increasingly driven by consumer money, as overarching capitalist systems within the Western world come to the foreground and, globally, central government funding for heritage projects decreases. This consumer-driven approach to public history has led to

ethical and moral dilemmas among the profession, directly relating to authenticity and authority over the past; and concerns that public history no longer has the power to be unbiased or to speak for the marginalized, and that commercialized representations of the past threaten the truthful preservation and presentation of history.

Ownership

Ownership of the past and history is central to the practice of public history. Public history seeks to balance perceived and actual professional ownership of the past alongside developing public ownership and autonomy in its relationship to the past. Achieving this requires public history to engage in the renegotiation of public and professional power relationships through collaboration and consultation, with the aim of developing autonomy and community cooperative ownership.

The grass-roots movement, the indigenous rights movement, racial history, and feminist history have all served to influence changes in ownership of the past and its interpretation. Wider public ownership of the past has also been enabled through the integration of new historical methodologies for research and communication, such as digital media and oral history. These mechanisms applied to public history have enabled the public to participate in historical research, interpretation, and presentation, and as such have given the public a voice and ownership in the historical narrative.

Recent work on the historiography of heritage proposes that public outreach, including public history, is often shaped by political developments and agendas.[62] It is Smith who, through the concept of "Authoritative Heritage Discourse," refers to the politically determined nature of heritage, and suggests that professionals are powerless to work against political context.[63] Carman takes a more critical view of the role of politics in heritage management in what he refers to as "Authoritative Heritage Management," suggesting that despite "inherent nationalism" and political influence in heritage management, there is yet scope to consider and apply a diverse range of values and motivations.[64] As such, public history has been used and abused by politics to push political agendas, including indigenous rights and socialist agendas, for example, in the Smithsonian National Museum of the American Indian (Case Study 24).

The practice of public history is not democratic, but is heavily influenced by external factors beyond the public or even the professional. Therefore,

public historians are often mediators of competing values and different interpretations of history. Their role is to balance the financial and political need to maintain wider support for the subject of history and to provide a voice to communicate the public's history.

Conclusion

The craft of public history, of communicating and enabling public involvement in the past, is intrinsic to the historical discipline.[65] As such, seeking to explore the history of the subject requires an understanding of the intrinsic connection between "history" and the public, and of the role that our interpretations of the past play in social and personal psychology and in a society's cultural traditions. This chapter has aimed to provide a summary and brief historiography of the public history movement. It demonstrates that the practice of public history is temporally specific and its development and historiography relate to its unique cultural and social situation.

This chapter has introduced the ideas, theories and methods, and key debates surrounding public history. These concepts were introduced to the reader to provide an overview of the complexities of public history and to provide a platform for debating the definition, its application in practice, and nature of the sub-discipline. This provides a basis for critical evaluation of public history's application in practice.

2

Museums, Archives, and Heritage Centers

This chapter investigates how history is managed and presented in museums, heritage centers, and archival facilities. Through the analysis of the history and complex development of these public history institutions, it seeks to provide an understanding of the complex and institutionally embedded historiography of the subject. Consequently, this chapter critically examines the core principles, methods, and practices used in these historical "institutions" to present and interpret history to the public, for example, through the use of exhibitions, re-creations, **reconstructions**, and multimedia platforms.

Essential to this chapter is providing advice for acquiring jobs in the "institutional" sections of the public history sector, including

how to acquire the relevant postgraduate qualifications in museum and archive management. The value of membership of local, national and international professional organizations is discussed, including the importance placed upon this by employers in the sector. The professional and ethical codes of conduct that these organizations and their members adhere to are considered, and so is its impact on the practice of public history.

Introduction

Museums, archives, and heritage centers are not only storehouses for history, they are active **public history** facilities where stories about the past are created and communicated to the public. In simple terms, museums are associated with communicating the past through historical artifacts. Archives are where historical records are stored. Heritage centers present the re-creation and reconstructions of history. In reality, this division is more complex, these facilities and their functions are not mutually exclusive. As organizations, they rely on each other's historical material to present a comprehensive story of the past; as such, they are intrinsically linked. For example, heritage centers may display artifacts like a museum; museums may hold archival collections, and archives may acquire such an arrangement of material that they can create museums. Subsequently, the boundaries between their functions are often blurred.[1]

These institutions provide some of the first examples of nationally supported and publicly funded public history facilities, even if their origins are more closely aligned to private collections, for example, the Musée du Louvre in Paris was founded on the private collections of the French royal family.[2] The development and nature of museums and archives are closely linked to changes in dominant social and political ideologies surrounding the subject of history and tend to reflect current approaches to public history. These facilities provide an ideal starting point for understanding the development of public history's application in practice. Museums and archives, more than any other public history activity, provide a historiography of public history and an ideal starting point, to understand the development of public history's application in practice.[3] It is these organizations that first enabled the public to be transformed from being passive consumers of history to being active participants in the "interpretation" of the past.[4]

Consequently, museums are at the forefront of the critical enquiry into public history and provide key examples of innovative approaches to historical communication, which will be examined in this chapter.

Museums and archives are regarded as the "powerhouses" of a nation's heritage, with their collections representing the dominant cultural and national identities.[5] They have the potential to control the public's views of history and the past through influencing national thought.[6] The selection of historical items, the creation of archives, their interpretation, and their presentation are all driven by individuals, such as curators and archivists, and by internal and external political agents such as museum boards and national and international government and non-governmental organizations.[7] As a result, decisions concerning what and how history is presented are neither objective nor inconsequential.

Curators and archivists create narratives of history based on their personal interests, and embedded world-views, including their wider social and political perspectives.[8] The artifacts collected and displayed in these "public spaces" are symbols of the dominant cultural paradigms that have been specifically interpreted and presented to represent national identity and collective memories. This is also true of the grand architecture of many national museums, which represent "corporate images" of a nation. For example, the neo-classical design of the British Museum aimed to reflect the glory of Western civilization through reference to Greek and Roman architecture. The building and its contents sought to highlight the leading role of British colonial power in the civilization of the modern world in the eighteenth century.[9] Curators and archivists often walk a narrow path between being marketing tools for the nation and its political agendas, and representing the public, playing a dual role.[10] In recent years, museums have increasingly sought public "stakeholder" feedback on their contents, and the consumer has begun to exert increasing influence on the direction of public history.[11] The public has increasingly been regarded as a consumer "paying for a service" through ticket fees or through paying taxes. As such, visitor choices, patterns, and trends in behavior and demographics have all been examined and assessed in order to influence the "production" of public history, such as exhibitions.

A brief history of museums

The concept of publicly accessible museums, buildings containing collections of historical material including art that are open to public, developed in Italy

in the sixteenth century, with one of the premier examples being the Vatican Museum. The widespread growth of the public museum originates from the eighteenth-century Enlightenment period. The earliest of these public institutions were based on objects from private collections. For example, the British Museum was formed in part by collections by Sir Hans Sloane.[12] These encyclopedic museums contained items gathered from around the world, objects that represented the reach and power of Western influence.[13] During the nineteenth century and early twentieth century there was a dramatic growth in these historical "powerhouses," as national governments supported their development. Often this was done in direct competition with other nations, with the aim of becoming national monuments to display power and global influence. Museums dating from this period include the Metropolitan Museum of Art in New York and the Budapest Museum.[14]

The museum displays of the seventeenth and eighteenth centuries were assemblages of material collected, compared, and classified based on the theories and observations of their curators.[15] This meant objects were categorized according to typological development, such as changes in shape or type of decoration. These changes were associated with different cultures or time periods. This approach detached objects from their original social and cultural contexts, based on the belief that this was an "objective" and scientific approach to history.[16] This allowed curators to manipulate and create alternative realities, enabling them to control both the public's relationship with, and understanding of, history.[17] Museums and archives became the agents that controlled and created history. Histories were constructed *for* the public rather than *by* the public in a safe, custom-built environment.[18] The provision of these facilities was intended to better society through social education of the public.[19]

Museums have developed as places to educate and entertain the public in specific regional and national narratives. For the public, they became places of curiosity, spaces to experience strange things, and to be shocked and astounded.[20] In 1889, the Museums Association was formed in the UK, with the aim of developing museums and promoting their value to the public. This supported the sector and provided the tools to establish museums as civic engines and educational facilities.[21] Similar associations to support archives at a national level appeared in the 1930s and 1940s with the formation of the Society of American Archivists (1936) and the Society of Archives in the UK (1947).

In the late nineteenth century the first open-air museum was opened in Skansen, Sweden.[22] Historic buildings that represented the traditional

cultures of Sweden were transported to, and reassembled at the site, collected from around the country with the aim of sustaining the development of cultural identity and regional traditions.[23] Two world wars hampered the spread of this practice, and the further development of public history in museums and archives, as many museums closed and put their collections into storage. After World War II, the desire to safeguard the future of large-scale historical assets, such as buildings and monuments in Europe and the USA, resulted in the re-emergence of open-air museums. The presentation and interpretation of the past through this form of "living history" supported the development of public history.[24] **Public history** became a mechanism to represent the story of ordinary people, for example, the nineteenth-century Old Sturbridge Village in Massachusetts, a development that echoed the rising interest in social history among academic historians.[25]

Following World War II, and within a year of each other, both the International Council of Museums (ICOM, in 1946–47) and the International Council for Archives (ICA, in 1948) were formed under the auspices of the United Nations Educational, Scientific and Cultural Organization (UNESCO).[26] The emergence of these organizations was a direct response by professionals and politicians to the large-scale destruction of many public history facilities, and the loss of many historical items, documents, and collections in Europe during World War II. The formation of these organizations presented international recognition of the importance of museums and archives among the wider public. The important role of museum and archival "professional" public historians, in the future of the creation, management and communication of history was now recognized. ICA and ICOM both aimed to promote standards, develop ethical guidelines in the care and management of collections, and to advocate for public access and education, seeking to apply these objectives to museums and archival facilities at an international level.

During the late 1960s and 1970s, museums and archives sought to change the public's perception of them as symbols of elite power. This was achieved through implementing new approaches to presenting, displaying, and accessing history.[27] This "democratization of museums and archives" required institutions to be transparent and to justify their use of public funds.[28] In an attempt to change history's public relevancy, curators and archivists drew ideas from the social history and radical history movements.[29] For example, the Museum of London was created within the Barbican building complex in 1976 to provide education and social betterment for residents.[30] This public-centered approach to the past enabled the development of a new

form of public history institution: the heritage center.[31] Heritage centers were spaces specifically designed to explore people's pasts and create memories within historical contexts through active learning.[32] The rise in heritage centers, with new buildings being specifically designed for the use and display of history, was in part, a response to the rise of consumerism in the public history sector. The past was a growing part of the global tourist industry and the building of heritage centers to cater to the needs of tourists represented a way to tap into this new-found financial resource for history.[33]

During this period, museums and heritage centers introduced new mechanisms for communicating historical knowledge to the public. This involved the adoption of different learning techniques and strategies, such as participatory and practical learning. As a result, museums and heritage centers began to use reconstructions and re-creations, audio and visual technology, and to incorporate visual aids within their exhibitions. These aimed to introduce the public to a more entertaining educational experience.

The 1980s and 1990s saw continued change in the power relationships between museums and archives and the public. Visitor surveys, such as Merriman's, highlighted a gap in the visitor demographics.[34] This demonstrated that museums were failing to engage the majority in history, indicating that low numbers of ethnic minority groups, teenagers, and young adults visited museums, which mostly attracted white, middle-class individuals.[35] Public history institutions recognized the need to change their approach to public history by implementing new ways of engaging the public in "their" past. Museums were redesigned, refashioned, and expanded in order be a tool for education and cultural betterment.[36] This encouraged wider access to museums, in which they also sought to become instruments for the promotion of cultural diversity.[37]

In the UK, wider access was encouraged through the introduction of free entry to museums, a scheme supported by the national government.[38] It is worth noting that, despite this scheme, visitor demographics to museums did not substantially change. Archives also came under pressure to engage with the public and sought new ways of becoming relevant and accessible, for example, by promoting open access and encouraging the use of archives for personal genealogical research. The former ethos of preserving and safeguarding the past for the future changed to one of enabling its use and value in the present.

In the early twenty-first century, public history in museums and archives has been increasingly influenced by visitor feedback and the consideration of

community values. Organizations sought to alter their relationships with the public, through actively encouraging the public to engage in decisions regarding the display, discovery, and presentation of the past, often through consultation and partnership projects.[39] The role of the curator and archivist changed from keepers of the past to presenters and communicators of multiple pasts.

Museums

Each museum is contextually unique, influenced by location, demographics, and collection policies. Furthermore, the typology of museums, ranging from encyclopedic and national museums, to local and community, and to private and institutional, affects a museum's public remit, collection policy, and funding, as well as space and location. Subsequently, these factors and a museum's context will influence the methods used to communicate and engage the public in history.[40]

Encyclopedic and national museums

Encyclopedic "society museums" were developed in the eighteenth century, aimed at presenting collections of historic objects to the interested public.[41] In Europe, by the nineteenth century many of these private collections had become national museums, housing internationally important discoveries. They aimed to display a story, "the history of mankind," to the national public, acting as agents to highlight national identity, supremacy, and power, such as the Louvre in Paris.

National museums receive a percentage of their funding from national government.[42] There are exceptions to this rule, for example, the Smithsonian in Washington, DC, which was set up with private funding, was given to the government to establish a national museum; however, it has since become a publicly-funded body.[43] National museums are self-contained, employing thousands of staff within various departments, such as temporally-specific or object-specific curatorial departments, for example, the Metropolitan Museum of Art has departments ranging from Ancient Near Eastern and Medieval Art to Modern and Contemporary Art and Photography. Museum departments also include curatorial and museum support departments, such as conservation, marketing, and education.

The structure of museums relates to their internal organizational hierarchies. For example, curators report to the heads of their respective

departments, who report to directors and the board of trustees. Regardless of individual job descriptions and departments, each member of staff has a specific role in the presentation and communication of public history. These institutions have begun to set standards for smaller museums, working with government and non-governmental bodies, including the International Council for Museums.[44]

Local or regional museums

Local museums collect and present historic items from specific local and regional areas or were formed through the opening up of former private collections to the public, such as the Geoffrey Museum in London.[45] Many of these museums were established to act as educational and communication tools for local history and to develop "civic" pride.[46] The central ethos behind local museums is to present locally relevant "public" history to the local community, encouraging a diverse range of residents to engage with "their history." As such, public history projects, including exhibitions, are created in these museums through working closely with community members and amateur history societies to develop relationships, new ideas, and new collections. These projects include oral history projects and artistic representations of the past. One example of this approach is the Museum of Docklands' Thames Foreshore exhibition in London, which displays items from the River Thames alongside reminiscences and modern photographic images.[47]

Regional museums receive various local or state government support, and are often heavily subsidised by community grants and private donations. For example, the Museum of the City of New York receives government funding for core activities but requires additional funding for exhibitions, modernization, and its public programs.[48] Therefore, exhibitions and public history activities in these museums are closely aligned to both private and public agendas.

Funding restrictions in these local and regional museums influence the nature of public history that they can provide. Public history projects often have limited budgets, small numbers of staff working on them, and rely heavily on volunteer support. Public historians working in these museums require a broader skill remit to meet these challenges, including the ability to undertake all aspects of the day-to-day running of these organizations, their management and design. These museums and their staff face the pressure to adapt regularly to changing budgetary demands and are under the highest

threat of closure due to regional and local funding cuts in the UK. As a result, local museum networks, such as the London Museums Development Team, have been set up to support these smaller museums and their staff. This is often achieved with the support of large national museums in the area and through government grants, such as the Museums Libraries and Archives Council's, Renaissance in the Regions scheme. These networks aim to provide training in museum management and grants to support mandatory changes, such as disabled access and implementation of environmental policies.

University museums

University museums store, conserve, and present large collections of material derived from individual scholarly research. For example, the Flinders Petrie Museum at University College London contains collections from Petrie's research expeditions to Egypt and the Near East in the eighteenth century.[49] Originally this material aimed to support future academic research and provide teaching collections for university students.[50] Recently, this remit has altered, mirroring changes in university agendas, including widening participation and student diversity. Therefore, these repositories for research material have sought to develop into public history facilities, encouraging engagement from people beyond the institutions. This attempt to open up these university collections to the wider public aims to provide a balance between the wider audience and research needs.[51]

University museums have subsequently developed projects in collaboration with local schools and community groups, such as Newcastle University Museum's (now part of Great North Museum: Hancock) work supporting the creation of school museums[52] and the University College in Los Angeles providing spaces within their university museum facilities for community learning.[53] These museums' outreach public history projects have involved the creation of out-of-the-case collections for wider education and training by schoolchildren and teachers, alongside strategies to encourage a broader ethnic and cultural diversity of users through translation of historical and learning resources into many different languages.[54]

Open-air museums

Open-air museums present history in outside spaces and often in a landscape context. They frequently endeavor to bring history to life through the use of re-creations or reconstructions of past buildings. These museums often use

live interpretation and **re-enactment**, in which history is transposed into the present as real people recreate past historical events or actions.[55] These museums focus on hands-on activities, and experiential learning. A good example of an open-air museum is West Stow Anglo-Saxon Village, an Anglo-Saxon reconstructed village in Suffolk, in the UK.

Live interpretation, including re-enactment, often struggles to find a balance between historical fact and fiction and, as such, falls between entertainment and education. Another technique often used in open-air museums is experimental history or archaeology. This involves testing historical theories and construction techniques today, for example, at Butzer Ancient Farm, Sussex, where attempts are made to understand the technology and techniques used to build items, such as Iron Age houses, Roman villas, and Anglo-Saxon boats. This creates replicas or reconstructions of originals based on physical evidence from both above the ground and underneath found by archaeologists and historians. Often this technique is regarded as providing a "factual" element to historical recreation, and more authenticity.

Community museums

Community museums aim to communicate local and individual stories that are important to the local community.[56] These facilities communicate a specific story about a local person or people, or specific building or site of historical interest, which a community feels has been under-represented by the establishment or is especially important to their local identity.[57] Often, these small local museums were established to tell a story of a particular person, who is perceived as important by the local community; for example, Elizabeth Gaskell House in Manchester tells the story of Elizabeth Gaskell, an important nineteenth-century novelist, most famously the author of *Cranford*.[58] Community museums also act as mechanisms to promote and communicate a specific local history, such as Washington Head Quarters Museum in White Plains in the USA, which aims to promote the role of the community in the American Revolution.[59]

Community museums arose from the community's interest in history and community historical activities, including local history society work and the collection of archives and artifacts. These museums developed out of the **grass-roots** and anti-establishment movement; which saw "the public" take control of their own "heritage," through creating their own history. Until the 1960s, there were relatively few community museums, the grass-roots movement of this era and the burgeoning volunteer movement supported

their growth.[60] The public nature of these organizations and management of these museums means that though they seek to work against the "authoritative heritage discourse," they can also serve individual and local political agendas through their historical representations. Thus, they are not only places where dialog relating to ownership is attested, they are arenas in which the authenticity of established historical accounts comes into question. Consequently, community museums can represent the multiple voices about and of the past in that area, such as the Wing Hing Long Store Museum, in Tingha in New South Wales.[61]

Local community museums provide a space for individuals to research personal histories and genealogies. The majority of community museums are run independently of government organizations, by community members, often members of local history societies, who come together to develop a space to present history. These members volunteer their time freely to support the development and communication of local history. The museums, the development of exhibitions, collections, and their management are all controlled and maintained by community "volunteers." These community volunteers play a vital part in the continued development of these museums.[62] Local museums are establishments for "community history," often combining archives, artifacts, heritage items, art and library material, yet they typically have a narrow range of collections. In these buildings and public spaces, a range of "community history" work takes place, including community exhibitions, schools activities, and archival and genealogical research. Recently, a support network has been established for community museums, for example, in Australia, this network has been supported by the national government.[63]

These museums rely on private funding and grants specially for their community work, from organizations including the Heritage Lottery Fund in the UK, a grant scheme to use National Lottery revenue and government guidance. Consequently, community museums increasingly are performing a pivotal role in community history and non-history-related outreach activities, providing spaces for exhibitions, meetings and local groups, and activities.

Private museums

Private museums are often linked to privately owned buildings and the personal collections of material stored within them are opened up to the public. These museums are frequently located in former residential buildings,

such as stately and historic homes. The collections formed in these private buildings were usually developed due to an individual's interest in history, through deliberate collection during their personal travels. These collections, such as those at Tatton Park in Cheshire, formed by the Egerton family from the sixteenth to the nineteenth centuries, can be esoteric in nature, with a range of items from various historical contexts.

The opening up of these collections is, in part, a response to the growth of commercial heritage and associated financial gain. This financial benefit gained from opening a former residence to the public often supports the conservation and maintenance of a historic building. Access to these collections, in their entirety, is often possible on request from individual researchers or members of the public. As a result, public history in these museums can be restrictive and insular, for example, encouraging people to visit to undertake specific research that may be mutually beneficial to the individual and the organization, or by opening collections up only on dedicated open days and allowing access only through guided tours. The public history model applied in private museums has a greater affinity with the archival model of interaction than that of museums.[64]

These private collections and museums often lack the funding to engage in more innovative public history projects. Recently, with the support of organizations such as the Historic Houses Association, formerly disparate private enterprises have been supported and provided with free advice and funding to enable wider public access to their historic resources, for example, the Sir John Sloane's Museum in London.[65] These private collections give historians an insight into the creation and formation of public history from its inception at an individual level.[66]

Working in a museum

Museums have individual agendas, guidelines, and remits that influence their practice and presentation of public history.[67] The focus of the institution and the nature of its original collections will affect how they archive, display, and present history to the public.

Institutions and individuals working in public history are influenced by non-governmental institutions' guidelines. External guidelines and standards impact on museum policies and professional standards, such as the Code of Ethics of the International Council of Museums (ICOM).[68] Professional bodies, such as the Museums Association (MA), developed to

support curators and museum professionals, influence the development and nature of public history within institutions. These organizations have enabled individual institutions to communicate different approaches to public history and consider new and contextually diverse methods to the presentation of the past. It is these non-governmental institutions and professional bodies that have defined the skills required to work in museums.

Key skills for working in museums

- Imagination and creativity
- Team-working skills
- Communication and interpersonal skills
- Professional development
- Project management expertise
- Budget management experience
- Creative writing skills
- Evaluation skills
- Independent research skills
- A postgraduate degree in Museum Studies

Professional bodies in the museum sector have been established to develop guidelines and codes of conduct for their members. The central aim is to support the future development of museum professionals through training courses, such as the Associate of Museum Association (AMA) training scheme. This course is designed to support future industry leaders and provide graduate training to those wishing to be employed within the sector. AMA membership requires the completion of either an accredited Master's degree in Museum Studies or a General National Vocational Qualification in heritage management. In addition to these qualifications, individuals are required to undertake continued professional development, which is supported by the AMA mentoring program.[69] The completion of a relevant postgraduate degree prior to employment within the museums sector is increasingly demanded by public history organizations.

Despite the prevalence of postgraduate degrees in Museum Studies, there are a number of different routes to employment within this sector. For example, a museum educational officer may be employed due to their previous degree and postgraduate qualifications, or because of previous work as a teacher. Similarly, there are two very distinct routes undertaken to become a curator, despite the fact that this job will require a degree in history

or a related subject. Some curators will have obtained this role through completion of a specialist PhD, usually relating to museums or artifacts studies, while others will have gained these positions through exposure to the sector by extensive volunteer work undertaken simultaneously with a Master's degree in Museum Studies.

Archives

Archives collect, conserve, and manage material from the past, principally primary documents that record the past.[70] Archives were previously regarded as repositories for official documents, places to preserve and store official records. This has recently changed to include social history and unofficial historical documents.[71]

The wider remit of archives pertains to an increasingly diverse range of material records, ranging from audio-visual and digital material to ancient written documents. This demonstrates how the precise nature and definition of archival material are changeable and contextually specific, dependent on organizational acquisition policy and guidelines.[72] Many modern archives strive to be less prescriptive in what they select, however, more traditional archives continue to distinguish themselves from museums by only collecting official written texts, such as typed script and printed material.

The administration of unofficial records, their collection and acquisition into "official" custody validate and authenticate them to become part of history.[73] This raises questions as to the function of archives and the authenticity of this "official" history.[74] Archives can be a conscious and deliberate collection of material to fit specific political agendas or based on the acquisition of material with no specific agendas other than personal interest. These two different types of archives offer alternative views of the past. Therefore, it is the role of the archives to ensure both versions of the past are incorporated into history. As such, many archives seek to be guardians of multiple histories rather than custodians of the official past.

National archives

National archives were first created in Europe in the sixteenth century and were the predecessor of museums.[75] They were established to collect and collate copies of nationally important documents, such as royal decrees and legal documents. This storage was eventually seen as inadequate for

long-term survival of these documents and ideas of conservation became paramount. Subsequently, specific facilities were built to store and conserve original documentary material and to provide copies in a single location.

National archives around the world are funded by national governments in order to store the nation's most important historical documents; for example, the Domesday Book in the National Archives in London and the Declaration of Independence in the National Archives Museum in Washington, DC. These publicly-funded institutions have a wider remit beyond the needs of academic researchers: to present and preserve the past to the national and international public. In the past two decades, the collecting remit of archives has changed to include more esoteric material, such as oral history testimonies and personal archival histories.

Large-scale national institutions employ a wide range of people to catalog and conserve the historical material stored within them, including specialist staff to support public history, such as educationalists and community outreach officers. These often well-funded institutions have a broader public remit, and support and develop national standards for archives. They also provide advice and training for regional and local archival staff. Their wide remit means they are able to obtain additional funding from the private sector or public grants. Alongside the availability of space and support staff, these funding streams enable such institutions to engage in wider national archive initiatives, including national oral history projects.

Regional archives

Regional archives were potentially the first archives to be created in the twelfth and thirteenth centuries; for example, in Burgundy and the Italian city-states. They aimed to store and conserve regional historical documents, such as tithe maps, local newspaper clippings, and birth and death certificates. They contain primary and secondary historical sources that pertain to that region, storing the history of an area within one locality. Each county or state has its own separate archive service, which contains local material; copies of this are frequently also stored in national archives. Local archives aim to be easily accessible and include local historic environment records. They are often linked to local government services, such as planning, environment and leisure. These regional history centers are where research starts for historians investigating a specific area, historic building or individual. Increasingly these resources are playing a role in independent research, including tracing family trees through census records and birth and death certificates.

Regional archives are funded by local government and are subject to budget reductions due to national and regional political and economic pressures. They are often located within county council and state government facilities, such as town halls, council offices, or regional museums. As such, many government facilities and agencies have symbiotic relationships with archives.

Private archives

Private collections contain documents, usually pertaining to specific individuals or groups or places. This includes specific archives relating to cultural groups, such as the Jewish History Archive, an international archive that has its base in the USA, and collects and collates primary material relating to Jewish history from around the world.[76] Private archives are funded and supported by individuals or charitable trusts. Therefore, they often do not have the same financial constraints as government-funded organizations, but consequently do not necessarily have a remit for public access. The nature of public history within these organizations is usually focused on communicating specific pasts and histories to specific interested parties rather than to wider demographics.

Working in archives

The process of archiving and the role of archivists are, in part, determined by guidelines and standards established by professional and non-governmental bodies, such as the International Council for Archives (ICOA), the Society of American Archivists (SAA), and the Archives and Records Association (ARA). These support the changing and broadening of the remit of archives and of archivists, including aiming to encourage the public use of archival facilities and their resources.[77] As these institutions are publicly funded, public use has become part of the core remit of regional and national archives. Therefore, national organizations, such as the Society of American Archivists, have supported increased public use and the value of archival facilities and material to their three key priorities of technology, diversity, and public access and advocacy.[78]

Archival facilities spend an increasing amount of time and money on marketing themselves to the wider public, producing online resources and providing educational material. They have become major public history institutions, by considering individual research needs, including improving

access and increasing staff support to individuals and groups involved in historical research. Access requires new partnerships to be developed in order to change the material that is incorporated into archives. Part of the modern remit of archivists involves developing and creating new material to form modern archives, preparing material that will be relevant in the present and in the future. One example of this would be the establishment of an Olympic archive, through facilitating public involvement in its creation. This has changed the perceived nature and relevance of archives to their wider audience.

The role of an archivist has moved beyond archiving and safeguarding historical material, to providing and encouraging access to history.[79] It is vital that all objects that are either displayed or archived for public use have relevant information contained within them, such as provenance (context that the object was found in), classification of object (what the object was used for), date of object, and a descriptive passage about its context and story.[80] Access to this material has been enabled by the logical categorization of records. This requires a structured and staged approach, the process of the formation of catalogs, and enables documents to be sorted and accessed for research both by historians and by members of the public:[81]

- *Authenticity*: This enables the verification of items for appropriation to formal archives.
- *Acquisition*: Historical items are formally acquired through donation or purchase. This requires legal documentation relating to change of ownership.
- *Historical research*: Detailed background historical research into item, including linking to other primary and secondary sources in collections.
- *Accession numbers*: Numerical systems enable cross-referencing, easy location and retrieval from storage. A unique reference number is placed on an item or attached label. This number is also placed on a record card and central archive index.
- *Record card*: Creation of a record card and digitized record of item. This records basic document information and provides a summary of its historical relevance.

There are two main duties of an archivist; first safeguarding archives, with archivists acting as custodians of the past, and, second, to support the use of archival material for personal and professional research.[82] The philosophy that archivists should not be involved in or deal with policy has changed,

especially with the formation of non-governmental advisory groups.[83] Policy is increasingly influenced by the first-hand evidence and experience of the archivists. Therefore, national and worldwide bodies such as the International Council on Archives (ICA) are changing definitions of what archives are and what archivists should now do and broadening the job descriptions.[84] This has included using words like "effective," "relevant," "sustainable," and "usable," with archivists directly responsible for active participation, accessibility, and leadership.[85] This has broadened the role of the archivist beyond merely historical cataloging. As archives are no longer just about formative collections, but about understanding these collections and developing themes that will support public use, archivists are required to have a broad set of skills. These softer social skills need to be balanced against the requirements for the conservation, stabilization, and preservation of documents and artifacts.[86]

The role of archivists has changed from an ethos of storage and conservation for the future to looking at their use as an educational facility and resource for public usage.[87] This has required changing mindsets, increasing collaboration and communication, and modernizing facilities.[88] Archivists face new challenges in access, entrance control and safeguarding collections. In order to tackle these issues while maintaining the necessary degree of control to safeguard historical material, the UK National Archives have introduced a pre-access competency test for users of their archives.[89]

Archivists plan and implement a variety of public programs, both permanent and temporary. These are aimed at communicating archival material and placing it in its correct historical context. The key skills required to be an archivist increasingly focus on the ability to work with the public and produce public history from archives and record associations with the past and its peoples. This requires personal skills, including innovative thinking and the ability to implement new ideas, while also following national and international guidelines for best practice.[90] An archivist requires a broad knowledge of history, the ability to understand, research, and respect the past through balancing protection of the archival "resources" and their promotion to the public. Employers of archivists are looking for a balance between the technical skills needed to choose, document, and catalog material and an understanding of how these items can be used by researchers and the public.

To acquire a job as an archivist, an individual will require a relevant graduate qualification, such as a Master's in Archival Studies. These Master's courses are in some instances accredited by professional bodies, such as the Archives and Records Association (UK and Ireland).[91] The aim of these accredited Master's

courses is to bridge the gap between education and employment. They provide the theoretical background and methodological principles required by future professionals and require these to be applied through supervised placement experience. This equips students with the knowledge, experience, and skills to work independently as archivists. Professional qualifications also enable membership of professional bodies, such as the Society of American Archivists, the Australian Society of Archivists, and the Association of Canadian Archivists. An archival institution as part of employees' professional development encourages membership to these organizations.

These national organizations offer continued professional development training schemes to their members and for new staff in the industry. For example, the Australian Society of Archivists provides CPD workshops in "Introduction to Accessioning" and "Introduction to Archives and Record Management."[92] These courses aim to support the education and training of archivists, provide leadership training, and develop standards for the profession.

Key skills for working in archives

- Good people skills
- Excellent communication skills
- Forward-thinking mentality
- Logical mind
- Organized focus
- Able to undertake research in order to authenticate resources
- Committed to professional development
- Competent in using new digital technology
- Postgraduate qualification in archival studies

Heritage and visitor centers

Heritage and visitor centers are associated with historical or archaeological sites and places of historical significance. They aim to support public visits by providing additional narrative material to add to the historical story of a locality. They move the presentation of the past away from the object and document "safeguarding" to focusing on the visitor experience and communicating history in context.[93] Unlike museums and archives, which

are repositories of cultural objects and documents, these centers are, in their broadest sense, deliberately constructed spaces that present material about a specific site. These centers sought to move away from the museum-oriented approach of preservation and protection of history, to a public-centered approached, based on the presentation of history as a public "attraction."[94]

Many heritage centers were originally constructed with an anti-establishment ethos, creative places that focused on public engagement and experience of place. Throughout the 1990s and 2000s the word *heritage* was used as a replacement for *museum*. This reflected a deliberate act to distance themselves, or at least the public perception of them, from museums. In reality, many of these heritage centers remained focused on history, using objects to present historical narratives. For example, in 2005, the Royal Australian Naval Heritage Centre in Pyrmont in Australia opened, primarily with a remit of displaying naval weapons and to present a history of the service through historical items.[95] The central difference to that of museums was that heritage centers did not have the same duties of care to the preservation of these objects as registered museums.

Heritage centers received a lot of investment in the 1980s, specifically supporting their role in heritage tourism.[96] Heritage centers, such as the Jorvik Viking Centre in York in the UK, opened in 1984, supported through private funding and charitable trust ownership.[97] These charities and companies sought to generate income, and in some cases profit, from heritage tourism. Subsequently, these sites have had large amounts of capital invested in the construction of heritage centers to develop them as economic and cultural assets. As heritage centers are usually not publicly funded organizations, their formal remits are often narrower than these institutions, yet they are able to be more adaptive and flexible in their approaches to public history; testing new ideas and taking more risks.

In contrast, visitor centers have a broad definition, and often incorporate elements of museums and heritage centers. They aim to inform the public about the present historical site, its background and its future, through visual and textual narratives. Visitor centers at historical sites provide facilities to support visits, including toilets, cafés, and shops, and these are essential to attract visitors, especially to more geographically isolated historical sites. These centers charge visitors to view sites and use funds raised from ticket sales to maintain, present, and conserve history. As such, these facilities are reliant on visitor numbers and associated ticket sales and therefore have close relationships with the tourist industry of a region (Case Study 1). The most successful among them are those that have a unique selling point (USP).

Visitor centers are often linked to government-managed and government-funded historic sites and properties, such as those owned by English Heritage (EH) and the United States Forest Service. During the 1960s and 1970s, these government organizations, particularly in the USA and the UK, invested public funds to build these visitor facilities, for example, English Heritage Stonehenge Visitor Center (1968)[98] and the United States National Parks Service Valley Forge Visitor Center (1978).[99] The aim of these centers was to both encourage and control public access to historical sites. Furthermore, this sought to provide a means to militate against current and future damage to the site, protecting the heritage through the education and management of visitors from deliberate and accidental destruction and damage to the physical remains.

Case Study 1 English Heritage, Stonehenge Visitor Centre

Stonehenge Visitor Centre was originally opened in 1968 by English Heritage as a temporary measure to control and support visit access to this internationally important Neolithic site.[100] This initial visitor center provided a means to raise funding to maintain, conserve, and research the site and to support visitors' basic understanding of the site. This was undertaken in a small area by the entrance of the site, and included interpretation panels, which included reconstructed pictures and descriptive text and audio tours of the site. This early visitor center struggled to cope with visitor numbers despite the relatively few who stopped off prior to walking to the historic site. Furthermore, the visitor center, in an attempt not to confuse visitors, did not discuss the multiple and complex interpretations of the site.

In December 2013, a new £27 million visitor center opened, privately funded, including the Heritage Lottery Fund, English Heritage, and private donors. This center combined visitor facilities, museum presentation, and interactive site elements, such as audio guides. The center focuses on telling the story of the site through a central exhibition, displaying the past, present, and future of Stonehenge through various mediums, including:

- *360° video*: A CGI video based on laser scans of inside Stonehenge. This aims to provide an immersive virtual experience to the visitor of an area of the site to which no direct access is possible, i.e. to the stones themselves.

- *Message totems*: Displayed key messages and ideas about the site.
- *3D models*: Laser scans and small-scale reconstructions of the three ages of Stonehenge and its landscape.
- *Timelines*: A large-scale timeline is placed on one wall. This highlights key periods of the site and its related archaeological evidence.
- *Object cases*: These display original archaeological artifacts from the site. These items have been loaned by local museums.
- *Landscape film*: This wall projects a film aimed to provide an overview of the historical landscape, including other features.
- *External galley*: This area outside the main visitor center provides the public with large-scale replicas of the stones and Neolithic houses.

The new visitor center at Stonehenge has struggled to deal with the underlying issues that exist with access and transport to the site. In part, this is a consequence of high visitor numbers, resulting in long queues to board the "land trains" to the site, which is located over 1.5 miles from the visitor center.[101] The location of this visitor center, away from the main site, poses questions regarding the purpose and perhaps the real nature of a visitor center when located so far from the vistas and context of the historic site.

Questions

1 What are the key differences between heritage centers and museums?
2 Would you define Stonehenge Visitor Centre as a museum or a heritage center?
3 What benefits and issues does the use of digital technology have for the communication of history at a historical site?

Reading and resources

- Besterman, T. (2014) Stonehenge Visitor Centre, *Museums Journal*, 114(5): 42–5.
- Stephens, S. (2013) English Heritage unveils Stonehenge Visitor Centre, *Museums Journal*. Available at: http://www.museums association.org/museums-journal/news/02102013-english-heritage-unveils-stonehenge-visitor-centre# .U8YyOFa3cds [accessed 1 March 2014].
- www.english-heritage.org.uk/daysout/properties/stonehenge.

Heritage and visitor centers present history that focuses on the user experience. Historians working in these centers create public displays and exhibitions often focusing on learning through practical experiences: "experiential learning." This can involve a range of interpretative innovations, such as interpretation panels located at specific areas around a site that provide information in context to the viewer. These activities aim to move away from the traditional glass case approach of communicating history, to interactive displays and activities that attempt to balance both education and entertainment.[102] This can involve using re-creations and reconstructions to communicate a story of the past. For example, in Jamestown in the USA re-created houses and people dressed in period customs re-enact past events using a variety of evidence and supposition, often mixing fact and fiction. These reconstructions and **re-enactments** serve to transport the visitor to another period, encouraging the public to learn and experience a version of the past.[103]

Key skills for working in heritage and visitor centers

- Excellent communication skills
- Innovative and creative thinking
- Customer service aptitude
- Excellent written communication skills
- Ability to undertake evaluation
- Project management experience
- Time keeping commitment
- Financial acumen and budget management experience
- Multi-tasking skills
- Team-working

Conclusion

This chapter has discussed public history in museums, archives, and heritage centers. It has outlined not only the differences between strategies taken by different institutions at different times, but also the commonalities of methods used. Collaboration between different institutions means that the separation between museums, archives and heritage centers is increasingly

narrow. This represents not only a blurring between organizational remits, but also between official and unofficial history, as public history has become about accessibility and usage rather than storage and protection. As a result, professional roles within these organizations have evolved from being custodians of a past to being purveyors of the pasts. This has changed the way public historians work at an institutional level and the skills required to work in these organizations. Museums and archives have learnt from each other to enable collections to be accessible places and spaces to explore and access history.

Routes into jobs in the museums, archives, and heritage sectors

Curator

History degree (2:1), Master's in Museum Studies, volunteer work. The job description requires:[104]

- Undergraduate degree in history
- Master's in museum studies (accredited by MA)
- Pre-entry work experience
- Vocational qualifications, such as AMA
- Political awareness
- Project management skills
- Research skills
- Planning skills
- Communication skills
- Knowledge and interest in relevant area
- Web/IT skills
- Teamwork and negotiation skills

Archivist

History degree (2:1), Master's in archival studies, volunteer work. The job description is:[105]

- Undergraduate degree in history
- Master's in archival studies (accredited by Archives and Records Association)

- Pre-entry work experience in archives
- Good communication skills
- Customer service skills
- Logical and organized approach to work
- Research skills
- Accuracy
- IT skill and experience of digital media
- Project management skills
- Ability to work independently and as part of a team
- Responsive working practices

Heritage Center Manager

History degree (2:1), Master's in public history, volunteer work. The job description is:

- Undergraduate degree in history
- Master's in archival studies (accredited by Archives and Records Association)
- Pre-entry work experience in sector
- Project management skills
- Financial and budget experience
- Team-working skills
- Good communication skills
- Marketing experience
- Customer services skills
- Broad knowledge of heritage
- Volunteer management experience

3

Methods of Communication in Public History

Chapter Outline

This chapter outlines the variety of media used by professionals working in museums, archives, and heritage centers to communicate and present history to the public. It provides insights into the methods used and skills required to successfully produce public history within these contexts. It will critically examine how various methods work in practice, from more traditional exhibitions to iPhone apps that provide images of the past. This chapter, through key case studies, aims to support an understanding of the potential strengths and weaknesses of each approach used to present history to the public. This will seek to provide advice on the processes involved in creating public history in these organizations, such as working with stakeholders, writing exhibition panels, preparing an exhibition proposal, and using audio

and visual media. It investigates the various stakeholders and the variety of people these organizations work with to produce history, including graphic designers, marketing professionals, external contractors, and public steering groups, and describes the skills sets these groups of people provide for the presentation of history to the wider public. Consequently, this will consider the ethical and moral implications of public historians' work, the management of history in the public domain, and the responsibility of the historian.

Introduction

Public history supports the understanding and creation of narratives about the past at a personal level. This can serve to reinforce or question personal memories or test preconceptions about the past.[1] The practical and social activities that are associated with public history are regarded as fundamental to the formation of memories and knowledge.[2] This suggests that the process of visiting a museum or archive, and engaging in active learning through interactive technologies or exhibitions could be crucial to this process. Museums and archives are places where memory and history come together, and as such can act as "theatres of memory," where intangible ideas about the past are played out using tangible historical evidence.[3] These spaces serve to connect items and events with the present, creating new memories, knowledge, and perspectives about history for the visitor.[4] They can challenge personal beliefs and ideas about the past, providing a space for personal negotiation with the past in the present.[5] As such, museums and archives impact upon the production of public history.[6]

Exhibitions

Exhibitions display and present "authentic" cultural material to the public in order to communicate knowledge about the past; these are central public history activities for museums and archives.[7] Exhibitions fall under different classifications, ranging from permanent, temporary, or traveling, sometimes described as "blockbuster" exhibitions, such as the British Museum's Tutankhamun exhibition (1972).[8] It is exhibitions and the ability to view "real" objects from the past that are the primary motivation for the public

visiting museums.[9] Creating public exhibitions requires a balance between displaying "real" authentic items and communicating their story within a wider historical context. This requires a consideration of the wider public in order to understand how to present history to diverse groups of people in an accessible and stimulating manner.

Creating exhibitions requires negotiations with external organizations and other institutions, both nationally and internationally. Curators arrange the movement and temporary loan of items from other collections around the world, and work with other museums' staff and experts to create a narrative for these items. The ability to move objects around the world is dependent on the preservation and conservational condition of the items. As a result, often objects which are perceived as high status or elite, such as those made of precious metals such as gold or silver, or those which have received conservation treatment for previous display are able to be transported. Yet everyday items, such as pottery, wooden tools, and documents often cannot be transported safely because of their fragility. The movement of objects around the world requires the ability to manage logistics and work with foreign officials to negotiate the loan of items.[10] Political sensitivity and diplomatic skills are key; for example, the "Forgotten Empire Exhibition" (i.e. Persia) at the British Museum required negotiation with the Iranian government to enable permission to be granted.[11]

Permanent exhibitions

Permanent exhibitions are "core" to museums, located within the central museum space. Typically they are found within the museum's original building and contain material from the museum's initial inception. These permanent exhibitions reflect the original collection policy of the museum and form part of its main narrative. Permanent exhibitions receive the majority of central museum funding and are priority learning and outreach areas. As such, they are subject to revamping and reinterpretation in the hope of rejuvenating museum visitor interest and increasing footfall.[12] These permanent exhibitions often have a curator who oversees the collections and their maintenance and organizes loans of material.

Temporary exhibitions

Temporary exhibitions are created to exist in a space or spaces for a finite amount of time. They can be classified as short-term (1 week to 6 months) or

long-term (6 months to 1 year).[13] Consequently, financial investment and the materials used are often limited. These exhibitions are frequently created to either fit into a specific space within the museum, for instance, a community galley or entrance/foyer, or to act as a platform to communicate a topic and the museum's work to the wider public. These exhibitions can also be situated outside the museum, for example, the "Their Past, Your Future Exhibition" (Case Study 2). These movable exhibitions are lightweight, usually involving pop-up displays, or canvases, and have a limited amount of items on display. Their size means they usually have minimum audio and visual aids. These temporary exhibitions often coincide with a museum developing a new space and are used to raise visitor numbers and market a museum. When branding these exhibitions, a clear, concise message is essential. Despite the ability to present history in new arenas, it has been questioned whether these exhibitions improve visitor experience and diversity.[14]

Case Study 2 "Their Past, Your Future" Exhibition

The "Their Past, Your Future" touring exhibition was created in 2005–2006. It was funded by a £1.2 million grant from the Big Lottery Fund, and created by the Imperial War Museum, designed and constructed by Fraser Randell and Land Design Studio.[15] The exhibition aimed to create awareness, specifically in the younger generation, of World War II on its sixtieth anniversary. Nine identical versions of the exhibition were created, which toured simultaneously over 70 locations in the UK over 12 months. These exhibitions presented life in World War II through the memories of the people who had lived through it. As such, it contained reminiscences, which were presented in audio and video format in the exhibition spaces. The exhibition also included passages from personal diaries, photographs, and objects from the specified period. This was all contained with a pre-constructed tented space that aimed to symbolize the army tents of World War II. Crucial to this was that it was heavily branded and provided a vast array of educational and marketing material that linked all host organizations to a central theme.

The exhibition traveled to various localities around the UK, and was presented in a variety of public spaces, including libraries, shopping malls, and recreational parks. The organization received a £25,000 grant to undertake additional public outreach work, specifically relating to World War II in the localities. Outreach projects

ranged from additional educational provision, the use of re-enactors and storytellers, and archaeological excavations of World War II Blitz sites in London.

The locational choice presented several issues, as the size, shape and commitment to display for six-week periods meant that many organizations were unable to support this exhibition. Despite the financial investment, the marketing strategy, the variety of locations and the diversity of outreach undertaken, many of these exhibitions failed to attract large visitor numbers or produce diversity in visitor types. Locations such as shopping malls frequently failed to produce large footfall, even from accidental visitors.

Questions

1 What are the considerations and restrictions in creating temporary exhibitions?
2 Are there differences between traveling and temporary exhibitions and can these two forms work successfully together?
3 What defines a successful exhibition? How can this be achieved?

Reading and resources

- Worthington, C. (2005) A lost battle, *Museums Journal*, 105(10): 389.
- http://archive.theirpast-yourfuture.org.uk/server/show/nav.00n011

Traveling exhibitions

Large-scale, traveling "blockbuster" exhibitions grew in popularity in the 1960s.[16] These exhibitions were centered on objects and documents beyond the specific museums' stores. Items for display are sourced from other museums, private collections, and increasingly from "exotic" locations outside the country. They offer limited and unique visitor access to the public of rare and unusual material; this provides a draw to attract new and repeat audiences and acts as a marketing tool for the host museum: for example, the Tutankhamun exhibition. Temporary exhibitions have limited time-spans and rely on movable exhibition panels, temporary display cases rather than expensive permanent equipment. Larger temporary exhibitions often have huge financial and staff investment, so these exhibitions often charge an additional entrance fee. These serve not only to attract larger audiences but also to market the innovative work of the museum. A recent successful

example of this is the Pompeii Exhibition at the British Museum (Case Study 3).[17] Despite temporary "blockbuster" exhibitions demonstrating increased visitor numbers, it has been suggested that they decreased visitor time spent in the museum.[18]

Case Study 3 British Museum, Pompeii Exhibition

The British Museum's "Pompeii: Life and Death—Pompeii and Herculaneum" exhibition opened in June 2013 and ran until September 2013.[19] The exhibition, which charged visitors £10 for entry and was free for members, was sponsored by Goldman Sachs, an investment banking, securities, and investment management firm. The creation of this exhibition involved the staff from the British Museum, including curators, collaborating with the Italian government and archaeological officers in Pompeii and Herculaneum to develop a story through the borrowing of objects, human remains, and large architectural features about the history of these Roman towns and of the volcanic eruption that buried them.

The Pompeii exhibition aimed to guide visitors through the lives and deaths of the town's inhabitants through historical and archaeological objects from the site. Visitors were initially guided through the exhibition via a galley circuit based on movement through different rooms of a Roman house. These rooms had specific recreated copies of the painted wall plaster and architectural features associated with specific rooms, such as fountains and baths, with display cases showcasing key items found within these rooms. For example, in the bedroom, display cases presented wooden bed frames and erotic art. The exhibition proceeded to lead the visitor into the town's shops and temples and into the last days of cities. In the final galley of the exhibition, sound and light were used to create an atmosphere, giving the illusion of the darkness of the ash and the eruption of Mount Vesuvius, after which lava casts of the dead inhabitants of Pompeii were presented. The change in atmosphere was supported by lighting; with the rooms in the houses lit slightly dimmer than the bright light of the gardens; and the red darkness of the moments before and after the volcanic eruption.

Displays also aimed to provide mechanisms for learning, including Key Stage, school learning, and family learning. Children's activity packs were provided for families, which involved find and seek

elements and pictorial illustrations of key Roman themes, such as food, family life, and death. Hand-held audio guides provided visitors with the choice to access additional information either in audio, textual, or visual form. The public was encouraged to engage with the exhibition through curator tours, evening lectures, and music and film nights for members.

The Pompeii exhibition was a "blockbuster" exhibition that attracted over a half a million visitors in six months.[20] It was credited with increasing visitor numbers and membership of the museum. Despite these positive statistics, these exhibitions do not support repeat visitors and large visitor numbers restrict movement within galleys and often lead to shorter time spent, which could impact on learning. As such, these blockbuster exhibitions could be regarded as merely part of the cultural tourist trail, entertainment rather than education. External sponsorship of these exhibitions does not come without problems for curators, who are responsible for militating against potential ethical and moral implications of external support and agendas, and maintaining professional integrity.

Questions

1 How do temporary exhibitions draw in new audiences?
2 Do you think blockbuster exhibitions mean a less worthwhile visitor experience?
3 Why are blockbuster exhibitions financially valuable to both sponsors and museums?

Reading and resources

- Lewis, P. (2013) Life and death in Pompeii and Herculaneum, British Museum, London, *Museums Journal*, 113(6): 46–9.
- https://www.britishmuseum.org/about_us/news_and_press/press_releases/2012/pompeii_and_herculaneum.aspx

Types of display and catalogs

Exhibition displays often contain items behind glass cases. This was once regarded as the main form of communication of history within museums and archives. Historical items are placed here to create a conscious and subconscious barrier between the viewer and the object, and the viewer and the curator.[21] Museums assemble objects through creating abstract

relationships, such as object classifications, for example, Anglo-Saxon brooch typologies. These present-day relationships are known as "object-hood," and often link object type with time periods to provide what is perceived as "stable classifications."[22] Objects and their arrangement within exhibition spaces create the illusion of distinctive and stable histories, such as "Prehistory," yet in reality these are abstract concepts, which are changeable, situational, and highly complex.

Exhibition displays include brief textual descriptions of historical items, including what the item is (type), its date (temporal period), and where it was found (context). Descriptions provide the public with additional information and scope for interpretation. Historical items can be arranged temporally, typologically, contextually, or thematically:

- *Temporally*: Objects are displayed based on chronological sequencing, and the development of objects through time periods. Cabinets of items move sequentially through time and display a range of objects based on this section criteria. This traditional temporal format for displaying items in exhibitions can be observed in permanent galleys in Victorian museums, such as the British Museum and the New York Metropolitan Museum.
- *Typological*: Items are displayed based on their function, with assemblages created in relation to object type. This type of assemblage can be free from historical context, with artifacts displayed as science and art. These displays often have overarching texts describing the nature and the function of objects rather than individual textual information for each item, for example, cabinets containing only axe heads. This gives the viewer ideas of stylistic traits and aids identification. Occasionally this will be linked to the chronology of objects highlighting changes in stylistic traits over history, for example, the National Museum of Denmark displays singular temporally specific object types in an exhibition case, such an exhibition case displays over 50 bronze axe heads from Bronze Age Denmark.
- *Contextual*: Contextual displays involve assemblages of materials arranged on the basis of the location of their discovery. Objects are selected based on sharing commonality through location rather than type or chronology. These may have a secondary underarching assemblage arrangement within specific cases, based on object type. Contextual displays such as in the Bavarian State Archaeological Collection, Munich, where display items are based on where they were found. This gives the viewer a contextual perspective of objects. This

display type is frequently used at visitor centers at historic places including Eltham Palace, London.

- *Thematic*: Thematic displays are based on concepts and ideas as opposed to time periods and assemblage types. For example, in the National Museum of Scotland in Edinburgh, objects in their archaeological gallery are displayed based on themes such as farming and food processing. This re-socialization and redeployment of objects involve deconstructing complex assemblages and reassembling them into new narratives. These new narratives can be established through working with the public, such as Melbourne Museum's collaboration with the local Aboriginal community. This created objective narratives based on intangible Aboriginal stories and traditions rather than temporal frameworks based on Western concepts of linear timelines.[23]

This form of public history can break down prior relationships, yet it is deeply complex, time-consuming, and challenges pre-established and individual thought.[24] This action-centered, anti-Western, and anti-textual approach questions historical stability in order to construct new realities and not merely re-establish different patterns of historical stability. This lack of a single narrative challenges conventional forms of viewing and forming knowledge and can be deeply confusing to socially and politically established meaning. For example, the British Museum's "Pompeii: Life and Death" exhibition challenges moral ideas, through seeking to be anthropological rather than scientific in its approach. As such, it aims to help the visitor understand the human experience of death rather than show only tangible remains and objects associated with Pompeii. This exhibition acts as a social agent to disconnect the practice of public history from mainstream history.[25]

Logistics

Creating exhibitions is a complex process requiring planning and management skills. It is time-consuming and expensive, in terms of both staff and materials. Yet creating and maintaining exhibitions and public programs are part of the main objectives of the museum and will influence public perceptions of history, the institution, and public interest. Not producing quality and publicly applicable exhibitions and programs represents a failure to provide a public service. It is important that each stage of a public history program considers, consults, and actively involves the public.

Creating an exhibition requires a unique idea, carefully researched by the curator, which will present new research or a different perspective on

historical knowledge. The ability to start the process of creating exhibitions requires undertaking evaluations of existing exhibitions, visitor surveys, and in-depth public consultation (see "Qualitative evaluation" on p. 70). These test the validity and appropriateness of a specific exhibition idea. This "market research" provides additional information on the public and institutional "value" and wider impact of public history projects, such as its social, economic, knowledge, and political values.

The stages of exhibition management are:[26]

1 *Planning*: The project team will hold meetings to discuss the process, the timing and the tasks, and to develop the project aims and objectives.
2 *Research and interpretation*: Primary and secondary sources will be researched by curators; and ideas will be interpreted.
3 *Design*: Choices are made about the format and layout of the exhibition and the use of pictures, texts, and objects. The internal architecture and the floor layout that will influence the flow of people will be considered. Display panels and cases are chosen, as are colors, the layout of text, graphics, pictures, and lighting. Any additional requirements are considered.
4 *Writing of key texts and editing*: Information is compiled, evaluated, and edited.
5 *Production*: Cases, panels, displays will be produced; objects and items will be prepared for installation. Loans and insurance will be acquired for objects.
6 *Installation*: Technicians will install lighting, electrics, and sound and place display cases. Curators and conservators will place objects in the display cases.

Exhibitions are required to work within the core objectives of the museum. Approval requires completing a feasibility study, which assesses the appropriateness of objects, their stability, ownership, and availability; the space; the resources of staff and money; timing; the cost; and the core team (Figure 3.1). Once approved, budgets will be set and objectives formalized. Larger exhibitions with significant financial investment and risk may bring in an externally contracted project manager. This person will have appropriate experience and may be required to have management qualifications, such as PRINCE2 and APM. This person will develop a project brief, which will include timescales, task lists, team roles and risk assessments (Figure 3.1). The risk assessments provide evidence of viability and prevent risks of non-completion.

Exhibition Proposal Application	
Project Name	
Contact Name and Email	
Contact Address	
Summary of conceptual approach and subject of the exhibition	
Describe key collections used	
Describe Visitor Experience that the exhibition will support	
Identify the key audiences of the exhibition	
Estimate square footage required	
Timescale required and dates for exhibition opening and closing	
Funding required (does the exhibition require additional external funding?)	
Key team members (partners) and brief overview of roles and experience	

Figure 3.1 Exhibition proposal form

Source: Ideas adapted from Museum of Vancouver Exhibition Proposal Application. Available at http://www.museumofvancouver.ca/about/exhibitionproposals [accessed Dec. 10, 2013].

Table 3.1 Job divisions and staffing

Administration	Professionals	Technicians	Craftspeople
Board Members	Curators	Photographer	Preparers
Director	Conservators	Lighting engineer	Electricians
Project manager	Designers	Sound engineer	Marketing team
	Education specialist		Security

Source: Herreman (2004, p. 96).

Curators and archivists do not work in isolation to produce public history projects. They work with a range of craftsmen, professionals and members of the public to produce public history (Tables 3.1 and 3.2). The motivation for this is to produce publicly relevant projects, which have value to a diverse public audience. This requires the skills not only of the curators but of those who are not specifically trained in history. These people bring new ideas,

Table 3.2 Exhibition professional job roles and descriptions

Project teams	Skills
Designers	Advise on effective use of space, visual design, and interpretative selection
Marketing	Support production of advertising material Advise text/pictures—market appeal of project Conduct and support market research
Press team	Provide and contact media in order to reach a large audience Write press releases Support and develop communication skills
Conservators	Prepare and stabilize objects Advise on the appropriateness of objects chosen
External contractors	Lighting and develop exhibition equipment Media equipment and expertise
IT/Graphics	Support the development and digitization of material for the web and develop interactive material, including games for exhibitions
Registers/Loans/Admin	Support the acquisition of inter-museum loans of material for exhibition. Provide legal advice and insurance both for objects and public programs
Outreach officer	Liaise with community groups and members; encourage collaboration and coordinates volunteers
Educational specialists	Advise on national curriculum and community learning
Finance	Provide budgets and financial advice, and hiring of external contractors
Other stakeholders	Support exhibitions and provide content
Membership team	Arrange events to encourage repeat visits Support and encourage members to donate money to support the museum
Visitor services	Organize the logistics of booking and ticketing
Technicians	Advise on logistics of display, including the creation of display cases; if external contractors are not being used, installation, lighting, and electrics.

enabling new interpretations and presentations of objects, displays, and museums to be formed.[27]

It is only after the exhibition is open to the public that public history has a "real" impact on the people viewing and experiencing the history. At this point the role of the public historian is to develop mechanisms to facilitate public engagement and enable the public to form personal relationships and memories with history.

Audio-visual aids

Recent technological developments in the methods curators use to communicate history to the public have involved the use of multimedia and audio-visual technologies, within the exhibition spaces. This has supported, in some cases, history changing from a passive process to an active public activity.

Audio clips

Audio clips can be used at specific points in the exhibition or played as background noise. These audio-aids are created by compiling pre-recorded audio narratives that provide additional information about specific displays or objects. These can be accessed by the visitor while viewing the exhibition, either through lifting up a receiver, pressing a button or accessing narratives through mobile bluetooth technology, such as smartphones. These delivery methods are linked to specific displays or objects.[28] This technique removes weighty texts and enables the viewer to focus on the items and displays. Unlike a tour guide, these narratives can be accessed and experienced at the visitor's own pace. For museums, the recent addition of personal audio devices is relatively cost-effective in comparison to the previous static audio installations. Audio tours have been used extensively in open-air museums and heritage centers as they mitigate the need for interpretation panels and intrusive items on site. The incorporation of "real" oral history testimonies into exhibitions has become increasingly prevalent. This aims to provide a "social" historical view of the past and provide a diverse set of narratives to engage the public in history.

Museums use music and sound clips to create atmosphere in a static space. The National Museum of Denmark Bog Bodies Exhibition uses sound clips to create a dynamic and tense atmosphere. This sensory medium can contextualize displays, with background noise, such as wind and waves helping to transport visitors to the context and time period in which the objects were found. For example, the Jorvik Viking Centre, in York (UK), helps to re-create Viking streetscapes through using historically associated street noises, such as animal sounds and reconstructed voice clips of Viking villagers. This was combined with pumping smells associated with manure and rotten food into the reconstructed area.[29]

These approaches require a careful balance between sound and volume, as too much of either can distract the viewer from the "factual" evidence on display. It is important to note that they can also prove problematic for visitors with hearing impairments and those using hearing aids. These

multisensory techniques have been criticized as providing the public with a false reality of the past in the present and accused of creating people who fail to truly engage, who "look but do not see" and fail to imagine or critically engage.[30]

Visual aids

Reconstructions, **re-enactments**, and **replicas** seek to visually communicate history to the public. These techniques are frequently used in heritage centers and open-air museums (Case Study 4) and aim to support the public in visualizing and experiencing a version of the past.[31] They create a feeling of "time travel" for the viewer, treading a precarious line between education and entertainment. As such, they run the risk of becoming theme parks that sensationalize and simplify history rather than providing historically authentic reconstructions.[32] Government organizations, such as the US Forest Service, have a reluctant relationship with re-enactors and until recently banned this activity on all their sites. This ban was in part due to issues with historical **authenticity** and the validity of re-enactors and attempts to maintain and control professional standards and truthful representations of the past. Despite this, re-enactors, living historians, and storytellers are increasingly employed in museums and places of historic interest to support learning, including on some government-owned sites, for example, those owned by English Heritage, such as the Battle of Hastings. These living historians frequently work with public historians, using historical evidence to develop accurate stories of the past, which are entertaining and educational.[33]

Case Study 4 Colonial Williamsburg

Colonial Williamsburg, Virginia, in the USA, is a heritage attraction that has re-created and reconstructed a former eighteenth-century village that existed within the locality of a 301-acre landscape.[34] Within this site the re-created streetscapes, which include churches, taverns and schools, are peopled by re-enactors, also known as "costumed interpreters," who are really modern-day people wearing period "authentic" replica costumes. Re-enactors aim to bring the past to life through re-creating potential scenarios and activities from eighteenth-century history, through acting out religious and social situations.[35]

The reconstructions of the past, using re-enactment, re-creations and replicas in Williamsburg are based on historical and archaeological evidence. Archaeological excavations, conducted by the Department of Archaeological resource on the three colonial settlements in Virginia of Williamsburg, Jamestown Island, and Yorktown, have provided artifacts and building evidence that have aided reconstruction of the buildings and replica items used in the reconstructed village.[36] Furthermore, historical research of documentary sources and paintings from the period has supported the "peopling" of the past and the re-creation and the re-enactment. Both the historical and the archaeological evidence used here are limited, especially in regards to understanding the people of the past, their actions, and specific activities. This evidence is creatively interpreted to provide an exciting historical story, one that is ethnically diverse and socially acceptable, rather than accurate. For example, the treatment and living conditions of slaves and indentured servants are overlooked, potentially due to being too off-putting and morally uncomfortable for visitors. Furthermore, re-enactments and reconstructions must adhere to organizational constraints, such as the health and safety requirements, which influence the physical situations they are able to re-create and the potential historical "authenticity" of the site as a slice of eighteenth-century life.[37]

Questions

1 Can re-enactment be authentic? If so, how is this achieved?
2 What are the ethical considerations of undertaking re-enactments and re-creations?
3 How can reconstructions and replicas seek to be more historically accurate?

Reading and resources

- Robertshaw, A. (2006) Live interpretation, in A. Hems and M. Blockley (eds) *Heritage Interpretation*, London: Routledge, pp. 41–54.
- http://www.colonialwilliamsburg.com

Replicas are copies of original artifacts, often used in museum exhibitions. This is usually due to conservation issues, with the original items too unstable or fragmented to be put on public display. Many items from the Staffordshire Hoard, displayed at Birmingham Museum and Art Gallery, in the UK, fall

into these categories and as such have been replaced by replicas. Replicas enable items to be present in multiple locations, a technique useful for objects that are nationally significant. For example, the Sutton Hoo Anglo-Saxon hoard, a collection of items found during the archaeological excavations of a sixth- to seventh-century Anglo-Saxon royal burial site and ship burial in Suffolk, in the UK. These include highly ornate gold and precious stone items, such as the ceremonial helmet and the great buckle, which are, through replicas, simultaneously displayed at Ipswich Museum, Sutton Hoo, and the British Museum.

The production of "authentic" replicas and reconstructions is time-consuming and expensive, and can potentially mislead the public into believing fakes are real. It is essential, when using replicas, to provide appropriate labels and descriptions with clear statements about authenticity and provenance of the object so as to not mislead the viewer.

Research into teaching and learning, "**pedagogical** research," indicates that visual and audio aids support learning through enabling an active engagement in history.[38] This assists the public in the acquisition of new knowledge and the development of transferable skills, such as confidence and communication.[39] Public historians have been criticized for their reliance on visual aids, accused of supporting the commodification and **Disneyfication** of the past.[40] It has been suggested that an over-reliance on visual aids neither challenges nor stimulates the audience, failing to give them credit for their ability to think and form their own interpretations and memories.[41] Audio-visual technology has been criticized for prioritizing entertainment over education, and failing to be authentic and factually accurate.[42] This is part of a wider "anti-heritage" standpoint that has argued that public history dilutes historical authenticity and opens history up to biased and uncontrolled misuse.[43] The existence of this counter-movement demonstrates the complexity of managing and presenting the past and shows how the modern public historian must balance the use of modern techniques against the inclusion of factual evidence.[44]

Interactive technologies

Museums have been at the forefront of adapting new technologies to actively engage visitors with history, such as visual and touch-screen technology (Case Study 5). This has included the use of iPads in the permanent galleries, such as in the Grant Museum of Zoology, London,[45] and in the temporary "Treasure" exhibition at the Natural History Museum,

London.[46] This interactive touch-screen technology has replaced many permanent interactive screens and stand-alone computers. These moveable and interactive panels are of lower cost and benefit from being easily replaced and reused.

Social media provide the visitor with an on-demand service, encouraging personal interaction with the displays and enabling access to additional historical information. They can include hyperlinks connecting to web resources and social media sites, such as Twitter, Facebook, and Instagram. This provides a facility for the public to develop instant online forums, conversations, and blogs with public historians and engage in wider historical discourse.[47] For example, the Grant Museum of Zoology, in London, uses iPads located at specific points within the gallery to encourage the public to ask the curator questions relating to items on display, using their online discussion forum.

Case Study 5 The Jersey War Tunnel Museum

The Jersey War Tunnel Museum aims to tell the story, from both sides, of the occupation of Jersey during World War II by Nazi Germany.[48] The museum is located in the tunnels, "Hohlgangsanlage 8," which were originally created by German prisoners-of-war, to act as a barracks and ammunition store and later as an underground hospital for the German occupying forces.

The various galleries within the museum use audio-visual technology, such as "talking heads" to communicate both sides of a complicated story about war, occupation, integration, and liberation. The talking head technique uses digital screens as replacements for mannequin heads (Figure 3.2). These talking mannequins are positioned around the exhibition and dressed in historically accurate costumes. The screen displays a clip of an actor talking to the viewer as if it is a specific historical character from the past. This enables multiple views of the past to be presented through visual and audio means. In this particular example, the mannequins depict German soldiers from World War II, which are positioned throughout the exhibition. Each mannequin represents a different character in keeping with different exhibition themes; for instance, a medical soldier in the infirmary. The use of different video clips aims to provide a human face and story to the German soldiers stationed in Jersey during World War II and gives a personal narrative of history.[49]

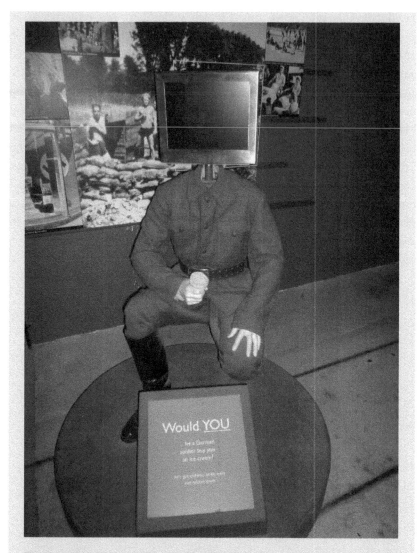

Figure 3.2 Talking heads at the Jersey War Tunnel Museum

Source: Faye Sayer.

The use of this audio-visual technology in exhibitions is not without issues, as it is prone to break down, as seen at Agincourt, France. Furthermore, this technology could be accused of distracting the visitor from the "factual" historical evidence, by failing to balance historical education alongside entertaining fictional gimmicks.

Questions

1 What benefits does the use of audio-visual technology offer traditional museum exhibitions?
2 Do visual media, such as talking heads, aid the contemporary understanding of the past?
3 Is it possible for audio-visual media to portray a "balanced" view of the past to the public and, if so, how?

Reading and resources

- Heal, S. (2005) Living with the enemy, *Museums Journal*, 105(8): 40–1.
- Simpson, R. (1998) Multimedia special: effective audio-visual, *Museums Practice*, 9: 44–6.
- http://www.jerseywartunnels.com

Touch-screen software programs, such as mobile phone and tablet apps, are used to support access to historical material in external public history environments. For example, the Museum of London "Street Museum" app enables the user, based on their location, to view contemporary London alongside its historical vistas. This program has been created using archival photographs, drawings, and historical descriptions. Another technique used in museums and public history sites is Quick Response (QR) codes. These codes store large amounts of data that can be scanned by the visitor via their mobile phone to access information on screen about a specific historical item or location. This technology benefits from being contextually adaptable and providing the public with a choice on where to access information and on what they wish to access information.

The use of digital technology to create open source historical material has changed the nature of the public's interaction with history.[50] The digitization of material to create online catalogs and digital archives, known as **cybermuseology**, provides public access to official and unofficial historical material (Case Study 6).[51] This technology has enabled public engagement with the creation of historical collections, supporting access to and public interaction with history.[52] The use of auto-CAD technology and 3D laser scanning has created digital archives and museums, providing virtual tours of buildings and objects. This has enabled the public to view history in micro detail and at multiple angles from the comfort of their home. For example, the Smithsonian National Museum of Natural History, in Washington, DC,

offers a panoramic virtual online tour of the museum and its galleries. This tour enables virtual visitors to move from room to room and explore collections from a desktop computer or hand-held device in external, non-museum environments.[53]

Technology has the potential to bring multiple collections together and save existing technologically redundant collections. For example, the British Library, the British Museum, the Museum of London, and the Victoria and Albert Museum Immigration Project has used digital technology to collate and communicate multi-format resources to the public.[54] Digital technology provides a method to record history; for instance, the September 11 Digital Archive Project uses digital media as a tool to collect oral history and photographic records of the terrorist attack on the World Trade Center, New York (Case Study 29).[55] This approach does not come without issues, large unfocused chunks of information lacking coherent themes can be difficult to meaningfully translate, authenticate, and provenance.[56] These resources have security issues, and require careful mediation and control.

Case Study 6 London Archaeological Archive and Research Centre

The London Archaeological Archive and Research Centre (LAARC) opened in 2002, to present and promote access to the Museum of London's archival material.[57] It contains 8,500 items from 3,500 sites within the Greater London area and, as such, it is the largest archive in the world.[58] It was established to provide international standards for the deposition, safe storage, and conservation of historical and archaeological collections, as well as public access to support research and teaching. The archiving of such a large and internationally important collection has required the use of innovative ideas and technology. This has included the use of movable storage units, online catalogs and locational systems, and the creation of a glass and pottery typology and research room. The online catalogs provide public search engines to access detailed information about specific objects; these can be searched for under themes, object type, location or date, and provide detailed descriptions and photographs of objects.

Initiatives, such as the volunteer learning program (AVLP) and the volunteer inclusion program (VIP) demonstrate LAARC's commitment to public history. The VIP is an ongoing program developed to

encourage diverse audiences to use and be trained in collections' care and management through on-site training. Part of this program has involved mini borough-led archive initiatives which aimed to encourage the utilization of existing collections by community members to tell the history of their local areas.

These online and public archival projects have sought to encourage members of the public to provide material from their personal collections for archive use. This "crowd-sourced" history has provided a tool to collect more diverse histories beyond the usual archival remit. Yet, this is not without issues as it challenges professional collections' remits and standards. As such, the maintenance of the quality of data stored and the cataloging of material can be problematic.

Questions

1 Are digital archives a valid mechanism for providing public access to historical and archeological resources?
2 Cybermuseology has changed the way the public interact with history; what implications has this had for the presentation and communication of the past to the public?
3 Can "crowd-sourced" historical data provide a valid form of historical material?

Reading and resources

- Hogsden, C. and Poulter, E. (2012) The real other? Museum objects in digital contact networks, *Journal of Material Culture*, 17: 265–86.
- http://archive.museumoflondon.org.uk/laarc/catalogue/
- http://www.museumoflondon.org.uk/collections-research/laarc/

Handling collections

Handling collections, used within and outside public history organizations, support educational activities.[59] These collections of historical material are based on specific time periods and are often linked to National Curriculum themes. These can be combined with storytelling sessions, in which objects are used by specialists to illustrate historical stories, stimulating the imagination and encouraging children to engage with items through drawing, handling, and discussion.

Object-handling tables have been set up in museum galleries, often run by curators or volunteers, which enable visitors to touch and ask questions about historical items. For example, in the Smithsonian National Museum of American History, The Price of Freedom Gallery uses an object-handling table, manned by volunteers, to present and discuss specific items of clothing and weapons used during the American War of Independence. This enables visitors to touch and explore different objects associated with this period of history and learn through interaction with the object and the trained volunteer.

Handling collections are developed for use outside the museum setting, such as to support classroom learning. Canterbury Archaeological Trust has developed Roman handling collections for use in schools to support children's learning of Roman history through the tactile activity of handling archaeological and historical items.[60] These handling collections are developed to be used alongside activities and combine education and entertainment, such as guessing the object or creating an object timeline. The use of conservationally stable originals or **replicas** enables objects to be touched by the public, providing a "real" sensation of their size, use and function and encourages the public to interpret and discuss history.

Outreach events

Communicating with the public requires curators and archivists to undertake public lectures and to engage with the wider media. The communication of history to the public is now increasingly important in public history institutions. The creation of after-hours events, such as a night at the museum and singles social nights, have been used to encourage new audiences to engage with history, specifically young adults. Events are often ticketed or "members only" to provide a unique opportunity to have "elite" access to history and converse with curators in an informal setting. These social events place history within a dynamic social arena and aim to break down the barriers between the public and the professionals.

Museums increasingly undertake more diverse and multi-disciplinary public history outreach events, which aim to encourage a wider audience to be interested in the past. As such, museum outreach events are frequently linked to community history and include elements of archaeology and heritage, such as community archaeology excavations: for example, the Museum of London's Shoreditch Park Excavation.[61]

Knowing your public

The evaluation of users and non-users is a central component of the work undertaken by public history institutions. This allows organizations to understand the public, and assess and provide evidence as to which techniques do and do not work. Evaluation enables a public history project to recognize its real and potential public values. This can help justify the necessity for the application of new approaches. These evaluations are undertaken prior to, during, and after public history programs, supporting the continual development and adaption of approaches based on public feedback.

Market research

Market research of stakeholders prior to exhibitions has become standard practice in public history organizations.[62] This approach has been defined as "a visitor-centered approach."[63] The reliance on external grants to fund public history activities requires organizations to undertake pre-event consultation with the public. These involve the use of focus groups with potential stakeholders to test new ideas and receive feedback on public history initiatives. Museums, such as the Victoria and Albert Museum, use professional external organizations to arrange focus groups outside the museum environment and to provide public feedback and input on forthcoming exhibitions. These visitor and non-visitor surveys enable the adaption of public programs in order to mitigate the risk of failure.

Quantitative evaluation

Quantitative surveys provide statistical data, which can indicate visitor trends to inform future practice.[64] These often take the form of visitor surveys, which provide demographic information about the visitor, time spent in the museum and routes of movement. This type of analysis gathers empirical data through closed question interviews and multiple-choice questionnaires. This produces quantitative information that can be subjected to statistical analysis, such as Merriman's museum visitor survey.[65] This "quantitative" approach is based on questions that guide the participants into producing limited answers, these are usually focused on market values.[66] The results from quantitative surveys provide numerical estimates of

the ideas of the person who designed the survey, and can simplify complex concepts. Hooper Greenhill's application of quantitative survey methodology to investigate the educational role of museums firmly establishes this technique as a tool for museum evaluation.[67] This survey analyzes school demographics and uses sets of multiple-choice questions to develop an understanding of the impact of museums' lessons on learners such as the development of skills, including numeracy, literacy, and communication.[68]

These surveys do not allow for open-ended responses or the specific detail needed to assess the multiple and often unquantifiable and interwoven personal values of the public history.[69] Rather, a quantitative approach lends itself to accentuating pre-determined research biases, which affect the formulation of questions and only allow participants to provide the answers that have been pre-selected by the researcher.

Qualitative evaluation

Qualitative methodologies draw on anthropological and sociological methods to enable the broader analysis of social and personal values.[70] This approach produces specific individual responses rather than numbers and generalizations.[71] Qualitative evaluation uses various techniques, such as visitor conversations and observations. It can involve analysing visitors' comments cards, recording open interviews, or watching visitor footfall and interaction. For example, footfall surveys test the time the visitor spends in the exhibition space and their movement around the museum. This can help to illuminate visitor engagement, attention, and interest, and therefore indicates the relative merits of different design strategies.[72] This enables analysis of what a visitor thinks and how visitors use the space, supporting the development of public history for the users rather than passive receivers.

Museums have set a precedent for research into the social learning outcomes of public history.[73] Quantitative research can apply psychologically accredited measures, such as Positive and Negative Affect Schedule (PANAS) and the Visual Analogy Scale (VAS), to measure the impact of public history. For example, the Centre for Museum Studies, University College London, has used both techniques to investigate the impact on hospital patients of handling historical objects, suggesting that practical engagement with history directly impacts upon personal well-being.[74] Similarly the Happier Museums project suggests that tactile activities enable "practical learning."[75]

This social research is playing a crucial role in the adoption and development of public history, as public historians seek to understand their audiences and to have a wider social impact.

Conclusion

This chapter has discussed the methods of communication used in public history. External and internal influences have altered the practice of public history in museums, archives, and heritage centers. The introduction and development of digital technology and social media have influenced the nature and practice of public history in these organizations. This change in historical communication has altered the way these organizations interact with and engage the public in historical dialogues. Critically, it is the changing political and financial pressures at regional, national, and global levels that have affected the public remits of these organizations, increasing their scope as educational and social spaces, and as such changed the style of communication and access remits.

4

Teaching History

Chapter Outline

History and historians figure in a variety of educational environments, including schools, universities, and extra-curricular and lifelong learning classes. The chapter investigates the inclusion of history within national, state, and local curricula, in both the humanities and social science subjects. This aims to provide a multi-disciplinary, and as such, cross-curricular understanding of history's application in educational practice and the impact of recent changes in approaches to teaching, such as practical learning.

This chapter analyzes the changing role of history and historians within schools and considers how this evolution has shaped both teaching methods and the interactions that academic historians have with schools, providing analysis through case studies of how

teachers and historians can productively work together. The chapter assesses the variety of teaching methods, often referred to as **"pedagogical"** approaches, including participatory and practical methods, such as experimental and cognitive methods, that aim to engage and educate both school pupils and, indeed, the wider public in learning about history. It examines how these teaching methods have changed over the last few decades to be more inclusive of diverse learner needs, adapting to different learning styles and the various contexts in which teaching and learning can occur.

Introduction

New approaches to teaching history have included the use of more practical and experience-led teaching in the classroom, including the use of artifact handling collections, role-playing exercises, and the introduction of multimedia and sensory equipment. All these approaches aim to make learning and teaching history more user-friendly, or "public-centered," which has included introducing elements of entertainment and participation. This chapter investigates the ways in which public historians working in various contexts, such as museums, archives, and universities, can support widening participation in educational programs through historic fieldtrips, historic site visits, and online learning packs.

An examination of the skills historians have as educators and the contribution that historians can make to teaching and learning will be outlined. The chapter provides guidance on the levels and types of post-graduate qualifications required to pursue a career in historical education, either in specifically dedicated learning institutions or teaching positions in other organizations, such as in museums and archives as schools' outreach officers. As such, it investigates the key skills required to teach history and the transferable skills that studying history provides for teaching other subjects, such as geography, mathematics, and English.

Background

The educational value of history continues to be the focus of academic research into public history.[1] History's educational value is often linked to its ability to create new knowledge and understanding of the past. Furthermore,

historians have claimed that history can improve literacy, numeracy, and critical thinking.[2] Despite the potential wider educational benefits, the majority of research has, until recently, related to formal learning environments, such as schools and universities.[3] This relates to the fact that the formal learning environment is a structured and easily accessible research environment, which can be readily quantitatively assessed and evaluated. Informal learning is a more intangible environment in which to conduct research: it is learning by watching, doing, thinking, and feeling (Figure 4.1); it is diverse, flexible, and as such more difficult to assess.[4] Subsequently, research has tended to overlook the educational potential of teaching history within informal learning settings, such as museums, historical buildings, and the media.

Informal learning is unscheduled and impromptu, occurring in leisure time, including the learning obtained from visiting historic sites or watching a historical television program. Informal learning strategies require less formal pedagogical practices that combine entertainment and education, which are seen as fun and relaxed and appeal to a broader audience.[5] The success of informal educational activities is highlighted by the popularity of the Council for British Archaeology's Young Archaeology Club (YAC).[6] YAC

Figure 4.1 Outside classroom learning in Chichester
Source: Faye Sayer.

has recognized the multiple values of historical education, stating one of its learning outcomes to be developing "inquisitive and well rounded young people."[7] It states that teaching history should not be contained within formal learning situations or strategies.

Pedagogical approaches to teaching history

Teaching provides the framework to support the development of learning through the application of diverse methodological approaches to educational activities. These approaches are linked to specific learning outcomes, lesson plans, and assessments. Teaching history requires an understanding of learning as an active process and recognition that it is a personal experience. Developing historical learning activities for formal education environments, such as schools and universities, and for open learning environments, such as museums and historical buildings, requires the adaption and use of a variety of pedagogical approaches, dependent on the context of learning: for example, the learner's environmental setting. The teacher should also consider how to account for diverse learning styles, such as: (1) accommodating, i.e. learning by doing and feeling; (2) assimilating, i.e. learning by watching and thinking; (3) converging, i.e. learning by doing and thinking; and (4) diverging, i.e. learning by feeling and watching.[8]

The traditional and often standard Western approach to formal historical education and classroom learning is teacher-led learning, referred to as **behaviorism**. This approach is designed to condition the learner through "stimulus response" to external stimuli.[9] Conditioning of the learner is achieved by the teacher positively reinforcing learning and negatively discouraging behavior.[10] For example, a positive reinforcement, such as a reward for right answers could be a gold star or merit, and negative reinforcement could be a telling off or de-merit. Thus, this method influences learner behavior and encourages learning. Learning through a teacher conditioning "behaviorism" seeks to change learner behavior over time, and can easily be assessed by observation.[11] This method fails to take into account individual responses to learning, as it considers all individuals as blank slates without free will, who are all influenced equally by their environment. As such, it does not consider individual learners' requirements or the diverse cognitive structures that influence the individual's ability to learn.

More recently, a consideration that the learner is an activity participant in the process of learning has resulted in alternative teaching methods being introduced in and outside the classroom. **Cognitive learning** introduces the idea that learning is an internal mental activity, rather than an externally controlled action.[12] This method considers the learner's internal cognitive structures, which are influenced by previous knowledge and experiences. Learning is regarded as a developmental process, in which the learner makes sense of new information through observation, categorization, and forming generalizations.[13] This method suggests teaching should be a cumulative process, based on developing structured thinking appropriate to the learner's needs and stages of development.[14] This method suggests that successful learning has to be personally meaningful, and should support personal interaction with the material and the environment.[15] This method is often applied in higher educational environments, such as lectures, seminars, and tutorials, as it enables increased learner control and ability so the teacher can support different learning requirements and styles. Cognitive learning can be measured through an individual's progress and ability to recall information. This method is based on logic and the belief that learners choose logical answers, which are influenced by their prior internal knowledge and experience and the evaluation of external evidence.

Open-learning environments, such as historical sites, require **pedagogies** based on flexible, participatory, responsive, and individual learning, such as **constructivism** and experimentation.[16] Constructivism is an approach to teaching in which individuals are encouraged to apply their own structure to learning. This learning theory suggests that individuals construct their own understandings, for instance, of history and the past, based on their experiences and reflection upon these experiences. Consequently, learning is associated with individual interactions involving the surrounding social environments; therefore, knowledge is constructed based on the context of learning.[17] For example, visiting a historic site will have different meanings and produce different experiences for each person, often based on previous memories, knowledge, and experiences. As such, this learning experience can be supported by public historians providing the visitor with more diverse historical experiences on site, for instance, light and sound shows, multimedia reconstructions, or guided tours. This theory suggests that learning activities developed within different public history organizations should be adapted based on contextual requirements, thus, every site, museum or heritage attraction should be considered an individual learning experience.

The experiential approach is based on the concept of social learning; it requires participation in learning, with learning associated with personal experience, observation, and self-reflection.[18] As such, this approach is associated with hands-on group activities, such as participatory involvement in community archaeological excavations, in which people engage in the experience of archaeological excavations, including social interaction with people with whom they share experiences and ideas about the past through discovery, which encourages the process of personal interpretations of the past through experience. This approach encourages learning through action, reaction, and adaption and is influenced not only by previous personal experiences but also by the external environment.

Constructivism and **experimental learning** approaches are based on social learning. As such, they can be difficult to apply formally and assess using traditional quantitative methods. As a result, there is a reluctance among many educational practitioners to apply these methods, especially within the formal educational sector. In part, this is due to the fact that these methods require more qualitative methods for assessment, such as conversations and observations of learner behavior, which are more difficult to implement in a formal educational setting of subject standards and standardization, that require measurable marking criteria.

Education in public history often blends together a range of "pedagogical" approaches, including experiential, behavioral, and cognitive; this is referred to as **flexible** learning. This approach aims to give participants a choice and flexibility in how they learn and are taught history.[19] The application of this approach enables the teacher to consider both the context of the learning environments and the diverse learning styles of the learners.

Flexible learning approaches offer scope for museums and historical sites to create and deliver educational programs, which are tailored to the public and relate to the demands of the **consumer**.[20] This requires the provision of non-traditional resources and the development of non-traditional teaching practices, such as history trials, reconstruction, experimental history, and role-play. These methods are based on the theory that both learning environments and individual learning styles are critical to knowledge acquisition.[21] This contextual approach encourages the public to discover, learn, experience, and engage in discussion and critical thought by feeling, watching, doing, and thinking.[22] The emphasis is on individual development, personal choice, and adaptation of learning outcomes based on individual needs, known as constructive alignment.

Social approaches to learning, such as flexible and experiential learning have had positive impacts on learning outcomes for people with behavioral

and emotional learning difficulties and with specific learning difficulties, such as dyslexia and autism. These approaches enable multisensory learning, which supports different learning styles, including more practical and visual learning.

It is vital for educational establishments to consider the needs of users, including those with special educational needs, such as physical and mental disabilities. This includes public historians consulting with users to provide appropriate resources for learning needs, such as providing information in large print, Braille, or sign language and supporting appropriate access requirements. For example, the Museum of London has used YouTube to present signed learning resources for their collections to be used by deaf people.[23]

The introduction, in the United States, of the Americans with Disability Act of 1990 and, in the UK, of the Disability Discrimination Act in 2005, has affected all public sector organizations such as museums and archives. These Acts seek to promote disability equality, including removing barriers which prevent access and providing appropriate, practical, and demonstrable ways to facilitate access to material for all users.[24] As such, organizations including the Natural History Museum in London and the National Museum of American History in Washington, DC, have enabled access to the building for wheelchair and disabled users through the use of ramps and lifts. Public historians are now required by law to adapt activities for all user requirements and demonstrate a consideration of different learner needs, irrespective of the nature of the educational activities that are being undertaken.

Learning outcomes and lesson plans

Learning outcomes are defined as "specific, measurable achievements that can be assessed. These are what the learners will be able to do at the end of the educational activity."[25] The decision to develop formal learning outcomes and measurable achievements for the user is dependent on the nature of the public history organization and the visitor demographics, "the learners."[26]

Public history organizations must develop learning outcomes related to specific educational activities. Historical learning outcomes are associated with the context and nature of the historical resources and are adapted to the educational setting, such as inside and outside the classroom. Learning outcomes developed in public history organizations are directly linked to formal education requirements, and thus to Key Stage learning and

National Curriculum benchmark "requirements" within schools.[27] A central consideration for public historians when developing learning outcomes relating to educational activities is flexibility, measurability, and sequential structure. Learning outcomes can be intended and modified rather than prescribed, closed, and quantitatively measurable. This encourages adaptability for learners, including life-long learners, and is better suited to informal and open learning environments. For example, learning at historical sites, such as historic battlefields like Gettysburg in the United States, is often personal and less structured and more haphazard in style; subsequently, learning outcomes on these sites are related to social experiences and linked to personal growth.[28]

Developing learning outcomes with and for adults requires a broader view of learning and a consideration of social and emotional needs, such as boosting confidence and self-awareness.[29] Developing learning outcomes for both specific learning activities and non-specific, non-planned learning activities is integral to museums and public history organizations. To support public history organizations to incorporate learning outcomes into their activities, a plethora of online resources have been developed.[30] For example, the Museums, Libraries and Archives Council (MLA), a former UK government body that is now part of the Arts Council, has sought to support public history work through developing the "online inspiring learning framework."[31] This provides online outlines for potential learning outcomes of educational activities. This includes generic learning outcomes, such as knowledge, skills, attributes and values, engagement, inspiration and creativity and activity, behavior and progression.[32] This research recognizes the importance of less formal learning outcomes achieved through these educational activities. As such, through online material, it enables institutions to set out schemes for understanding, defining, and evaluating social learning outcomes.

Writing "intended" and planned learning outcomes involves understanding the factors that underpin successful learning; these include prior knowledge and experience, social interaction, and involvement with the physical environment.[33] To successfully understand these factors, public history organizations and public history professionals must formally define "learning." For example, the museum sector in the UK suggests:

> Learning is a process of active engagement with experience. It is what people do when they want to make sense of the world. It may involve an increase in skills, knowledge, understanding, values and the capacity to reflect. Effective learning leads to change, development, and the desire to learn more.

It is about personal development, which leads to change. That change can be cognitive, cultural, emotional, social, sensory or physical.[34]

It is essential to the success of educational activities that learning outcomes are concise and comprehensible, and can be achieved, assessed, and evaluated. These include outcomes that are specifically related and suitable for levels of learning, such as age groups and abilities, considering the understanding, skills and attributes.[35]

Museum learning outcomes can include the following aims:

1 Increase learning in a subject area.
2 Develop knowledge of history.
3 Increase self-confidence and self-esteem.

Lesson plans and resource packs

Developing lesson plans and resource packs for learning activities is an essential task for public historians planning to work with external educational organizations. It enables the communication of ideas in a format that teachers can understand and that can be incorporated freely into their existing educational structures (Case Study 7).

Key criteria for lesson plans include:

- defined objectives
- specific learning outcomes
- outline of lesson procedure and timetable of activities
- key tasks
- extension activities

Lesson plans enable the user, for example, the teacher, to understand how the lesson will be run and divided within the time scale. Specific learning activities are linked to steps within the overall lesson and to specific learning outcomes. These student activities can include additional materials, such as learner handouts. Options for extension activities can also be included which enable the lesson to be adapted for specific learners. Various public history organizations provide comprehensive online lesson plans for a variety of historical periods, which are linked to their collections. For example, the Smithsonian's "Lincoln" resources, and the Microsoft Office-sponsored "Track the Life of a Legislative Bill." These are linked to specific learning outcomes, stages of activities, and additional resource material. This includes visual and audio support material.[36]

Case Study 7 "Bones Without Barriers" Project: Oakington Key Stage Curriculum

Oakington Heritage Project, in Cambridge, is a collaborative project, directed by Manchester Metropolitan University (MMU), the University of Central Lancashire (UCLAN), and Oxford Archaeology East (OAE).[37] This project is based on the excavation and exploration of an Anglo-Saxon settlement and cemetery. This project, as well as being a university research and training project, also sought to communicate and work with local schools to develop materials for use in and away from the classroom. As the project was based on the Anglo-Saxons, a variety of learning resources for Key Stages 1, 2, and 3 were produced. These learning resources sought to provide on-site educational activities linked to the UK National Curriculum. Furthermore, they also aimed to offer activities that engaged the children in different learning styles, including participatory and active learning. The activities also sought to cross disciplinary boundaries and offer teachers mechanisms for supporting learning beyond merely that of history, and presented learning outcomes that were both in keeping with age groups but developed transferable skills such as confidence and team-working. As such, it included site visits, talks, involvement in the excavation, and also discussion activities, such as debates.

Activity

This activity expands upon the ethical discussions surrounding the archaeological excavation of human remains. It encourages young people to research debates surrounding archaeology and human remains and places them in teams to argue the pros and cons of the public being able to witness excavations. The research project, "Bones without Barriers" has unique permission from the UK Ministry of Justice to excavate human remains without using screens.

 Set the scene for your debate. Your local community wants to build a new sports hall. Legally, there has to be a survey by archaeologists because pieces of a Roman pot were found there previously.

- During the survey the archaeologists uncover human remains dating from the sixth century. What happens next?
- The young people should think about how they feel about the thought of skeletons being removed from their resting place. Do they think this is right or wrong and why?
- What do they think the benefits of investigating the skeletons are?

Learning outcomes

- All young people will understand that there is on-going debate about the excavation of human remains and the role of members of the public as witnesses.
- Most will engage with contemporary debate and form their own opinions.
- Some will understand the ethical points of the arguments and express their own opinions in a thought-out and persuasive manner.

Extension activity

Take the young people out into your playing field where you have placed a closed gazebo. Ask them to guess what could be behind the gazebo. Explain that it could be archaeologists who have found human remains and are currently excavating them. Who would want to see? Who would not? Split the young people into two groups: those who would like to see what is behind the screen and those who would not. Get each to state their reasons.

Questions

1 What are the motivations for developing learning packs for history education to support outside classroom learning?
2 How would you develop a successful learning activity for a historic site; what elements do you think are important to include?
3 What considerations do public historians working in public sector organizations have to take into account when creating educational activities?

Reading and resources

- Jones, A. (1995) Integrating school visits, tourists and the community at the Archaeological Resource Centre, York, UK, in E. Hooper Greenhill (ed.) *Museum, Media, Message*, Leicester: Leicester University Press, pp. 156–64.
- Jones, A. (2004) Using objects: the York Archaeological Trust Approach, in D. Henson, P. Stone and M. Corbishley (eds) *Education and the Historic Environment*, London: Routledge, pp. 173–84.
- http://www.boneswithoutbarriers.org/
- www.inspiringlearning.gov.uk

Evaluation and adaption

Developing educational materials requires the assessment of the educational value of history, both within the formal structure of the National Curriculum and the informal settings of public history projects. Prior to undertaking public history educational projects an evaluation of the potential obstacles to achieving educational "learning" outcomes and values is essential. This evaluation aids the development of the project and helps in making decisions regarding appropriate use of methods and techniques.

Educational evaluation requires the application of various assessment methods, including both qualitative and quantitative analysis to assess the values and issues (see Chapter 3).[38] These evaluation techniques can be applied before, during or after educational activities to assess the potential and actual educational outcomes. These include:

- *Concept mapping*: A form of mind mapping, similar to spider diagrams. A visual tool to understand how participants link things or ideas together. This helps us understand how knowledge is created and organized.
- *Formal and informal interviews*: Recorded and transcribed interviews undertaken with users about experiences and values of specific event or learning activity. This can include the use of closed and open question surveys.
- *Visual imagery*: The evaluator provides a statement or word for which participants produce a drawing, painting, or picture. This can take place after the activity and serve to represent an experience. This reduces the needs for verbal communication of information and enables openness. This supports the assessment of subconscious values.
- *Focus groups and workshops*: A group of people brought together in a communal space where open dialog and discussion are encouraged between the group and the facilitator. Usually the facilitator will start the discussion using open-ended questions or statements. This encourages a dynamic user survey to help understand why, what and how values are created. This enables participants to engage in critical self-reflection.
- *User diaries*: The participants undertake to complete a written, drawn and/or photographic diary of their experiences. This form of evaluation requires a close relationship with the participant. Thematic analysis of

the diaries can provide visual and written evidence of educational outcomes.

- *Critical incident technique*: Collecting direct observations of human behavior over sustained periods of time. This enables the evaluator to understand changes in behavior and responses over time in response to external conditions. This technique is used to identify individual responses and how these relate to success and failure of tasks.
- *Vignettes*: A method of providing respondents with a hypothetical scenario. Their reaction to this scenario is used to assess individual responses and processes.

The value of studying history at graduate level has been the focus of recent investigation by scholars and educationalists.[39] These studies have focused on graduate employability; on specific skills that history graduates gain during their university education that are of use outside of education; for example, "soft" skills, such as communication, self-awareness, and empathy are learnt alongside skills such as evaluation, critical thinking, writing, problem solving, and team working.[40] Booth and Booth's research indicates a disparity between what can be achieved and what is reflected in the learning outcomes of historical education.[41] It is this disparity that needs to be readdressed by public historians. This requires teachers in higher education establishments to develop a pedagogy, which provides a "pedagogic" learning journey for students. This necessitates more complex teaching and learning, which encourages personal journeys and plays a role in student development.[42] Continual improvement in history teaching techniques aims to increase the value of this subject to employers.

Key skills for teaching history

- Enthusiasm
- Creativity
- Flexibility
- Excellent verbal and written communication skills
- Patience
- Knowledge of a variety of historical periods
- Understanding of teaching theories and method
- Confidence
- Ability to plan and organize work

Schools, history, and historians

A history of history education

In many countries in the West, history has become part of the core classroom curriculum, in both primary and secondary education. In order for historians to work alongside schools, it is essential for them to understand the nuances of history education that exist in different countries and in some cases in a country's regions and states. This influences which specific elements of history are taught in the different curriculum stages, which are age-specific. This section examines the development of history within the school curriculum and investigates the differences and similarities in curricula, and how this influences teaching practices.

History's founding as a separate and defined subject in schools is not globally consistent. In some countries, history appears as one element in overarching subjects, for example, in the USA it is currently taught as part of the overarching subject of social studies. In others countries, such as the UK, history appears as a distinct and separate entity from other subjects.

History as a defined subject, taught as a separate subject within schools, has taken longer to become part of the core educational curriculum than "scientific" and "factual" subjects such as mathematics and science.[43] For history to be recognized as a separate subject, it had to transcend beyond facts and dates, and its former association with classics, and justify its wider individual role and value to education and society.[44] In the USA, in the early twentieth century, historical scholars in the American Historical Association (AHA) fought for the government to introduce history in primary schools.[45] History was first introduced as a separate subject taught from primary to secondary school level in the USA in 1909.[46]

The introduction of history as a subject in the UK occurred piecemeal and in an ad-hoc way, which was due to the divided school system. In the UK, the school system was, and to some extent still is, based on class, and included private schools (fee-paying), state schools (government-funded), and grammar schools (attainment-based but existing in both the state-funded and fee-paying sectors). As such, though compulsory education was introduced in 1870, an overarching National Curriculum in the UK, including history as a subject, was not introduced until 1988.

The formal integration of history was a gradual process, in which historians fought to communicate and prove its benefit to wider personal development. The inclusion of history in national, state, and local school

curricula is linked to the subject's relationship with national agendas and its broader value.[47] The nationalization of education and the creation of a "national" curriculum, which set the standard and subject matter, were not established until the 1980s in Australia and the United Kingdom. In Australia, it was through the support of the Australian History External Reference Group, that the Australian government started the progress of nationalizing its history curriculum, which was not successfully launched until 2011. The introduction of history in the school curriculum in the USA, the UK, and Australia serves to highlight the critical role of historians in the process of determining and establishing what type of history is taught in schools.[48]

The standardization of history curricula and their requirements, such as subject matter, themes, temporal spans, and essential aspects of national and world history vary from country to country. National curricula have prescribed subject requirements and listed subject material, which is linked to specific stages of learning and learning outcomes. Teaching is often determined through textbooks and national guides for the subject.[49] The prescribed nature of a history curriculum makes teacher choices and deviation from lesson plans difficult. Yet this curriculum provides a framework for museums to integrate their material within formal education, enabling historians to open up discussion with teachers and devise lesson plans to suit these curriculum requirements.

A curriculum is not a stable entity; national overarching and defined history curricula have been subject to change. For example, the recent changes to the history curriculum in the UK have seen a shift in focus to national rather than worldwide history. This change in history's role within the school system and wider national curriculum is determined by a country's dominant social and political ideologies (Case Study 7). This change reflects the influence of politicians, and, to a lesser degree, teachers and historians, in how history is viewed and valued by the wider public.

Research indicates that families and the home play a critical role in the formation of a child's historical knowledge and their connection to history.[50] This family history is often perceived by the public as more important than prescribed history, thus, the family's versions of historical events are frequently more trusted than history teachers' or public historians' versions of the past.[51] It is important for teachers and curricula to integrate these personal stories into history lessons in order to make the subject more appropriate and accessible.

National curricula reflect public choice by favoring periods of history in which the public have a stronger interest and reflect the past they choose to

commemorate and remember.[52] For example, in the UK history syllabus, particularly at secondary level (ages 11–18) the focus is on World War II history, while in the USA this syllabus focuses, through elementary and middle school (ages 6–14) on aspects of Constitutional history including the War of Independence and the Bill of Rights.

Case Study 8 Education in the USA

In the USA, history at secondary (high school) level is integrated within social studies, which includes aspects of civics and economics, language, arts and literature, and fine arts. This reflects the changing politics of the national and dominant views of history. In the 1980s, there was a move away from the traditional, history-centered approach, which led to history being integrated within social studies. This enabled the concept of history to be broader, more interpretive and less scientifically rigid and prescriptive.[53] This included the integration of archaeology within historical education and the ability of individual states and teachers to broaden the nature of history and utilize historical sites and museums. The subsequent Bush administration saw a return to a more traditional focus on "people, places and events."[54] History focused on traditional stories, and on the arrival of the Europeans and the "civilization" settlement of America.[55] In this paradigm there was little mention of the multiple cultures that make up the American population, or the huge time periods involved. This could be a contributory factor in the modern public's temporal confusion about the past, including their inability, in many cases, to put together accurate timelines of past events and peoples.[56]

These changes to history in the USA, since its inclusion with the national curriculum framework, would suggest that it is not only the broader nature of history as a discipline that is affected by government changes and dominant socio-political ideologies, but also the topics that are taught in schools. Consequently, these changes in the topics and teaching of history in the school system have the potential to influence the wider public's and future adults' understanding of the past and its role in the present.

Questions

1 What are the risks if history is taught through a standardized national curriculum?
2 Is a national curriculum for history needed? If so, which elements are important to include?

3 How do teachers integrate personal and family history into classroom learning? What benefits does this have?

Reading and resources

- National Council for the Social Studies (2010) *National Curriculum Standards for Social Studies: A Framework for Teaching, Learning and Assessment*. Silver Spring, MD: NCSS.
- Yarema, A. (2002) A decade of debate: improving content and interest in history education, *The History Teacher*, 35(3): 389–98.
- http://www.k12.wa.us/socialstudies/ealrs-gles.aspx

Recent changes in how history has been taught have been affected by internal and external politics and changing approaches to teaching and learning. Historical associations play an increasing role in bringing together academics and teachers, such as the Historical Association, in the UK, and the American Historical Association, in the USA.[57] These organizations have sought to improve relationships between historians and teachers, and historians and policy-makers, which has enabled new dialogs. These new dialogs have supported the development of curriculum and teaching practices both within and outside of the classroom. Relationships have also been established between academics, professional historians, and teachers. This has influenced teaching methods and content development, moving away from a focus on textbooks to the consideration of new pedagogical approaches and the incorporation of new technologies.[58]

Changing approaches to teaching

In the 1970s and 1980s, the pedagogical approaches to teaching diversified as teachers embraced pedagogies beyond the behaviorist approach. This shifted the dominant approach to teaching from a teacher-centered model, in which learners were passive receptors, to the incorporation of a more student-focused and active approach. This approach to teaching was based on the concept of learning by doing. It proposed that learning happened through personal experiences, through a system of actions, interactions, and reactions.[59] Research by psychologists and sociologists into learning through action, such as Vygotsky's social learning theory[60] and Bruner's discovery learning theory,[61] has influenced approaches to teaching history. This has

encouraged the use of more dynamic teaching methods, enabling flexible learning.[62]

Collaboration between history teachers and academics has informed teaching practices and approaches to classroom learning and led to new approaches to historical learning.[63] In response to academic historians' growing concerns about the teaching and content of history, formal commissions have been set up to bring together scholars and teachers to assess the quantity and quality of history taught in classrooms.[64] For example, the Bradley Commission in the USA (1988), concluded that history in the USA was under-taught, lacked depth, and failed to place history in a world context.[65]

Reviews of formal history teacher training qualifications, including their content, in the USA, the UK, and Australia, have investigated how these courses equip future history teachers to develop new approaches and teach history as a specific subject.[66] They have indicated a weakness and lack of depth in teacher training at college and university level, especially at primary and formative educational levels, which do not require teachers to undertake specific historical training.[67] This lack of historical knowledge means that teachers follow textbooks and, thus, typically omit conflict and suspense, making history seem boring.[68] A solution to this would be to base teacher training in both pedagogical practices and developing historical awareness.[69] This requires a system of discourse to be set up, to encourage closer working relationships between history teachers and historical scholars.[70] The Historical Association in the UK has supported developing this discourse between teachers and scholars through workshops, conferences and online discussion forums.[71]

Historical textbooks and classroom learning

In the UK, the introduction and rigidity of the National Curriculum have in part led to an over-reliance by teachers on textbooks when teaching history.[72] Textbooks provide mechanisms for standardization of teaching approaches, structure, and resource materials, which aid assessment, quality assurance, and benchmarking of the subject. History textbooks aim to provide guidance and support material to aid teachers and students in the subject. This includes subject overviews, ideas for teaching outlines, key illustrative case studies, or question and answer sections. Yet, history teachers, in part due to a lack of historical background training and

preparation time, have used textbooks as core teaching material, in some cases photocopying and repeating material verbatim to the students. This over-reliance on textbooks when teaching history can result in poor teaching standards, as teachers have lost the ability to move away from traditional "behavioral" teaching techniques. This lack of inspiring teaching practices can lead to a disinterest in the subject of history, and a lack of real-world relevance, which impacts on the wider public values associated with the subject.

Textbooks should be used as a teaching aid and a backdrop for learning, rather than the primary source of material and central teaching method. This requires reconsidering and questioning the content of history within the National Curriculum framework. Teachers should be empowered to have the flexibility to experiment with material and teaching practices and move away from generic elements in historical teaching.[73]

The pattern of textbook reliance by history teachers is a worldwide issue, due to poor communication between education professionals, subject experts, and teachers. While teachers have first-hand knowledge of students, contexts, and teaching practices, the textbooks are usually written by scholars, who have little understanding of the dynamics between pupils and teachers, and their diverse learning needs. Recently, teachers and scholars have worked together to tackle this issue, with academics providing guidance and standards for publishers of textbooks and with teachers providing the content: for example, Neil Smith's *History Teacher's Handbook*.[74]

The use of techniques, such as active participation in discovery, role-play, and class presentations and discussions can make history teaching in the classroom more real, vital, and meaningful to students. This has required history teachers to draw on situationalist theories, which consider the context of learning and provide the tools to enable learning to be a culturally embedded "activity."[75] Central to this is active participation in knowledge creation.[76] Adapting these learning methods and theories to historical education has required greater flexibly in the methods and materials used, including interacting with different resources in class, such as biographies, historical fiction, novels, short stories, and films.[77] This encourages students to create history through interviewing relatives, and visiting exhibitions and historical places. This method aims to encourage students to challenge history, to consider history in relation to current events and provide a temporal reference. This has supported students' interaction with history through contextualization and personalization of the past.[78]

The application of this method of social learning requires history teachers to develop learning activities that draw together national, local, and family historical narratives, to provide an overarching story that represents historical diversity, multiple perspectives and challenges historical stereotypes.[79] This can be achieved through encouraging personal research into family history and opening up a discourse between families and schools.

Family involvement in teaching history is critical to its impact and long-term value, as it supports history's wider relevance, beyond the school environment.[80] Breaking down the perceptions of history often formed in the home environment requires schools to develop methods to make and explore this family history within the current national context.

Public historians within historical institutions, such as museums, have supported teaching history within the classroom. Museums, such as the Chicago History Museum (Case Study 10) have worked with teachers to embed interactive activities in traditional classroom activities, including recreations and re-enactments of historical periods. In private schools, with high levels of financial support, such as Brighton College in the UK, teachers have employed external historical experts to develop and provide additional lectures and produce support material for students.[81] At Key Stage 2, "Teaching the Tudors," history teachers have worked with museums and external historians to produce learning resources and classroom packs, which encourage imagination and active engagement with re-creating the past through re-enactment that draws on historical sources. This has required the introduction of flexible and experiential learning approaches that enable personal learning. It is worth noting that implementing these methods requires resources, time, and funding, something many schools lack. As such, schools increasingly are relying on external organizations, including historic buildings and museums to support historical education.

Public history educational departments, such as those found in museums, have sought to further encourage this symbiotic relationship by employing former teachers to develop educational activities that link in with museum displays and material. This has, in part, been enabled by changes in curriculum and teacher flexibility, but also by museums broadening their traditional remits of display and presentation. As such, museums have found new ways to work with teachers that move away from worksheets to hands-on activities (Case Study 9).

Case Study 9 Baltimore County Public Schools Program of Archaeology

The collaboration between history teachers and scholars led to the creation in 1984 of the Baltimore County Public Schools Program of Archaeology, in the USA.[82] This program adopted archaeology as a vehicle for history to reach a broader school audience. It was integrated into the core "national" social studies curriculum in 167 state schools at K-12 level for children in both primary and secondary education (ages 4–19 years old). This aimed to provide students with "performance-based learning," using real-life, hands-on activities to discover history and encourage deeper more personal self-reflective learning.

Central to this educational program was providing practical learning activities, including the archaeological excavation of a historical site, which was linked with specific learning outcomes such as critical thinking, multicultural equality, and interdisciplinary study. This aimed to provide tangible historical evidence to back up textbook and classroom learning.[83] The success and proven educational benefits of this program led to it receiving federal and state-level funding.[84] This government funding was subsequently withdrawn in 2007 due to wider economic cutbacks and changes in state government agendas. Consequently, despite educational support, this program was forced to close in 2007.

Questions

1 What are the challenges of developing historical education in schools?
2 How can historians support historical education in schools?
3 What are the issues with public history programs being linked to government funding?

Reading and resources

- Jeppson, P.L. (2008) Doing our homework: rethinking the goals and responsibilities of archaeology outreach to schools, in J. Stottman (ed.) *Changing the World with Archaeology: Activist Archaeology*, Greenville, FL: University of Florida Press, pp. 1–58.
- Jeppson, P.L. and Brauer, G. (2003) "Hey, did you hear about the teacher who took the class out to dig a site?": Some common

misconceptions about archaeology in schools, in L. Derry and M. Malloy (eds) *Archaeologists and Local Communities: Partners in Exploring the Past*, Washington, DC: Society for American Archaeology Press, pp. 77–96.

• http://www.p-j.net/pjeppson/or/

Professional historians and educators

Education in museums and archives

Museums are defined as educational establishments; this is noted by the Museums Associations in Canada, the USA, Australia, and the UK. Research indicates that for the majority of the public, visiting a museum is synonymous with learning about the past.[85] Subsequently, education is at the core of museums' remit as they provide an arena for outside classroom learning and permit the public to access knowledge about the past. The large collections of historical material and historical experts all contained in one place in a museum mean that museums have the potential to provide an ideal setting for teachers and pupils to learn about specific historical events and periods. The central issue is that curators, for the most part, are not trained teachers and often lack the inclination, ability, and time to develop educational activities.

In response to the growing external demand for educational activities, museums have heavily invested over the past 20 years not only in producing entertaining and educational museum displays, but also in developing educational departments, employing historians and educational specialists, including former history teachers, as part of their core staff. The remit of these staff is to develop curriculum activities that are linked to museum displays, exhibitions and collections. In some cases new exhibitions have been developed and old exhibitions have been re-designed to meet educational demands and provide appropriate learning environments. For example, the Museum of London recently refurbished its Roman London Gallery in order to support current educational practices. This has included the installation of audio and visual technology, incorporating reconstructed shoemaker and glassmaker's workshops, and the development of new educational activities. For example, Londinium

2012 uses displays of modern objects, films, and poetry to aid learning, encouraging children to learn through forming associations with the past in the present.

The focus for many museums has been the provision of formal educational activities linked to primary and secondary education. These activities have been developed to meet specific "learning outcomes." As such, online tools have been developed to support museums and archives to achieve more formally focused and targeted learning activities. This has aimed to encourage and support non-educational specialists to develop activities that are based on learning methods and theories and are therefore more appropriate to curriculum-centered learning. For example, the Museums, Libraries and Archives Council (now part of the Arts Council) project "Inspiring Learning for All" provides documents that support the development of learning outcomes.[86] Linking activities directly to the learning outcomes in the History curriculum enables historical education to be undertaken with the support of teachers but led by professional historians, giving the pupils a different perspective on history. Educational activities developed by public history organizations are, for the most part, grounded in formal outcomes.

Education delivered by museums goes beyond classroom- and curriculum-oriented learning. Museums are developing as life-long educational establishments. Life-long learning in museums aims to provide access to learning and to history for the whole public, including those beyond school, with museums providing a space and forum to enable this.[87] This has involved professional historians, academic historians, and educational specialists collaborating to provide access to history education for more diverse audiences, including:

- young learners
- young adults
- adult learners
- older learners
- family (intergenerational) learning
- intercultural learning
- inclusive learning

The provision of education for adult learners has become increasingly vital in today's economic climate, as many universities have dropped their provisions for life-long learning classes, deeming them as unprofitable.[88] The British Museum has developed a program of life-long learning

activities, which bring in subject experts from both the museum and universities.[89] These courses are delivered to the public either over the course of a week or through a serious of evening and weekend sessions. For example, the "Sharing Learning Project," a partnership project with the University of the Third Age, is an eight-week project that assists older learners (aged 50–88) to research their own chosen historical topic as a future resource.[90] This project includes adult-centered classes and courses, which offer specialist training for "older learners," including amateurs, in specific aspects of history. Working with older learners requires flexibility, patience, and a suitable comfortable and safe working environment.

Museums and archives have sought to use their own in-house expertise, and experience of historical education, to support teachers in developing new methods to teach history (Case Study 10). This has involved delivering teacher workshops and training sessions using historical collections stored in museums and archives. The National Museum of Australia in Canberra offers K-12 (primary to secondary education) history training to teachers and trainee teachers so they can learn and experience history, discuss the curriculum, and explore galleries. It provides teachers with educationally-focused guided tours and previews of new exhibitions to support future use and adoption of material for teaching. The provision of online educational blogs and the hosting of the History Teachers Association of Australia annual conference have further aided the development of an open dialog and ideas exchange between teachers and professional historians.[91] This was, in part, developed in response to the recent introduction of history within the national curriculum. The teacher-training program has supported the development of educational material, such as digital overlays for galleys (AURASMA), teacher notes, educational games, and activities for school and home use.[92] This continues to be developed using a remote mobile tele-presence, which provides digital outreach through the use of laser guided robots.[93]

Offering vocational courses for teachers in museums is being adapted by many Western museums, including the National Museum of Denmark in Copenhagen. These courses provide continued professional training and a forum for future collaboration between teachers and museum professionals.[94] Museums no longer see themselves as passive educational facilities but rather as active educational establishments.

Case Study 10 Chicago History Museum, History Connections and Artifact Collections Project

The "History Connections and Artifact Collections Project," at Chicago History Museum, has involved museum educators working with local teachers to write and develop classroom resources for grades 1–12. These resources include lesson plans, online and downloadable activities, and artifact kits. They are based on key topics, including "The Hidden Life of Artifacts," "Early Chicago: The Fur Trade," "Industry and Innovation," "Transportation History," "The Great Migration," "Growing up in the '60s, '70s, '80s," and "Chicago Architecture."[95] The aim was to provide mechanisms to support students' active participation in the discovery of history, uncovering the hidden life of artifacts. This aimed to ignite curiosity and critical thinking by supporting the development of classroom artifact kits, interpreting the past in their own cultural and social contexts to develop their own conclusions. For instance, activities linked to the theme "Growing Up in the '60s, '70s and '80s" includes "Back to the Future" which is linked to grades 3–5.

"Back to the Future" is inspired by the movie of the same name (1985), encouraging students to write a story imagining what it would be like to travel back in time and meet their parents as elementary school students.[96] Teachers collect artifacts, i.e. films, toys and entertainment, records, yearbooks, video games, and books. Students are asked to look at and choose their favorite objects and complete a worksheet. This material can be downloaded, copied, and adapted for use in the classroom. Additional activities include interviewing their parents and collecting old photographs from them. It is hoped by investigating history through the development of artifact kits, this will stimulate interest through active participation and personally relevant history. These activities aim to develop historical empathy, to understand the relationship between the past, present, and future, develop writing skills and encourage creativity.

These historically related educational outreach activities do not require the museums to provide hands-on support for schools visits. Rather, their success requires the investment of time by teachers, both in the classroom but also in the preparation of resources for lessons. Students' ability to complete educational activities also requires family support. Consequently, it could be questioned

whether these in-classroom activities have the same benefits to students as that provided by museum visits and related hands-on activities.

Questions

1 How can artifacts in museum collections be used to provide a tool for learning?
2 How can museum professionals and historical educators working together aid learning?
3 Do online activities provide a tool for learning that is comparable with visiting a museum?

Reading and resources

- http://www.chicagohistory.org/education/resources/index
- http://www.chicagohistory.org/education/resources/hands/growing-up

Public–private partnerships have supported the development of virtual educational resources. The development of these resources has often been in response to user evaluations, which have raised issues relating to the nature of historical education in these establishments. In 2004, the National Museums Liverpool in the UK developed the Transatlantic Slavery Gallery Virtual Tour. This CD-ROM was a direct response to the teacher feedback relating to the difficulty that some school groups had with using the Transatlantic Slavery Gallery.[97] Narrators on the CD guided student learning through linking the gallery and its objects with eyewitness testimonies.[98]

Public and private partnerships and funding have enabled museums to produce online educational games for use in the classroom. For example, the Portable Antiquities Scheme, a scheme hosted by the British Museum and supported by the Department of Culture, Media and Sport, has worked with teachers to develop a virtual Anglo-Saxon village and PAS Explorers.[99] This provides a virtual and interactive tour of an Anglo-Saxon recreated village, in which children can explore, ask questions, and interact with elements of Anglo-Saxon life, such as trading, house building, and cooking. Furthermore, media companies, such as the BBC, have provided online educational resources for schools, including interactive timelines, questions, games and web chats with historians (Case Study 11).

Case Study 11 British Broadcasting Commission (BBC) Lesson Plans

The British Broadcasting Commission (BBC) has launched lesson plans that link into the UK National Curriculum. "History for Kids" encourages education in the home through games and quizzes, with sections including world history, ancient history, British history, and hands-on history. "Hands-on History" enables children to actively participate in learning through specially created video clips, such as animated cartoons, e.g. "A Day in the Life of a Ten Year Old in Norman Britain." Learning activities can be downloaded, such as create your own castle, create your own Bayeux tapestry, and the I Spy Castle Guide, a guide to how to identify a Norman castle.[100]

These activities have been developed in collaboration with teachers and experts. They aim to provide a fun and entertaining educational platform to encourage extra-curricular learning. The nature and content of these activities, including drawing on methods more readily associated with entertainment such as cartoons and comedy, provide a window into the complex debate surrounding the balance between education and entertainment.

Questions

1 Do online educational experiences reduce the need to visit historical sites?
2 How can educational games balance the need to be entertaining with the expectation of having educational value?
3 Considering the variety of techniques used to encourage learning, which methods are most successful?

Reading and resources

- Samuel, R. (2012) *Theatres of Memory: Past and Present in Contemporary Culture*, London: Verso, Chapter 8.
- www.bbc/historyforkids

Education at historical sites

Education occurring at historical sites and places of historical interest requires the application of more diverse and flexible teaching methods. This includes the adoption of practical methods, such as experiential and

cognitive approaches. These methods support multisensory learning, supporting visitors to learn through touching, seeing, smelling, and doing.

Historical sites have collaborated with teachers, to adapt their archival and historical material to work within pre-existing curriculum and classroom lesson frameworks. For example, the Oakington Heritage Project in the UK recently developed a children's festival on the Anglo-Saxon site, which included food historians, re-enactors, experimental history, and reconstructions. This was linked with Key Stages 1, 2, and 3, and specific learning relating to the Anglo-Saxon period. The material from the historical site, adapted to form part of lesson plans with the normal school curriculum, is easier for teachers to implement within a contained and managed learning environment. These collaborative projects aim to initiate a discourse between pupils, teachers, and historians relating to history and to provide visual aids based on local and contextually relatable historical evidence (Case Study 12).

Case Study 12 Mystic Seaport: The Museum of America and the Sea

Mystic Seaport: The Museum of America and the Sea is located in Connecticut, USA. The "living" history public museum is based on the re-creation of an eighteenth-century historical seaport and its landscape (Figure 4.2). It contains a museum, reconstructed historical ships and a reconstructed historical shipping village. These physical reconstructions of the past aim to depict and communicate the coastal life in New England in the eighteenth century to the public, including schools and heritage tourists.[101]

Mystic Seaport's educational team have recently developed a series of on-site activities, including "Ship to Shore" and "History on the Go." "Ship to Shore" is an overnight educational visit, in which children can spend the night aboard a ship, the Corad. This activity has been developed to adapt its material to specific curriculum requirements, such as immigration.[102] Mystic's "History on the Go" program brings history collections to schools.[103] This has taken items already in their collections to put together handling collections and learning packs to be used by teachers in the classroom. The collections are linked to educational resources relating to specific key stages and are available for teachers to use in the production of lesson plans.

Figure 4.2 Eighteenth-century re-created Mystic Seaport Museum
Source: Faye Sayer.

The on-site educational activities at Mystic rely heavily on the use of replicas, reconstructions, and re-enactments of history. These activities aim to encourage a broad audience to engage in historical learning, and thus increase visitor numbers, including heritage tourism and school visits, to the site. In order to achieve this goal, on-site educational activities incorporate multisensory elements, which are also entertaining. The visual techniques used to support learning, such as reconstructions, require historical assumptions and generalizations in order to provide simpler historical constructs of time periods. The constructed histories are believed to be appropriate to children, to curriculum requirements and to the time available for the activity. Thus, historical education at Mystic also comes under the category of historical entertainment, and the site treads a delicate balance between being an educational facility, a heritage asset, and an entertaining leisure activity.

Questions

1 Are reconstructions and replicas legitimate tools for use in educational programs valuable to the learning experience?

2 What is the educational value of participatory activities and overnight educational experiences?
3 How can educational programs balance the requirement to provide visual learning without resulting in the **Disneyfication** of the past?

Reading and resources

- Bartoy, K. (2012) Teaching through rather than about, in R. Skeates, C. McDavid, and J. Carman (eds) *The Oxford Handbook of Public Archaeology*, Oxford: Oxford University Press, pp. 552–65.
- Rentzhog, S. (2007) *Open Air Museums: The History and Future of a Visionary Idea*, trans. S.V. Airey, Stockholm: Carlssons and Jamtili.
- http://www.mysticseaport.org/learn/educators

Developing education programs for use on historical sites is complex, and can be difficult to organize. Their success requires creativity, imagination, and commitment on the part of staff and teachers. For example, evening "sleep-overs" combine learning with a social activity and have been used successfully at various museums and heritage centers around the world, including a Night of the Mummies at the Museum of Vancouver in Canada.[104] Yet, these creative ideas not only require a balance between entertainment and education, but also extensive management and the undertaking of risk assessments.

Historic sites can provide unique learning environments for all ages and encourage the use of a variety of teaching methods. These sites support learning outside the classroom and can meet the diverse learning needs of the public. Educational programs at these sites can be linked into wider educational strategies such as tourism.[105] For example, the public history program at Alexandria, Virginia, has linked its educational activities to both the state school curriculum and to educational tourism. One of these initiatives has been the "tour de sites," a guided and unguided bicycle tour of the historical and archaeological sites around the city.[106]

Public history educational initiatives are now standard practice on many historical sites and have enabled historical education to reach and appeal to a broader audience. Historic sites such as the seventeenth-century colonial settlement of Jamestown, Virginia, have sought to encourage educational tourism by using re-enactors. This has aimed to provide the visitor with a

visualization of the past and thereby encourage learning through experience, i.e. "experiential learning."[107]

Providing educational activities at historical sites can include the provision of active participation in the learning and discovery of history. Discovering the past projects at historical sites are frequently led by public historians rather than teachers, and require more face-to-face collaboration between teachers and external educators. The support required for teachers to engage in external learning is complex, requiring pre-trip activities to prepare the class prior to visits to historic sites and assistance in necessary logistics, including the completion of risk assessments, organization of travel, and insurance. The pay-off for this extra work is that this learning stimulates the senses and makes history enjoyable.[108]

Educational activities at historical sites not only focus on schools, but also on life-long learning and adult education. Public historians recognize that history has benefits beyond historical education, such as improving literacy and numeracy.[109] For example, the Jigsaw project run by Oxford Archaeology East is a community heritage project that combines volunteer training at historical sites with professional mentoring.[110] This project is supported by the Heritage Lottery Fund and is specifically designed for adults who have not had formal education, to provide valuable transferable skills.[111] The project aims to encourage engagement in heritage education and aid future employment.

Historic buildings, such as those properties owned by organizations, such as English Heritage, Historic Royal Palaces, and the United States National Park Service (NPS), can provide backdrops for historical education. They can serve as visual aids to reinforce historical knowledge gained in the classroom. The use of these historical places as arenas for historical education to take place requires focused frameworks for the integration of a building's historical story within specific curricula. As buildings are static entities, they can fail to actively engage the public, lacking the sense of uncovering and discovering the past that outside arenas, such as archaeological sites, encourage. As such, many historic buildings rely on guided and unguided tours to point out important features and explain the building's history to the public.

Developing education programs for historical buildings is complex. These properties often were in existence through multiple periods of history and involve interwoven stories, which are not only specific to the building and its residents but are linked to the building's wider historical context. Educational specialists are often employed by the estates, companies, and charities that

own and maintain these buildings to help develop tools to communicate their unique historical stories within a broader contextual historical framework. Educational communication is achieved using a variety of historical sources and various mediums for communication.

The historical education program at Chatsworth House in the UK focuses on providing schools with tours of the building relating to specific time periods.[112] These tours are linked to the National Curriculum, such as Key Stages 1 and 2, the Victorians.[113] Tours are conducted by actors playing the role of historical characters who guide pupils through the house. Specific rooms are re-created using historical items to provide visual aids to learning and re-enactors re-create the actions in the past to illustrate the use of the room. For example, in the kitchen, a Victorian cook re-creates food from the period and in the lounge a maid talks to the children about her life and experiences. This approach makes assumptions regarding the function and use of a room from one historical vantage point, one that might be interpreted as static and sterile. Yet, this form of storytelling and re-creation aims to provide the visitors with a comparison of history with modern lives and enables links between the present and past to be formed.

Education in historic buildings seeks to create an arena for living history, often using re-enactors and storytellers. These historical actors aim to create an interactive theatre for the past to support diverse audiences to understand and imagine history. Storytellers engage in detailed research of specific periods and people in history, and work with curators and teachers to provide a historical narrative to educate. For example, at The Hermitage, President Jackson's plantation house in the USA, storytellers provide historical and educationally focused tours of building.[114] These tours relate directly to the president and his career, with stories linked to specific curriculum requirements. This estate has sought to challenge conventional historical accounts through organizing a community excavation of the slave quarters of the house. The excavation has provided new historical evidence of the presence of slavery within a presidential home, contradicting previous historical beliefs that President Jackson's anti-slavery political stance meant he did not personally support this practice.[115] This activity has provided an opportunity for the public to engage in practical education and in the wider ethical and moral debates surrounding slavery, which link directly to the national curriculum in US schools.

Larger historical landscapes that contain multiple areas of historical interest or importance, ranging from buildings to archaeological sites, such as those owned by the United States Forest Service (USFS), require more

diverse teaching mechanisms to engage the public in the past. For example, the USFS in Minnesota has developed a framework to deliver historical education to the wider public called Passports in Time (PIT). The PIT banner provides a framework in which numerous educational projects can co-exist, including internships, volunteer training, and schools programs.[116] This program aims to recognize and support the broad educational value of historical landscapes, supporting educational tourism, recreational and leisure learning, adult learning, and school learning.

Academic historians and education

Academic historians are no longer primarily focused on undertaking ground-breaking and original historical research, leading to the production of articles and books, aimed at communicating new information to other historical scholars.[117] Rather, in the current Western "consumer environment of academia," in particular in the US and the UK, the role of the academic in the university system focuses on teaching: providing students with educational guidance and expert-led teaching in specific subject matters.[118] In many universities, particularly the post-1992 UK universities[119] such as Oxford Brooks University and Manchester Metropolitan University (MMU), teaching is not regarded as secondary to research, and undergraduate and graduate students are not treated as passive recipients of knowledge. University teaching has embraced new techniques beyond lectures and group tutorials. Institutions are now regarded as a place to teach future historians and instill a breadth of knowledge that will prepare students for workplace employment. Academic historians are under pressure to make classes result in specific learning outcomes, transferable skills and employability agendas to support this student development and post-university careers.

The pressure to provide "better teaching" and "better teachers" has led to many universities requiring all new teaching staff to undertake teacher-training courses. This has included the Post Graduate Certificate of Academic Practice (PGCAP) in the UK and the Post Graduate Certificate of Learning and Teaching in Higher Education (in Australia). These courses offer formal diplomas and Master's-level qualifications in teaching and learning in higher education. In the UK and Australia, these courses are accredited routes by which members of staff can become Fellows of the Higher Education Academy (HEA); this is deemed vital to maintain subject standards, including benchmarking and to uphold university teaching standards.[120] In

the UK and in Australia, many universities, such as MMU (UK) and the Australian National University (ANU), have made membership of the HEA a priority for all staff, and have supported accreditation.

Teaching courses, such as the PGCAP, aim to provide teaching staff with a detailed understanding of the diverse pedagogical approaches that can be applied within their teaching, and support the development of appropriate learning outcomes.[121] This has enabled new ideas to be generated and shared among scholar teachers teaching history and has encouraged staff to consider the multidisciplinary value of history to other students in different subjects, such as art, computer graphics, and English. For example, arts students in various universities, including MMU, have collaborated with history staff and students to use historical resources, such as archival objects, to create final project portfolios, which include illustrations, jewelry, ceramics and 3D models. New modes of teaching practice have been adapted in history departments, including in-practice learning through placements and group presentation activities.

New mechanisms for teacher training are driven by considerations of the demands and learning needs of students and, in some cases, future employers. This has led to history departments adapting their teaching practices in order to develop more flexible units and courses. This has involved universities providing students with diverse curricula, and situating learning to meet diverse learner needs, resulting in the introduction of flexible and experimental teaching practices, and the use of blended learning technique. The blended learning technique includes students, in part, controlling the learning and teaching, both its content and environmental context.[122] The result of this has been the creation of units and modules that include elements of placement learning. These have progressed teaching and learning beyond the normative classroom setting into the workplace environments, such as museums, archives, heritage centers and media companies. These modules aim to support individual learning styles and to develop student skills through action-led learning.[123]

Workplace learning units, such as those offered by Manchester Metropolitan University, the "History in Practice" course, have been developed through partnerships with external professional historians in public history organizations, such as the People's History Museum, the Museum of Science and Industry, and the Wigan Archives. Professional public historians and scholars have worked together to develop learning outcomes in supervised history placements. This unit seeks to encourage active learning and self-reflection, and produce real-life impacts for the

organizations, such as increasing visitor numbers and visitor diversity through student-led organization of open days and the development of new exhibitions. Alongside more traditional learning outcomes, such as acquiring new knowledge of history, these placement units aim to teach students transferable skills that prepare them for the world of work, both as public historians or for a diverse range of graduate careers.[124] These units have proven beneficial to host organizations, providing them with skilled volunteers to support public history work and develop new initiatives. For example, the Museum of Science and Industry, in Manchester, offers student placements to support the volunteer development through the institutional archives of History Pin, a community web-based initiative (Case Study 14).

The success of these singular public history modules and the demand for real-world applicable courses have led to the introduction of undergraduate and graduate Master's courses in public history. This has included the University of York (UK) and the American University (Washington, DC) graduate courses in Public History, and the Central Connecticut State University (USA) and the University of Hertfordshire (UK) undergraduate courses in Public History.[125] Collaboration with employers and practicing public historians in organizations has enabled these courses to become highly sought-after additions to a graduate's portfolio. The workplace experience and skills developed on these courses are highly desirable to employers, particularly in the heritage sector. These courses have been developed to prepare graduates in applied practices and approaches to history.[126] This vocational training requires a more structured approach, with defined learning outcomes and the incorporation of new teaching frameworks.[127] Other courses, including Museum Studies and Archival Studies MA courses, have been developed which focus more on individual elements of postgraduate training and preparation for work in public history organizations. Graduate qualifications are regarded as essential requirements for graduate employees in public history, particularly museums and archives, and are a prerequisite to becoming a Member of the Museum Association.

In the early twenty-first century, university staff in the UK, Australia, and the USA have been increasingly encouraged to diversify student enrolment, encouraging a more diverse range of individuals to attend university. In the UK, this was linked to the Labour government's initiative to open up higher education to all. This encouraged a range of widening participation programs, including AIMHigher, which has now been taken over by the Higher Education Academy.[128] AIMHigher worked regionally with local universities

to develop with academics a range of educational activities for secondary school pupils to take place within the university environment.

Academic staff at the University of Exeter developed an activity that combined the subjects of history, archaeology, biology, and geography. This activity encouraged pupils to use historical, archaeological and geographical evidence to put together a story of the past. A central component of this was a reconstructed burial; pupils were asked to uncover how, why, and when this person died. These activities and their development came with financial support and the potential of encouraging future students. Despite the changes and closure of many widening participation programs, including AIMHigher in 2011, the relationship between schools and academics has continued. For example, at Manchester Metropolitan University, history staff have worked closely with teachers to develop sessions for secondary school pupils that specifically focus on linking university history with National Curriculum history: for instance, using the Simpsons cartoon to teach elements of American History.

Teaching history at an undergraduate, graduate and postgraduate level is the area in which many historians feel comfortable, their natural habitat. The pressure to make history a more vocationally relevant subject and to provide students with skills for future employment has encouraged academics to draw on the skills of teachers to influence their pedagogical practices. Professional historians, including museums, archives, and media professionals have also influenced course content and have in some cases been invited to teach specific modules in public history and community history.

The role of universities in historical education goes beyond teaching undergraduate and graduate degrees to providing continued adult education. In the 1970s, universities such as the University of Oxford and the University of Bristol started providing extramural classes.[129] These classes, often held at evenings and at weekends, provide a university-accredited education in a non-academic setting, such as village halls, community centers and libraries. For example, the University of Oxford's Department for Continuing Education provides on-site and off-site courses, which are led by qualified practitioners and scholars. These courses are delivered both in person and online, such as "Civil War and Revolution: Britain Divided." Short day or weekend courses and summer schools, such as "The Byzantine World", are also a popular method of delivery.[130] Although initially popular, the frequency of these courses has declined over the past 20 years as many universities, such as the University of Exeter, have deemed them to be unprofitable, despite their continued popularity among students.[131] This

decline in adult educational courses in the UK is related to the withdrawal in 2007 of government subsidies for equivalent lower-level qualifications and with universities increasing their adult education fees to full-time fees.[132]

Historical scholars have a long-standing commitment to providing historical education to a mainstream, public audience. This has focused on traditional teaching activities, similar to those delivered to university students, but delivered in different settings and to diverse audiences, for example, lectures to schools and historical societies. Public lectures can be problematic; they require the consideration of a diverse audience, with different knowledge bases and expectations on content.

Recently, there has been a movement towards different, more populist educational activities, such as the writing of popular historical books, for example, David Starkey's *The Monarchy in England: The Beginnings* (2004), and presenting television programs, such as Lucy Worsley's *Elegance and Decadence: The Age of Regency* (BBC4, 2011). These populist formats require historians, as public educators, to write and present history in a more accessible manner, moving away from traditional academic language and delivery.[133]

Conclusion

Teaching the past should be approached with care; education is an important tool for the translation and appropriation of history. Formal education has been accused of teaching a false, simplified and stereotypical view of specific groups of people in the past.[134] Historical teachers, like all historians, have a moral and ethical obligation to be aware that what they teach and how they communicate the past to the public, even from an early and formative age, has a direct impact on public viewpoints and perceptions of the past. The diversity, or lack of, in historical teaching, can result in public and political tensions, and cause distance from the present.[135]

Teaching history requires communication between historians, scholars, and teachers. In recent years, professional communication between these groups has been supported by educational establishments and charities, who have delivered conferences, workshops and journals and developed support networks and internet resources to encourage open dialog between the sectors.

The introduction of diverse and more learner-oriented pedagogical approaches, including experimental and cognitive methods, has sought to

engage teachers, students and the public about history and to promote its value in modern society. These methods have enabled historical education to be inclusive, adapting not only to different learning styles but also to various teaching contexts. This has included the use of more practical and experience-led teaching in the classroom, including the use of handling collections, role-playing exercises, and multimedia and sensory equipment. This has shaped teaching methods and the interactions that historians have with school and teachers.

Historical education has, in recent years, sought to support learning through the use of media technology, such as the internet and television. These practices are more commonly associated with entertainment and, as a result, educational practices often tread a fine line between being educational tools and public entertainment.

Public historians' ability to teach history relates to their ability to encourage learners to engage with the subject matter. This requires those teaching history to have a breadth of understanding of history, learners, and teaching techniques. Successful delivery of education programs involves public historians adapting learning materials to internal and external environmental contexts. The appropriateness and potential learning outcomes of different teaching techniques, such as hands-on activities and re-enactment, are dependent on context, both historical and present-day. It is critical that public historians consider the ethical and learning implications of teaching mechanisms before their application in practice, such as historical reconstructions. This involves a careful consideration of a method's appropriateness, validity, and authenticity. Historical education has a lasting conscious and subconscious impact on the public and their perceptions of the past, which can be both highly emotive and potentially dangerous.

Routes into the history education sector[136]

Academic historian

History degree (high 2:1); history Master's (Distinction), PhD history. Additions: PGCAP/Teaching Diploma. The job description is:

- PhD in relevant area
- Research and teaching experience in history

- Ability to contribute to history teaching at undergraduate and postgraduate levels
- Publications of international quality
- Additional:
 - High student satisfaction
 - Experience of virtual learning environments, including online teaching aid
 - Strong ongoing international research

History teacher

History degree (2:1), potential Master's in history, teacher training qualification (such as PGCE [UK]). The job description is:

- Undergraduate degree in history
- Qualified teacher status, including PGCE (or relevant teacher training qualification)
- Experience of classroom teaching

Museums educational officer

History degree (2:1), Master's in museum studies/public history. Additions: PGCE/teacher training qualification. The job description is:

- Bachelor's (undergraduate degree) in history (or related subject, i.e. archaeology)
- Two/three years experience in museums (delivering educational programs)
- Preference for qualifications such as MA in Museum Education, Museum Studies
- Knowledge and experience of teaching and learning theories and methods
- Knowledge of the National Curriculum (PGCE)

5

Community History

Chapter Outline

This chapter examines how history operates at a "community" **grass-roots** level. It investigates the historian's role in community history projects and how this leads to the production of community history; including the production of a legacy in the form of exhibitions, books, and heritage trails. It examines how and why this growing field is so strongly supported by various government and independent organizations. It provides a toolkit of skills needed to support these projects, including facilitating grant applications by providing templates, advice on writing for popular audiences, and guidance as to how to manage these projects so they are grown organically from the "bottom up." This requires specific skills and has the power to address sensitive issues such as family connections and personal

and cultural identity. This highlights the need to balance the different inputs of the community and the historians in these projects, often requiring a shift in authoritative power relationships.

The chapter draws on international case studies to highlight examples of best practice in these complex projects, which provide guidance on methods and principles, including ethical codes of conduct. Detailed methodology sections are linked to activities on the web; including oral history, standing building and landscape surveys, community excavations, community archive research, and the use of culturally embedded technologies, such as Facebook and Twitter.

Introduction: what is community history?

Community history can be defined as the engagement of a community, usually geographically determined, with their local history. Community history projects facilitate the community becoming involved in the process of historical investigation, interpretation, presentation, and protection. They are public history projects that are run by or with a specific community of people.

Community history has been used by historians to justify their role and indeed history's role in society.[1] It represents a way of doing history with, for and by the public, rather than merely by and for the professionals. The broad definition of "community history" means that an immense variety of public history projects fall within its classification. The methods involved in community history range from traditionally associated historical activities such as historical archival research, building and landscape surveys, to less traditional historical activities, such as oral history, metal detecting, and archaeological excavations. This has resulted in community history engaging in a vast array of media to present and communicate history to the public, including books, websites, digital media, community museums, heritage trails, exhibitions, excavations, and public conferences.[2]

The word community in the context of community history disguises the numerous communities that exist within (often arbitrarily) geographically constructed areas.[3] The word "community" has been used by internal and external political groups to create a framework of unity and identity. In the UK, during the Labour government of 1997 to 2010, politicians, including the

former Minister for Culture, Media and Sport, David Lammy, extensively used the word community, often directly associated with history and heritage. Perhaps it is pertinent that this period was one of increased national insecurity, directly resulting from the rise of terrorist threats and actions, such as the 7/7 London bombings, the UK engagement in the wars in Afghanistan (2001) and Iraq (2003), and the global economic crisis of 2008.[4] The socially and politically created "entity" of community appears on the surface to be temporally stable and geographically coherent, but the realities of how a community defines itself and how it is defined by outsiders often conflict.[5]

The phrase "community history" is used to describe the heritage project at Hungate, York, a site that has not had a resident community since the 1930s, but which lies at the heart of a heavily populated city and is therefore indisputably within a busy, peopled landscape that is rich in historical and archaeological heritage. This illustrates how the definition of community is determined by individual, collective, institutional, and political agendas, and how as a result it is often contested.

The history of community history

The formation of community history stems, in part, from the formation of "community" and "personal" history. Local history societies provide some of the earliest formal and established examples of community history.[6] The majority of these societies were established in the mid- to late-nineteenth century and were, in the first instance, based on the philanthropic interests of their members, specifically relating to the practice and communication of history. These societies provided a medium for those interested in historical pursuits to share ideas and broaden their knowledge. They aimed to support individual historical objectives and encourage group research, often including family history, genealogy, and heraldry.

Local history societies forged close links with professional, academic historians; who in some instances were also members of the societies (often honorary) and who were invited to give monthly lectures on specific topics. It was through these societies that links were established between professionals and the community, albeit only where that community consisted of interested amateurs. These societies supported professional communication and engagement with a community beyond academia. The wider community and the public role of local history societies is promoted through the foundation of local history networks, such as the American

Local History Network and the British Association for Local History. These networks and associations of local history groups aimed to encourage and assist the study of local history as an academic discipline and individual and group leisure pursuit.[7] The goals of local history are supported through the production of publications, such as by the local historian, websites and the organization of conferences; these provide a mechanism for training, advice, and communication.

Prior to the 1970s, professionals regarded "community history" as history carried out by amateurs and local societies, rather than with the wider community. History and engagement with the community were to be found at this point between the professionals and amateurs, or formally with the schools and the educational system.

The 1960s saw a rise in community history undertaken by collective groups of individuals, including, for example, the History from Below movement.[8] This movement coincided with, and benefited from, the emergence of history workshops; a new practice that provided a platform for ordinary people to investigate, document, present, and preserve personal and communal narratives in history.[9] The History from Below movement was regarded as a way of expressing and constructing alternative versions of the past through the investigation of tangible and intangible heritage.[10] This new empowerment of the people and increasing public ownership of the past were arguably a part of the wider "grass-roots" movement, the prevalent broader political paradigm; the idea of public autonomy and democracy was used to support the idea of community-driven research into history. The influence of the grass-roots movement upon history specifically sought to empower the individual and collective groups of individuals to influence historical research and interpretation.[11]

During the 1960s and 1970s, there was a dramatic change in the nature and extent of community history, with History from Below being championed in a number of academic publications, including E.P. Thompson's book, *The Making of the English Working Class* (1963), which encouraged Marxist, radical, and socialist approaches to historical research.[12] These movements were associated with history outside academia. This period saw the beginnings of the public history movement, with formal initiatives, such as history workshops in the UK and the *History Workshop Journal* (1976), which were formed to encourage "community" history initiatives, such as oral history projects.[13]

The History Workshop movement was founded in the same era as the trade unions, the social history movements and the Workers Educational

Association (WEA). This resulted in the formation of organizations, which aimed to support and represent the working classes, and those who were under-represented. Independent organizations that emerged from this period, such as Ruskin College, Oxford, in 1966, specifically aimed to provide training for the public in historical research and provide a public voice in historical dialogs.[14] This was the foundation of the History Workshop movement and its early formation was based on the broader idea of public history. This resulted in projects such as QueenSpark, Brighton in 1972, now known as QueenSpark Publishers, which developed as a form of community action over development and use and preservation of community buildings and landscapes. This community action project included a community history group, to represent, preserve and raise local awareness of the area's heritage.[15] Formal initiatives influenced local history societies, whose role in community history developed, as many professionals sought their help to carry out community history projects. Interest in these societies by the general public increased as personal pasts were promoted through academic research and government-funded projects. For example, the Bradford Heritage Recording Unit (BHRU) was set up in 1983 by Bradford Council and local government and was financed by the government-funded Manpower Services Commission, which sought to provide temporary employment for the unemployed. This community history facility and its associates aimed to record the stories of the multicultural inhabitants of the city and provided opportunities for the local community to engage in community history. As a result of these wider movements, government funding, academic research into community history and membership of amateur history societies all grew, and in the 1970s and 1980s many new local societies were formed, which still make up many of the 654 local historical societies in the UK at present.

This period also saw an increase in public interest in genealogy and family history, particularly in Australia and America. This family history movement traces personal histories through reflective, backward progression rather than forward motions; as such history is understood to start in the present and work back through time.[16] This reflected a search for identity, and for individual and collective ancestry, potentially representing overarching feelings, including personal insecurity in the changing and increasingly multicultural world.[17] This resulted, in some contexts, in a growth in individualist, self-oriented, and self-serving history, acting to affirm and reaffirm one's own place in society. The growth in family history and genealogy had a direct impact on the inclusion of different stories in history, including intangible heritage. For example, Aboriginal Australian personal

histories were traced through this method of inclusion and incorporation of intangible and personal heritage. Consequently, indigenous rights had an impact on the public practice of history.[18]

During the 1960s and 1970s, the political focus in the West turned to social inclusion and education. Subsequently, there was an increase, specifically in the UK, in government support for community work. These decades saw the first use of the phrase "community history" and concepts relating to communication and public history began to be formally discussed in the academic literature.[19] At this stage, community history was neither developed nor widespread enough to be recognized as a sub-discipline, but many of its principles were being applied in an ad-hoc and localized manner to historical education initiatives, principally led at a local level by individual academics and professional historians. The social and educational values of history were acknowledged, and new educational courses were perceived as moving history away from its upper- and middle-class origins.[20]

The 1980s saw a global focus on economics, policy, and increased local government and state responsibility for budgets. During this decade, increased regulations were attached to heritage, and quasi-autonomous non-governmental organizations (**quangos**) and privatized public sector organizations were created.[21] In 1983, the Historic Buildings and Monuments Commission for England, supported by the National Heritage Act, established English Heritage. This institution was formed from the pre-existing government national heritage organization called the Ministry of Works.[22] English Heritage began work in 1984, sponsored, supported and guided by the Department for Culture, Media and Sport.[23] Quangos such as English Heritage considered the costs and benefits of history, and acted as advisors to the government as to its value.[24]

Community history projects were, in this period, linked to regeneration projects.[25] The Liverpool Albert Dock regeneration project in 1984 was, in part, instigated due to the recognized historical importance of the site as part of the national ship building history, which included Grade 1 listed building statutes.[26] This historical site was abandoned in the 1970s and by the 1980s had become derelict.[27] In 1984, as part of the city's wider urban regeneration plan and community pressure to preserve its historical importance, the site was redeveloped.[28] This aimed to support the area's economic growth, provide employment, alongside promoting and communicating the community's unique history. These projects indicated a realization, both by the government and historians, that history had values that extended beyond knowledge creation. This was a period of

renewed community activism; with members of the community feeling disenfranchised from the government and the establishment, and lobbying for greater control. This to some extent was linked to urban regeneration schemes in which communities and their history came under threat from development. It was during this period that whole areas of cities were demolished, with entire communities moved and re-housed, for example, in Birley Fields, Hulme, in Manchester.[29]

The community activist movement empowered groups of people to challenge traditional historical interpretations, particularly those historical representations housed in government-funded museums. The local history and grass-roots movements of the previous decade had given this community a voice in history, including academic support from many professional historians.[30] However, during the 1980s, tensions developed between "community history" and "academic history," which manifested as a polarization between the established and anti-establishment views of history. This was particularly prominent in Australia and the United States, as Aboriginal and Native American populations engaged in activism and political campaigning to change established views and empower community control over history.[31] The community history movement of the 1970s had given these disenfranchised groups a voice that became the platform on which the political activism of the 1980s was based.

The 1990s saw political agendas in much of Europe, the United States, and Australia shift to focus on social agendas. This included developing shared resources, developing education, and widening participation. The theory of education underpinning social betterment, and creating identity, was highlighted in the UK by the previous university grants systems being abolished, in favor of financial support through long-term personal loans and subsidies for students from lower socio-economic backgrounds to study at university (though the effectiveness of this is debatable). The focus on equality and education for all came with financial incentives for organizations, such as museums.

This period saw a change to how professionals viewed history; the word heritage became used to describe "community history" and its projects. Increasingly, history became an all-encompassing phrase, used to refer not only to the "tangible" physical evidence of the past but also to the "intangibles," i.e. the non-physical evidence of the past including people's memories, beliefs, folklore, stories, and feelings. This change was important for community history as it enabled the public to have a wider input into what was defined as history and what was of historical value, and to justify the

purpose and value of community history to political, academic, and professional audiences.[32]

Museums reflected this change in professional and public relationships, seeking to involve the public in the process of knowledge creation and presentation, and they developed collaborative exhibitions, "people's shows" to move beyond the assimilation of authoritative narrative to meaning-making of history in the present.[33] It was during this period that the Smithsonian National Museum of the American Indian was created.[34] The museum aimed to represent and promote both the tangible past and the intangible stories of the Native American people. As such, all elements of this museum, including the internal and external architecture, the galleries and displays were designed and created through a collaborative process between Native Americans, academics, and government heritage professionals, in which the past was re-negotiated and retold.

During the late 1990s and the early twenty-first century, community history thrived by meeting the government's social and education agendas. Large-scale community history projects such as Shoreditch Park in London, received significant external grants, such as those from the Heritage Lottery Fund (Case Study 15). As a result, the number of professional community historians increased dramatically, with many positions funded either through public grants or directly, by in-house organizational funding, for example, as roles as museum staff.

The early twenty-first century has seen the introduction of technological advances and new initiatives to support the potential **consumerism** of community history. This has included the use of **digital media**, such as the internet, to support historical knowledge and research to be shaped by the community. This has resulted in community blogging and **crowd-sourcing** of history, enabling history to be created directly from and by the public.[35] Examples include the crowd-sourcing of images and oral history testimonies such as the September 11 Digital Archive Project (Case Study 29), and the historical image project History Pin (Case Study 14). The dividing lines between the producers and consumers of history are becoming increasingly blurred, with, in some cases, the community itself driving many community history projects, directly controlling the intellectual ownership of history.[36]

For much of the last decade, community history initiatives have operated under increasing financial pressure caused by the global credit crunch, requiring more innovative approaches to compensate for the funding cuts suffered by many large organizations such as English Heritage, Museums,

Libraries and Archives Council, and the United States Forest Service. This has led to the closure of many organizationally led and state-funded community history projects, such as the Baltimore County Public School Program of Archeology (Case Study 9).[37] Despite this, grass-roots History from Below and volunteer-led projects have continued to thrive, driving community history back to its local roots.

Methods for community history

Over the past 30 years, community history has expanded beyond the traditional approaches to public interaction with the past that were more commonly associated with local history societies, such as professional lectures. It has sought to support and link individual research pursuits; such as investigation of family trees and genealogies. As the access to history develops, the breadth and nature of community history undertaken by individuals, societies, and groups are increasingly organized and diverse. Community history's growth is linked to organizational and government support, developing relationships outside the profession and communicating history to new demographics that have enabled community support. There is still demand from local societies and groups for professional lectures on specific topics from history; there is also community demand for support and guidance from professionals in creating more proactive and engaging activities, with particular emphasis on facilitation. Therefore, for the professional, community history has become the essence of what public history sought to be; providing support to community-driven initiatives and encouraging a wider audience to engage in and understand history.

The top-down approach

The **top-down** approach is initiated and led by professional historians who enter into consultation with the communities they intend to work with, typically with pre-determined research agendas. The top-down approach could be regarded by professional historians as being ethically and professionally accountable to the public. It should take into consideration the community's wishes by adopting a reflexive approach to the interpretation and communication of historical findings. With this approach, the scope of community history is broad, and is still managed by professional historians.

It is the most normative application of 'community history' worldwide, and includes projects such as Birley Fields, Manchester (Case Study 26).

The top-down approach engages the community in the co-production of history, by involving them in the process of historical research, and its interpretation and presentation. It does not require the community to be involved in the entirety of the historical process and historians are selective in what the community are "able" to be involved in. The community, to some extent, is still excluded from the setting of the initial research agendas, but ultimately the historian, the outsider, is still in control of the past. As a result, this approach to history could be criticized as being more of a public relations exercise for history that could be defined as "community consultation history."

History from below

The bottom-up, grass-roots, community-based history approach enables all aspects of a historical project to be controlled, at least in part, by the community. These projects are often initiated by communities and facilitated by professionals. This enables the community, often with the support of professionals, to set research agendas and develop appropriate methodologies. Therefore, grass-roots public history is more flexible in its methods and aims. Yet, though these are publicly led and the aims usually focus on local benefits, they can become private endeavors and serve to meet the internal values of communities. For example, the local community might want to gain economic benefit from history alongside reinforcing control over their traditions, land, and cultural beliefs through history.

The bottom-up approach is advocated by many public historians, and public history organizations. Archives and museums are supporting these grass-roots initiatives by providing free training, professional advice, and facilitating the use of their resources to the wider public.[38] In addition, amateur societies can ask for the assistance of public historians to support their work and help develop further projects; either by developing mutually beneficial research agendas or by offering consultancy fees.

Despite the different levels of professional support for community history, the bottom-up approach has had issues with ownership and power relationships, including where projects have become slaves to personal agendas rather than promoting democracy. Thus, the community can merely serve a professional's purpose by conducting their research for them, or historians can be used for a community's political and economic purposes. Such examples suggest that even when projects are initiated from within the

community, they are instigated and controlled by a minority of interested parties within the community, for example, amateur groups or a locally resident historian, rather than the whole community.

Case Study 13 Muncy Community Heritage Park Project

Muncy Historical Society is a small but active amateur history group consisting of residents of the town of Muncy, Pennsylvania, in the USA. The society holds regular meetings, which include inviting guest lecturers to talk to their members about historical sites or people relating to the geographical area. Muncy Historical Society has been proactive in researching and communicating the local history of the area to the wider community. This has included setting up and running a local community museum in the town. This community museum aims to showcase Muncy's nineteenth-century history, including the state-registered historic railroad and its role in the industrial heritage of the nation.

In 2006, the society and its members developed and launched the Muncy Canal Archaeology Project. This project aimed, through historical and archaeological investigation, to create a heritage park on the site of the nineteenth-century canal and watermill. As such, the project involved an extensive landscape survey undertaken by its members, which identified historical features in the fields and woodlands surrounding Muncy. In 2007–2008 this culminated in the community archaeological excavation of the lock-keeper's cottage.[39]

The excavation was on privately owned land, and was directed by the Chair of Muncy History Society (Bill Poulton), with the support of an independent archaeologist (Robin Van Auken). The society aimed to provide historical evidence to support the site being state-registered as a historic site, which would enable the society to apply for state funding for the creation of a heritage park on the site. This society-led bottom-up project aimed to encourage the local community to engage and participate in historical research, through activities, such as the excavation, and a schools object-handling session, and make this historic canal area of Muncy a community heritage asset.[40]

This project highlighted some of the issues with bottom-up community history projects. It indicated that local involvement is often limited in numbers and diversity. This in part related to the

small size of the project and the restricted visiting times, which resulted from limited financial support and manpower. Projects with limited funding and lack of professional support can result in poor standards of historical and archaeological research. In Muncy, this resulted in issues with maintaining professional excavation and recording standards and poor conservation of historical finds. As a result, it could be suggested this project failed to serve the whole community, but rather it supported individual and amateur political goals.

Questions

1 How can community history projects maintain professional standards?
2 Are there issues with organizing community history projects that have wider public value? What mechanisms can be implemented in order to prevent these?
3 Which is a more appropriate form of community history; bottom-up or top-down?

Reading and resources

- Simpson, F. (2009) Community archaeology under scrutiny, *Journal of Conservation and Management of Archaeological Sites*, 10(1): 3–16.
- www.muncyhistoricalsociety.org/dig /index.html

Community history projects

Community history projects often combine a range of methods and diverse forms of historical enquiry and communication. They vary from smaller projects run by local history societies, including archive research projects, to larger multi-method projects managed by organizations, such as museums (Case Study 15). These projects can result in the creation of community history exhibitions and self-published history books, which are often supported by local museums or academics, aimed at showcasing and communicating the project to the community.

Community history projects can seek to be collaborative efforts, reaching a wider number of community members through varied proactive activities with a broader appeal. This can include community excavations and building

and landscape surveys. Although often initially smaller in scale and scope, through the support of professionals and the community, these projects can become larger multi-stranded efforts that have longer-term sustainable outcomes, for example, the Alexandria Public History Project. These projects can result in sustained to future grant or government funding; for example, the Portable Antiquities Scheme, a national community historical and archaeological artifact recording scheme in the UK, now receives long-term general government funding and is hosted by the British Museum.

Working as an independent public and community historian or with an organization requires the application of key considerations and approaches to developing community history:

- *Research*: This includes a demographic (i.e. age and sex) and contextual understanding of the history and heritage of an area. Detailed research into population, organizations, and pre-existing community groups is required.
- *Public consultation*: Organizing public and group meetings to discuss the proposed project. Consultation with community members, including teachers, local societies, regeneration teams, and individual residents provides an understanding of how to communicate, collaborate, and present history in the local public domain. The setting up of steering groups of interested stakeholders (those with an interest in the project and those the project will affect), can help make the project more applicable and relevant. It is through consultation that the public can have input into the project and develop a sense of ownership.
- *Support*: Consultations with stakeholders are vital to gain public support. This will need to be demonstrated for any grant applications, usually through letters of support from community organizations and local residents.
- *Project design*: Based on previous activities, including consultation and initial research, the stakeholder steering group creates a list of key aims and objectives of the project, including how these aims will be achieved though community involvement.
- *Activities*: The selection of activities, the key mechanisms, and methods required to meet the community history project's aims and objectives. This can include a range of publicly engaging activities, which will be determined by the nature of the public and the content of the project. The aims and objects of the project may change over time, which will require an organic and responsive method of working.

- *Budget*: The private or public source of the project's funding will shape what the project is able to afford to do. Aims, objectives, and activities will be tailored according to this budget. Budget management prior to the project requires a detailed breakdown of expected costs, including people's time and equipment. Overseeing these budgets requires the adaptability of the project and the historian to work within the financial restraints and potentially recruit volunteers to assist with the project.
- *Timetable*: A detailed timetable with key dates, tasks, and milestones. This provides a logical and clear outline of the key tasks and individual responsibilities for these tasks and meeting targets on agreed dates.
- *Tasks and organizational structures*: Key tasks and roles are allocated to staff and volunteers. This requires project management, leadership and an inclusive division of tasks, so that everyone feels involved and plays a role in the final project. Gantt charts and project manager software are often used to accomplish this. On larger-scale community history projects, especially those that are grant-funded, a project manager will be appointed to organize this and the volunteers.
- *Marketing*: Community history projects need to reach new demographics; this requires effective marketing and the advertising of activities and dates to encourage the wider community to participate. This can involve social media campaigns that use platforms such as Facebook and Twitter, as well as posters and adverts in the local press, and press coverage on television, radio, and newspapers.
- *Outputs and dissemination*: Dissemination aims to communicate the project and its findings to the widest possible audience. This can include creating a website, writing a book, or publishing popular journal articles.
- *Evaluation*: This provides a mechanism for the analysis of what was done, what worked, what didn't, and scope to consider the potential changes required for future projects and best practice. During the project quantitative and qualitative evaluations will be undertaken, including surveys and visitor numbers and demographics, to understand the impacts the project has had on community values.

Oral history projects

Oral history is history in action; it provides a narrative of the past as told in the present. This method bridges the gap between formal historical

knowledge and social memory, through professional and the public collaboration in order to understand the cultural landscapes of the past.[41] The practice of oral history can be an act to uncover hidden histories, those untold, unwritten, or forgotten histories that do not make it into archives and into the formal records, but rather lie hidden or dormant inside the historical actors' minds; for example, the Chinese gold miners in Rushworth.[42] Oral history projects seek to uncover these histories and tell the human story of the past, usually focusing on a specific place.

Oral history is a form of social history, which enables an understanding of the past by unraveling the multiple intersecting and connecting layers of personal and communal experiences and memories.[43] This is achieved by the historical actor, a person in the present, personally recounting memories and stories of events, places and people in the present, through the act of talking, answering questions, and listening. As such, oral history can act as a mechanism to control and define identity, and as a tool to understand how actions in the past create personal and communal identity in the present.[44] The act of creating oral history can enable people to connect or reconnect to a place through the triggering, linking, and sharing of memories.

Research methods

The research methods utilized in oral history approaches were first developed in social sciences such as anthropology, sociology, and psychology. They require the interviewer to understand human interaction and communication and to carefully balance this with discourse analysis. From the initial aims of oral history projects, during interviews and the interpretation stage, consideration of the approach used in relation to ethical considerations must be upheld.[45]

Oral history projects usually focus on researching specific moments or periods in history. For example, the "Their Past, Your Future" project was focused on collecting stories from World War II veterans in the UK (Case Study 2). However, the same approach could be used to study narrower historical moments or areas, such as understanding the history of a specific townscape, landscape, or even streetscape. The nature of oral history means that it can only be used to chart more recent historical periods and actions, from which there are surviving witnesses to provide first-hand accounts. The requirement for surviving witnesses means that the majority of oral history projects focus on twentieth-century history. In addition, the type of data collected by oral history methodologies means that projects have frequently

focused on the changes taking place over a period of history, such as the development of communities, the influence of immigrant populations, or the impact of industry or war. Michigan State University's South Africa: Overcoming Apartheid, Building Democracy,[46] and Penn State University's "Back from Iraq, The Veterans' Stories Project,"[47] are both examples of this practice.

Oral history projects require background historical research to shape their specific aims and objectives. This provides a focus for the interviews, identifying themes to consider when talking to the participants. It determines the selection criteria for interviewees based on the nature of historical research. Critically, this requires consultation and collaboration with the community, often working with local history societies, community groups and community members to help shape the interview process, locating people to become involved and take part in interviews and developing community support for the project. In some cases it is the community who drives the process with the support and facilitation of the oral historian.

Interviews

Interviews should be carried out in a setting in which the interviewee and interviewer feel comfortable and safe. This likely to be a familiar quiet space, such as the interviewee's own home or place of work or a community space. The environment where the interview is carried out will determine the relationship of the interviewer with the interviewee and affect the openness of answers to questions. The aim is to establish an environment in which the interviewer and interviewee feel comfortable, and that is safe and relaxed. Background noise is another essential consideration, and it is important to engineer a degree of privacy to these interviews with minimal interruption. Personal stories, memories and potentially controversial topics are often considered private matters and though the information is being shared freely and the interviewee is aware these records will become public, they are still unlikely to be comfortable discussing them in a public space. Quiet, private places not only provide a sense of security for the interviewee but also an uninterrupted space for the interview to take place. Although one-to-one conversations are often easier to manage, there are some situations where group interviews may provide the best dynamics for oral history. These can provide a freer flowing space and support network to discuss memories and triggers for memories from others and can then lead to more detailed interviews with individuals.

The interviews themselves should be framed around the predetermined project themes. They aim to be conversational and create a dialog between the interviewee and interviewer, in which talking triggers and encourages memories to be uncovered.[48] The interviewer will help the interviewee recount and create their own story of history, rather than leading. This may require guidance by the interviewer, maybe providing a trigger such as a photograph and open-ended questions to provide a structure and a starting point for the conversation. These questions should be plain in language and non-suggestive in nature, for example, the non-leading question, "What do you remember about the living conditions?" is preferred to, "Living conditions must have been really bad, can you tell me about them?", as the latter is more likely to influence the response. The interview should always start with the name of the interviewer and date of interview, ideally followed with the location of the interview, the name of the interviewee, and any other relevant information, such as their address or date of birth. It is critical that the researcher follows ethical standards and that these are provided to the participants and they are made fully aware of the nature of the project, the intent, and the planned use and availability of the material after interview. A record of the interviewee's consent must be collected; typically a form is signed which provides agreement to the outlined terms and the ongoing use of this material for future work.

Specific projects will require, due to personal, political or religious sensitivities, that the participants remain anonymous. Anonymizing data is part of the ethics code set out by research institutions for all social anthropologists and oral historians.[49] This seeks to respect and protect the interviewee from any potential future problems relating to any data supplied for use in study, for instance, transgressors whose data could be used in a future court case against them. The anonymizing of data will be clearly outlined in the initial interview agreement, and will stipulate all names will be changed to unidentifiable codes and access to original material by those outside the research project is prohibited. Names can either be changed to number or letter codes which only the interviewer and data analyst have access to.

Recording

It is essential that interviews are recorded; this provides archival material that can be used for future research. Recording enables material to be checked and permits reinterpretation of the original study material at a later date, potentially in light of new evidence or modes of interpretation.

A range of equipment is used to record oral history testimonies, including digital recorders and camcorders to tablet computers. The choice of technology depends on the context of the interview and the reliability of the technology, i.e. its ability to record for long periods of time, to provide adequate quality of recording for future use, and to transfer files to digital storage. Advice on the appropriate use of technology is laid out in the "Guidelines for equipment of oral history in the digital age."[50]

The normative approach is digital recorders, in part, due to their ease of use and unobtrusive nature, as well as their ability to capture high quality recording and to store large amounts of data. However, advances in digital, hand-held video recorder technology have led to their increased use in recent years. Such devices often work better in group oral history work, enabling the association of people with voices and encouraging analysis of body language and personal interactions. These observations can enable deeper levels of interpretation by adding additional layers of nuance to participants' responses and can provide a human face to a story, which is valuable if the material is to be used for exhibitions. The use of video camcorders presents some difficulties for oral history projects, specifically undermining the interviewee's sense of anonymity, and it can be an intrusive presence which may, especially in one-to-one interviews, make the interviewee uncomfortable and self-aware. Practical considerations include the need to set up the video and recording area in advance of interviews. This issue has largely been overcome with the development of mobile computing technology that allows for immediate recording and uploads of video data.

Storage and interpretation

Oral history interviews collect a vast amount of digital data. Both this primary data evidence, and copies of this data, should be stored in order to provide a permanent archive of the material for future use and reference. This data should be treated as any primary source material and appropriately labeled, including descriptions of the person being interviewed, the title, the time, the date, and their relationship to the project. This material should be uploaded and permanently stored in an online database, with digital copies provided for the archives and the participant. This provides both transparency of research and the chance for the participant to comment. To enable the material to be used in exhibitions, books, and television and radio programs, it will require editing to meet the requirements of such formats.

The initial stage of these recordings is transcribing the material, the writing out of the conversations in long hand. The material is then analyzed, using techniques such as critical discourse analysis and coding.[51] The text material is evaluated based on themes, which can be either pre-determined or not fixed. These themes can be color-coded in the text to link the themes to key phrases.[52] Material can be used to create historical narratives, such as books; for example, *Rich in All but Money: Life in Hungate, 1900–1938*, which develops the story of Hungate in York through the oral history testimonies of former residents.[53] Recently, the use of analytical software such as ATLAS has aided this analysis and mitigated against the need for the lengthy transcription process; this enables data files, audio, video and textual data to be uploaded and qualitatively analyzed, the program itself generates themes and patterns in the oral data sets.

Historical building and architectural surveys

Historical building surveys are detailed studies of the architecture of a building; this identifies historical stories of a building based on architectural features that relate to specific time periods and stylist traits. These studies identify and record the physical nature of a building, its historical associations and state of preservation, i.e. the current condition of a building. They involve an individual or team of individuals engaging in a detailed recording of a building's features; including taking photographs, writing descriptions, and producing architectural surveys and drawings.[54] Projects often involve the local community, providing an initial training on historical, architectural identification and recording and then equipping individual members with pro-formas that provide a checklist of all the relevant details that will need to be recorded. This enables a large-scale area, such as a village or district to be investigated and recorded by amateurs, volunteers, and local community members, who through their involvement in the survey will gain a new understanding of their surroundings and the layers of history within it.

Different elements involved in the process of historical building survey can include:[55]

- drawing a scaled floor plan of a building
- producing a detailed photographic record
- narrative description of current state of building

- narrative description of internal and external architectural features
- evidence of development of building: alterations and additions
- current use of building
- use of surrounding space
- archival research; census surveys; planning consent; change of use

Historical building surveys range from investigating a single building to an entire residential area and can include a diverse variety of structure types, for example, community buildings, churches, residential buildings, shops, and even street architecture such as lamp-posts. A good example of a varied historical buildings survey with a strong community involvement is the Wakefield Building Survey. This project was initiated by Wakefield County Archaeological Society, supported by local community outreach officers, and led by members of the community and the amateur historical society, who were responsible for mapping historical buildings and the architectural features in the area. This included taking detailed photographs of buildings and creating a map of places of historical interest. The material was collated and added to the existing historic environment records' online database, to provide the public with access to and information about local historic sites. This was then linked to heritage trails of historic buildings for both schools and individuals.

These surveys create a typological survey and historical chronology of the architecture of an area, which can provide information to help aid conservation work and feed into "buildings at risk" surveys and registers, and listed buildings surveys.[56] Public-led surveys have the ability to challenge professional ideas of historical significance and to create a list of buildings in an area that are not only understood by professionals to be historically important, but which also incorporate structures that the public regards as important to its local heritage identity. The value of an approach that incorporates the views of the local community is highlighted in the building survey of the chicken shed at Çatalhöyük, Turkey.[57] This survey, which followed English Heritage guidelines and standards for data collection and analytical techniques, illustrates the juxtaposition between the community's perceptions of historical importance based on historical functionality and relevance in the present and professional historical importance based on longevity and historical positioning.[58]

Building surveys provide an understanding of the unique history and development of an area and its buildings, placing it within a wider historical context. For individual buildings, a survey creates a biography, which can be linked to archival records to tell a story of the building and its occupants

through changes and additions in architectural features. The Australian ABC TV program *Who's Been Sleeping in My House?* (Case Study 20) and the BBC's *Restoration Man* (2009) illustrate the value of understanding the unique histories of a house through its features, enabling a story to be created about a place and its people. This can, in some cases, lead to the house being granted special protective status. For example, in the UK this could include graded "Listed Building" status, which gives national protection for the preservation of nationally and regionally important historic buildings, or being awarded a Blue Plaque, which recognizes the historical use of the building, a sign that highlights the historical importance of a building because of its historical inhabitants.

Recent technology has enabled these surveys to include more diverse public input and interest: for example, the History Pin project (Case Study 14). Technology can enable the development of more detailed building surveys, and techniques such as AutoCAD planning and laser scanning allow a building's structure to be recorded in three dimensions. This provides data for future reference and interpretation and can aid restoration work. This technique was used by English Heritage's archaeological team at Whitby Abbey in the UK in the scanning of the Manor House to aid historical recording of the architectural features and restoration of the building prior to it being made into a visitor center.[59]

Case Study 14 Google History Pin

History Pin was created through a partnership between We Are What We Do and Google. It uses Google technology and mapping software to create a digital photographic and descriptive record of a historical building's past.[60] This includes working with worldwide history organizations, including museums and archives, such as the National Archives and Museum of Science and Industry (MOSI). This project has created a network of publicly accessible and "socially relevant" interactive historical photographs linked to maps.[61] Material created can be accessed through the internet and mobile phone applications. The software enables multiple photographs to be overlaid onto a map position and enables the user to chart changes to the historical landscape.

This online, open access material enables a virtual historical tour through these images and to access more detailed information. This allows the user to visualize historical changes from their sofa.

Furthermore, the software has the capacity to enable the user to post comments on blogs and to insert additional material, providing crowd-sourced material to create a continuously developing local, national and international historical survey and story of a place.

The creation of History Pin was supported by the development of digital media. This supported organizationally-led top-down community history projects. These projects are restricted by individual organizational "buy-in," time, and, therefore, MOSI relies of volunteers' support to digitize archives and facilitate community engagement. History Pin highlights issues with the ownership of historical resources and their long-term storage. This technology encourages public involvement but does not encourage public ownership of history; rather it is firmly maintained and controlled in the professional domain. This raises questions as to the long-term sustainability of crowd-sourced history and its ability to develop community-led projects.

Questions

1 What issues does crowd-sourced history have for the authenticity and validity of historical records?
2 How can community history that is managed by organizations' "history from above" be able to support legitimate "history from below" and community ownership of history?
3 How have the development and use of digital technology, such as blogs, and social media supported community history projects?

Reading and resources

- De Groot, J. (2009) *Consuming History: Historians and Heritage in Contemporary Culture*, London: Routledge, Chapter 6.
- http://wearewhatwedo.org/portfolio/historypin/

Non-governmental organizations (NGOs) and government agencies, including volunteer action groups and charitable trusts, provide support for community building surveys and preservation and presentation initiatives, for example, NGOs, such as the World Monuments Fund, the Buildings Trust International,[62] the Landmark Trust and governmental groups such as Historic American Buildings (HABS), Australian Heritage, and English Heritage. These organizations support community-driven initiatives to preserve and protect buildings, by providing advice to communities in planning protection and conservation.

Community archaeology excavation

Archaeology and history are closely aligned in their aims of pursuing the past through investigation and the interpretation of data. The principal difference is that until recently history has focused on investigating the written and, increasingly, the spoken word and recently the material culture of the past, whereas archaeology focuses on the interpretation of the physical remains of the past that exist both above and below the surface (Figure 5.1). For the public, this means that both the physical remnants of the past, as revealed to them by history and archaeology, and the memories and emotions linked to their experiences of these places and artifacts, become part of their heritage.[63] As such, the public is less aware of the disciplinary divisions between these two subjects than the professionals. Perhaps, then, it is not surprising that community history and archaeology societies often pursue the same interests and engage in similar actions when seeking to investigate the past. As a result, an increasing number of these societies seek to add value to their projects by combining both historical research and archaeological

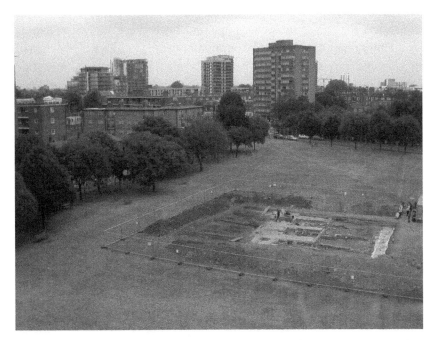

Figure 5.1 Community archaeological excavations at Shoreditch Park, London
Source: Faye Sayer.

investigations. This has most frequently included combinations of archival research, landscape survey, and archaeological excavation.[64]

For the public historian, archaeology can provide a mechanism to engage the public in their past and support the visual communication of history.[65] It has been suggested that the discipline of history can learn a great deal from how archaeology communicates the past to the public, creating engaging projects that visually excite in order to educate and entertain.[66] Public historians have begun to work closely with archaeologists, developing projects with the public that combine the use of historical sources with that of archaeological remains. In Washington, DC, the publicly viewable excavations of the historic building The Hermitage combined historical research with archaeological evidence, uncovering the forgotten and historically unrecorded slave quarters.[67] This provided information about the conditions and even the presence of this practice in a former presidential home. The archaeological recovery and interpretation of personal items have resulted in a highly emotive human story that the written records alone could not capture.[68] Similar heritage projects focusing on uncovering unwritten histories have occurred at sites around the world. Additional examples include the African American Burial Ground in New York and uncovering evidence of Hoodoo in Annapolis.[69]

Projects that combine archaeology and history can be referred to as "community heritage projects." Community heritage projects are designed to combine various forms of tangible evidence of the past, including traditional archival and architectural history alongside non-traditional history, such as physical features beneath the ground. These projects combine the official documented past with the past that is hidden and untold. These projects usually aim to investigate the past of a specific area and/or location; for example, the history of a specific community area in a city. Subsequently, community heritage projects can be initiated by multiple stakeholders, including the local public, at a grass-roots level; by organizations, such as museums; or by independent public historians, seeking to support community agendas and facilitate local involvement.

Projects facilitated and initiated by external organizations, such as museums, universities, and professional commercial organizations, involve a strategic process of planning. This includes specific project stages such as public consultation, communication, and education. These strategic stages are evident in the Birley Fields Community Heritage Project (Case Study 26) and the Shoreditch Park Community Excavation (Case Study 15).[70]

Case Study 15 Shoreditch Park Community Excavation

Shoreditch Park Community Excavation, London, was developed in 2005 by the Museum of London in consultation with various stakeholders, including community residents, council representatives, museums services, and community organizations.[71] This project was funded by the Big Lottery Fund, to directly support the communication of the sixtieth anniversary of World War II and to aid the education of the wider community in the effects of the war on everyday people. In the case of this site, it aims to communicate and engage current London residents on the impact of the Blitz on inner-city London residents. The result of this was seven distinct phases, including consultation, historical research, marketing, communication, participation, education, and dissemination.

This project ran from 2005 to 2006, and combined extensive historical research with large-scale open-area excavation of an urban area (Figure 5.1). This aimed to investigate the features of demolished streetscapes and to reconstruct the lives of the people who lived there during World War II. The work was undertaken by archaeologists from the Museum of London who guided and supported local residents, University College London students, and members of the London and Middlesex Archaeological Society in the excavation of the site.

This "proactive history" uncovered buildings and personal items from the twentieth century, including World War II pin badges and children's toys that helped trigger former residents' memories.[72] The recorded testimonies of such residents provided further historical insight.[73] Despite the positive elements that archaeological excavation brought to the project, this project had issues with sustainability and long-term public buy-in after the excavation had finished. As such, there was little interest in the follow-up post-excavation recording and finds processing work. The central issue was that this project, as with many others, was driven by individuals within the Museum of London; thus, after the external funding finished and key staff left the organization, the project ceased. This potentially highlights issues with community buy-in and ownership, and long-term sustainability of top-down approaches to community history projects.

Questions

1 Can top-down projects provide community buy-in and ownership? If so, what mechanisms are required for this to successfully be achieved?
2 How can community heritage projects become sustainable?
3 How does involving archaeological elements in community history projects support public engagement and participation in the project?

Reading and resources

- Kiddey, R. and Schofield, J. (2011) Embrace the margins: adventures in archaeology and homelessness, *Public Archaeology*, 10(1): 4–22.
- Simpson, F. (2011) Shoreditch Park community archaeology excavation: a case study, in G. Moshenska and S. Dhanjal (eds) *Archaeology in the Community*. London: Heritage Publications, pp. 118–22.

Archaeological sites provide a focus for public interest in the past and as such can create "theaters" of memories. These sites enable history to become personally relevant, by uncovering and sharing lost historical memories and creating new memories about the past in the present.[74] Archaeology does not have to be involved in large-scale open-area excavation, such as at Shoreditch Park (Case Study 15). It can use less intrusive and smaller-scale ventures, including test pits in gardens. This technique has been demonstrated in multiple localities around the globe; including Sedgeford, Norfolk,[75] Bellarine Bayside, Melbourne (Case Study 16),[76] Annapolis, Maryland (Case Study 27),[77] and Shapwick, Somerset.[78] These projects often combine techniques to investigate the past, such as field walking, standing building survey, geophysical survey, botanical surveys, and test pitting, with traditional historical research techniques.[79]

This multidimensional approach to historical and archaeological research provides a comprehensive visual map of the history of an area. It can make discovering and creating history a personal collaborative process, through the creation of memories and ownership. The success of the multidimensional approach relies on its ability to bring together community members through communication, creating a network of public researchers. This approach enables the public to influence historical research and to develop fluidity in

research agendas. Through excavating people's own backyards, it seeks to encourage a wider demographic of people to become involved in history.[80]

Case Study 16 Bellarine Bayside Heritage Project

Multidimensional approaches to public history projects can be beneficial to projects that work with indigenous populations, such as in Bellarine Bayside, Australia. In 2010, local archaeologists developed a heritage project in collaboration with local community members including the Wathaurong, the local Aboriginal tribe. This project aimed to investigate and chart the history of a 24-km landscape along the coast.[81] Prior to undertaking fieldwork, the heritage professionals engaged in extensive consultation with various stakeholders, developing a collaborative method of investigation that involved the multiple communities, and had the ability to analyze a vast landscape.[82] This process involved combining test-pit and landscape survey alongside recording intangible histories, such as storytelling and spiritual beliefs.

The test pitting involved excavating 1-meter square trenches in areas around the village, city, or rural landscape (Figure 5.2). This approach combines the benefits of a simple and quick excavation technique that enables completion within a day, with maximum spatial coverage, and the required understanding of the depth and date of underlying deposits.[83] These test pits aimed to uncover the history of an area from fragments of human activity in the soil, such as pottery shards. Test pits are excavated stratigraphically, i.e. in a sequential series of spits or layers, which are given a unique reference number (context) so that the various finds can be allocated to specific layers. This provides evidence of the extent and date of human occupation.[84]

In this project, each meter-square pit was staffed by a mixed team, consisting of a Wathaurong representative, an archaeologist, and a local non-Aboriginal resident. Each team was responsible for the excavation of its test pit, as well as the recording of the different archaeological contexts and the physical finds they contained, for example, a number of stone toolkits were discovered during this project. This information was recorded alongside the spiritual interpretations of the landscape and stories of the objects' traditional usages and values. These groups worked together to record tangible

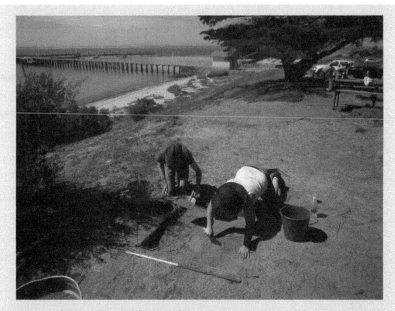

Figure 5.2 Test pit at Bellarine Bayside
Source: Faye Sayer.

and intangible evidence of the past and interpret the "story" of the landscape. This aimed to enable two disparate communities to share ideas and provide a voice for each group's history. This innovative approach to investigating the past recreated the "whole" history of an area and moved the process of investigating history beyond the Western approaches based on linear physical timelines.

The project was not without issues; archaeologists often struggled to interpret, communicate, and represent intangible "pasts" as "evidence" within official documents, which required physical evidence to mitigate against development. Furthermore, with respect to this prehistoric indigenous history, despite being open to the local community, the local "white population" often struggled to understand the relevance and validity to them and their community's heritage.

Questions

1 What mechanisms can be used to enable the successful development of community projects?
2 Can the use of intangible history help develop historical research and community-oriented projects?

3 How can community history projects benefit from adopting elements of indigenous heritage projects?

Reading and resources

- Ford, A. (2009) *Bellarine Bayside Foreshore: Redevelopment, Cultural Heritage Management Plan.* Geelong: Dig International Pty Ltd.
- Greer, S., Harrison, R., and McIntyre-Tamwoy, S. (2002) Community based archaeology in Australia, *World Archaeology*, 34(2): 265–87.

Local history societies play a key role in this hands-on research. For example, Muncy Historical Society instigated their own community-led excavation project of a nineteenth-century watermill and canal site (Case Study 13).[85] Amateur history societies and community groups frequently seek out the support and advice of professionals in these projects. Muncy Historical Society employed a professional archaeologist to lead the community excavation and provide guidance in creating a "heritage park."[86] This public demand for facilitation and support in undertaking community history projects has led to various volunteer, private, and government sector organizations providing free advice, training, and public forums to enable community-led action. Organizations such as the Council for British Archaeology, the Institute for Archaeologists, and the European Archaeology Association, now provide public and community forums to encourage professionals to collaborate.[87] Similarly, the Heritage Lottery Fund has financed schemes to provide expert-led guidance to local amateur societies; for example, the University of Exeter's X-Arch project aimed to encourage numerous local communities in Devon to develop their own public heritage projects with the support of professional archaeologists and historians.[88] Examples of successful outreach by this project include Brayford Community Archaeology Group and Bow and District Historical Society.[89]

The ability of the public to become actively involved in the process of archaeological excavation depends on national codes of conduct, professional standards, national and international legislation and protection, and access to and ownership of the land. Health and safety laws, governing such things as depth of excavation or necessary personal protection equipment, also influence excavation and survey. Furthermore, the nature and context of a site will influence its appropriateness for community heritage projects. For example, it is easier in the UK to gain permission to excavate more recent historical sites

such as those containing nineteenth- and twentieth-century remains as they are not for the most part protected by scheduling, and professionally are not felt to be as complex or important as earlier periods. However, nineteenth- and twentieth-century sites are often more visually exciting as remains are more likely to survive intact. Even if a site does not have the ability to enable public involvement in excavation, it can still support viewing, tours, and other community activities, such as at Hungate, York.[90] For many community members this will fulfill their desire and ability to be involved.

Heritage trails

Trails, such as guided or non-guided walks, link historical sites or areas of historical interest together, often in a linear or circular pathway that can be walked or viewed by the public. The creation of trails involves background historical knowledge of a specific area, including architectural or landscape features, which enable the development of a list of places of specific historical interest. These places are usually physical features of history in a cityscape or rural landscape and can include important buildings, such as churches and monuments.

Trails are based on creating a story of a place through a physical journey and the act of searching to discover historical locations. They are regarded as a proactive way to physically discover the past and to take a personal journey into history. The points of interest, such as historical sites, are usually located on a map, each point being given a specific number, corresponding to its place on the route. The trails path will usually form a circle from beginning to end. This pathway into the history of a place engages the public, the trail finder, in a history of a place, but also allows them to interact with an environment. The visitor can access the trails either in a booklet, in a physical map, on the internet or through a software application, or as an image of the trail printed on interpretation panels around the site. Points on the trail are provided with further information to aid the visitor's interpretation and understanding of the area.

Trails that exist either in rural locations often benefit from interpretation panels around the tour route. These rural trails are usually linked to outdoor pursuits, such as walks; for example, the National Trust trails combine a variety of different distance walks based on both nature and heritage sites.[91] Trails in urban environments are frequently linked to tourist and sightseeing activities such as the Alexandria Historical Cycle Tour or Boston's walking

Freedom Trail. These walks are developed to form a route of history buildings and historic sites around the city.[92]

Technological development has supported historical trails, as mobile technology enables hand-held maps or devices with apps to deliver tours based on touch technology; for example, the Coasts Tour of Britain. Interactive applications enable the public to choose which aspects of the tour they are interested in, and the community can create routes of interest that are both changeable and responsive.[93]

History trails can be guided tours, which give the opportunity for community involvement in creating the tours and through acting as tour guides, giving explanations and stories and contextualizing history. A more grass-roots, but nonetheless institutionally led example of this is found in Bristol, where the University of Bristol has worked with homeless people to develop a tour based on perceptions of their city, their memories, and important personal places.[94] This trail was created by adopting a "map regression" approach, that of looking at the maps of an area over a period of time and noting the changes on the maps, including the destruction, alteration or creation of significant historical buildings. This spatial data is correlated with historical accounts and other records, including diaries, to produce the final tour.[95]

Community exhibitions and publications

Archival research, excavations, oral history, and other materials created during community projects can be used to produce tangible public exhibitions.[96] This gives the community opportunities to create their own narratives to communicate their past to a wider audience; by choosing the photographs, the texts and the cultural materials, they tell the historical story of a place. These displays are presented in community spaces, often in community galleries such as the Hulme exhibition at the Zion Centre in Manchester. Innovative community exhibitions enable the public to add to them. This can create a space in which narratives can be discussed to encourage open dialog and conversation.

The following elements should be taken into consideration when writing for popular audiences:

- demographic considerations: literacy of family, children, adults[97]

- choosing appropriate and relevant information
- word limits: less is more
- types and complexity of words
- themes
- stories
- editing
- must be accessible and informative
- what is your story?

Community archives research

Community established archive projects are developed as a platform for local community members to share memories and histories of the past.[98] These often support and enable the formation of group history through sharing personal histories and finding common links and themes within these histories. Community archival projects bring together various individual strands of research, specifically research into family histories, building histories and historical events from a specific place together into one shared and open arena, such as a website, an exhibition in a regional archival facility, or a book.

Community archives established themselves during the 1990s and 2000s with the emergence of computer technology and the web.[99] A large proportion of these archives are now internet-based. They provide a platform for members of a community and former community members to share resources and knowledge, through uploading photographs, oral history testimonies, and new primary sources to an open website for people to share and have free access to. For example, Wickford Community Archives is managed and created through a network of local volunteers. The website provides access to oral history and historical records from the area.[100] These archives are community-driven, often based on themes and specific period specializations that are of interest to the local area or a specific local person or people within it. Museums and public history organizations support these community enterprises, helping to develop community archive facilities and local history archives by providing skills training, specialist support and web platforms; for example, Google History Pin (Case Study 14) and the London Archaeological Archives and Research Centre (Case Study 6).

Conclusion

Diverse ranges of multi-sensory activities are currently being used to communicate history and the stories of the past to the public, including music, theater, and art. Performance arts offer imaginative and innovate ways to engage new audiences and give them a voice within the story of the past. Community festivals, such as the Manchester History Festival, draw on these multi-disciplinary approaches to community engagement, and public participation. As such, this event combines exhibitions, history talks, music, food recreation, re-enactors, and external activities, such as archaeological excavations and city tours.[101]

Community history projects often include the tangible physical history and intangible non-physical history. These projects seek to move history away from the traditional Western concept of history, which is visual and physical, to include historical evidence in the form of memory, traditions, and folklore. Therefore, approaches to community history are complex, and they can often, despite consultation and communication, have very different agendas and values for the community and the historians. It has been advocated that the focus of history should be about weaving these together, accepting different viewpoints, values, and interpretations, and accepting the community's right to appropriate the historical findings.[102]

Working with the wider community requires historians to consider alternative power relationships.[103] Successful community projects are developed from collaboration between all stakeholders, which facilitates communal action and the co-production of historical knowledge.

Increasingly, community history projects require leadership or sustainable support from volunteers in the community. The creation of volunteer networks in organizations can help facilitate this work and form new links within the community. This requires leadership, strategic thinking, and the ability to provide management strategy for projects.

There are ethical and moral considerations when carrying out community history work, which requires self-awareness by community historians, regarding the dangers and ethical implications of their work and the impact of this on personal, local, regional, and national identity and the social dynamics within a community. As such, many institutions have ethical codes of conduct for engaging in community work, which often include extensive consultation and prior professional agreements pertaining to ownership to be put in place. Engaging with and in community history requires an understanding that relinquishing control of history can result in bringing to

light the conflicting values of history and enable its potential misuse for external agendas. The resulting community history is a delicate balance between representing the multiple values of history and heritage and maintaining professional integrity and historical accuracy.

Routes into community history

Community historian

History degree (2:1), Master's in history (or related field), work experience in public history sector. The job description is:

- Undergraduate degree in history
- Master's in history
- Political awareness
- Understanding of the legislation relating to historical assets
- Project management skills
- Leadership and teamwork skills
- Excellent communication skills, both verbal and written
- Financial acumen (to complete grant applications)
- Flexibility

6

Media History

Chapter Outline

This chapter will examine how and why historians use popular media, including television, film, radio, newspapers, and popular fiction books. It will investigate how these media have provided an easily accessible platform for the communication of history to the public. The chapter is divided into media-specific sections, which examine how history in these formats is written and performed in a way that is fundamentally different from normal academic prose. It will discuss the challenges of this translation by providing an example of academic prose linked to an exercise to adapt this to popular media,

be it journalistic, televisual or audio. Each of these sections will draw on various professional experiences to provide examples, including how to write a documentary television proposal and how to translate academic prose into a popular fictional book.

This chapter will examine the use of history in visual and audio media, looking at the variety of documentary and cinematic presentations. It will examine what makes for a successful program through case studies and open this topic up for reader debate as to the balance between academically credible approaches versus the alleged "**Disneyfication**" of history. It will examine how this written form is fundamentally different from normal academic prose and discusses the challenges this can create through misinterpretation and spreading misinformation. It will draw on a range of case studies from best-selling historical fiction, popular historical non-fiction, broadsheet articles, and magazines.

Introduction

Despite popular history's wider appeal and perceived public success, this format of communication is not regarded positively in all quarters.[1] It has been accused of dumbing down history, lacking authenticity and truth, and falsifying history,[2] and Downing suggests media history is "certainly not real history."[3] This reflects a more complex philosophical debate about democratic knowledge, society's balance of power, and the potential dangers that the misrepresentation of history can cause in sensitive areas such as religion, immigration, or recent political conflicts. It also raises a more fundamental question concerning the ability of history ever to be the "real truth" and to reveal a "real" past, rather than an interpretation drawn from strands of evidence that are far from complete. It is part of a wider debate that has been raging in media history since the 1980s. As such, it is time to move the debate forward, to consider the possibilities rather than the issues, discussing how to make it better and considering what is required to transform history into a media format.[4] In essence, history is never completely factual, rather it is similar to television programs, a hybrid between fact and fiction. It represents a specific viewpoint in time, history translated through the eyes of a modern perspective that is affected by culture, politics and society.

Background

Public history in the form of television, radio and popular writing has exponentially grown in the last two decades.[5] The mass public production and consumption of this form of historical communication have resulted in its categorization as popular history.[6] Communicating history to a wide audience requires the adaption of historical stories, ideas and research. This translation of academic historical rhetoric into an accessible format, such as television, radio, books and magazine articles facilitates its consumption by a large public audience. The high circulation of popular historical communication in multiple accessible media formats and genres makes it the central means by which the public engages in and with history.

The success of the translation of history into popular culture relates to its hybridity and subsequently its ability to communicate the subject within multiple genres, such as films, television, radio, and books. History is adapted to the mass public market through the telling of exciting and interesting stories in an accessible language. This draws on the discursive skills of historians and their ability to act as a "storyteller of history" to bring multiple strands of information together.[7] Mass media has transformed history into entertainment and a form of social knowledge.[8] In order to survive in a consumer-driven cultural market, history has repackaged and rebranded itself to appeal to a broad public audience.

The broad impact of this form of public history is directly linked to its high circulation and wide demographic consumption. This has been quantitatively equated to books and magazine sales, television viewing figures, and radio listener numbers. For example, *Rome* (2005–7), a television series based on the Roman Empire in the first century BCE, was launched in the USA and the UK in 2005. For the show's pilot, HBO recorded 3.9 million viewers and BBC2 recorded 6.6 million viewers.[9] These figures have been used to imply the success of the medium, especially when compared to other forms of consumed public history and historical communication such as museums.

Public history has drawn on ideas for communication from the media, and looked at how to use audio and visual technology to communicate with a broader demographic and encourage a spectrum of learning. Museums, such as the Imperial War Museum, have used video archive footage, oral historical accounts, background sound, and lighting to create an impact and emotional response to exhibitions. Public history as media history has, over the last decade, been one of the most influential methods for the communication of history to the public.

For historians to transform historical accounts into media stories requires a careful balance between professional ideas and public requirements. As such, the boundaries between professional and public become blurred, as the creation of media history requires a balance between academic credibility and validity and providing a popular and understandable narrative. It is this balance that has proven difficult for many historians and media professionals, for example, BBC1's *Bonekickers* (2008), a drama based on a team of archaeologists uncovering and interpreting the past. Despite the professional involvement in the program's creation of Professor Mark Horton from the University of Bristol, the show received widespread criticism from television critics and professional archaeologists and historians.[10] These criticisms stemmed from the poor representation of the profession and the professional approaches to investigating the past, including the show's absurd and unbelievable storylines; for example, in the episode "The Army of God," the Knights Templar are discovered and the team go on a dangerous search for the "True Cross."[11]

Successful stories for popular media require the production of a single narrative reaching a clear and satisfying conclusion. Therefore, the multiple interweaving stories, the complexities of interpretation and the missing evidence of the complex "real" historical narrative are often covered up, hidden beneath a stable and linear text. These issues with representing the complexities of historical interpretation are the reason why this form of popular history is critiqued in the academic community. This is compounded by the lack of what academics refer to as "scholarly apparatus," footnotes, citations and referencing, in works of popular history. Populist accounts have thus been linked to the "dumbing down" of history for the purposes of entertainment, leading to misinterpretation and a misinformed public.[12] This misrepresentation and **Disneyfication** of the past in order to create a mass market and sell a product produces ill-conceived and untruthful programs.

Historians and public historians can learn vital skills from media professionals, both in their presentation in history and in their ability to communicate and to understand the wider public audience and the public appeal of history. Conversely, media professionals could learn new skills and modes of historical representation and enquiry from historians, including techniques for research, such as oral history testimonies and the analysis of material culture. Popular media translate historical ideas and theories into stories. Each strand of media history can add to the historians' ability to communicate the past to a wider demographic. Historians, program-makers, publishers, and other media professionals should seek to approach popular

history through more collaborative and co-productive methods, seeking a symbiotic relationship rather than a relationship of distrust.

Popular writing

Popular literature has used historical stories since writing began; this ranges from works such as the Icelandic sagas of the eighth century to the fifteenth-century novels such as Malory's romance tale, *Le Morte d'Arthur*, and the historical novels of the nineteenth century, such as Charles Dickens' *A Tale of Two Cities* (1859). This popular literature mixed historical fact with folklore and myths, serving not only to communicate historical events and the lives of the noteworthy, such as kings, but also to tell an entertaining story about the past to the public. As such, historical fact was intermixed with fiction even in the primary sources.[13]

The growth of popular historical "factual" writing in the last century can be traced back to 1936, when Ernest Gombrich published *A Little History of the World*.[14] This book aimed to communicate the major historical developments of mankind to children outside the classroom. As such, it used accessible language and exciting stories of historical people and their actions to portray the past and spark the imagination of children. The book included chapters on the Neanderthals, "The Greatest Inventor of All Time," Classical Greece and its "Heroes and Their Weapons," and World War I, "Dividing Up the World."[15]The introduction of *History Today* in 1951 by Brendan Bracken, Minister of Education during World War II, sought to encourage widespread engagement of the public in historical debates.[16] This publication was credited with the creation of popular history "mixing styles, genres and periods to achieve a fusion of intellectual excitement and readability."[17] The format and writing style of *History Today* impacted on how historians communicated with the public, encouraging the adoption of popular writing styles, more careful and publicly focused editing of their work and the use of pictures to illustrate points.

In the 1980s, the use of historical rhetoric in popular literature grew, with book series such as Bernard Cornwell's *Sharpe* firmly placing historical fiction in the public "entertainment" domain. In the 1990s, historical writing attempted once again to balance education and entertainment, which resulted in historically-themed children's books, such as the *Horrible Histories* series (Case Study 17). Alongside this, there was during this period an increasing number of books to accompany television series, such as Michael Wood's *Conquistadors*. These books sought to provide additional

popular "academic" information to a wider audience, who watched the television program.

The high viewing figures for historical television programs and large sales of historical books continued into the present; as a result, in 2000, the *BBC History Magazine* was launched, aiming or perhaps even competing with *History Today* to provide factual historical information to the public, enabling them to read academic narratives and debate in an accessible format. The success of both these popular historical journals has seen their launch all over the world, most recently in digital format.[18]

Previously, the dominant medium for conveying stories of the past and culture was the written format, in books and newspaper articles.[19] This medium is decreasingly used by the public to access information about history. Despite this, it is still the most trusted form for information and study.[20] Despite the value of such texts, there are issues with the way history is written that thwarts the ability to communicate with the public. White suggests this is because the writing of history is suspended in time, in a formal nineteenth-century style, which is perceived as a dull art form.[21] What is required is a style of writing that uses self-reflection and enables the multiple voices of the past to be communicated. The reader should be encouraged to view the past not as linear and not only through characters, but also through the voice of the writer.[22] Experiments with historical writing have led to a new narrative style, drawing on the informal discourse of television, as seen for example in Simon Schama's *A History of Britain* (BBC, 2000–2002).[23]

Popular publications include a plethora of written texts, embracing popular history, fiction and factual books, and newspaper articles. These were some of the first media formats by which the public could obtain information about recent historical research and stories relating to and drawing up of historical ideas. They focus on two factual strands: (1) the presentation of historical research and its translation to make it accessible to a wider audience, for example, in newspaper articles; or (2) using historical ideas and periods to create a fictional story, such as the Flashman novels by George MacDonald Fraser.

Types of popular publications

Print media

Magazines enjoy a large public circulation, in part, as they are available on news stands and in large retail outlets. They aim to appeal to the

mass public and to specific interests and groups such as hobbyists and amateur historians.[24] They provide the public with interesting snippets of information, ground-breaking discoveries, and an arena for debate. They can be of general interest such as *BBC History* or topic-specific, such as *Military History*. The editors of these publications work with academics to provide a source of information to the public, producing a mixture of educational and entertainment content. They combine historical analysis with images and adverts to appeal to the wider audience. The publications rely on recurrent interest, encouraged by new ideas and the use of personality writers to write articles, such as Sir Ian Kershaw's article on "The Hitler Myth." These ideas link to websites and interactive polls, classrooms and study guides, a meta-content which encourages interaction.[25]

Newspaper articles

Tabloid newspapers commission freelance or academic historians to write regular articles or comment on historical news, such as Tristram Hunt for the *Guardian* and Dominic Sandbrook for the *Daily Mail*. These journalists make a statement about the breadth of history as a discipline and its influence on contemporary politics and economics. Historians are frequently asked to comment on historical press items, often in the form of interviews with journalists. The platform History & Policy provides a forum to support this, providing journalists with quick access to academic contact details and specialisms.[26]

Print media uses press releases produced by historians to communicate their research as the background for a piece. Writing is a complex process, a means of creating a narrative, which is a skill that requires collaboration with journalists and an understanding of the different vantage points of each newspaper, their audiences, and their particular cultural and political stance. Understanding the rhetoric of newspaper articles pertaining to history is a form of historical research. These newspaper articles are sources rather than facts and represent the dominant ideology and current social cultural contexts of the time when they were written.[27] Until the 1990s, historians writing narratives in the form of short pieces for newspapers was a regular occurrence; yet, as Steele comments, historians are often less capable at creating these narratives, often preferring now to take the easier option of acting as talking heads on television.[28]

Popular books

Factual texts

For most historians, books provide a comfortable and familiar platform for communicating history. However, translating this often weighty academic and technical prose into a popular accessible format requires creative writing skills that draw on self-reflexivity, clarity of expression and a personal style to communicate effectively.[29] The writing of popular historical books, whether based on fictional or factual narratives or a hybrid of the two, is a mutually beneficial process for both publishers and authors as it provides authority, profile, and profit too. Books have a breadth of appeal, due to the different types of treatment of history that they can offer: narratives, political diaries and biographies, autobiography, a combination of fiction and fact, with popular books based on historical events or periods.

Fictional texts

Popular books about the past are often not written by historians, but rather those authors with an interest in history, usually one particular period. The authors draw on historical ideas and a degree of historical fact as the basis for their stories. Historical narratives form the framework for character plots, thus blurring the lines between fact and fiction, and between genres, such as romance, action, and history. These include novels such as Philippa Gregory's *The Other Boleyn Girl*, which has sold over 8 million copies worldwide.[30] These popular publications are widely regarded as fiction rather than fact. Yet it is worth noting, as is the case with other popular history authors, Philippa Gregory was an academic historian who moved into popular fiction, and therefore her novels do contain primary and secondary research into the topic.

In contrast to these popular historical novels, political diaries and autobiographies provide first-hand accounts of history that give the public intimate access to historical decision-making and political debates.[31] These autobiographical books are frequently commissioned to commemorate individuals and brand them through celebrity endorsement; for example, former UK Prime Minister Tony Blair's memoirs *A Journey*.[32]

The success of popular fiction and autobiographical books often relies on their ability to create an emotional connection between the characters and the reader. For example *The Kite Runner* (2003), by Khaled Hosseini, which

has sold over 10 million copies internationally, uses the framework of a friendship between two central characters, Amir, "a Pashtun" boy and Hassan, a "Hazara" boy, and their families, to illustrate the complexities of the history of Afghanistan.[33] Interwoven with the human story is the history of cultural divisions, the effects of changing political regimes, the influence of Taliban control and the results of wars on the people. The blending of historical narratives and emotional stories has proved a successful formula.

Case Study 17 Horrible Histories

Horrible Histories, a series of children's books by Terry Deary, has been regarded as a success in combining education and entertainment. As such, they are regarded as important tools in making history accessible to children. They include titles such as *Smashing Saxons* and *Rotten Romans*, aiming to appeal to children by presenting "history with the nasty bits left in," making it jokey and gory through the use of multimedia. This includes illustrations by Martin Brown, who uses comedy drawings of people from the past, as well as maps and letters, and the inclusion of educational activities such as lists and questions. They have worked with the National Curriculum frameworks in the UK, providing information to support learning, encouraging parents and teachers to draw on the information given in these books to aid children's historical education.

Museums and television programs have drawn on this technique of art and comedy to communicate history to a wider audience, including the BBC. For example, the Imperial War Museum's Horrible Histories Spies exhibition used Terry Deary's writing and Martin Brown's illustrations to help communicate the role of spies in World War II to children.[34]

Despite widespread public success and its use within the wider public history domain, this blending of historical facts with entertaining fictional stories and anecdotes can lead to issues with the public perceptions of the past. These books use, maintain, and create stereotypical and simplistic versions of historical time periods and people. For instance, the *Vicious Vikings* establishes the Vikings as "fearsome" bearded seafarers and raiders; little material is provided on their role as traders, and settlers or on the lives of Viking women.[35] Furthermore, the division into cultural groups of people based on time periods such as the *Cut Throat Celts* implies a clear

cultural division and even replacement of people between time periods, rather than portraying the intermixing of ideas, migration, and assimilation of people and cultures and the impact of trading on history.

Questions

1 How can elements associated with entertainment help books successfully communicate history to children?
2 Does the success of popular historical literature require a simplification of history or are there other mechanisms to support this?
3 What benefits do popular publications have for the translation of historical knowledge to the public?

Reading and resources

- Deary, T. (2007) *The Vicious Vikings: Horrible Histories*, Danbury: Scholastic Press.
- http://horrible-histories.co.uk

Where historians have successfully bridged the gap between popular books and academic studies, their work is often based on television programs. It is such books that reach broad markets and have an impact on the wider public perception of history, such as Simon Schama's *A History of Britain*.[36] These books provide the basis to establish relationships between historians and the public, and are often commissioned based on the high viewing figures of the corresponding television show. Therefore, commissioning these books offers a lower risk than that of publishing an unknown entity, as a market has already been established through the television show. Therefore, these authors can usually demand higher sales percentages than stand-alone publications.

Radio history

Radio has verbally communicated facts and ideas to the public over the airwaves since the 1920s. Initially, radio focused on providing factual information and news pieces that the public could listen to in the comfort of their own homes. Audio public broadcasts were the central point of entertainment and information for the public in the beginning of radio, but

they also recorded history as it happened.[37] Radio has since been used as a medium to provide information to the wider public and involve them in current debates.

It was not until the 1950s that radio shows were produced that broadcast not only news, but told stories, often drawing on historical subjects. Initially program-makers drew on historical information, often from universities, to debate contemporary events, yet during the 1960s radio started to record history as it happened and to discuss the influence of history on current political events. During the Cold War, the BBC World Service, funded by the UK government, recorded history in action in various locations, including Russia.[38] These programs linked historical events and politics to current events and provided different historical perspectives on this. History on radio, like no other medium before, provided a unique access and a way to communicate complex and multiple interweaving interpretations and perceptions of one historical event. This provided a framework for television and other public media to attempt to convey complex narratives through new technology. Radio enabled easy access, quick recording, flexibility and mobility so that it could go to multiple locations and record ideas, editing them into a program. This method for presenting history gave the public the feeling that they had first-hand and unique access to material.

Radio producers and companies started asking historians to appear on shows, to offer opinions and talk on air about specific topics. In the 1970s and 1980s, local history became popular on regional radio stations, with academic historians having weekly shows, such as Mick Aston's long-running BBC Radio Oxford show. History provided the stories for the radio and more popular media to communicate them; for both parties, it was a beneficial situation. By the 1990s, historians and radio programmers had started to collaborate formally to create shows based on historical events, for example, BBC Radio 4's *In Our Time*.[39]

This century has seen the development of radio and history partnerships. These collaborative partnerships seek to produce projects that understand the complex working of history in the public domain. This has resulted in radio productions such as BBC Radio 4's *History of the World in 100 Objects* (Case Study 18).

History on the radio works in multiple formats and genres; it can be drama, news or debated in documentaries. Occasionally productions, such as afternoon plays or game shows, draw on historical facts. The lack of visual aspects has to some extent enabled history on the radio to be more contained. Traditional formats for radio focus on the anchor (lead) presenter and

personality, who is usually not a historian; for example, Melvyn Bragg hosts *In Our Time* (BBC Radio 4). The traditional radio format focused on a presenter based outside the studio undertaking the role of a narrator, which included interviewing members of the public and asking them to tell their story of a specific period.[40]

A variety of radio formats are used to translate history into the public domain, including scripted essays, studio interviews, and live panel discussions. The use of pre-scripted essays on radio to communicate history is in keeping with a traditional format. Radio essays usually involve an academic historian undertaking a form of public lecture that is then broadcast to the radio audience; for example, Sam Edwards' *How Should We Remember the War?* scripted essay on BBC Radio 4.[41] Studio interviews involve specialists discussing specific tales of the past through the use of personal interviews with those who remember or have experienced past events, such as *A Human History* with David Hendrey (BBC Radio 4). Alternatively, there are live panel discussions, which result in debates between various professionals on a specific historical topic, such as *Moral Maze* (BBC Radio 4). Radio debates help develop traditional debates through the use of personalities and topical issues into an entertaining and educational public format.

Case Study 18 BBC Radio 4, *History of the World in 100 Objects*

BBC Radio 4's *History of the World in 100 Objects* series was a collaborative venture between radio producers and the curators of the British Museum and the final product reflected this collaboration in its hybridity of structure.[42] The program attempted to provide a historical timeline by using some of the most significant cultural objects and artifacts displayed in the British Museum. It aimed to highlight some of humankind's greatest achievements while the specific objects provided a platform for discussion of cultural development and the foundation of society in more depth. For example, "The Silk Road and Beyond" theme consists of five episodes based on five objects. This theme debates the impact of the wide-reaching trade route, established in 500–800 CE, on the development of culture. In one episode Neil MacGregor uses the helmet and South Asian gems, found at the seventh-century Sutton Hoo burial site, to debate the notion of this period being regarded as "the Dark Ages."[43]

The program was recorded on location, with background noise and individual curators who acted as narrators. The curators provided the research and the script for the programs and through detailed discussion of a single object per episode provided a detailed descriptive narrative and linked this into the objects' representation of culture and their influence on today's society. This program used different curators with a variety of styles, and highly descriptive narratives that were linked to web resources to help create a picture of the object and the location of the discussion. This format was not without its challenges as it required extensive time investment, with curators developing scripts prior to recording, and there were issues with consistency and the standards of the curators' radio presentations.

This scripted radio documentary involved elements of reality, and dialog outside the studio. This aimed to give the listener a sense that they were being granted intimate and unique access not only to the objects but also to the minds of the professionals. Collaborative programs highlight the potential public impact radio programs have when historians and programmers work together.

Questions

1 How do partnerships between historians and radio producers impact on historical radio productions?
2 What aspects and formats make for successful history-related radio productions?
3 Can historians learn anything about public communication from radio formats?

Reading and resources

- Bragg, M. (2004) The adventure of making *The Adventure of English*, in D. Cannadine (ed.) *History and the Media*, New York: Palgrave Macmillan, pp. 67–87.
- http://www.bbc.co.uk/programmes/b00sl6dt
- http://www.bbc.co.uk/ahistoryoftheworld/

Producing a documentary and scripted essay radio program requires the development of a research idea into a narrative, outline, and script. Historians work closely with producers to develop and research an idea, a story, and a narrative and provide the research for a radio piece.

When writing a scripted essay for the radio, there are central considerations:[44]

- Create a mental picture.
- Use a narrator as a device.
- Create action through dialogue. Provide a descriptive passage.
- Make the most of sound effects and music. Create emotion and background noise using audio material.
- Create believable characters. Characters' voices enable the audience to feel empathy or emotion towards them.
- Be precise and clear with your language. Consider your target audience and write appropriately.
- Draw the listener in. Provide a variety in the pace and length of narration.

Films

Historically based movies first appeared on screen in the early twentieth century, with D.W. Griffith's *Birth of a Nation* in 1915, a film set during the American Civil War and its immediate aftermath, controversial both at the time and ever since for its crude and racist portrayal of African Americans. Historical movies developed in the 1930s, particularly in the genre of Westerns. These movies, such as *The Big Trail* (1931), directed by Raoul Walsh, used a historical backdrop of action and adventure to entertain the audience, while simultaneously promoting a distinct ideological vision of the American past comprising rugged individualism, masculine courage and honor, female domesticity, and the racial subordination of Native Americans. Westerns continued to be popular genres for the presentation of history until the 1960s, when many began to question the values they epitomized. This period also saw the arrival of historical musicals, for example, *South Pacific* (1958), and factually inspired historical films, for example, *The Bridge over the River Kwai* (1957), directed by David Lean. These historically fictional musicals were a mixture of romance, comedy, and history, similar to Westerns, and principally aimed to entertain rather than educate or present historical fact, while reinforcing contemporary socio-cultural values and hierarchies, particularly pertaining to race and gender. It was during the 1960s that historical films became increasingly factually inspired, seeking to present historical events and periods more accurately and to challenge rather than confirm conventional narratives of the past.

Many focused on war, for example, *Zulu* (1964), directed by Cy Endfield, and *Lawrence of Arabia* (1962), directed by David Lean. To a degree, these films celebrated traditional masculine heroism and even colonialism, but all had an edgier sub-text of exposing war's brutality and the moral ambiguity of Europe's global conflicts. In the USA, filmmakers, responding to America's unpopular war in Vietnam, subverted the Western to tell the story of colonization from the Native American perspective in films such as *Little Big Man* (1970), directed by Arthur Penn. By the mid-1970s and the 1980s, filmmakers were drawn to the subject of war but a new and stark realism was evident in their work. The Vietnam War, for example, was no longer approached through allegory in revisionist Westerns but was addressed explicitly in films such as *Apocalypse Now* (1979), directed by Francis Ford Coppola; *Platoon* (1986), directed by Oliver Stone; and *Full Metal Jacket* (1987), directed by Stanley Kubrick. In the 1990s there was a return focus on romanticized historical fiction, creating blockbuster films based on heavily mythologized events, which sought to entertain as opposed to being historically accurate; such films included *The Last of the Mohicans* (1992), directed by Michael Mann, and *Braveheart* (1995), directed by Mel Gibson. Historical adaptations of literature also became popular in the 1990s, for example, the film *Emma* (1996), directed by Douglas McGrath. In the twenty-first century, large budget historical films were produced, based on historical evidence that drew on academic research and primary sources. These films focused on biographies and nationally important events and people, such as *Lincoln*, directed by Steven Spielberg; *The Iron Lady*, directed by Phyllida Lloyd; and *The Long Walk to Freedom*, directed by Justin Chadwick.

To understand and embrace the role of films and televisions in communicating history requires a change in mind-set. This form of historical discourse often directly conflicts with the empirical learning and understanding of history learnt at school and university, especially if it is not focused on primary sources, validity, and scientific fact.[45] This is the main reason why this medium for the translation, creation, and consumption of history is criticized as being false, lacking truth, and validity.[46] As such, it has been judged as producing mindless consumers of a false past for the sole purpose of entertainment and economic gain.[47]

The production and consumption of historical television are complex, and cannot merely be linked to consumerism. Studies investigating the consumption of history, such as The Present, the Past Project (in the USA) and The Past Project (in Australia), suggest that the majority of people access

the past through film and television as opposed to books or study.[48] For example, 81 percent of 1,500 people sampled in The Present, the Past Project had watched a historical film or television show during the preceding year.[49] These studies reveal that though these items were popular, they were regarded as less truthful and less persuasive than any other historical media.[50] Therefore, contrary to Jarvie's[51] and Ascherson's[52] assertions, films and television programs are not passively consumed and their representations of the past are not merely accepted by the unquestioning public. An illustration of this is the 1991 film *JFK*, directed by Oliver Stone. This film was criticized by the press and politicians for its representation and misrepresentation of history, which did not correspond with traditional historical evidence. Subsequently, this film sparked a Congressional inquiry to reinvestigate the evidence in the assassination of President John F. Kennedy.[53]

Films can be linked to national identity; they question cultural belief and identity and offer opposing ideologies from those that are dominant.[54] This can lead to conflict and public outrage; as a result, films and television programs can be deemed to be too politically sensitive to be aired—for example, *The Battle of Algiers* (1966), directed by Gillo Pontecorvo, which chronicled the brutal struggle against imperialism in North Africa, was banned in France until recently, being regarded as too politically contentious.[55] This suggests that films and television should not only be regarded as a means of entertainment or as means of escapism from the present but rather as playing a role in shaping the public's ideas about history. They can act as a trigger, providing a platform for the wider public to consider and debate history and historical "truth."[56]

Examining historical films can provide an understanding of the complex external and internal dynamics that influence wider historical thought and understanding. Rosenstone suggests historical films can contribute to historical discourse. As such, he suggests that historical films should be analyzed as historical sources and he sets out the criteria for their analysis which includes:[57]

- *Genre of film*: documentary, drama, romance.
- *Topic of film*: the historical period or person the film focuses on.
- *Authorship*: including the analysis of writer, director, and filmmaker.
- *Context of film and its delivery*: the period when it is produced and the potential social political influences.
- *Impact on history or historical understanding*: how it reflects, comments upon and/or critiques the already existing body of data, arguments, and debates about the topic.

Creating a historical story for film requires a system of enquiry, interpretation and the industry conventions. This method moves beyond the beginning and end of a story to investigate the middle ground, the humanistic drivers for events and periods.[58] In order to create characters, filmmakers want to understand the motivation for actions rather than merely depicting the action and its result.[59] This results in a deeply complex sociocultural construct of the past, combining social and cultural history with imagination and storytelling. The difference from this and other narrative discourse is the types of evidence used. While empirical historians rely on written primary sources and other verifiable material evidence, filmmakers create a story through a montage of the past. This combines oral history, generational stories, memories, and photographs with the empirical historical facts to create a more artistic history. This construct requires imagination, flexibility, and understanding the psychology of people. Film medium enables new voices and stories to be heard and to represent the history of not only the elite and heroes but also on those forgotten and not represented in primary sources: for example, slaves, workers, and minority groups. The 2013 film *12 Years a Slave*, directed by Steve McQueen, uses film to communicate the autobiographical story of an African-American slave in the nineteenth century. This visual medium enables an exploration of the impact of slavery on African Americans and their treatment by their owners. As such, this medium provides a voice for the unheard and unrecorded and changes the historical message.[60]

Films are visual metaphors for the past, representations of an idea. They are highly complex, and politically influenced, thus, they are an historical representation that is socially and cultural specific. Sorro's study of historical representation in Italian film concluded that the content and representation of the past in films are directly influenced by current socio-political movement, and they represent more the time they were created than the period they try to recreate.[61] Therefore, films create history not only of the past but also of the present, a historical construct from a specific moment in time.[62]

Historical film development

The creation of historical films is similar to that of writing a book or setting up an exhibition. It involves a series of processes to reach an end product. This product is not the final film but rather the reception of its story by the public, and this reception is directly affected by each part of the preceding process.

The development of the story requires the creation of a new narrative, a strong central linear plot, and a careful and in-depth consideration of the characters, specifically the central character of the film.[63] It requires a mismatching of realities, combining historical facts and ideas, with myths, legends, and dominant ideologies.[64] These narratives and characters must exist with and seek to represent a genre, style, and narrative context.[65] Characters act as agents for history; as such, they rely on individuals, a star, to create a visual image of the past, to construct a "window to the past" from a specific vantage point; they are vital in the construction of historical events and period in the film.[66]

Historians and filmmakers can work together and develop reciprocal relationships.[67] For example, the historian Natalie Zemon Davis, who researched and wrote the biographical book, *The Return of Martin Guerre*, based on a sixteenth-century French legend of the same name, went on to act as consultant on the film production. This reciprocal relationship enabled her to understand the complexities of both interpreting historical sources for the public and the production of historical knowledge, alongside providing the tools to develop her research and access to primary sources.[68] Among others, Davis suggests these collaborative relationships require open dialog to be established between the filmmaker and the historian prior to filming, whereby both parties consider the practical implications of a working partnership.[69] Yet, this open dialog and sharing of ideas happen infrequently. The most common scenario is that the historian's first input into the film-making process is through historical ideas taught in school. Historians can be brought into a project that is already underway as an advisor or consultant, to advise on the minute details rather than the overall story, usually answering specific questions, such as, "Is this the right type of armour?"[70]

The central issue with historians and filmmakers working together is a misconception of each other and wariness due to professional and personal insecurity. The academic historian's insecurity perhaps stems from their unique specialism and their lack of knowledge of the film industry.[71] The filmmaker's insecurity often results from worries over critiques of their work, alongside time and financial constraints.[72] Academics and film-makers are hampered by a misunderstanding of each other's motivations which results from a failure to engage with each other and to understand how different communication systems work. There are few historians who understand media and the filming process, which includes production, editing, and script-writing, and few filmmakers who understand how history

investigates the process that historians use to produce knowledge. This process has been helped by the publication of *Film and History*, an interdisciplinary journal of film and television studies. This journal has enabled film-makers and historians to share ideas and experiences, as well as methods and practices, including opening up discourse regarding the wider benefit of film for history and history for film.[73]

A common misconception, made by historians when analyzing films, is that they are aimed at general audiences. The reality is each film targets a specific audience; they are similar to any form of public history, aimed at a specific demographic, such as age, nationality, or social and ethnic groups. Films are divided into categories, such as romance, science fiction, action and Westerns, and may aim to target a group interested in a specific genre.[74] Dominant historical film culture is now forming genres of its own, including the Civil War—for example, *Cold Mountain* (2003), directed by Anthony Minghella—and World War II—such as *Saving Private Ryan* (1998), directed by Steven Spielberg.[75] This will be reflected in the detail and ideas conveyed in the film and therefore not all films are created equal as they target specific interest groups. It is vital to understand these genres before working in collaboration with filmmakers, and developing or even pitching an idea.

Television history

History on television initially appeared in a rather haphazard manner, in news reporting and in the guise of game shows, such as *Animal, Mineral and Vegetable* (1952–59). *Animal, Mineral and Vegetable* brought together historical and archaeological experts, such as Sir Mortimer Wheeler, to identify objects from museums and historical collections.[76]

The first deliberate attempt to use history on television was in the 1960s on the BBC, in documentary format— for example, Kenneth Clark's *Civilisation* (1969)—and in fiction, such as the BBC comedy, *Dad's Army* (1968–77), which centered around the lives of the Local Defence Volunteers, "The Home Guard," of a small town in the UK during World War II.[77]

The 1970s saw a growth in television programs produced to deliberately communicate historical facts to the public. This included historian A.J.P. Taylor's BBC television lectures on topics such as "The War Lords," a program that controversially critically assessed Churchill's failings and successes in the public domain.[78] During this period program-makers focused on producing academically credible television, including documentaries of

historically important events, such as ITV's *The World At War* (1973–74). This documentary detailed, in chronological order, the key worldwide events of World War II, such as the Jungle War in Burma and India and the United States' entry into the war.[79] These historical television programs used archival footage and interviews with veterans recalling first-hand accounts to aid the public's historical understanding.

The success of historical comedies and documentaries opened up the possibilities for history on television; by the 1980s, a number of historical comedies had appeared on television, including *Blackadder* (BBC, 1983–89) and *'Allo 'Allo!* (BBC, 1982–92). The 1990s saw a shift in focus, with an increasing number of programs, especially in the UK, being commissioned that were based on adaptations of nineteenth-century novels, such as Jane Austen's *Pride and Prejudice* (BBC, 1997). By the 2000s, television history was a global industry, with American and Australian television companies, such as National Geographic, commissioning history programs aimed a targeting their specific audience demographics. This period saw the widespread occurrence of historical reality television, in the form of *Time Team* and *Colonial House*, which were increasingly centered on entertainment.

By the twenty-first century, the mixing of genres and the Hollywoodization of historical television had become increasingly prevalent. Television companies attempted to draw in new audiences through producing programs that combined personal stories, drama, historical accuracy, elements of comedy and reality such as HBO's *Band of Brothers* (2001) and *Deadwood* (2004). The high viewing figures and television companies' financial support for these programs indicated that history had now become part of mainstream public entertainment.

Television, as a medium for communicating history to the wider public, has become prevalent in modern society. As such, there is a plethora of history on television, ranging from the traditional documentary style (*Coast, Elegance and Decadence: An Age of Decadency*) to more drama-based programs (*Downton Abbey, Foyle's War, Sharpe, Hornblower*).[80] This mode of historical translation plays a pivotal role in public history today, acting as a historical outreach tool for the masses. Television has become the closest most people will get, or even want to get, to experiencing history. Viewers experience the thrill of discovery from the comfort of their own sofas, as "historians" act as historical guides, visiting sites around the world and uncovering the clues of the past lands and peoples.

The high viewing figures, especially for historical dramas, such as *Downton Abbey* (approx. 9.2 million), and for historical reality programs

such as *Time Team* (approx. 2.6 million), suggest that for many members of the public this is an appropriate and culturally relevant means of communicating historical ideas.[81] Alternatively, this medium for historical communication has led to history becoming merely entertainment for the public. The variety of genres that historical television draws upon, from documentary, reality, comedy, game show and drama, enables this medium to reach a broad demographic.[82] Historical television appears to have an impact on the public and be of social and knowledge value to the viewers. Therefore, it could be regarded as a successful medium for the communication of history and its stories.[83]

Historical television has been successful in bridging some of the boundaries between historians and the wider community, and has offered the public an opportunity to experience history.[84] Critically, television could be described as creating the illusion of engagement in the subject, as the public are excluded from historical research and interpretation, something that remains firmly in the realm of the professional. As such, the public passively consumes history, and television history fails to engage people in their past on a physical level or psychological level. This lack of physical or psychological engagement prevents memories forming and information being retained.[85] Television provides a vicarious experience of the past; therefore, it could be described as merely "voyeuristic entertainment."

A critical consideration for historical television is the format, meaning the type and category of program. Historical television categories include drama, reality, and documentary. For a new program to be commissioned, it must work within pre-existing genres and programming schedules and be regarded, through comparative programs or market research, as having the potential to be successful. This success requires the program to have a story which has public relevancy. This is attained through interaction with viewers on a personal and emotional level.[86] For historians to create a television program, to work with television program-makers, they must understand the public. This involves considering the specific demographics they aim to communicate with and to be open to new modes of communication and research.[87]

In the past twenty years, there has been a growth in the analysis of people's public perception of history. Statistical research indicates that the past is associated with the physical effects of discovery.[88] Perceptions are based on stereotypical notions of history drawn from mass media and its **Disneyfication**; this fantasy is what gives history its appeal. As such, numerous academics have criticized the popular representation and image

of history as creating dangerous stereotypes.[89] The lack of formal analysis of the value of television history has led to a professional reluctance to open the process of history up to the public. This could explain why in the USA, history television programs have focused on the traditional documentary format, either single expert presenter-led or narrator-led.

Case Study 19 History Channel, *Sex in the Ancient World*

The History Channel's *Sex in the Ancient World* program was first aired in 2009. This program was based on a traditional narrator-presented format, who provided the core narrative script throughout the series. The addition of experts, reconstructions, archival and museum material provides the screen footage for the documentary.

Sex in the Ancient World is a history documentary focused on sex in different periods of the world, transporting the viewer to various exotic locations around the world. Experts, including Bettany Hughes, discuss directly to camera the historical and archaeological evidence associated with a place as factual information. The information is used to provide a story, drawing together facts and local stories; for example, in one episode the narrator and presenters discuss the sexual representations within Ancient Egypt, including those found in tombs and on papyrus. These expert presenters share "unique" versions and new discoveries of history, which are intersected by photographic and video clips. The result of this is sensationalization. This program draws on the explicit nature of this historical material and creates a voyeuristic interest in this topic.

This narrative documentary format aims to appeal to a specific demographic through its traditional narrative lecture format. Subsequently, historical documentaries are usually watched by those with a previous interest in the past and history.[90] In contrast, historical television documentaries such as BBC4's *Lost Kingdoms of South America* and *Lost Kingdoms of Africa* are presenter-led by young male experts, Dr Jago Cooper and Dr Gus Casely-Hayford. In these programs presenters explore the continents and their history with the viewer through ethnographic, artistic, historical and archaeological evidence; in this way, they aim to appeal to a younger and more diverse audience, interested in both the past and travel.

Questions

1 What are the benefits and issues of narrator-driven television programs? How does this affect the depiction of history on television?
2 Can historical television documentaries ever balance education with entertainment, if so, how can they be successful?
3 How can historical documentaries appeal to a wider audience, beyond those already interested in history?

Reading and resources

• De Groot, J. (2009) Consuming history: historians and heritage, in *Contemporary Culture*, London: Routledge, Part IV: History on Television.
• https://www.youtube.com/watch?v=8AX13TvHt5g

Types of television

Documentaries

Documentaries are the closest historical television programs come to portraying historical truth. Yet critically, they are still creative treatments of the historical facts. Creating a documentary is as much about the narrator, presenter, location, music, and visual imagery as it is about the content. It is, as De Groot suggests, a montage of the real and imaginary material carefully selected and edited to communicate a story.[91] Documentaries, such as Kenneth Clark's *Civilisation* (BBC, 1969) and Mary Beard's *Caligula* (BBC, 2013), are led by academic historians, where single figures narrate a story about an epic historical period.[92] These documentaries are often heavily reliant on archive footage, which could explain the plethora of World War II documentaries.[93] Thus, documentaries, until more recently, overlooked unrecorded histories, such as those linked to gender and race.[94]

Documentaries are reliant on the personalities of the presenters, such as eccentric and charismatic characters: David Starkey (*Music and Monarchy*), Simon Schama (*A History of Britain*), Bettany Hughes (*The Spartans*), and Mary Beard (*Caligula*). These presenters become the anchors, able to tell an engaging story and add their personality to this "performance."

They become the public's trusted authority on a topic. The alternative to the academically focused presenter is a celebrity presenter with no particular qualifications as a historian. Comedians are often the primary celebrity choice for these programs. Non-historians offer a unique perspective on history that balances factual information and entertainment, asking questions to which the public seeks answers; therefore, they are able to engage a new and broader audience. For example, Al Murray, though he studied history at college, is better known as a stand-up comedian in the UK, and presented the *Road to Berlin* (2004), a history series for the Discovery Channel about World War II.

Documentaries have benefited historians, enabling the production and collection of new historical research outside the realms of academia, including first-hand accounts. Television has helped develop methods, such as oral history, to research arenas of history previously under-explored. This has impacted on the mainstream practice of history and public history.[95]

Case Study 20 ABC, *Who's Been Sleeping in My House?*

ABC Australia's *Who's Been Sleeping in My House?* (2010–present) is a historical program developed with professional historian and archaeologist, Adam Ford.[96] This program focuses on combining documentary and reality elements to investigate the lives and homes of real people throughout Australia, piecing together the facts and fictions of their houses. This program was led by presenter Adam Ford and based on a single "home," a historical house, uncovering its history through the people who had lived there.

The program aimed to appeal to both regional and national audiences, by piecing together the history of Australians that was not recorded in history books; for example one program uncovers the alleged secret Nazi radio station hidden in the attic of a family's home in Adelaide.[97] The program sought to draw new audiences to history through telling unique and personal stories of the past, and as such create emotional connections between the viewer, the house owners and the former residents. This program relied heavily on first-hand accounts of history, intermixed with archival research. As a result, this show was a mix of historical fact and fiction, yet was presented as factual evidence.

Questions

1 Why does the presentation of personal histories on television make for good television programs?
2 What are the issues with personal stories being presented as a valid historical fact?
3 What impact do presenters have on the success of television programs?

Reading and resources

• Downing, T. (2004) Bringing in the past to the small screen, in D. Cannadine (ed.) *History and the Media*, New York: Palgrave Macmillan, pp. 7–19.
• http://www.abc.net.au/tv/whosbeensleeping/

Drama

Historical television series aim to tell an entertaining story of the past and its people through the use of historical fact and fiction. Historical television dramas during the 1990s and 2000s were largely adaptations of novels by nineteenth-century writers, such as Jane Austen, Thomas Hardy, and Charles Dickens. These created nostalgic and sanitized versions of the past, appealing primarily to a middle-class and educated audience. They drew on historical customs, music, and buildings, to create a degree of accuracy within a story. Historical settings provided a mechanism for the story to be told. These historical dramas were more about human interaction, society, and relationships than about history itself, based on central characters, such as Mr Darcy in Jane Austen's *Pride and Prejudice* (BBC1, 1994). The global success of these popular dramas was based on selling an idea of a nostalgic and often romantic past.[98]

Television companies have recognized the public appeal of history, describing it as the "new sex" and "new rock and roll."[99] Historical drama has entered the mass public market, with huge budget productions being created and sold to consumers, such as HBO's *Deadwood* (2004–2006), and Steven Spielberg's *Band of Brothers* (2001). The distinct move away from the sanitized portrayal and glamorous versions of the past in the twenty-first century was supported by previous smaller-scale "masculine" mainstream dramas, such as *Sharpe* (ITV, 1993–97) and *Hornblower* (ITV, 1998–2003). These dramas, based on twentieth-century books, sought to show the lives of

the "common" everyday man, rather than the "glamorous" elite portrayed in nineteenth-century novels. These versions of the past were dirty, sexy, and violent.[100] The programs drew on historical ideas but did not attempt to claim factual authenticity. Rather, they used history as a platform and framework for that narrative. Historical dramas often have similarities with films in their presentation of the human stories behind history. These dramas aim to entertain, and many seek to cater for a global audience not typically interested in history.

Reality history television

Reality history television has bridged the gap between fictional (dramas) and factual (documentaries). Reality programs, such as *The Trench* (BBC, 2002) place members of the public in historical situations, and then film their experiences. This television format focuses on human relationships as opposed to historical fact and as such have required historians to relinquish control of history to the public.

Reality television does not provide authentic or "real history;" rather, it provides an entertaining and present-day experience of the past.[101] The final product is not only affected by modern social cultural norms, which in turn affect human reactions and interactions, but also by modern health and safety controls. For some, reality television has been seen as history dumbed down, with history becoming a commodity for television companies.[102] Its appeal to television companies relates to its high revenue and viewing figures for relatively low production costs. Reality television requires little pre-production work, small numbers of crew to film, and limited editing time. Furthermore, the "cast," often the public, require little, if any, payment for their involvement in the production. It is this perceived commodification of history and historians' lack of control of the genre content that have led to professional unease and professional criticism of this kind of history on television.

Despite the issues with reality television, this genre of historical television has enabled television historians and producers to consider the importance of visual media.[103] This process has enabled television historians to consider other ways of visually communicating history to the public, including 3D virtual reconstructions to evoke emotions and the "spirit of the moment." This approach has given historical television a mechanism to communicate history to the public that has "freed up history TV from the tyranny of the archive image."[104] This has supported the development of non-archive-based television programs, such as *Sex in the Ancient World* (Case Study 19).

A significant development in history television has been the move away from tried and tested factual and documentary-style formats to publicly oriented formats, such as drama and reality, that mix fact and fiction. The development of a hybrid of reality and documentary styles has attempted to successfully communicate and engage a wider audience in the past (Case Study 21). The BBC television series, *Restoration* (2003–6) enabled the public to interact with decisions in the restoration of historically significant buildings, such as the Victoria Baths, Manchester, through polls, while also providing historical evidence in documentary form through celebrity endorsement of the building. The high viewing figures for these historical television programs indicate that this hybrid is regarded as successful in engaging and entertaining the public.

Case Study 21 Channel 4, *Time Team*

The introduction of Channel 4's *Time Team* in 1994 to UK terrestrial television channels saw a movement away from the experts and talking heads in history programming in the UK.[105] It was not until 2009, with the launch of *Time Team USA* on Public Broadcasting Service (PBS), that this format appeared on terrestrial channels in the USA.

Time Team focuses on the reality of the process of historical discovery, and has hallmark discussions and arguments about the strategy and interpretation between professionals on archaeological and historical sites around the UK (Figure 6.1), and in some cases further afield in Spain, the USA, and the Caribbean. These "real" elements are fundamental to the live historical process. The main narrative and scripted components of *Time Team* were delivered by a non-historian, Tony Robinson, a comedy actor more famed for his role in the 1980s comedy, *Blackadder* (BBC). This presenter was a deliberate choice by the creators (including former teacher, Tim Taylor, and archaeologist, Mike Aston), as it was hoped that a household television name would enable the presentation of the past in this program to appeal to a broad audience. As such, the presenter would play a key role in asking the questions of the professional archaeologists and historians that the public wanted to know and in a way that the public could understand.

The initial program aired on Channel 4 in 1994. The large viewing figures, 3.1 million at its peak, resulted in its development for digital and international markets. Although the program was

Figure 6.1 Hallmark discussion on *Time Team*
Source: Faye Sayer.

decommissioned in 2011, it is still regularly repeated on terrestrial and digital channels, and new *Time Team* "special" and "documentary" programs continue to be commissioned, such as "The Lost Submarine of WWI." The program's decommissioning can be attributed to falling viewing figures from 2010, in part, due to changing scheduling and less regular slots, and changes in cast members, including Mike Aston's departure, and Helen Geake's and Stuart Ainsworth's reduction to occasional roles to make way for new, younger, cast members.

Time Team led to a plethora of historical reality programs including *Edwardian House, The Trench, and Colonial House*, to name but a few. These publicly facing programs are becoming one of the main types of popular historical television. Their popularity, on the part of television and production companies, relates to their low production cost. Potentially, for the public, it is because they seem to capture their sense of interaction and real-life emotion. Despite its longevity and high viewing figures, *Time Team* has received widespread criticism regarding its alleged lack of professionalism and the simplification of historical interpretation presented as fact.[106]

The program has also been accused of replacing content with characters, such as Phil Harding.

Questions

1 How does media hybridity work in practice? What lessons can historical television programs learn from archaeological television?
2 Why does the historical reality format appeal to the wider public, yet often not to historians?
3 What factors influence the success of historical television programs?

Reading and resources

- Clack, T. and Brittain, T. (2007) Archaeology and the media: an introduction, in T. Clack and T. Brittain (eds) *Archaeology and the Media*, London: University College London, Chapter 1.
- Taylor, T. (2000) *Behind the Scenes at Time Team*, London: Channel Four Books.
- http://www.channel4.com/programmes/time-team;
- http://www.timeteamdigital.com

History has a broad impact on televisual culture and can act as a historical backdrop for a wide breadth of television programs. The range embraces comedy, children's programs and game shows, such as *Dad's Army* (BBC, 1968–77), *Maid Marion and Her Merry Men* (BBC, 1989–94), and *University Challenge* (BBC, 1962–present).[107] Principally, these programs offer entertainment first with education as a secondary concern.

Working in and with the media

Relationships between historians and program-makers have been regarded as a one-way street and are at best mixed.[108] Historians are called on to support research and provide their expertise and research material for these programs.[109] This can be a one-way relationship, with historians providing knowledge but with little control over its use and its presentation. The need to alter this relationship, to remove "professional distance," and creating dialog is essential in order to develop historical television.[110] This change enables historians to collaborate with media companies to produce shows,

support research, write scripts, advise on filming, and appear on screen or on air as experts. It can create a medium for the communication of a historian's research to a wider audience, creating real value and impact for their work, which is critical for the future funding of research.[111] Developing a relationship between the presenter and the producer is also critical in creating and shaping history; this helps to translate narratives from the academic realm to the public one.[112] Historians' skills and their ability to create stories about the past mean they are valuable assets to the media industry, generating income for media companies through raising viewing figures and advertising revenue.[113]

The growth of history in the media has increased the job market for historians. The demand for trained media historians has led a number of universities to offer undergraduate and postgraduate courses in media history, including Bournemouth University and its Centre for Media History. These courses focus on preparing students in the basic communication, research and technical skills to work in different elements of the media industry such as editing, documentary-making, journalism, and social media marketing. Correspondingly, these courses often have close working relationships with media companies.

Key skills for working in the media

- Strong research skills
- Good literacy skills
- Excellent communication skills
- Team-working
- Time management
- Flexibility
- Creativity
- Accuracy

In order to develop relationships between history and the media, the International Association for Media and History (IAMHIST) was formed in 1977. This scholarly organization aims to provide knowledge sharing through its journal and conferences. IAMHIST supports the development of media historians through its postgraduate forum and media training courses.[114] Agencies specifically aimed at supporting historians' careers in the media industry have been created, such as Past Preservers.[115] These agencies provide historians with advice on getting jobs within the media,

including on-screen work; for example, creating a show reel, producing a CV, and taking a head shot:

- *Show reel*: This is about showcasing talent on scene. A show reel is an edited show segment usually 2–3 minutes long, introducing the individual and compiling the best clips of their media appearances. This is a compilation of conversations and interview pieces to camera, usually 10–15 pieces. This can involve new work, which showcases different talents, and can include shooting different screens, scripted and unscripted pieces to camera.
- *Headshot*: This is the professional, head and shoulder (passport-type photo) but is 10–18 cm in size.
- *CV*: This should include biometric information, address, agent details, skills, credits and web links.

Historians working in public history organizations, such as museums, are increasingly provided with media training; for example, the British Museum currently provides day training courses for all curatorial staff. This training provides individuals with guidance in answering media enquires, writing press releases, presenting ideas within a media format, fielding questions, and giving notes on body language, voice projection, and personal presentation. Media training benefits public history organizations, as the involvement of staff in media, especially on-screen, can provide free marketing for the organization and lead to wider capital investment for research and visitor facilities. An organization's presence in the media helps them meet their wider remit of communicating history to diverse demographics and impacting on wider society.

Specific jobs in media

An historian's work in television, radio, or film can be on-screen or off-screen, producing, directing or presenting, which enables historians to gain narrative skills to translate history and communicate it to a wider audience. Historians and history graduates have skills, including discourse, research, and communication, that are valued in the media world.

Historians can undertake various jobs in media:

- *Runner*: This is a first job, a taster of media life. It involves assisting everyone, being on call to do tasks such as to meet and collect people, moving items around from one location to another, and providing assistance to the rest of the crew.

- *Researcher*: The job involves engaging in primary and background research to add details and accuracy to the narrative. This information is presented to the scriptwriter, director, and talent (see below) so an accurate and original story can be created.
- *Production Manager*: This role provides an organizational overview. The job involves project management of the production, and organizing all aspects of this, such as recruiting the staff, crew and talent, putting together the production schedule, and managing the budget.
- *Crew*: Professionals employed to capture the visual and audio material. They have responsibility for the sound, light, and camera work on set.
- *Talent*: The presenter, a personality who narrates in front of the camera or radio. They are the mode of historical translation to the public and act as a storyteller. This role requires the ability to present ideas with confidence, show personality, have a clear voice, and ability to learn scripts. Many have had media training before appointment to this role.
- *Consultant*: Academic and professional historians will be asked to advise on the detail and accuracy of the script and visual elements during filming, such as customs. These are usually experts in specific periods or individuals.
- *Producer*: Employed by the production company and responsible for final quality and ensuring the end product meets the commissioner's requirements.
- *Director*: Employed by the production company, usually with input from the television company. The person appointed to have overall responsibility for the story, the look and sound of the final product. It is their job to create a story through visual and audio material, overseeing filming, deciding what and how something is recorded and putting together the edits of material for the final version.
- *Commissioner*: Employed by the television company to direct programming choices. Decides if the idea has potential for success and whether the program fits into the company's long-term strategy and programming schedule.

Book proposal

No matter what genre of popular writing historians decide to engage in to translate history into a popular narrative, there are vital points when pitching an idea to trade and academic publishing companies.

Commercial trade publishers, such as Random House, usually publish popular fictional historical novels. Submission of draft manuscripts is usually through a literary agent, a person who has established a professional relationship with the publishers and who is trusted to have made a preliminary assessment of the potential of the author's work. An author finding a suitable agent is often the first stage in this process of commissioning for popular fictional historical authors.

Academic publishers, such as Bloomsbury Academic, focus on factual historical literature and academic textbooks. Often the first step in getting a book commissioned by an academic publisher is the author directly contacting a commissioning editor or editorial assistant. Editors can support potential authors to develop book proposals. The editorial team provides advice to the author on writing style, the format and the ideas the company are looking to develop; they can also offer advice on reviewing successful proposals. Consideration for commissioning of academic work requires the submission of a detailed book proposal, chapter, or book manuscript for peer review. Large academic publishers, such as Routledge, Thames and Hudson, Bloomsbury, and Tempus have specific requirements and stages in order to have books commissioned (Figure 6.2).

Self-publication offers an alternative route for the publication of historical literature. This approach is entirely controlled by the author, who writes, edits, produces, markets, and sells the book. The internet and the availability of web resources to support this process, including editing software and internet "web" books, have supported the process of self-publishing.

Popular "academic" factual book proposals require an outline, chapter briefings, an audience, and a market, whereas fictional "trade" novels require whole chapters or even drafts of complete books to be submitted to editorial boards. Popular historical books, especially historically-based publications rather than factual books, have huge profit margins, but also are a commercial risk. In academic publishing, a first book by an unknown author can expect a low 4–5 percent commission percentage. Trade publishers often offer higher commission percentages upward of 10 percent and larger advances and commissions for personalities.

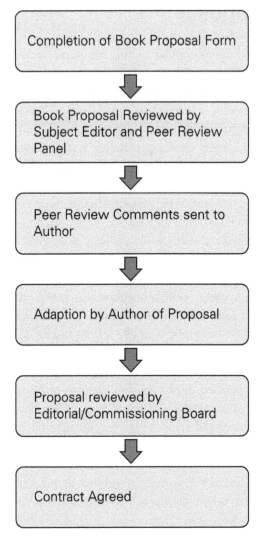

Figure 6.2 Flow chart of the process of book commissioning

Key requirements for academic books proposals

- *Title*: Make this sharp, understandable, and new.
- *Summary*: Brief summary of two lines about what could be put on the outside or cover of the book.

- *Description*: Potentially this will tell the audience what the book does and how this will help them, and is a valuable asset to them. This is where you are selling the book.
- *Key features*: Are you doing anything new and different from other books? Will you include photographs?
- *Contents and chapter synopsis*: Provide an overview of each chapter, what your main aims are and how you are going to do it.
- *Word count*: Most publishers are looking to publish books of approximately 80,000–100,000 words. This will depend on the market.
- *Submission date*: Make this reasonable and achievable.
- *Market and completion*: Including international markets and competing or comparable books.
- *Author information*: Including contact details and biography of author.

Television proposal

Pitching an idea for a television program requires the ability to construct a story. This narrative must, whether it is a drama, documentary or reality idea, draw people in and evoke powerful emotions through storytelling.[116] The idea must work within a genre and fit into the programming of a channel, and consider the channel's future focus. To be commissioned the program must first produce a proposal.[117] The proposal must have the following features:

- *Title*: Must be catchy and audience-related.
- *Ownership*: Who owns the idea and concept?
- *Duration and number of episodes*: This needs to fit into the television company's schedule. Investigate what the normal length of their show is; for example, most history documentaries are 60 minutes long. Is this going to be a feature documentary? How many episodes will it need to tell the story? How will the story be divided? Lastly, what is the specific story in each episode?
- *Genre*: Documentary, drama, or reality?
- *Outline*: This outlines a story and presents a different idea. It is focused and carefully structured work with a specific producer and characters. It can be in the form of a one-page piece or a pitch "demonstration" tape. This requires collaborating with an executive producer with good background knowledge and experience. Other considerations include a multiplatform context, understanding the market, and talent spotting.

- *Style*: Short, sharp, and succinct. Provide visual aids, such as photos.
- *Development process*: This starts with the idea and ends when money has been awarded, the green light given to production.

Writing scripts and proposals is a craft, like writing for a museum exhibition; it requires a consideration of the audience. It must have something that makes it different, to "stand out, and draw on ideas from the successes of other programs."[118] Often prior to developing an idea for media, historians will work with a production company to develop an idea. This is often the most successful route as they have experience of pitching and understand television and channels, have relationships with directors, producers, editors, and personalities. It is worth noting that this is not the case if the screen rights to a book have been bought by a production company, as often at this point the agent will act on the author's behalf and may have little control over the final product. If the proposal is seen as having potential by all parties, this will initially be pitched by the production company to a programming committee and then the commissioning editor. Television programs are high cost and therefore high risk for television companies; therefore, for many television programs a pilot will be commissioned first before a series—for example, *Sex in the Ancient World* (Case Study 19) and *Time Team* (Case Study 21).

Conclusion

The media, including television, radio, and popular publications, is increasingly playing a part in historians' ability to communicate a story and ideas.[119] Working with, in or through the media, historians can learn to understand audience demands, values and aspirations, and create new historical dialogs. Understanding the different motivations and values and developing trust between diverse groups of people is critical to developing this relationship. It can break down professional and public boundaries that enable historians to become successful "public historians."

This collaboration between historians and media professionals enables the successful communication of history and relays the story of the past to the public. This relationship is mutually beneficial to all parties. For academics, the relationship can impact on the authenticity and validity of history portrayed in the media, dispelling historical myths and introducing historical factual evidence. For producers, developing relationships with historians can provide access to new and unique historical stories and details.

The growth of history in the media indicates that there is a market for and value of history to a wider audience and that media history impacts on the profession. Media has wider benefits to history, rescuing historical buildings, highlighting political causes, and providing a sense of commonality, in which the wider public can see the benefit of the past. The discipline of archaeology can offer lessons for the presentation of history to the public, both within and outside the media's domain. The public presentation of archaeology has demonstrated the benefits of mechanisms, such as the use of hybrid, discursive and interactive media formats to successfully present the past to the public through visual media. The popularity of archaeology television programs, such as *Time Team* (Case Study 21), demonstrates how the wider engagement of the public in the process of uncovering the past can be achieved. This also serves to demonstrate the issues media formats can raise in their "authentic," "valid," and "professional" communication of history to the public.

Media historians require specific narrative and communication skills, specifically the ability to create a story through a popular narrative framework and to tell that story in a way that is emotional and humanistic. Critically, the role of a historian in the media requires a careful balance between entertainment and maintaining historical accuracy.

Routes into media history

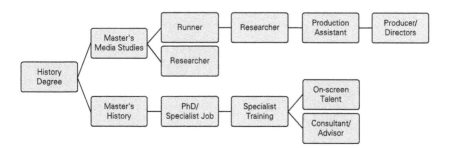

Figure 6.3 Overview of public history careers in media

Media historian (on-screen/advisor)

History degree (2:1), Master's in history (or related field), PhD in specialist field, media training. The job description is:

- Undergraduate degree in history
- Master's in history
- PhD in specialist field
- Media training
- Excellent verbal communication skills
- Strong personality
- Eloquence
- Broad and in-depth knowledge of history
- Adaptability

Media historian (production)

History degree (2:1), Master's in media or history, work experience in media (runner). The job description is:

- Undergraduate degree in history
- Master's in media/history
- Internship and/or pre-entry work experience
- Project management skills
- Strong research skills
- Excellent communication skills, verbal and written
- Teamwork and negotiation
- Adaptability

7

Policy, Politics, and History

The role of historians at a government level and the vital role that history plays in national, regional and local arenas are often overlooked by historians and the public. Historians are increasingly involved in the development and creation of policy, which influences specific policy frameworks designed to manage history and historic preservation and presentation. This chapter demonstrates the importance of history to the various government agencies involved in developing mitigation and preservation advice, including heritage-specific agencies such as English Heritage and the Historic

Environment Offices in the UK, and the State Historic Preservation Offices in the USA. Furthermore, it examines the role of historians and history as a subject in providing advice relating to the wider impact of history in non-heritage-specific branches of government, such as the Environment Agency and the Ministry of Defence, both in the UK. Working within this constantly changing, challenging, and important sector of history requires specific skills, including excellent written and verbal skills and adaptability.

This chapter seeks to show international examples of best practice in government legislation, guidance and advice, and future mechanisms for public history within policy and politics; for example, as enacted in the protection of historical sites and in educating the military to incorporate cultural sensitivities when operating in foreign environments. Historians' involvement in history policy can help shape history for the future, both for the good of the profession and for the service of the public.

The impact of policy on public history

The process of "doing" history, particularly the undertaking of historical research, is regarded by some as exclusive in nature because of the exclusion of the public, the majority, by the minority, the academics.[1] This exclusion, which occurred in part due to the professionalization of history in the 1970s, has counter-intuitively led to a plethora of new guidelines, policies and bureaucracy, all advocating an increased inclusion of the public in the past. This has directly impacted upon the practice of history and the development of organized public history. The practice of public history can be associated with politics and linked to ethical and moral obligations to provide public rights to increased access to historical production. It is these moral and ethical principles that have guided the instigation and methodology behind many public history projects. These methods and motivations have been discussed extensively in literature relating to the practice of public history, particularly in non-Western contexts such as South Africa.[2]

The principles behind public history are directly linked to broader political movements, such as the indigenous rights movement, the effects of which dominated academic research and heritage management during the early 1990s. It was during this period that public history began to appear

extensively in the academic literature in both Australia and the United States.[3] Publications focused on the rights of the indigenous and/or native "communities" to be involved in decisions relating to the treatment of "heritage" on "their" land.[4] Despite the UK and European countries being less affected by indigenous rights issues, this political movement was based on understanding and communicating alternative "public" histories, and resultantly influenced the practice of history and professional conduct in relation to the public. In the UK and Europe, the development of postmodern and humanistic approaches to the practice of history included supporting the development of the history of the black, labor and women's movements. Public history sought to provide the various ethnic, social and political groups, i.e. "the public," with a voice in history, transforming power relationships between historians and the public.

It is essential, in the first instance, to discuss the relationship politics has with history, and to understand how politics has shaped the development and practice of public history. Writing over 30 years ago, McGimsey touched on the subject of federal and state influence on heritage, going some way to deconstructing the effect in the USA of federal and state finances and policies on the practice of heritage.[5] This demonstrated how the political history of federal Acts affected the practice of history and public history. Neumann's recent survey of how federal and state laws in the United States were passed, including the Historic Environment Act of 1966, offers some further insight as to the complexity of political influence on historical practice.[6] This research deconstructed Democratic and Republican Senators' representations in the passing of the Bill and indicated a Democratic majority in support of the Bill, against what appears to be Republican opposition.[7] These ideas were consolidated by Jeppson's work on education and public heritage, discussing the effect on the heritage sector of the changes in US government representation in the last decade.[8]

The development of public history in Australia and North America was, in part, a response to the growing legislative guidelines that surrounded the practice of public and historical research; guidelines that are often interpreted as a by-product of "post-colonial guilt."[9] This can be defined as colonial-descent guilt regarding the treatment of indigenous populations during "white" settlement, including land acquisition, forced indigenous child adoption, and the killing of indigenous people. These guidelines, which include the ICOMOS Burra Charter (1999), the Australian Heritage Commission "Ask First" document (2002), and the Native American Graves Protection and Repatriation Act (1990) among others, were related to

the ethics of doing historical work, and the importance of historians communicating their work and engaging with indigenous communities prior to, during and after the completion of their research.[10] This post-modern and humanistic approach had a theoretical impact on the practice of history within the public domain in Europe and impacted on the wider development of public history.

Contrary to the above, it could be suggested that this post-modern approach allowed history to become easier to politically manipulate, as the controls over history and the use of factual historical research declined, often replaced by intangible heritage research. The result of this was that few decisions could be made about what was important in heritage and history, as everyone had equally valuable views and interpretations of the past. During this period, the erosion of a belief in absolute values and truth in the heritage sector resulted in a lack of professional conviction. This caused both the public and the historians to become confused as to the definition of history, their roles in its creation and interpretation, and its relevance to modern society.

International policy and guidelines

The introduction of international guidelines has impacted on the practice of public history; if these guidelines are signed up to by a country, they can encourage a radical re-think of respective national heritage policy and practice. Although international guidelines are worded carefully to appear to advocate for inclusivity, in reality, they often seek to keep control and power in the hands of the "professional" historian.

The Valletta Convention (1992), formally seen as the convention for the protection of archaeological heritage, has impacted on the participation of the public in wider history. This convention aims to promote a more balanced relationship between historians and the public and increase inclusivity: "to promote public access to important elements of its archaeological heritage."[11] However, earlier, in Article 3, it states these projects should be "carried out only by qualified, specially authorized people," advocating that only professionally trained people are capable of researching their past. Despite promoting greater public access to history, the Valletta Convention fails to promote active engagement in the past by non-professionals.[12]

The United Nations Educational, Scientific and Cultural Organization (UNESCO) was founded in 1945 to promote peace and security through

education, science and culture. The UNESCO Convention states that it has three main functions:[13]

- to advance the mutual knowledge and understanding of peoples;
- to give fresh impulse to education and to the spread of culture;
- to help to maintain, increase and disseminate knowledge.

This international organization plays a pivotal role in promoting and protecting internationally significant and culturally important sites, including historical sites or landscapes, such as Stonehenge and the Great Wall of China. UNESCO is financially supported by individual country contributions. This compulsory support requires all member countries to financially contribute to UNESCO's activities. It receives additional private and voluntary funding from some member countries and individuals to support internationally important activities, such as the World Heritage Fund (WHF) and its Rapid Response Team, which provides aid and support to cultural heritage at risk.[14] UNESCO provides international financial support to the state to carry out emergency work to protect important historic sites.

UNESCO employs permanent and temporary staff in various locations around the world to support the continued international protection of heritage and historical sites and places of cultural importance. UNESCO collaborates with international experts to provide specialist advice and guidance on specific issues and topics, such as conservation and World Heritage Site (WHS) listings.[15] For example, archaeologists, architects, and structural engineers provided advice on the conservation and stabilization of the Leaning Tower of Pisa.[16]

The organization plays a pivotal role in advising governments and preventing the destruction of culturally significant sites. For example, in 1960, they played a critical role in the strategy to protect Abu Simbel in Egypt from the construction of the Aswan Dam, which would have led to this important New Kingdom temple site being submerged by Lake Nasr.[17] In 1972, UNESCO launched the World Heritage Convention, a document drawn up to be supported by national governments, with the specific aim of protecting and preserving the world's cultural and natural heritage—specifically the historic environment.[18] This provided a framework for the protection of cultural heritage, best practice, and a fund to support the protection of history. Their work placed history, including historic landscapes, cityscapes, and buildings, firmly in the international political domain and sought to develop international government relationships to support historic sites and represent the public's

interests. In 2011, UNESCO recognized the importance of a holistic approach to historic urban landscapes, advocating for the use of the SWOT analysis: Strengths, Weaknesses, Opportunities, Threats.[19] Each of the four SWOT categories recognizes elements of community influence on heritage and heritage influence on community. For example, a strength of the community is heritage "intimate knowledge," a weakness is "lack of communication," a threat is "illegal looting," and an opportunity is "educational training." The SWOT analysis serves to illustrate the importance of the participation of communities in the protection and conservation of these historic landscapes and the incorporation of their traditional practices in management plans.

UNESCO World Heritage Sites are historical sites or locations, which are deemed to be of international importance. Applying for WHS status and listing provides funding and tourism opportunities, and management support and guidance in visitor strategies, conservation and protection (see Heritage Management Plan). This strategy and definition of WHS have defined the presentation of culture and history to the local, national and international public, through defining what, as an organization, they regard as important to preserve and present. Until the 1990s, the significance of a site focused on the importance of the physical remains; yet this has since changed to take into account the intangible heritage of a place and its value to the wider community.[20]

The International Council on Monuments and Sites (ICOMOS) is a non-governmental organization (NGO) dedicated to the conservation of the world's monuments and sites.[21] It was set up in 1965, to oversee the principles outlined in the Venice Charter (1964), the international charter on the conservation and restoration of moments and sites.[22] ICOMOS aims to support the development and application of theories, methods, and scientific techniques that preserve and protect heritage.[23] This NGO's aims are linked to UNESCO's wider cultural heritage mission. This international organization has created interdisciplinary national committees and international scientific committees, establishing a network of experts, including historians, to set standards and oversee best practice in relation to the protection and conservation of buildings, historic cities, cultural landscapes, and archaeological sites. ICOMOS has supported the exchange of ideas and new heritage initiatives around the world; for example, the *Heritage@Risk* journal seeks to provide a means of academic and professional communication on heritage debates.

The Burra Charter was established by ICOMOS in 1979 and revised in 1999.[24] The charter provides guidelines for the conservation and management

of places of cultural significance in Australia, based on the country's unique cultural experiences and perspectives.[25] This includes the diverse and intangible heritage, including places of value to Aboriginal groups and their descendants. The charter seeks through an ethnically driven management structure and sequence of investigation, decisions and actions to preserve the value and cultural significance of historic and heritage places for future generations.[26]

Historians working with these organizations require the following characteristics:

- a breadth of historical understanding at an international level
- cultural and political sensitivity
- the ability to uphold ethical codes of conduct and conventions
- the ability to work with multiple different disciplines to engender the best solution
- a willingness to undertake often extensive travel

NGOs and international organizations such as UNESCO and ICOMOS require preventative action and rapid responsive reaction to sensitive situations, such as war or national disasters. Jobs within these organizations usually require additional language skills, specifically French (UNESCO is based in Paris), and often a third language. These organizations take on interns, and provide training schemes for graduates around the world. Employees of these international organizations work to encourage the application of international guidelines and policies, and to provide critical training in the protection and preservation of history.

International and national charities

International and national charities often work alongside international and national government cultural and heritage organizations. In the twentieth century, numerous philanthropic organizations were established to raise awareness and funding for the protection and preservation of historic buildings and monuments, for example, the Society for the Protection of Ancient Buildings (SPAB), the Landmark Trust (LT), and the World Monuments Fund (WMF, see below). These organizations support elements of public history through fund-raising activities, including public talks by leading scholars and prominent personalities—such as *Time Team* presenter Tony Robinson's WMF lecture—building open days, and charity campaigns

encouraging individuals and private organizations to donate money for specific projects.

The WMF is an international charity, which supports, through donations achieved by fund-raising and activism, the preservation and conservation of historically significant buildings—for example, the historic site and temples at Angkor Wat, in Cambodia.[27] Its central remit is to encourage sustainable futures for these historical buildings through promoting and supporting schemes for visitor access and public involvement. At St Paul's Cathedral in London, the WMF provided expert advice and financial support, which enabled the building's renovation scheme, and it aims to encourage proactive involvement of the public in the project and the building's future.[28]

The Landmark Trust is a European-based charity that seeks to rescue historic buildings at risk around the world. This is in part achieved by renovating and transforming the buildings into holiday homes, which provides a sustainable future and economic income to maintain these often Grade I and II listed buildings, and enables them to be presented and used by the paying public.[29] It is worth noting that the expensive rental costs of hiring these buildings for holidays is prohibitive for large sections of the public, who can gain access to these properties only on limited open days. The work this charity undertakes and the maintenance of these buildings are supported by a network of local volunteers. Principally, this charity enables historical buildings to become usable places in the present. For example, the trust has recently restored the medieval Astley Castle in Nuneaton, Warwickshire, in the UK. The award of the 2013 RIBA Stirling Prize for architecture recognized the sensitivity displayed regarding the history of this structure throughout its restoration and the balance of this with the creation of a usable living space for holiday renters.[30]

The Society for the Protection of Ancient Buildings (SPAB) is a UK-based charity providing expert advice to save old historical buildings from decay, demolition, and damage.[31] This organization campaigns to save ancient buildings through government pressure; thus, it acts as a statuary local government advisor in applications that involve the demolition or alteration of listed historical properties. The society aims to provide wider public education as to the value of historical buildings. Short courses for home-owners provide practical guidance on the conservation and maintenance of residential historical buildings.[32]

National charities were often established to support government policies and agendas relating to history and public heritage. For example, in the UK, the Heritage Lottery Fund (HLF) was set up in 1994 by Parliament.[33]

Officially the HLF was seen as a non-departmental public body, to which the Secretary of State for Culture, Media and Sport issued policy directives.[34] Therefore, the work of this organization and its key objectives are influenced by government heritage policy. This organization uses money raised from the public sales of National Lottery tickets to provide grants to a wide range of community heritage projects through the UK. These projects include: (1) historic building restoration and conservation projects, such as Valentines Park, Redbridge; (2) museums and archives projects, such as the building of Creswell Crags Museum and Archaeology Park; (3) oral history projects, such as Jacksdale and Westwood (1914–2014); and (4) community archaeology projects, such as Shoreditch Park (Case Study 15). Research by the public think tank Theos indicates that low-income individuals spend a disproportionately high amount of money on lottery ticket sales, including scratch cards and Lotto (draw-based games), in relation to the HLF money received by these economically "deprived communities."[35]

These charities provide grants to support public history projects and initiatives. These grants require organizations and community groups to collaborate to write funding applications to gain access to financial support for specific heritage projects, often those that aim to support diverse public access to heritage. Specific skills are required to write funding applications for these external bids and some heritage organizations employ specialist grant teams to write these applications.

Writing funding applications

A funding application should include the following features:

- *Outline of project*: Summary of main tasks of project. This should include the project's main aims and what will be achieved.
- *Project plan*: What the project will do, why it is needed and what issues or specific challenges it will address.
- *Evidence of consultation*: Preparation for the project and evidence of public consultation and evaluation.
- *Community outcomes*: An outline of the key potential values of the project for the local community. This includes the social, economic, and knowledge benefit to the community.
- *Stakeholder benefits*: Who will benefit from the project (professionals, the public, third sector)?
- *Demographic range*: Understanding of audience and potential benefit to a wide and diverse demographic range.

- *Project management*:
 - How will it be managed to meet the project aims?
 - Who will do this?
 - Outside support and help, including the public and the third sector.
- *Timescales*
- *Sustainability*: Long-term future of project: how will work be continued after the project funding ends?
- *Activities*: Including activities to support public access, educational and training activities.
- *Costings*: This will usually require the host organization to match a percentage of the overall funding. For HLF, this match funding is a minimum of 10–15 percent dependent on the amount of funding applied for. Matching funding should also be demonstrated through in-kind support, such as use of facilities, staff and volunteer time.

National and federal policies and guidelines

The majority of European countries have a national government organization responsible for overseeing the protection and preservation of that country's heritage, such as the Danish Heritage Commission and English Heritage (Case Study 22). These organizations are financially supported by central government and typically overseen by an overarching government department for culture or environment. These organizations and their funding reflect national economic pressures and changes in government agendas and governments, and as such can serve to represent dominant political ideologies.

Case Study 22 English Heritage

English Heritage (EH) was until 2015 the UK's government's statutory advisor on the historic environment, providing government and public advice on the protection, promotion, and preservation of heritage. In 2014, EH received two-thirds of its funding from the government through Grant in Aid; the reminder of its funding is self-generated by membership, property revenue, and fundraising.

In 2015, English Heritage was divided into two agencies, Historic England and English Heritage. English Heritage aimed to act as an independent and eventually self-sustaining charitable organization, responsible for overseeing the protection and preservation of 440 of the UK's historic sites, including Stonehenge and Whitby Abbey. Historic England would provide planning advice and advise government on future policy documentation and also provide this advice to private organizations around the UK. As a government and publicly funded organization, Historic England aims to support the public understanding and appreciation of history by creating public literature, public heritage advice and improving public accessibility to heritage assets. Previously, under the title English Heritage, this brand of the organization was involved in research relating to understanding the public's value of, and relationship with, heritage and has produced guidelines and literature to support its findings, such as "Heritage Counts" and "Power of Place".[36]

Historic England took over responsibility from the previous English Heritage for compiling and maintaining the UK's Listed Buildings Register.[37] All buildings built before 1700 are listed, as are most built before 1840 that maintain their original features.

Listed Buildings Grades are:[38]

- Grade I: Buildings of exceptional interest and international importance. These include buildings such as Buckingham Palace and York Minster.
- Grade II*: Nationally important buildings of more than special interest. These include buildings such as Manchester Town Hall and Battersea Power Station in London.
- Grade II: Nationally important buildings and of special interest. This is often the grade of listing for inhabited houses. These include buildings such as the BT Tower in London and Manchester Victoria Station.

This list provides a comprehensive list of noteworthy historical buildings in the UK, including the Palace of Westminster in London, which influences their protection and preservation. Listing informs planning consent at local government levels, and aims to preserve the authenticity of historical buildings and affects their ability to be developed and conserved. As such, the listing of a building will directly affect the public's ability as house-owners to change and alter a building's architecture and aesthetics.

The levels of responsibility entrusted to government heritage organizations vary between different countries, but usually include overseeing the protection of nationally significant buildings, subsidising national museums, and providing regulations for the protection of heritage and cultural assets, such as historical buildings or sites of national historical interest (Case Study 22). These government organizations maintain heritage, historical sites and buildings registers, which are often accessible online.

Along with instigating national guidelines and legislation, national organizations are responsible for the implementation of international charters, such as UNESCO and ICOMOS. In some circumstances they will fund both domestic and overseas research; for example, the German Commission for Ancient History and Epigraphy funds research in Burma and Sri Lanka. These organizations act not only as representatives and protectors of national heritage and historical assets, but also as government advisors.

In the United States, the Department for Agriculture's United States Forest Service and National Parks Service is responsible for a large proportion of federally owned land, which is governed by federal heritage laws, such as the National Historic Preservation Act.[39] The US National Parks Service is responsible for more than 400 national parks, including Wounded Knee

Battlefield and Mount Rushmore in South Dakota.[40] Their staff, ranging from park rangers to educational specialists, are responsible for developing public history programs that cover a wide range of historical periods and assets, from presidents' houses to American Indian landscapes. Employees manage online and on-site historical educational programs that provide accessible and relevant historical information for both formal and informal learning about the past, to national and international visitors.[41] Park and forest rangers are employed to provide onsite support and tours and to balance this with the need for conservation and the prevention of environmental damage to sites from visitors (Case Study 23).

Case Study 23 United States Forest Service: Passport In Time

The United States Forest Service (USFS) manages in the region of 193 million acres and 155 national forests.[42] The organization has a commitment to "caring for the land," which includes preserving and presenting the nation's history and the heritage that are contained in its landscape. This national organization is funded primarily centrally through the US government.

The USFS supports managed public access and public involvement in the management and maintenance of heritage sites in its landscapes, such as Gold Mountain Mine, South Dakota.[43] The management of USFS land involves balancing the financial need to supply commodities, such as timber, with supporting recreational usage and providing ecological management. This management can include placing restrictions on public access to certain areas and from undertaking certain activities, such as agriculture. In this way, landscape management and "ownership" can create conflicts with those who believe they have and perhaps do have tribal land claims to areas.

In 2000, USFS launched the "Passport In Time Program" (PIT). This federally supported public history program has since been rolled out across 117 forests in 36 states.[44] This program provides a platform for volunteers to work with historical practitioners and academics and provide hands-on educational training in historic investigation, interpretation, and future management. Volunteers work with professionals to gain the skills needed to investigate, conserve, present, and restore historical sites. PIT works in that each time a volunteer attends they received a stamp, indicating their time

working with the project leader. These stamps can be collected on projects run by the NFS around the country. This aims to encourage continued involvement and provide experience that is officially recognized in the heritage community. This program is an example of education in action and has provided life-long learning opportunities for members of the public and future practitioners around the United States.[45]

Questions

1 How do national heritage organizations balance the protection and preservation of history with enabling public access?
2 Do national organizations encourage wider public interest in the past, or merely cater for those who already have a pre-existing interest?
3 How can heritage organizations successfully link multiple historical sites together to provide the public with a holistic story of the past?

Reading and resources

- Jameson, J. (2004) Public archaeology in the United States, in N. Merriman (ed.) *Public Archaeology*, London: Routledge, pp. 21–58.
- http://www.fs.fed.us
- http://www.passportintime.com

Historians working in national heritage require a broad knowledge of a country's history, and the national and international government legislations governing heritage assets, such as national planning policies affecting historical preservation and investigation. This requires employees to have the ability to communicate with all sectors of the community, from the public to politicians. This includes solving public enquiries and providing public advice and support, such as how to preserve a historical building or how to renovate scheduled buildings within international and national guidelines. Government historians provide heritage advice to other government agencies, political parties and individual government officials. This advice promotes history's importance to a country and its citizens, and helps to justify the funding that historical activities receive. Government historians promote the wider use of government records, historic resources and open access to this material, often through the use of digital technology.

For example, Heritage Gateway in the UK, which links Historic Environment Records from different countries, allows the public to assess the government's historical records, including desk-based assessments, reports from recent archaeological investigations, small finds reports from the Portable Antiquities Scheme, sites of historic interest, scheduled ancient monuments and listed buildings; this data is linked to area maps and GPS co-ordinates.[46]

The recent global economic downturn, in North America and Europe, has resulted in growing financial pressure within publicly funded heritage organizations. Government-funded heritage organizations have come under increasing pressure to justify their public spending. The delivery of value for money to the taxpayer has become increasingly prominent, especially at a time when public spending and funding for culture are decreasing in order to reduce national deficits. In the UK, the impact of reduced government funding for cultural activities has meant government agencies such as English Heritage having their budget cut by a third (Case Study 22), Heritage Lottery funding decreasing by 30 percent, and MLA funding reduced by 25 percent.[47]

Policies on the movement of objects

Public history has been defined as the actions of the public in history;[48] this includes individuals collecting and discovering historical objects, such as with metal detectors and objects in private collections. National and international governments aim to protect history found by the public in their personal pursuit of the past. In the UK, national legislation, such as the Treasure Act governs the selling and acquisition of historical and archaeological items found by the public.[49] The Treasure Act requires the public to report items defined as treasure, which includes items containing over 10 percent precious metal (gold or silver); two or more coin hoards; and two or more prehistoric metal items found together. These are regarded as items owned by the Crown. Once reported, such objects will be assessed and valued by the Treasure Committee, based at the British Museum.[50] Items can then be purchased by the museum, with the full market value given to the finder and the landowner as a reward. This process is overseen by the Department for Culture, Media and Sport.[51] The UK government has supported, through the Museums, Libraries and Archives council (MLA),

now incorporated into the National Arts Council; various public initiatives to educate and work with the public to record individual objects found on public and private land. This includes funding the Portable Antiquities Scheme (PAS), which employs Finds Liaison Officers in England and Wales, often based in regional museums.[52]

Historical items in the collections of museums and archives often are objects acquired during the nineteenth and early twentieth centuries, before legislation governed the movement of objects between countries, and required authenticated provenance and legal acquisition of objects from a source country, site and peoples.[53] Museums and archives display and store items which are contested or questionable in their legal acquisition. This includes potentially looted and/or questionably obtained items from source countries, such as the Elgin Marbles at the British Museum, controversially acquired by Lord Elgin from Athens in the nineteenth century.[54]

Issues regarding the illegal movement of historic objects and their provenance in large public history organizations have led to the introduction of charters to protect the movement of objects, including national Acts—for example, the US Antiquities Act of 1906—and international treaties, such as the UNESCO Convention on the Means of Prohibiting and Preventing Illicit Import, Export and the Transfer of Ownership of Cultural Property (1970) and the Hague Convention for the Protection of Cultural Property in Event of Armed Conflict (UNESCO).[55] Museum collections are currently governed by strong codes of ethics in relation to object acquisition and authentication.[56]

Earlier museum collection policies resulted in numerous national and regional museums, including the Smithsonian in the USA, entering into dispute with indigenous groups over artifacts in collections in these institutions. New land rights and claims question the legality of maintaining possession of indigenous associated items and this is a particularly charged issue where it relates to collections including items that are deemed to be of religious or spiritual significance or to contain ancestral remains. In countries such as Australia, New Zealand, Canada, and the USA, and increasingly in Africa and Central and South America, legislation has been enacted to govern and protect the future collection of these remains and in some cases to repatriate objects and human remains to tribal communities.[57] This has resulted in many museum and archive collections being re-evaluated and de-accessioned, in cases where links to descendant indigenous communities and objects can be proved; for example, the National History Museum returned the remains of 18 Aboriginal people in 2006.[58]

Indigenous and Native remains

The indigenous rights movement and legislation on international, national and state levels, for example, the Native American Graves Protection and Repatriation Act (NAGPRA) in the USA, and First Peoples and First Nations in Canada have affected the actions of historians around the world. The First Peoples and First Nation Cultural Heritage and State Act to protect indigenous land includes introducing notions of intangible and tangible heritage.[59] This has led public historians working with tribal communities to create exhibitions and specialist museums, for example, the founding of the Smithsonian National Museum of the American Indian in Washington, DC (Case Study 24).[60] These museums and exhibitions aim to present the untold and often misunderstood indigenous histories of an area or country, providing a historical voice for the native populations. Legislation at both national and state levels has required historical or ancestral landscapes to be granted permission from ancestral community elders and co-corporations. This often requires the presence of a tribal representative on historical projects and the negotiation of methods used to investigate the past, and can include, for example, preventing access to sacred areas or restricting access to tribal information. Collaborative working relationships that develop trust can provide new historical information and despite this, these historical viewpoints have yet to be effectively quantified or factually validated. As such, public historians can be easily manipulated to serve "indigenous" tribal agendas, with historians working for indigenous populations to legitimize land claims. Crosby's work in Fiji provides evidence of heritage professional manipulation by indigenous communities for political and economic purposes.[61] Heritage professionals were commissioned, and in a sense controlled, by the indigenous population, to undertake archaeological and historical research on tribal land. This research aimed to reinforce control over indigenous traditions, land, and cultural beliefs, and as a result provide economic benefits in the form of grants, land claims, and tourism revenue for this community.[62] Tensions arose in this project between the indigenous community and the professionals due to the reinterpretation and manipulation of historical and archaeological data by the community to serve indigenous political agendas.[63]

Working on indigenous projects needs to balance respect for indigenous rights and viewpoints with providing an objective view of history that combines tangible and intangible ideas (Case Study 24).

Case Study 24 Smithsonian, National Museum of the American Indian

During George Bush Senior's administration (1989–93), the US government attempted to make multiple voices of the past into one national voice through federal acts, including NAGPRA. It subsequently saw, through an Act of Congress in 1989, the establishment of the National Museum of the American Indian, under the "federally" controlled Smithsonian Institute. This museum, which opened in 2004 in Washington, DC, after almost a decade of dialog and consultation, has been described as an ambitious attempt to educate the public and make Native American Indians part of American "national" heritage.[64] This museum was carefully designed in consultation with Native communities both internally and externally to represent the landscape and as such the voice of the Native communities.

The result of this collaboration has been an architecturally unique building, based on the organic and flowing landscape of the American Indians, with constantly changing exhibitions both within and outside. Unlike other Smithsonian and national museums in Washington, DC, this building is not classical, postmodern in style; rather, it contrasts in color, being yellow rather than gray and fluid in design. Internally there is an open central space, in which on each floor exhibition spaces can be accessed. In the balcony area there is touchscreen technology and interactive displays. Displays are not traditionally temporally specific, rather they are arranged in themes, such as animals. This museum attempted to balance out the white American history portrayed in the Smithsonian American History Museum and Natural History Museum and provide a voice for a disenfranchised group, yet at no point have these histories been brought together. Recently, perhaps in response to this museum, a federally financed building is underway and will become the Museum of African American History; this will be positioned within the same geographical locality, along the National Mall in Washington, as the other museums.

Questions

1 Is it right to have separate museums for different elements and perspectives of history or should ideas be integrated?
2 Do museums that seek to represent a previously untold story and voice challenge ideas and historical perceptions?
3 Should the creation of museums be driven by political ideologies?

Reading and resources

- http://www.nmai.si.edu/subpage.cfm?subpage=about
- http://nmai.si.edu/visit/washington/architecture-landscape/

The United States

The Native American Graves Protection and Repatriation Act (NAGPRA) is part of public law in the United States.[65] This Act directly pertains to the sites and remains that relate to Native American lineal descendants, Indian Tribes and Native Hawaiian organizations.[66] This Act is two-fold: first, it requires federal agencies and federally funded museums to provide inventories of items such as human remains or funerary objects and reach agreements regarding repatriation or disposition. This may be in the form of reburial or long-term curation, according to the wishes of proven lineal descendants.[67] Second, it protects Native American burial sites, artifacts found on site, including human remains, funerary objects, and sacred objects. This requires consultation with tribes whenever historical or archaeological items are encountered or expected to be encountered.[68] This has resulted in items being left in situ, in the ground where they were found, or sites only being investigated or excavated under the supervision of specific tribal representatives.

Australia and New Zealand

National and state laws protect the history and heritage of indigenous peoples in Australia and New Zealand. The National Aboriginal and Torres Straits Islander Heritage Protection Act (1984) aims to protect and preserve areas of historic and heritage interest to indigenous communities, and to intervene in the return of indigenous remains and objects, many of which are stored in museums and in other government organizations, both in Australia and internationally. The Australian government's "return of indigenous property program" was established to repatriate Aboriginal material located in government-funded museums, including the National Museum of Australia, who have since returned over 1,000 individual and 360 sacred objects.[69] At the state level, many states have adopted legislation to protect, promote, present and preserve Aboriginal heritage, including at sites which may be developed; for example, the New South Wales and Queensland Aboriginal Cultural Heritage

Acts (2003), the Victoria Aboriginal Heritage Act (2006), and the Torres Strait Islander Cultural Heritage Act (2003). The Victoria, New South Wales and Queensland Acts include the need for consultation and collaboration from Aboriginal communities and recognition of various tribal groups (Case Study 25).

Case Study 25 The Victoria Aboriginal Act

In 2006, the Victoria State government ratified legislation to protect Aboriginal heritage, known as the Aboriginal Heritage Act. This Act, overseen by the Office for Aboriginal Affairs Victoria (OAAV), aims to protect and preserve the Aboriginal heritage within the State of Victoria, including the city of Melbourne, on both private and public land.[70] It is one of the few state heritage acts that legalized the need for not just consultation, but also collaboration with Aboriginal communities when undertaking development work on both former and current indigenous landscapes that may impact on Aboriginal culture.

The state provides financial and legal assistance to support Aboriginal tribal representative bodies, also known as traditional owners, to play an active role in the historical investigation of claimed landscapes. This has directly affected planning and development "mitigation" control, with sites and landscapes being commercially developed and altered in the future through build work, such as Bellarine Bayside, Melbourne, requiring as part of planning consent to undertake pre-consultation with Wathaurong tribal representatives, the recognized original indigenous population.[71] In the pre-development stage, for example, during on-site archaeological or historical investigations, and during development, tribal representatives supervise the actions of both heritage professionals, such as archaeologists, and building contractors, to prevent damage and to record indigenous heritage. These individuals provide methodological support and interpretative guidance to contracted heritage teams and state historic preservation. As such, final planning consents require heritage reports to go through collaborative approval, involving the archaeologists, state historic preservation officers, and Aboriginal communities. These individuals are paid for by the developer and supported by the state government as part of the state's obligations to cultural heritage management (Aboriginal Heritage Act 2006). Recently, the OAAV have, in partnership with the

University of La Trobe, provided heritage training programs for registered Aboriginal parties.[72] These accredited courses, such as "Certificate VI in Aboriginal Cultural Heritage Management," provide heritage training in areas such as archaeological techniques, historical archiving, heritage legislation, and strategies for community engagement.[73]

Questions

1 What are the issues when balancing the need for factual history and indigenous rights and concepts of intangible heritage?
2 How can historians work with indigenous communities to develop effective working relationships?
3 In what ways can indigenous history affect the practice of history in the public domain?

Reading and resources

- Ford (2009), available at: http://diginternational.com.au/page3.htm
- http://www.dpc.vic.gov.au/index.php/aboriginal-affairs/aboriginal-cultural-heritage/review-of-the-aboriginal-heritage-act-2006

Working with local, regional, and state government organizations

Public history at a community level is affected by regional and local policy that aims to protect and preserve history and to present and enable community involvement. At the local "state" level, public historians, particularly in Australia and North America, enforce national and regional guidelines, frameworks and legislation regarding historic preservation. Each state has different local guidelines and legislations, some states are more progressive in their approaches to including and consulting with the public and indigenous communities, particularly the Melbourne State Historic Preservation Officers, and the New South Wales State Historic Preservation Office (Case Study 25). Working with heritage-specific government agencies requires the overseeing of national and local heritage and historic assets and actively participating in new policy writing to support the long-term maintenance and presentation of the past.

Heritage Management Plans

Heritage Management Plans (HMPs) provide a "vision for the future" of heritage by developing a strategy for the long-term and sustainable management of historical sites.[74] HMPs are designed to give technical guidance to managers of historic buildings, landscapes, and estates. A key aspect to these HMPs is balancing four factors: conservation; public access; need for living in and working in the landscape in the present; and contribution to local, national or international heritage and to the regional and national economy.[75] HMPs are often linked to wider regional and national strategies, such as tourist strategies and environmental strategies.[76] Undertaking management plans is often a requirement for international and national government-managed sites, including those classed as World Heritage Sites and those owned by English Heritage, Natural England, and USFS.[77] Each individual agency has specific formats and guidelines for the completion of HMPs.[78]

HMPs provide a stakeholder-agreed understanding of a place's historical and public significance, outlining collaborative approaches to conservation, protection and presentation. They aim to clearly outline different stakeholder remits and responsibilities and clarify agreed costing and financial input. These plans are essential for the sustainable and future management of heritage sites. In the UK, the completion of an HMP enables tax exemption for a property. This relates to the Inheritance Tax Act 1984, which states that owners of historic sites and buildings are required to provide agreed, detailed steps with HM Revenue and Customs to maintain, preserve, and repair the property.[79] These management plans have benefits to the public history of a place, including improving visitor access, balancing the needs of the visitor with the need for site conservation, improved interpretation and appreciation and including the local community in the management and maintenance of the site.[80]

The key components of a Heritage Management Plan are:[81]

- *Purpose of the plan*: Brief overview of aims and objectives of the HMP.
- *Description of the site's history*: Complete historical and archaeological background of the site. This should include archival research and data searches.
- *Assessment of local/national/international significance and summary of current condition*: This should detail both the physical heritage and the intangible social and cultural value of the place.

- *Management issues*: Any issues including environmental, financial and ownership that may impact on the ability to manage the site.
- *Specific objectives*: This is in relation to specific plans for improving or preserving the condition of the historic site. This should be attainable within a specific time period.
- *Working programs*: This can include public programs and on-going repair programs.
- *Monitoring and reviewing*: What steps are going to be implemented to evaluate and review the project? Who is going to oversee the project monitoring and reviewing? Will this require a quarterly review document which includes a system of project status and risk identification, such as a traffic light system?
- *Appendices*: Including maps, photos and tables (such as budgets, task management charts).

Planning policies

The development and planning process in many Western countries includes policies relating to mitigation, protection, and recording of historical resources. This includes pre-development "pre-building" work, such as environmental impact assessments (EIAs), desk-based assessments (DBAs), landscape surveys, and historical and archaeological investigation and excavation. These modes of historical assessment seek to highlight areas of historical interest and understand the impact of building development on the landscape with regard to the tangible historical assets, such as historical buildings, cityscapes and landscapes, and with regard to intangible historical assets, such as tradition and folklore. Historic Preservation Officers (in Europe, the USA, and Australia) and County Archaeologists (in the UK) oversee these planning policies at regional or state levels.

A desk-based assessment (DBA) will include the following elements:

- an overview of the historical site
- a comprehensive historical overview of the area and surrounding landscape. This will require map regression, the use of primary sources and extensive archival research, both at local and national levels
- a list of the physical remains of a site and area: buildings, architecture, landscape features
- any previous research on the area: essentially a review of any secondary sources

- legislation that may affect any development
- suggestions for the future preservation and presentation of the historical remains

The principles and nature of these actions depend on the specific country; for example, in the USA, if building development is on public "government-owned" land and will impact on history either above or below ground, then a historical and archaeological survey will be carried out. In the UK, the completion of any such survey is linked to the granting of planning consent to any new building work on either private or public land.

The United Kingdom

The introduction of Planning Policy Guidance 16 in 1990 altered the practice of the protection of the past in the UK almost beyond recognition. It changed heritage and in turn the practice of history by the public from being locally controlled and local government-funded, to becoming a commercial enterprise with more centrally determined budgets. Perhaps by no means coincidentally there seem to be decreasing opportunities for the public to get directly involved or even access knowledge about their local history. With PPG16 came the mounting bureaucracy of quangos, which possibly can be linked to the increasing exclusion of the public from the practice of history and archaeology.[82] The launch of Public Policy Statement 5 (PPS5) in March 2010, replaced PPG15 and 16.[83] PPS5 and its replacement, the National Planning Policy Framework, officially recognized the immense public interest in heritage and its multiple values, its ability to provide a sense of place, social cohesion, and identity. Emphasis was on the provision of greater public benefit from heritage through consultation and collaboration within commercial contexts as a desirable outcome, for example, "where the evidence suggests that the asset may have a historic, archaeological, architectural or artistic significance to the local community that may not be fully understood from records or statutory consultees alone."[84] These new guidelines recommend public consultation and recognition of the value and benefit of heritage.[85] These national guidelines have influenced the approaches of public historians to the management and presentation of history on commercial sector and on development sites (Case Study 26).

Case Study 26 Birley Fields Project, Greater Manchester

The Greater Manchester Archaeological Advisory Service, UK (Historic Environment Records), has sought to be proactively responsive to these planning legislations and the public's desire for increased involvement in the process of uncovering history. They have aimed to make these national guidelines for the involvement of the public in development work on historic and archaeological sites around Manchester a necessary part of planning consent. This has seen development projects, such as Manchester Metropolitan University's building of a new campus in Birley Fields, a brownfield site in central Manchester, involve the wider local community in the archaeological excavation of a former nineteenth-century housing site.[86] This included distinct elements of public participation in the archaeological mitigation process, such as community involvement in the excavation, regular on-site tours, school-based on-site educational programs, public history exhibitions, public open days, and oral history sessions.[87]

Public history projects that locally integrated national guidelines require support from local government heritage professions. This support is often dependent on individual buy-in and the time of professional government historians and local government financial support. As such, these public history projects are subject to financial constraints and reductions in government funding. As these projects are linked to building development, they have issues with providing sustainable community involvement in history, as they are found in limited time frames prior to development; for example, Birley Fields was limited to a three-week period prior to building work commencing.

The integration of community history into planning consent, which is subsequently funded as part of the construction project, is now a regular occurrence within country heritage services. This wider local government commitment to community engagement in heritage has led them to launch "Dig Greater Manchester," a program designed to proactively engage members of the public from all areas of Manchester in their heritage through archaeology and historical research, in which each district provides heritage training for community members to become engaged in their past.[88]

Questions

1 How can national development policies and guidelines such as the National Planning Policy Framework successfully support public engagement in history?
2 Consider the mechanisms that can be in place at local and state levels to integrate elements of public history into the management of historic assets.
3 How do national heritage guidelines influence public historians' approaches to management and the presentation of the past?

Reading and resources

- Simpson, F. (2013) Birley Fields: exploring Victorian streetscapes in Manchester, *Current Archaeology*, 282: 28–33.
- www.gov.uk/government/uploads/system/uploads/attachment_data/file /6077/2116950.pdf

The United States

In the USA, the protection of historical sites and buildings during landscape and building development is referred to as cultural resource management (CRM). CRM developed in the 1960s, and took off in the 1970s, yet the laws that protected heritage and history during development only pertained to sites that were under federal control or ownership.[89] This strategy is maintained by State Historic Environment agencies. The reactions to development and changes to the historic landscape are determined by the historic professionals working in specific cities or landscapes. This encompasses a broad range of historic preservation programs in the US.[90] This developed out of the historical and archaeological management and recording work of the early 1930s salvage and rescue programs, which led to growing public, professional, and federal realization that legislation was required in order to preserve archaeological and historical resources from destruction during construction and land development.[91] These Acts, including the National Historic Preservation Act (1966), the National Environment Policy Act (1969), the Protection of Cultural Environment (1971), and the Archaeological and Historic Preservation Act (1974), have been credited with changing the character of historical research and preservation on federal land and federally controlled projects, indicating the growing level of importance ascribed to preserving heritage for the public.[92]

Political support for public historians occurred at local levels, with the cities of Alexandria in 1976 and Annapolis in 1981 (Case Study 27) funding full-time historians and archaeologists to initiate and develop public history programs.[93]

Case Study 27 Annapolis Public History Program

The city of Annapolis in Maryland in the USA has numerous laws protecting its historic heritage. The historic preservation zoning for the Annapolis historic district is established in the city's code, Title 21 (Planning and Zoning), Chapter 56 (Historic District).[94] This protects the archaeological remains, historic buildings, and integrity of the city from being destroyed by development. There are other laws that apply to the specific aesthetic integrity of this historic city; for instance, there is a ruling on signs that was implemented to limit the use of neon within the historic district. Maritime zoning is used to accomplish historic preservation in the Eastport neighborhood, albeit under a different set of legislation. This preserves the city aesthetically as a historic city, something which is regarded as vital to its tourist economy, yet often fails to represent the current population and their future requirements for services, such as transport.

Many of this city's regulations are enabled by state-level legislation; for example, there is legislation enabling the designation of municipal historic districts.[95] There is also an Act of the Maryland State Legislature that created underground utilities districting; specifically for Annapolis, this has required the large-scale mitigation and archaeological investigation of the city. The tourist industry of Annapolis consists of numerous guided tours, walking through the historic streets, buildings, and museums. Many of these buildings are recreated or reconstructed rather than being original. The longevity and economic benefit to businesses within the city center of these public schemes and partnerships, including the Archaeology of Annapolis and the Historic Annapolis Foundation, have led to the creation of a preservation ethic in the city center. For example, the owner of Governor Calvert House, listed under Historic Inns of Annapolis, created a glass-floored coffee room over the 1720s hypocaust system.[96]

The Annapolis public history project, which is supported by the local government and the University of Maryland, has to a large

extent focused on developing a tourist industry and encouraging national visitors. As such, this project has created a sterilized and historically stable version of the past, which to a large extent focuses on the wealthy white inhabitants and their buildings in the town center, alongside communicating the city's role in trading and military history. The majority of the public history occurring has overlooked the diverse demographics of the past and current local residents within the city's entirety, including a large African-American population who played a vital role in the city's development and trading history, including its slave trade. Despite this, public history projects offer numerous benefits to the economy, local politics and education. The project has struggled to forge links with more disparate communities, leading to activities and public history that potentially misrepresents and distances the public from the city's "officially" created and consumed history.

Questions

1 How can local government public history initiatives influence modern cityscapes and landscapes?
2 What are the issues with balancing the presentation of "official" history with the "unofficial" history of local residents?
3 What are the benefits and issues with city-funded public history projects to local residents?

Reading and resources

- Potter, P.B. (1994) *Public Archaeology in Annapolis: A Critical Approach to Maryland's Ancient City*, Washington, DC: Smithsonian Institute Press.
- www.marylandhistorictrust.net/aboutmht.html
- http://www.historicinnsofannapolis.com/governor-calvert-house. aspx

Public history in non-historical government organizations

Historians and their work, especially in the public sphere, are not just affected by government policy; they also work with and within government

organizations and agencies to change policy, and influence politics and history's representation in the public domain. The work of historians in these organizations can positively influence the presentation and preservation of history within the public arena. Government employees are at the forefront of public history's future, involved in developing innovative methods for best practice, strategies for sustainable and publicly funded and supported public history. Political and private organizations, such as local and national government agencies and NGOs, employ historians as permanent members of staff or consultants to advise on specific issues and projects; such as during development work.[97] Despite the potential to influence policy and decision-making that could impact on history, historians working for these organizations face difficult moral and ethical decisions as they are paid to represent the agendas and objectives of their employers.

Government agencies employ historians to provide advice to inform government officials, to advise on history and heritage policy and to help develop legislation and guidelines for the protection, promotion and preservation of the historic environment and national and regional heritage agendas. There are two types of historical associated agencies: large federal organizations, including the Department for Culture, Media and Sport and Arts Council in the UK, and the United States Forest Service, and smaller heritage-specific agencies, such as English Heritage, and the State Historic Preservation Office in the USA. Historians are frequently asked to assist in non-historically associated government agencies, such as the Department of Defense, to provide specific historical advice (Case Study 28).

Case Study 28 Department of Defense (US) and Ministry of Defence (UK), Military Training Program

In 2007, the US Department of Defense (DoD) received international criticism for the destruction of historically important sites. This followed specific incidences of military behavior during the war in Iraq, such as constructing a military base on the ancient Mesopotamian city of Babylon and their non-intervention during the looting of the national museum in Baghdad.[98] To mitigate against the future destruction of cultural heritage the DoD sought advice from historians and archaeologists to develop strategies for educating

their military personnel. This included developing military heritage training programs by providing briefings, posters, and playing cards.[99] These training programs were limited to permanent staff and were time-dependent. They were not delivered to temporary staff, such as the Army Reserve, many of whom served in Iraq.

Playing cards were developed with the DoD and Legacy Resource Management program. Each playing card showed a specific artifact or site and gave advice on the card as to how to avoid causing future damage to cultural heritage.[100] In collaboration with ICOM, the DoD developed a red list brochure of Iraqi antiques to prevent museums and collectors buying looted items.[101] The playing cards concept was later adapted by the UK Ministry of Defence who worked with historians and archaeologists, including those employed in-house, to develop a range of cards to educate troops about Kenyan heritage. These were distributed prior to deployment. This education and preventative public history saw the Ministry of Defence develop both a replica Afghan village in Norfolk and a replica burial site to teach soldiers about cultural sensitivities.[102]

These examples of military cultural heritage protection strategies sought to encourage defense organizations to use history as a tool to develop relationships and change approaches in combat zones. Consequently, this aims to use the past to help understand the present. This has involved working closely with local and specialist historians, local advisors and international and national government organizations.

Questions

1 Have these strategies of military heritage training reduced the destruction of cultural heritage in war zones?
2 Which strategy for the education of military forces has the potential to be most successful in changing the mindsets of individuals in the armed forces, in relation to history?
3 What additional values does heritage training beyond the history sector have?

Reading and resources

- Brown, M. (2010) Good training and good practice: protection of cultural heritage on the UK defence training estate, in L. Rush (ed.) *Archaeology, Cultural Property, and the Military*, Woodbridge: Boydell Press, pp. 60–72.
- Siebrandt, D. (2010) US military support of cultural heritage awareness and preservation in post-conflict Iraq, in L. Rush (ed.)

Archaeology, Cultural Property, and the Military, Woodbridge: Boydell Press, pp. 73–85.

- Zeidler, J. and Rush, L. (2010) In-theatre training through cultural heritage playing cards: a US Department of Defense example, in L. Rush (ed.) *Archaeology, Cultural Property, and the Military*, Woodbridge: Boydell Press.

History's impact on policy

This chapter has discussed the effect of policy on history in the public domain. This section will investigate history's potential to influence the public and the importance of communicating history to shape the views of politicians and external organizations' policies. Historians' influence on public policy can be linked to their involvement in curriculum reform, which started in the twentieth century in the USA. Historians around the world have sought to influence politicians and their perceptions as to the wider value of history, including education reform and planning policy (see Chapter 4).

Recently, history has been used to help understand modern policy issues, including social, economic, and educational problems.[103] Using past perspectives, the research skills of historians can provide a deeper understanding to complex social problems, and historical perspectives can provide comparative examples and demonstrate possible, future options.[104] Historians have begun to work closely with government and political organizations and politicians to support historians' wider political role in government agendas.

In 2002 the History & Policy group was launched in the UK with an accompanying website.[105] This aimed to tackle the issues of the lack of historical perspective and historical misuse in politics and in policy.[106] This was an opportune time, as a year later in 2003, this lack of both historical perspective and perceived value of history to politics was highlighted by the then UK prime minster Tony Blair in a speech to the US Congress: "There has never been a time, when except in the most general sense, a study of history provides so little instruction for our present day."[107] The History & Policy website aimed to tackle issues with history's lack of perceived wider relevance. The website has provided a forum for historians to develop research that related to politics and tackled political issues; to connect this

research with the policy-makers and to communicate relevant research. An important element of this is supporting and encouraging relevant research and providing a framework to enable historical research to be accessible to government officials, beyond the normative journal domain. This has involved creating a structure, notes and sections deliberately developed to appear similar to policy documents.[108] This aims to support history's role in the process of policy-making. This research and its application are limited, as the implementation of this research requires wider political support, without which the findings will remain unheard.

The History & Policy organization highlights the potential broad application of history to policy, from health policy to the "War on Terror."[109] The range of papers highlights the need for policy-makers to look back, to draw on history to look forward. Rogers' research on the Australian economic crisis of 1840 highlighted the parallels with the current economic crisis, illustrating how the past repeats itself.[110] It considered the Australian bank failure and the previous steps to rebuild and return to economic growth. This research provides lessons from the past as exemplars for future action and potential policy decisions.[111] It remains a frequently cited example of critically informed historical perspective among policy-makers and taxpayers.[112] This demonstrates how history can provide value beyond normative historical knowledge to wider society.

Conclusion

History and the practice of public history are affected by and affect policy at national, international and local levels. The role that heritage organizations play is integral to the practice of public history. Historians who work in the public domain perform a vital role in producing, establishing, and changing policy, which can directly relate to the historic environment and its protection and presentation to the public. Historians can affect policy, which directly impacts upon public history and the public practice of history.

The collaborative role of historians in the production of policy, in both an advisory level and in its construction and consultation, should not be overlooked. History and the knowledge and research skills that historians possess, have the potential to change the present and the future of the subject. This change occurs through providing long-term strategies and agendas in which historians work in government organizations to directly influence government legislation through evidence and knowledge.

The implementation of new guidelines and policies at the international, national, regional, state and local levels that affect and influence historical action requires public support. The role of the public historian is to gain public support, which is critical to communicating new ideas, forming public partnerships and gaining support for publicly relevant changes to policy that influence the practice of history.

Public history and the practice of communicating, consulting, and cooperating with the wider public are playing an increasing role in the production of Heritage Acts and guidelines throughout the world. The recognition that the public has ownership of and a voice in history and in historical presentation and protection is now impacting on the work that public historians in government organizations undertake and the nature of the public outreach they engage in.

Routes into policy and government history

Policy/government historian

History degree (2:1), Master's in history (or related field), work experience in public history sector. The job description is:

- Undergraduate degree in history
- Master's in history
- Internship and/or pre-entry work experience
- Political awareness
- Understanding policy frameworks and legislation relating to historical assets
- Project management skills
- Leadership skills
- Communication skills: verbal and written
- Financial acumen
- Teamwork and negotiation
- Adaptability
- Preferably language skills

8

Digital Media

This chapter investigates the use of various internet-based digital media platforms in the presentation of the past to the public. It examines how these socially and culturally embedded technologies have been used to create an interactive approach, one that has altered the practice of public history and impacted on historical research and communication. This chapter will provide case studies to highlight how digital media can be utilized in the practice of public history, illustrating the potential of digital media to impact upon popular perceptions.

Introduction

The use of digital and social media has become increasingly prevalent in the communication and presentation of the past to the public. As such, digital

media have in many instances come to represent a form of popular history. This chapter builds on previous discussions relating to the use of digital media in public history sectors, including museums, archives and heritage centers, in education, community history and political history. Digital media have been utilized within these sectors to translate, communicate, and present history to the wider public, creating digital networks for historical information to be shared beyond traditional audiences.

Public history has developed and changed through the use of digital media; this has included the use of digital networks to provide open access to museum collections, "cyber-museology," for the public; developing new mechanisms for communication through social media, such as Facebook and Twitter; and the use of web technology to enable active public participation in the selection, creation, and presentation of "crowd-sourced" history. These digital "social" mechanisms for the communication and presentation of the past provide arenas to explore critical debates within public history, including ownership, authenticity, entertainment and consumerism and commercialization of the past.

The history of digital media

The 1990s saw the global emergence of web culture, and the growth of the publicly accessible World Wide Web. The host servers underpinning this enabled public organizations to store information and relay this to web users around the world. During the 1990s the emergence of web culture in public history was linked to the growing community arts and history workshop movement.[1] Concurrently, increasing public participation in the process and production of historical dialogs was associated with increasing demand from the public for access to information. During the 1990s the use of internet chat rooms and the popular adoption of emails enabled users to exchange instant, digital messages. Emails would initiate a change in the nature of communication in professional and public domains, which would impact research and communication techniques used for public history purposes in the twenty-first century.

By the end of the 1990s, the World Wide Web had begun to be used as a communication device in the public history sector, including museums, archives, and universities. The creation of public history-related internet sites sought to enable online access for the public to historical resources, albeit one limited by Web 1.0 associated technologies. Some of the first

examples of these basic "static" internet sites were launched by the University of California Museum of Paleontology, in Berkeley in 1997 and the Museum of the History of Science, in Oxford, in 1995.[2] These websites provided basic information about the museum to web users, including location and contact details, online exhibitions, education and outreach events and online access to specific catalogs. These early websites provided basic visitor information and online libraries to support the interest of web users, but enabled no mechanisms for public interaction.[3] The use of the internet to create data and resources also created difficulties with the authentication and legitimacy of sources, which were open to falsification. Websites were also limited by host external server data restrictions, and from the late 1990s onwards, museums such as the Museum of the History of Science began to fund their own in-house servers.[4]

The twenty-first century saw the rise of social networks, such as MySpace and Facebook. This digital technology supported the creation and sharing of personal and biographical histories. Public history institutions, such as the British Museum, began to invest heavily in developing their own internet sites that aimed to provide web users with remote digital access to their organizational resources. The development of Web 2.0 technology enabled these websites to be more interactive and dynamic and to provide increased information to web users, including visual imagery, social media elements, and links to public browsing facilities such as Google, which promoted and prompted visits to affiliated websites. These dynamic, user-oriented web pages aimed to provide access for those looking to obtain additional historical knowledge and deliberately sought to encourage physical visits to the institutions.

Public history websites integrated public search engines within their central frameworks. These developed from simple online catalogs or databases, such as the University of California Museum of Paleontology online catalog.[5] In the twenty-first century, museums and archives in Europe, North America, Australia and New Zealand initiated digitalization projects, such as the National Archive in London's "Community Archive Access Project" in 2004. This resulted in the almost complete digitization of material culture and archival written records stored within museums and archives.[6] This activity, defined as "cybermuseology," created vast online digital archive projects, which provided open public access to historical material and allowed new digital connect networks to be formed.[7] This digital access also supported the development of community history and access to historical material, for example, the LAARC's (2002) online archive database (Case Study 6).[8]

History digital access projects resulted in public access to, among other things, census records and birth and death records. This access to demographic and personal information of past peoples enabled individuals to search for family histories, which in turn supported the development of genealogical research and the family and amateur history movement. Public interest and access to genealogy and family history resulted in the commercialization and commodification of these personal aspects of the past; online companies such as Ancestry were launched, specifically aimed at supporting individuals looking to create family trees and histories.[9] The genealogical industry provided frameworks to support people's desire to search for "their past" and their historical identity.[10] Public access to the past provided a mechanism to support the development of community websites and blogs, creating a public space to debate and communicate multiple viewpoints of the past; for example, in the UK, "A Tale of One City," Portsmouth's community history website and online archive.[11] Community websites shared similarities with community museums in their desire to represent the voice of the local people and to communicate untold and locally important stories from their history to the wider public beyond the professional "authoritative" historical domain.

Museums also introduced computer stations that were situated in specific galleries, such as the Museum of London's Prehistoric Gallery (2002). These public computer stations sought to provide visitors with additional exhibit and artifact information to support their visits. They also enabled visitors to provide feedback and comments about the displayed collection to the curators. The development of interactive and virtual digital technologies such as Google Earth enabled people to travel back in time and view changes in landscapes and townscapes over time through the use of historical imagery overlaid on modern maps.[12] Furthermore, commercial gaming technologies, such as *Tomb Raider* (1996), were integrated into the public history sector via exhibitions involving augmented reality "virtual reconstructions" and interactive games. Public history used digital media to make history entertaining and immersive and to encourage its deliberate consumption by the public: for example, PAS Past Explorers.

By 2010, social media, including Facebook (from 2006) and Twitter (from 2006), had firmly established their place in the wider public domain. This established social networks through the internet and provided an arena for social narratives to be communicated, transformed, and consumed. The development of digital and social media during this period transformed and "revolutionized" the nature of public history and mechanisms for its

communication.[13] The practice of public history in museums and community history groups, including amateurs, utilized this social technology to promote and communicate historical knowledge and research with the wider public. Museums, such as the Metropolitan Museum of Art in the USA, created social media profiles on a variety of platforms to develop online digital relationships with the broader public, specifically younger audiences.

The widespread access to mobile technology and the proliferation of smart phone usage resulted in technical and software developments, including mobile applications (apps), geo-locational software and QR codes (Chapter 3). Public history organizations invested in the development of apps for participatory and interactive access to history, for example, the Museum of London's "Street Museum" (Chapter 3). This digital technology also involved the use of smart phones as hand-held exhibition guides (Chapter 3). These hand-held mobile internet devices changed public interaction in history, including instant and non-location-dependent public access to history and historical commentary through social and digital media apps.

Digital media and social media supported the development of public and professional dialogs, which led to changes in the production and consumption of history. Digital media provided open access to history, creating consumerism of the past and a global knowledge economy.[14] This resulted in public involvement and interaction in the production and sourcing of history, "crowd-sourced history," including images and memories (Case Study 14). Digital history was deliberately created for public consumption through social media and websites. The narratives and tools used in the teaching and communication of history changed, taking ideas from other types of popular media, such as newspapers, by adopting the concept of "headlines." Consequently, the widespread public consumption of history became increasingly reliant on visual images to communicate the story. This resulted in public historians moving from a position of safeguarding the "authoritative" and official versions of the past to engagement in the public sourcing of stories and interaction with public production and research.

Changes in the creation, communication, and presentation of history were not all positive. The democratization of knowledge and consumerism of the past meant that control over historical content was no longer professionally validated. As such, despite the increasing accessibility of historical information, its sourcing and validity were no longer accountable to the professional; websites and other users failed to source historical data

from primary sources, neglecting to provide accountable factual evidence for suppositions or to recognize the copyright of material. For example, the formation of Wikipedia in 2001 as an open source, open access website that sought to provide publicly-sourced and validated information about topics, events, historical periods, and people, enabled the public to input content without moderation or validation from professionals, often resulting in poor or inaccurate referencing to original sources of information.[15] The creation of digital information with no quality control had the potential to mislead and misrepresent history and introduced serious issues regarding the ownership of knowledge and the potential manipulation of the past.

The internet

The introduction of the World Wide Web impacted on the production and consumption of history within the public domain. Digital technology changed the way that the public interacted with history and, conversely, how historians interacted with the public. Museums and archives invested resources in the internet, aiming to provide remote digital access to history. This included delivering a plethora of online resources, including:

- *Educational resources*: For classroom learning and to support public history visits by schools: for example, Chicago Museum's History Connections and Artifact Collections Project "Back to the Future" (Case Study 10).
- *Tours and trials*: Multidimensional maps and geo-locational software helped create hand-held or printable tours for the public: for example, the National Trust's Virtual Tours of the Landscape.
- *Archival resources*: The presentation of and public access to, material in storage and in galleries. This included material culture, such as historical artifacts and archival material, and audio, visual and written records: for example, History Pin (Case Study 14) and LAARC (Case Study 6).
- *Wider access material*: Providing resources for people with disabilities, such as the Museum of London's sign language YouTube resource and podcasts for the visually impaired.

Creating websites

The creation of websites by public history organizations and projects involves the development of content and the use of a host platform. Websites have

developed from the early internet technology associated with Web 1.0: simple content-providing tools in which the users were passive recipients of information. Today, these static information pages are often associated with websites belonging to private individuals, typically running free of host services. As such, these sites are more commonly associated with the first generation organizational websites of the 1990s, as well as community history and amateur history websites, such as the Stroud Local History Society in the UK.[16]

More complex and public-focused internet sites utilizing Web 2.0 technology have been common since the early 2000s, for example, as adopted by the Metropolitan Museum of Art in the USA. Web 2.0 is more visually impressive and dynamic, deploying software such as Flash to host videos and moving and changeable images. This internet technology enables users to interact with the website by incorporating elements of social media, blogs, and wikis. Although the improved functionality of today's web pages requires the use of more complex coding, the creation of public platforms such as Google and WordPress, which provide easy-to-use frameworks for the public to create websites, have meant that almost anyone can create a simple website at zero cost. This has supported the development of public history in the digital domain.

Digital media have been used in professional, commercial, and "organizational" public history domains, including museums and genealogy services. This often requires professional support and assistance to develop a professional and publicly accessible interface for a public history organization. Digital media help create a public "cyber" relationship with public history organizations that have the potential to be transposed to a physical connection; for example, creating the right website can raise an organization's profile and draw people into museums.[17] Websites can provide unique "behind the scenes" and "real-time" access to historical projects, for example, the restoration and conservation project carried out by the Metropolitan Museum of Art of Charles Le Brun's portrait of Everhard Jabach and his family.[18] It must be noted that providing too much information or the wrong information has the potential to decrease visitor numbers.

Creating a user-friendly website involves the following duties:

- providing information in a clear context
- developing concise and clear content
- using powerful images to emphasize points, i.e. photographs or pictures

- providing unique, behind-the-scenes access to historical material
- using multimedia and interactive features such as hosting video clips or moving images
- creating visual appeal: using dramatic color and consistent and easily readable fonts
- integrating browser and search features thereby enabling the user to access specific information easily
- linking into social media via blog-sites such as Facebook and Instagram

Online learning

Developing digital media have also been adopted in educational systems, including schools, universities, and life-long learning classes. Digital platforms specifically aimed at supporting teaching and learning, such as Moodle and Blackboard, have altered teaching techniques and enabled flexible and remote learning. They have also been used to provide a student-responsive approach to teaching and supporting learning, providing e-resources such as podcasts of lectures and seminars, online tests, exams and coursework submission and marking. Moodle and Blackboard are secure and controlled digital and social networks, with user access to resources and discussion forums only to registered users. For example, the Open University supports fee-paying adult learning, undergraduate, and graduate courses remotely around the world, almost entirely through the use of secure digital media. This has enabled history to be taught to students in any locality and context, supported by live tutor online tutorials and video-conferenced seminars and lectures. The academic taster material for these and other courses, including videos and podcasts of lectures, has been delivered to the wider public through the use of internet platforms and apps such as ItunesU, Technology, Entertainment Design (TED), and Academic Earth. Furthermore, e-books—digitized books available online to be downloaded to portable devices, such as Kindles, iPads and Readers— have provided instant and remote access to research material for students, academics, and the wider public.

Digital open-sourced platforms have been developed to support open and free public access to a wide variety of historical educational material, including seminars, lectures and interactive professional discussions and tests. For example, EdX, which was set up by Harvard University and

Massachusetts Institute of Technology, has been used to support a digital partnership between some of the leading global universities, including Columbia University and the Australian National University. EdX provides a platform for public access to historical educational courses; for example, "Civil War and Reconstruction (Part 1, 1850–1861)." Registered users can gain free and complete access to all course material, tests and online discussion forums.[19] This enables the public around the world to access "real" historical classes at their own pace.[20]

Internet course platforms, such as Cousera, have supported the development, by major universities such as Harvard and Princeton, of Massive open online courses (MOOCs).[21] These freely accessible and non-profit global courses, such as Princeton University's "Global History Lab, Part 1," aim to provide online education for vast numbers of people, including those with no previous educational qualifications.[22] It is worth noting that despite aims to attract wider audiences into education, over 60 per cent of those enrolling on these courses already have degrees.[23] These non-accredited courses are still in their infancy and as such the long-term validity and viability of "free" courses have yet to be ascertained. MOOCs are by-products of normal teaching and are not free to produce; they rely on the material, including lectures and reading lists, produced by paid university teaching staff, for use by fee-paying higher education individuals within the traditional teacher-taught university system.[24] MOOCs rely on online student participation, including watching videos, reading, engaging in discussion groups, taking marked computer tests and exchanging assignments with partners for peer grading based on set criteria. Consequently, this pedagogical approach supports larger student numbers without the traditional university 1:25 staff-to-student ratio for tutor support. As such, the potential of MOOCs to support personal learning and the marking standards of accredited courses is yet to be achieved.

Cybermuseology and digital networks

"Museum object networks" are collections of online digitized written records and photographs of artifacts. This "cybermuseology" provides multi-format resources through the use of the World Wide Web to a global audience, enabling digital access for the public and professionals

to the objects and historical items. This transports collections outside of their original museum context and curatorial interpretations, encouraging them to be re-interpreted, transformed and re-conceptualized through different public lenses. This technique can enable the object to gain personal significance, beyond traditional tangible and historical interpretations. Through open and remote access, these digital networks remove history from the institutional boundaries and physical barriers of access to create new gateways for information to be shared and history to be created.[25]

The Museum of Archaeology and Anthropology in Cambridge in the UK has used the online research platform and content management system Drupal to develop a collaborative digital object network based on its indigenous Australia collections. This project was established through working with Deakin University in Australia and indigenous Australian groups. By establishing remote links with indigenous groups in Australia over the internet via online object forums and live Skype broadcasts, this has enabled the exchange of curatorial and public ideas, and the reinterpretation of ethnographic collections.[26] This project demonstrates the role that digital media and the internet can play in connecting and collaborating with the public, encouraging a multi-vocal approach to the interpretation and presentation of history.

Crowd-sourced history

Crowd-sourcing began as a medium to fund and support films to be made that represented the "ordinary" people.[27] The development of home video recorders, mobile technology, and i.Docs during the 1990s opened up the potential use of popular media for publicly sourced history; for example, BBC Video Nation (1993).[28] The widespread use of mobile technology, YouTube and social media further proliferated this trend and the widespread, publicly-funded communication of community-sourced histories. The development of the World Wide Web has enabled the production of interactive documentaries, supporting this transition from the official production of history to its public production.

Interactive documentaries, "i.Docs," are produced for immediate public consumption online. These documentaries combine multiple historical sources, such as photos, videos, sounds and text, from both

primary sources and oral history, to encourage public participation and online exploration.[29] The production, presentation and consumption of history through this mechanism transforms it into a social activity, one in which the public can interact with the process, exploration, and modification of history during and after production, providing an organic representation of the past.[30] The Quipu Project, undertaken by Chaka Studio in collaboration with the University of Bristol, provides an interactive documentary on the forced sterilization of 300,000 women in Peru during the 1990s and its effects on the indigenous communities in an isolated part of the country.[31] This project did not rely on high-end websites to collect, edit and engage in community "history" dialogs, rather it was based on connecting with the community through appropriate means: women's networks, radio and free phone-lines. This meant that it did not exclude those who were not connected to the internet. As such, the internet was used as a hub and storage device, while phones, including mobile phones, were used to collect data and share material about the project. Despite the aims of these projects, which focus on representing public histories and untold and unheard stories of the past, these personal narratives are moderated, validated and edited by the host organization before wider public consumption, meaning that to some extent the material is scripted by external agencies. This editing alters the public's historical narrative and places authority for authentication firmly in the hands of the professionals.

Digital and social media transferred the creation of history and its narrative format beyond the control of academics and professionals. This created new types of history, which were based on early concepts of "history from below" and grass-roots movements. As such, public historians and historical organizations started to create projects that "crowd-sourced" history, recording the unofficial and multi-vocal past that existed, on unofficial and official websites, encouraging the public to comment and add their own stories and memories of historical events. The internet, blogs, comments, and interactive sites enable the public to upload stories, images, and audio and video clips of historical events, placing historical research, oral history, and social history firmly in the digital age. Although this has enabled immediate and reactive historical research and presentation, it has also created new difficulties with the storage of historical collections; digital media as a form of data storage is still an unstable entity and long-term solutions to massive data storage and the transient nature of many web pages have yet to be found.

Case Study 29 September 11 Digital Archive Project

The September 11 Digital Archive Project sought to use the internet to collect, preserve and present publicly "crowd-sourced" history as it happened.[32] This project was a collaborative research project set up by the Center of History and New Media, the American Social History Project/Center for Media and Learning, and the Library of Congress.[33] The project also partners with numerous organizations, including the National Museum for American History, and the Red Cross, to name a few.

Immediately following the New York terrorist attacks of September 11, historians set up a website to collect data from the public and public domains about the event; this included videos, audio material, photographs and written material. The project sought to provide a mechanism to enable a public contribution to the historical record and to record multiple experiences and memories of the terrorist attack on the Twin Towers. Furthermore, the website aimed to capture digital sources, including newspaper headlines, reports and emails.[34] The global nature of the internet allowed people around the world to contribute, to access and to use this data.[35] This event, and its historical records, were regarded as future history; something illustrated by the creation of the National September 11 Memorial and Museum, in New York, which opened in 2014.[36] The cataloging of significant quantities of information was achieved through this mechanism, including 150,000 digital items, 40,000 emails, 40,000 first-hand stories, and 15,000 digital images. This was regarded as essential to future historical study and relevance and as such the Library of Congress has acquired this digital collection for its archives.[37]

This public memory project was facilitated through the internet and social media mechanisms. The public could upload comments, photographs, mobile video footage, and audio footage to the site. This meant that the project could be both self-managed and regulated, with little input from researchers during this period of data collection. It is worth noting that the site was moderated for ethically and morally abhorrent content. The massive data collection illustrated the broad demographic of responses and their high number, something that traditional oral history mechanisms would not have been able to achieve. Digital media search engines were

also able to source and catalog vast amounts of data that were being produced on the web outside of this research, often transient and short-term in nature.

The September 11 Digital Archive project illustrates the value the internet can have in collecting history and the potential of crowd-sourced history for future historical study. The website collected vast amounts of publicly uploaded data, which had no cohesion as it existed without a thematic framework to support its future use for research and presentation. Consequently, these data sets required huge amounts of work to catalog, collate and theme, something that has to date not been completed, but will undoubtedly fall as part of the remit of the Library of Congress and will require volunteer support. The volunteer involvement in this archival process produces problems with lack of consistency in approaches due to lack of training or professional grounding.[38] Publicly-sourced historical archives such as this cannot be quality controlled or validated by traditional research mechanisms. Subsequently, the material produced is often anecdotal and deeply emotional, based on personal memory rather than factual information. Validating the authenticity of all these public stories and memories of people's experiences of this event is often impossible.

Questions

1 How has the internet enabled public history to develop as a subject?
2 In what ways do digital media support the collection, preservation, and presentation of history?
3 Discuss the issues relating to validity and authenticity of crowd-sourced internet history.

Reading and resources

- Cohen, D. (2013) The future of preserving the past, in H. Kean and P. Martin (eds) *The Public History Reader*, London: Routledge, pp. 214–23.
- Kazin, M. (2013) 12/12 and 9/11: tales of power and tales of experience in contemporary history, *History News Network*, September 11. Available at: http://hnn.us/articles/1675.html [accessed 10 Dec. 2013].
- http://911digitalarchive.org/index.php

Social media

Social media have altered the digital communication landscape, enabling individuals and organizations to form networks of open and shared dialog within a digital environment. Consequently, public history practices and modes of communication have changed in response to the growing global impact of social media. The popular digital media, which includes social networking sites such as Facebook, Twitter, Pinterest, and Instagram, have enabled public history to create open networks of communication with a global community. Social media platforms are free to join, as either an institution or an individual, as they receive their revenue from advertising. This social media is accessible through mobile devices using apps, which enable flexible, instant user access. Creating a social media presence "profile" has in the last decade become essential to all public history organizations and projects. This profile has enabled a tool not only for communication with a broad demographic of the public but also as an essential marketing and public relations tool for public history.

Facebook

Facebook is an online social networking service developed in 2004 by Mark Zuckerberg, initially aimed at establishing student networks and sharing social information within Harvard University.[39] This network was expanded in 2005 to other US educational institutions and in 2006, to the world; currently it is estimated that Facebook has 750 million users worldwide.[40] Public history organizations, groups and projects, such as the British Museum and the "Bones Without Barriers Project" (Case Study 7) have utilized Facebook to create public profiles. Creating an organizational rather than "individual" account enables the profile page to post a wider variety of content to a broader audience.

A Facebook profile page, like many other social media sites, can include a variety of features and links:

- name of organization
- type of organization: museum, art gallery, archive or community heritage project
- central image: photograph or painting that offers an insight as to the organization
- organization information: including location map, visiting times, contact details and hyperlink to main organizational website

- related apps, such as Instagram and Pinterest
- photo sharing area
- upcoming events: to promote and advertise open days, lectures, and new exhibitions
- posts to page: these are posted by followers or other Facebook organizations or users, which comment on the organization
- reviews: an area where users can rate the organization and provide commentary. This is often linked to external social sharing internet sites, such as TripAdvisor or Yelp[41]
- liked by this page: area where the organization can associate itself with other, potentially similar organizations to raise its profile
- status updates: this includes photographs to promote the research, galleries, archives, exhibitions and public activities

Facebook supports both passive and active interaction of the public in history. For example, passive interaction can involve a user visiting or following a profile page, while active interaction is commenting on a post or status update, posting photographs and sharing content with other Facebook users. Some of the most successful posts deliberately aim to be interactive, for instance, asking for feedback, for interpretations of history or for responses to specific questions. These interactive posts enable the user to feel connected to the organization and the process of history, which also enables organizations to understand users' demands and values.

Facebook terms include:

- *Like*: Liking content involves a user clicking on the thumbs up icon on the main Facebook page or a specific status update. This "like" will be associated with the person's name and appear on newsfeeds to the individual's Facebook friends.
- *Share*: This enables users to post links to items on their timelines, Newsfeeds and to their friends through a Facebook message. It provides the option of putting a personalized message with the shared link.
- *Comment*: This box, which is located below the status update, enables people to add a comment and content to the post. The comments area has in-built moderation tools.
- *Posts to page*: This provides links to any Facebook pages that have commented on your organization.
- *Embedded posts*: This enables public organizations to link Facebook material specifically to posts.

Visual content is critical to successful Facebook pages, usually judged by the number of followers, visits and high active interaction. For example, the Metropolitan Museum of Art has 1,186,894 likes and 778,695 visits, as of September 2014. This includes the regular, daily use of images such as photographs, paintings, videos, and interactive tours. The uploading of photographs of "mystery objects" and asking for public interpretations, as per the British Museum's "Mystery of the Week," also encourages high levels of online interaction; in this case, 57 shares and 81 comments for a single object. As such, this can provide a mechanism to break down professional and public boundaries and to engage the public in open dialog that both educates and excites. Other successful mechanisms link Facebook posts to topical debates and public interests, such as items associated with the soccer World Cup; for example, a Ming painting of the guards playing soccer in the Forbidden City.[42] Organizations can raise their public profile through following similar organizations, providing links within their own organizational websites and other social media sites such as Facebook. These posts can also promote and market upcoming exhibitions.

Profile pages aim to encourage the promotion and engagement of the public with historical collections. This can be achieved through posts for specific famous artists' birthdays. For example, the Metropolitan Museum of Art showcased its collections of the artist Gustav Klimt, including the Serena Pulitzer Lederer painting, on his birthday; this received 3,945 likes, 1,175 shares and 46 comments.[43] Followers can comment on status updates, share posts, or add their own photographs to create an interactive social website.

Creating an organizational profile on Facebook enables the promotion, or "boasting," of pages and status updates to members of the public who are not already following the organization. Boasting enables organizations to choose an age range, audience, gender and country that they would like to reach, potentially targeting those beyond their usual demographics. A boast will involve choosing five key words, which are linked to Google searches, such as history, museum or exhibitions. Boasting requires payments varying from £3 a day to reach between 1,600 and 4,200 individuals, to £350 per day to reach 100,000. If the lower limit of the figures is not reached, then payments will not be collected, while numbers over the payment criteria will not be charged for. This internet promotion provides relatively cheap advertising for public history organizations.

Facebook does not enable the organizations to read the personal information of individual followers, such as status updates; however, it does provide marketing data and user demographics. Weekly statistics indicate

the demographics of individuals, shown as either viewers, followers, sharers or commenters. This includes their sex, age range (e.g. 35–54), and geographic location. Similar to Google Analytics, this data provides basic statistical analysis as percentages, bar graphs and pie charts, which highlight weekly changes in user data. For example, the Smithsonian's National Museum of the American Indian Facebook page statistics for a particular week indicate that the majority of people engaging in the site are from Washington, aged 35–54 years old. Basic weekly information reveals that 1,800 are talking about the site; 85,000 total page likes, which rose by 0.5 percent from the previous week; and 439 new page likes, falling by 2.2 percent. It also indicates that there was slightly less active interaction than previously.[44] Facebook has enabled public history sectors to develop narrative and visual commentary and dialogs with audiences. Consequently, social media can act as a qualitative and quantitative evaluation tool for public history.

Twitter

Twitter is an online social networking and micro-blogging service created and launched by Jack Dorsey, Evan Williams, Biz Stone and Noah Class in 2006. This worldwide social networking site has at present over 500 million users. Users can "tweet" (share) short 140-character text messages and images with registered users, who can read and respond. Twitter provides a written basic communication tool for organizations and individuals in the public history sector. For example, the National Museum of American History (@amhistory) tweeted: "Depression-era Californian shell money and a fund lemonade stand (secret math) activity for kids" or "The Smithsonian wants to believe! Today in 2008: Museum acquires X-Files collection, including pilot script http://ow.ly/z6eAy."[45] The posting of tweets is often linked to photos and other social media sites, such as blogs or Facebook, in order to reach larger audiences.

Tweets can only be viewed by those who subscribe to Twitter, or if embedded within organizational or project websites as newsfeeds; for example, the "Bones Without Barriers" Project website.[46] As such, linking to other forms of social media and internet sites can be critical to creating a successful Twitter profile. Members of the public can tweet directly about your organization through hash tags. Active interaction of the public with Twitter and with tweets is less easily achieved as short "headlines" do not seek to encourage public commentary. Conversely, few people usually reply to tweets, as opposed to the high numbers who favorite or retweet them. For

example, the Metropolitan Museum of Art (@metmuseum) tweet, "In the 6th century B.C., Sparta was an artistic center & home to important artists & workshops" received 98 retweets, 102 favorites, and 4 comments.

The transient and curt nature of Twitter tweets (restricted to 140 characters), and the limit of re-tweeting only to followers, restrict public access to the information. Twitter's brief content and framework do not support detailed user responses. Subsequently, this medium often fails to initiate conversational dialog or the sharing of detailed information; something websites, blogs, and Facebook more frequently achieve.

Twitter terms are:

- *tweet*: Short comments or headlines posted on organizations' or individuals' Twitter feed page and on all followers' Twitter feeds. Through hashtagging other organizations such as the Library of Congress (@librarycongress) this will be linked to these other organizations. Within a tweet you can also promote your blog, website, Facebook page, etc. Individuals and organizations can also directly tweet other users.
- *retweet*: A small double arrow icon below the tweet. This is for sharing someone else's tweet with your followers.
- *replies*: Users can reply to a tweet by clicking below the tweet.
- *mention*: Within a personal tweet, Users can mention, "hashtag," other users.
- *favorites*: A small star icon below the tweet, used when users like the tweet.
- *following*: This enables an organization or individual to link into another organization or individual, enabling the user to see tweets and to post replies.

Twitter provides basic quantitative information, including number of followers, details of people or organizations you are following and that are following you, number of people who "favorite" your tweet, number of retweets of your tweet and number of tweets you have uploaded. This data, unlike Facebook, is not linked directly to any in-built analytical system. Consequently, gathering demographic user data, statistical data and thematic information for evaluation and marketing purposes is more complex, and involves purchasing or signing up to external software packages, such as TweetStats, SocialBro and Twitonomy.[47]

The use of Twitter by public history organizations has proven problematic, as in essence this medium focuses on self-promotion and following

individuals, such as celebrities, rather than creating public interaction and commentary. Twitter's principal public history purpose is to promote specific events or activities through headlines and newsfeeds, and to guide people to more detailed or interactive digital media sites, such as websites and blogs. This medium has acted as a newsfeed for public history organizations and their profiles, communicating exciting activities, ideas and behind the scenes news. As such, Twitter lacks the scope and space for public interaction that Facebook provides, as highlighted by the differences in numbers of those both passively and actively interacting between these social media sites. For example, the Metropolitan Museum of Art Facebook and Twitter figures indicate overall the higher sharing (retweet), likes (favorites) and comments (replies) on Facebook posts than tweets. This form of social media for public history is potentially a transient mechanism that, as with Flickr and MySpace, could be replaced by new social media platforms in the future.

Instagram

The social networking service Instagram was created in 2010 by Kevin Systrom and Miek Kriger. Instagram provides a platform for the online sharing of mobile phone photos and videos. This site is linked to other social networking sites, including Facebook and Twitter, and enables individuals and organizations to create accounts to upload, edit, and share multiple visual images through global social networks. Public history organizations, such as the Metropolitan Museum (@metmuseum), the Musée du Louvre (@museelouvr), the Museum of American History (@amhistorymuseum), and the Frida Kahlo Museum (@museofridakahlo), have used Instagram to depict and communicate visual history to the public. This includes sharing multiple images of exhibitions or specific objects within their collections and encouraging public commentary relating to this. These "Histagrams" or images of history can help the public to study and engage with past events via historical photos and pictures, such as a painting of Pocahontas or a photograph of Alexander Bell using a telephone.[48] Instagram has in recent years replaced the use of Flickr for many institutions and projects, demonstrating the sometimes transient nature of social media, which is entirely reliant on public usage and perceived public value.

Public historians and public history institutions have used Instagram to evaluate and understand visitor behavior through visitor comments, tweets, and "geo-tagging" photos during their visit. This can help museums to

understand visitor movement in space and specific interests. Critical to the success of Instagram and any photo sharing social platform, including Pinterest, is the provision of links to and within other social media platforms, such as Twitter and Facebook, which increase the size of social networks and the scope for digital sharing.

Pinterest

Pinterest is a social media platform created in 2010 by Paul Sciarra, Evan Sharp and Ben Silbermann. This platform, in a similar way to Instagram, shares photos and visual images but with the specific aim of providing a visual discovery tool by creating a creative and interactive visual resource for the public through sharing collections, "boards," of images. Consequently, in recent years, Pinterest has seen a growth in its use in the public history sector, specifically among museums, such as Chicago History Museum and the Diefenbunker Museum.[49] This growth is partially based on its ability to create themes and narratives through image boards. For example, the Diefenbunker Museum was initially built to protect the Canadian government from nuclear attack and has now become a National Historic Site and museum. This museum has used Pinterest to create thematic boards of visual imagery, such as Education and Programming, Diefenbunker Construction, Spy Camp and Cold War Facts and Figures. These boards include archival images, such as posters and photographs, alongside current photos taken by the museum and the public.

Pinterest incorporates the standard technological elements of social media sites, including the creation of a main page with basic information and links, and the ability of users, the followers, to like, share, comment on and create photos or "posts." The key difference is this site enables followers to "pin" meanings, visual bookmarks and collect images on Pinterest pages from other websites, and from personal photos.

Blogs

Blogs provide mechanisms for individuals and organizations to write online e-journals, diaries and commentary of specific subjects or stories. Blogs provide personal reflections and experiences, as such, these are autobiographical in style, with elements that are anecdotal, personal, succinct, simple, humorous, and topical. These personal ideas and debates provide open gateways to historical narratives, interpretations, and debates

that exist within the public domain. Blogs aim to share information and ideas to a wide audience and provide a mechanism for self-determined learning by the public. For example, the National Museum of American History's blog "O say can you see" provides behind-the-scenes information, curatorial opinions and research about their collections, while "Are these John Wilkes Booth's field glasses?" blogs on "absurd advertising for over 100 years."[50]

Blogs provide an easy and free way to publish short articles on the web. Blogs are simple websites with content organized by date; typically the most recent entry is displayed at the top of page. These blogs provide areas for public commentary of subjects and many blogging platforms, such as WordPress and Tumblr, provide the option for the reader to respond or ask questions at the end of the text.

Types of blogs are:[51]

- *personal research*: individual researchers promote and discuss their own research: for example, Tim Hitchcock's "Historyonics";[52]
- *points of view*: an individual discusses personal thoughts and interests: for example, Mary Beard's "A Don's Life";[53]
- *organizational blogs*: set up by public history institutions, such as archives and museums, to promote their work: for example, the National Museum of American History's "O say can you see";[54]
- *scholarly blog*: created to share opinions on a specific topic or theme, often between academics: for example, the University of Sheffield's "History Matters";[55]
- *event blog*: designed to promote and provide information regarding a specific upcoming and recent event: for example, the Institute of Historical Research's "Utopian Universities Conference";[56]
- *project blog*: designed to promote and discuss a specific project, providing information as it happens and before publication: for example Manchester Metropolitan University, the University of Central Lancashire, and Oxford Archaeology East's project "Bones without Barriers."[57]

Publicly-created digital content, such as blogs, Wikipedia, and other forms of social and digital media have issues with creditability of information. The content of these sources is based on the agenda of the writer or "blogger." Consequently this personal commentary should not be regarded as necessarily factually valid. Rather, it should be seen as an opinion piece by the author. Individual bloggers are in many cases, especially if not affiliated

to an organization, free from any ethical and moral responsibilities, such as considering the implications of their historical interpretations on the wider community. Blogs written by employees of organizations are responsible for representing the aims, ethos and ethics of that institution and its standards, as such content is often carefully managed and approved before it becomes public.

The growth of social media, such as blogs, has resulted in the creation of support networks to encourage, facilitate and advise on mechanisms, techniques and issues with blogging. Blogging for Historians was developed specifically to support and advise on academic, archival, and library history blogging.[58] This blog is based on creating "social scholars," providing online guides to blogging, educational interviews, and research on its impacts, along with supporting networking events and seminars, such as "Academic Guide to Social Media Blogging." These online resources and networking events aim to encourage best practice and the wider application of blogs within the history sector.[59]

Guide to blogging[60]

1 *Blog platform*: Choose an appropriate platform. Basic platforms such as WordPress are free. This will be determined by what kind of features you desire.[61]
2 *Type of blog and theme*: The motivation and aim of the blog, its opinion, research, or promotion.
3 *Title*: This should be clear, concise and encourage people to read it.
4 *Know your audience*: Who is going to read this and why? How will this influence language, content, and detail?
5 *Design*: What elements to include, including font, color, menu, images, headers, and backgrounds.
6 *Writing the blogs*: Clear, descriptive title; the content should be concise, easily readable and appropriate to the audience. This should include images or video clips (such as YouTube). Text should be carefully edited and proof-read prior to uploading. This should include key words, which will be picked up by search engines.
7 *Links to digital and social media*: such as specific websites and Facebook and Twitter.

Case Study 30 History Matters, University of Sheffield

The blog "History Matters" is an institutional "scholarly" blog, set up by the History Department at the University of Sheffield. This blog aims to communicate current research debates and provide a platform for the public and professionals to exchange ideas. The blog provides a forum to link research and ideas into topical debates, aka "history behind the headlines."[62] History Matters has various different subfields of blogs, from public history to LGBT blogs. The blog contains a variety of pictures, headlines and discussions; such as "Cultural Authenticity and Consumerism: The End of the Hipster," "How You Should Bury a Nazi" and "Please Stop Telling Me Margaret Thatcher is a Style Icon: Gender and Social Media."

"The End of the Hipster" is a blog post created by Sarah Kenny, a PhD student at the University of Sheffield. It is based on an article from *The Observer* (July 1, 2014) and is linked to a modern history debate relating to the development of British youth culture. The post makes a personal commentary on the article, describing it as "a bit melodramatic" and "I was struck by how familiar this narrative is," which seeks to provide a more personal connection between the reader, the blogger, and subsequently the material being discussed. The blog goes on to compare Hipsters to the Mod culture of the early 1960s, introducing links between past and present debates and seeking to provide historical context and relevancy to the debate. At the end of the blog, questions are posed to the reader, encouraging debate and seeking commentary.[63] Although not the most controversial or personal account of this subject, this blog post aims to provide a balance between valid arguments, backed up with sources and personal dialog. This is an example of a comfortable middle ground that allows historians to be "social scholars."

History Matters has enabled academics and academia to have wider impact in the public domain. These blogs are restricted by academic codes of conduct that include the requirement for authentication and validation of ideas. As such, these blogs often fail to reach broader public audiences beyond academia as they lack the anecdotal style and language of personal blogs. Central to their success is finding a balance between academic and popular writing styles; tailoring their content to be more publicly oriented while also

maintaining professional integrity; perhaps Mary Beard's or Tim Hitchcock's blogs offer some scope to explore this further.

Questions

1 What are the challenges to academics in creating public blogs?
2 What elements do blogs require to make them successful tools for communicating history to the public?
3 Are there mechanisms that can be put in place to protect blog content from being misused, and is this ever possible to achieve?

Reading and resources

- De Groot, J. (2009) *Consuming History: Historians and Heritage in Contemporary Culture*, London: Routledge, Chapter 6.
- http://www.historymatters.group.shef.ac.uk
- http://bloggingforhistorians.wordpress.com
- http://timesonline.typepad.com

Blogs are easy to use and many are free to set up, which has led to a plethora of blogging sites and bloggers. Consequently, blogs have a varied quality of content, causing confusion among public and professionals as to which blogs should be trusted to provide valid and credible historical content, as opposed to opinions and viewpoints. The publication of articles on blogs is not governed by the same rules as academia, requiring neither peer review nor accurate referencing, and often failing to copyright or authenticate data and resources. Although many blogs, such as those produced by public history organizations, universities and scholarly blogs, do follow copyright and referencing procedure (e.g. History Matters), many do not. This can result in the misrepresentation of history to and by the public, with little or no accountability.

Other social networks

In recent years, social media platforms have sought to provide mechanisms for professional collaboration as well as public collaboration. This has supported networking and the sharing of ideas and academic papers within a professional web domain; such sites include Academia and LinkedIn. These websites allow individuals to create a professional profile, including employment details and research interests, as well as to upload publications.

They enable the linking of the self to key words, such as public history and community history. They also help users to follow other professionals, to form networks of interested parties, to share research interests, and to promote work.

Employment in the sector

The constantly changing and emergent digital media sector in public history means that organizations are increasingly employing specialist staff to support the development and maintenance of social and digital networks. This includes social media curators and digital content managers. Public historians are increasingly required to understand, utilize and create digital media content, thus, employment in public history often requires specific digital media skills. Furthermore, the creation and maintenance of these resources mean that public history organizations employ individuals in a specialist capacity to support this, including computer programmers, IT developers and IT teams.

Social media as a form of public engagement and communication are increasingly managed by social media managers, who are in charge of updating tweets and status updates, as well as raising the museum's or public history organization's profile, to both the public and the press through newsfeeds and headlines. These social media networking services are maintained, updated and checked for content, to provide an appropriate public profile for the organization and a marketing and advertising tool.

Key skills required for a social media position

- Excellent written communication skills
- Accuracy
- Clarity and focus
- Problem solving
- Time management
- Team-working
- Verbal communication skills
- Creative thinking

Conclusion

The development of digital technology since the 1990s, including the internet and social media, has influenced the practice of public history. It has enabled public history organizations to communicate both passively and actively with broad demographic ranges of people independent of geographical locations. This public domain for history has changed how history is collected, stored, and presented, offering new mechanisms to support community history and publicly-led history projects. The development of digital media has given the public a voice and forced history to consider its future impact in the social public space. Digital media have provided public historians with information about history's audience, and information about visitors and visitor behavior in public history facilities; this has included the demographic make-up of visitors and users, the online use of collections and public feedback. This data provides an incredibly useful quantitative and qualitative evaluative tool for public history.[64] Consequently, digital media can help public historians develop a relationship with the public, alter content, and adapt public history activities to make history more user-friendly. This can help generate interest in the subject and support historical research.

The use of this consumer-driven, transient technology changes with the trends and whims of the public users. This has the potential to overlook traditional audiences and those unable to use digital technology; as such the use of digital media to collect, research, communicate, and present history should not replace more traditional methods of research and communication and involvement of the public in history, such as historic site visits, museum exhibitions, and archival facilities.

The use of digital media for public history is linked to debates regarding consumerism and commercialization for entertainment rather than educational purposes. Consequently, there are growing fears over this medium's lack of professional control, questions of providence, authenticity and the validity of evidence being presented, especially on publicly-controlled forums and within crowd-sourced history networks. As such, concern could be raised over the fictionalization and manipulation of this historical record for personal, political and social means, with blogs and social media often providing an open forum to discuss personal issues and complaints without fear of repercussions. This has wider ethical and moral implications for the subject. Some of this professional unease springs from issues with the management and control of the past and rights of ownership

to the past. This is particularly prevalent in digital media projects as questions are beginning to arise over the ownership of material created on public forums and the long-term storage and management of these historical sources.

The use of digital media in public history and history as a discipline is still in its infancy and as such there is much research still to be undertaken as to its value to and impacts on the profession. The use of digital media within public history will continue to develop; yet it is critical to its impact and wider value to the profession that use of these mediums is carefully considered and undertaken within a professional, ethical and moral framework.

Routes into digital media

Digital Content Manager/Social Media Manager

History or communications degree (2:1), particular experience of digital and social media. The job description is:

- Undergraduate degree: either in history, communications or related discipline.
- Excellent written communication skills: ability to write interesting, clear and accurate information about history for use in digital media.
- Broad knowledge of history and historical collections.
- Experience of editing and proof-reading (including audio, video, text and images).
- Experience of ability to use a variety of digital technology.
- Ability to work collaboratively.
- Good organizational skills.
- Knowledge of the use of development of digital media in the history sector.
- Knowledge of Adobe Creative Suite or related software packages.
- Experience of developing social media and digital content curation: apps, websites and social media.

9

Conclusion

This final chapter draws together the overarching themes of the book and provides a coherent synopsis of the practical application of history beyond university. It highlights the key skills and concepts that run through each of the public history sectors. Understanding these skills is crucial to developing students' potential future careers in public history.

Introduction

There are specific challenges that must be faced when working in public history sectors. Through case studies this book has sought to offer advice to mitigate and adapt to the professional demands, including moral, ethical and financial demands on this diverse and growing career path. This chapter has provided a synopsis of potential post-university public history careers, illustrated in a map of career pathways in history. This career overview provides directional support in applying for jobs in the public history sector and advice in future career choices, as well as practical and experience-led

support for applications into future employment, including key phases needed to illustrate competencies for job applications and personal statements.

History in the public domain

The social, economic, political, and educational value and impact of history have been widely theorized by both professional and academic historians.[1] This value directly relates to history's relevance in the public domain and its wider public impact, which includes the impact history has on people's everyday lives, on the communities they live in, and on their personal and communal identity. These impacts range from tourism, political and education policies to reducing crime rates and creating friends. Creating, maintaining, and supporting these multiple values associated with history is the principal aim and responsibility of public historians today. This aim is achieved through the use of a variety of methods and historical activities aimed to encourage participation, communication, and the presentation of history. These public history mechanisms, such as exhibitions, community excavations, oral history, and digital media are applied at both top-down and bottom-up levels. The diverse public history activities highlight how the active mechanisms of personal and communal communication are critical to history's value and relevance.

This book has discussed in depth through specific chapters, how education, the media, including digital media, community history, museums, archives, heritage centers, policies and political organizations have enabled history to be communicated to and with the public. Public history sectors and their associated activities and forms of communication and public participation have affected the public's perception of history and also been influenced by the public's demands, understanding, and interests. Critical to public history in all arenas is the ability to enable a two-way dialog between the professionals and the public. This dialog enables changing power relationships, ones based more on democracy and consultation and is the overarching principle of public history. The changing relationships between historians and the public, enabled by the practice of public history have created history with real-world impact.

Working as a historian in public history requires specific skills and training, which have been outlined in the relevant chapters. Each domain of public history, including museums, archives, heritage, education, media,

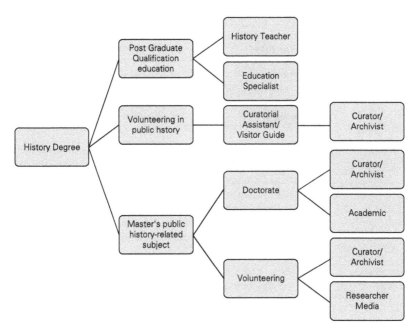

Figure 9.1 Overview of public history career pathways

digital media, community, political, and government history, has unique career pathways that can be followed by history students seeking to achieve employment within these sectors (Figure 9.1).

Studying history has value beyond gaining specialist subject knowledge. The study of history at undergraduate and graduate level provides the apparatus for individuals to gain skills beyond those required for the more normative applications, such as becoming professional and academic historians; those skills required to be a public historians and for careers beyond history.

The study of history engages students in classroom and non-classroom activities that provide individuals with transferable learning outcomes and employability skills. It is these transferable skills that can be applied to other careers beyond history; for example, research and creative writing skills can be applied to journalism and policy-making.[2] History education provides the foundations for research, business and analytical careers, such as the civil service and the legal professional. History has a role in the wider world and provides the skills required by a wide range of employers (Table 9.1).

Table 9.1 Competencies required by employers

Competency	Requirement	Demonstrate
Communication	The ability to communicate with a diverse range of people with clarity, conviction and enthusiasm.	Adaption of communication techniques for diverse audiences. Creation of new platforms for communication.
Partnerships and collaboration	The ability to develop professional relationships with a wide range of people both within and outside the sector. Demonstrate the capability to overcome challenges in these collaborative partnerships and foster future relationships.	Creation of new partnerships and relationships Involvement in multidisciplinary and multi-stakeholder projects. Experience of team working projects.
Capability building	The ability to develop one's self and others through training or mentoring.	Undertaking professional development courses, gaining educational experience, developing future plans for personal career development. Mentoring and supporting other people in their careers
Achieving outcomes	The ability to effect a long-term future that has value and sustainability.	Experience of work that has time-specific deadlines, specific outcomes (values) and that has been evaluated. Consideration of wider values.
Decision-making	The ability to be objective and use sound judgment, to provide accurate and professional advice. To set priorities and justify decisions. Develops creative strategies to minimize risk and create value and impact.	Experience of project management and problem solving. Showing evidence through examples of how decisions were made and what impact this had.
Professionalism	Supporting and improving an organization and its objectives.	Evidence of how the subject's experience fits into the organization's objectives and strategies. How they could support these objectives through their skills and experience.

Time management	Demonstrate the ability to work within specific, often tight deadlines.	Evidence of working to deadlines to archive specific outcomes and managing tasks in a time-pressured environment.
Computer skills	Demonstrate knowledge and application of relevant computer software.	Evidence of using specific computer programs; for example, those associated with data analysis and collection.
Independent research	Ability to work independently, to undertake primary and secondary research with minimal supervision.	Evidence of self-management, completing independent projects and working alone.

Understanding and demonstrating the essential required competencies and competency frameworks that exist for specific jobs are essential to completing successful job applications. Through incorporating these competencies in personal statements and CVs, the individual demonstrates their ability to do a job and that they meet the skills required (see Table 9.1). Many large employers, including universities and archives, apply competency frameworks to recruitment and promotion. The frameworks directly relate to the organization's strategic plan for the future and their core values. For example, the framework for civil servants includes "delivering results," "engaging with the public" and "setting direction."[3] As such, engaging with the public may require the candidate to provide evidence that they can communicate effectively with a diverse range of people and develop collaborative partnerships with internal departments and people and with external organizations and individuals.

Despite the diverse skills developed during undergraduate studies, history students often struggle to gain graduate-level employment.[4] This frequently relates to lack of communication between universities and graduate employers. This issue with communication has resulted in some employers being dissatisfied with the attributes obtained by students at university, specifically generic skills, such as communication, problem solving and team working.[5] Booth and Booth's research illustrates the disparity between students and leavers (future employees) in relation to the skills gained at from university versus the skills they require to gain employment.[6] Specifically, "softer" personal attributes such as self-awareness, empathy, self-reflection are the skills that are prioritized by employers, but not by universities, who seemingly place greater value on the development of evaluation, critical

thinking and writing skills.[7] To address this disparity, the wider history curriculum is beginning to provide for life after university, not just providing for life within academia; thus higher education establishments are developing pedagogical approaches, which provide a "skills journey" for students, linked directly to employability.[8] This approach requires complex teaching and learning methods, which encourage personal journeys and play a role in student development of both history-based skills and transferable and flexible skills.[9] These new approaches aim to engender greater value beyond the classroom for the practice of history and for history graduates.[10] Research indicates undertaking placement courses with specific learning outcomes can maximize the potential for future employment as it provides organized skills training tailored to graduate employer's agendas.[11] Undergraduate and Master's courses, such as public history, that offer student placements provide the greatest scope for individuals to develop these skills.[12]

It is critical for public history organizations that history students (their future employees) leave university with "real-world" experience of the uses and applications of history beyond the classroom, ensuring that they have practical and first-hand experience of putting into practice the historical knowledge and skills attained during their studies. Studying history at degree level provides the framework for those interested in working in the expanding public history sector, alongside providing the skills to gain employment beyond university and traditionally associated historical activities.

Experience gained from volunteering or on placement in public history organizations is critical to gaining future employment in public and private institutions. The precise nature of the experiences gained from placement or volunteering work will vary from institution to institution and from project to project. In some cases experiences will involved institutionally led, conventional activities, such as designing exhibitions; in other cases it could involve being led and guided by the community (community history) to create community heritage trails or support oral history projects; all these projects work towards a final product and output; which may be organic and changeable or fixed.

The benefits of employing history graduates

- *Enterprising*: Collaborative partnership projects based on multidisciplinary approaches.

- *New thinking*: New ideas and approaches to projects.
- *Knowledge transfer*: Develop and increase communication technologies and approaches.

This book has highlighted the ways in which historical techniques, knowledge, and insights are and might be applied in various contexts. It has introduced the key issues in the conceptualization and practice of public history and prepared the reader to debate distinct methodologies and criteria that may be deployed in public history. History has potential beyond academia, which is enabled by increasing partnerships with public and private external organizations.

Crucial to the practice of public history and postgraduate employment in the history industry is the ability to reflect on previous work and to critically evaluate the skills gained from each experience. This enables the evaluation of both the successes and failures of public history projects, including understanding the inputs and outcomes. This self-reflection is a form of qualitative evaluation, and aims to provide the personal space to critically consider both the nature of public history and to understand its impact.[13] Critical review enables public historians to learn from experience, is vital to facilitate a sustainable and meaningful future for public history. The ability to self-reflect is key to successful job applications, understanding the achievements and skills gained from previous experience.

Getting a job

Personal statements

The majority of job applications require written personal statements; these are descriptive passages that detail how the candidate meets the job requirements. This showcases a candidate's skills and experience linked to competencies, indicating what makes them ideal for the job (Figure 9.1). Writing personal statements requires the ability to link experiences and personal achievements with the key essential competencies listed in the job description. Employers will score the statement based on meeting the essential job description; candidates who meet the highest number of competencies will be asked to an interview. Presentation of personal statements usually involves choosing a style layout:

1 *Sections*: Division of text based on job description categories. This statement will read as a continuous prose.
2 *Bullet points*: These points will be numbered relating directly to job specification numbers. Each bullet point will relate to a different competency and skill listed in the job specification and will provide a sentence outlining experience that demonstrates this skill.

Curriculum vitae

Curriculum vitaes (CVs) provide employers with a visual overview of an individual's key achievements and a summary of their education and work to date. It is critical this showcases the applicant's key skills to future employers. The layout and format of a CV is essential in order to make it clear and concise; thus, CVs should not be more than two sides of A4, except in the case of academic CVs which are longer (see Online Resources for examples).

Key components of public history CVs (excluding academic CVs) are:

- Bio-overview: name, address and contact details.
- Education: schools and universities attended and associated qualifications and grades attained.
- Work experience: list of all past and present jobs. Provide a brief summary of key roles undertaken and their responsibilities.
- Further experience and interests: conference papers presented and society membership.
- References: This requires two professional references, consisting of either an academic or a former and/or current employer. These references should be chosen based on people with whom the applicant has a good relationship and are supportive of future careers. It is important to contact references prior to application and send details of the application in order for them to tailor the reference appropriately.

Interviews

Once applications have been submitted and reviewed by the selection panel or committee, usually involving human resources and senior organizational employees, candidates that best meet the requirements will be asked to interview.

The type of the interview will depend on the job, but in many sectors including museums, education and government, interviewees will often be

asked complete an activity during the interview, such as public presentation, historical object identification or a database input activity. This will be preceded by a formal interview in which candidates are questioned by a panel of institutional employees, including line managers and senior staff. Typically this interview will focus on questions aimed at testing how well a candidate meets the criteria for the job. This provides an opportunity for the employers to get to know the applicant and to judge whether or not they will fit in with the organization and whether they have any additional skills that may be of value to the job. Interviews are an opportunity to examine how a candidate thinks and acts under stress, as well as providing a test of their communication skills.

Key things to remember for interviews are:

- *Preparation*: Before the interview, research the organization online and read any material they have sent you, including the job description and the candidate criteria. If they have mentioned who is interviewing you, research them and their specialisms, remember to use this in the interview. Make sure you know the time, place and anything you have to bring with you; for example, proof of identity, permit to work and qualifications.
- *Practice*: Think of some questions that relate to the job specification. Prepare answers for them; you may want a friend or family member to role-play the interview with you. Consider your future in the job: what you would do if you got the position? What would your goals be?
- *Timekeeping*: Do not be late. Make sure you contact the interviewers immediately should you encounter any issues, such as transport.
- *Appearance*: Smart and clean clothes and shoes. Dress for the job you want in the future not for the job you have at the moment.
- *Introduction*: Introduce yourself, shake hands with the interview panel and wait to be invited to sit down.
- *Make eye contact*: Look the interviewer/interviewers in the eye when talking to them and sit upright. Smile and show your personality; do not giggle or nervously fiddle.
- *Give clear, concise answers*: Take a breath; if you have not understood what they have asked you, then ask them to repeat the question. Remember to stick to the point and illustrate your answer with examples.
- *Prepared questions*: Think of some questions you want to ask the interview panel; remember you are deciding if you want to work in this organization as well.

The future of public history

This book has highlighted the effects of changes in disciplinary methodological and theoretical frameworks on the practice of public history. These have not only been influenced by internal disciplinary developments in pedagogical practices, but also by external forces beyond the historical sector, including politics, policies, and economics. This serves to demonstrate how changes in dominant social and political ideologies have influenced the practice of history and public history.

Public history's key achievements, which include communicating and sharing ownership of the past with the public, relate to its ability to draw on multidisciplinary concepts and methods. Its freedom from academic conceptualization and recognition has given public historians the opportunity to explore new relations that history has to the wider world and to embrace its broader public influence. This has enabled the discipline's practice to be influenced by the community. As a result, history has benefited, economically, politically and professionally, from the relationship public history has developed with the wider community.

The challenge for the future is to find mechanisms by which public history can influence politics and practice, rather than merely being influenced by them. This requires developing new media for communication and opportunities for interdisciplinary collaboration. Public historians and organizations must continue to form multi-disciplinary partnerships, which integrate the practice of public history within a wider disciplinary palimpsest, providing history with public relevance. The aim of public history programs and organizations is to support the development of symbiotic relationships between professions, policy-makers and the public.

Public history is integral to the practice of history; by incorporating history and heritage and embracing intangible pasts, it supports historical research and its wider communication. The practice of public history has to enable history to become contextually meaningful and relevant to the public in the present. The effects of public history, "history in, with and for the public," are far-reaching, affecting wider historical discourse and narratives, changing historical content, altering history's values and impacting directly on public lives through policy implementation and education. Public history should not be regarded as a separate sub-discipline but rather as an essential component in the practice of history, an overarching moral and ethical framework that encompasses elements of the entire discipline. Understanding

this will enable history to move beyond its traditional boundaries, something that is essential to its long-term public support and survival. It is essential that public historians understand the innate need to broaden history's scope, and museum, archives and heritage professionals seek to collaborate with an increasingly varied number of stakeholders and partners to adapt and communicate a relevant past.

Understanding the external influences and factors that affect the practice of history both within and beyond academia is an essential element of being a public historian, as is understanding the public, their values and the potential impacts of any public project upon them. This is a challenge, as the varied and complex social units that make up the public often seem rather confusing to many historians. This challenge can be met through communication, partnerships and collaboration, requiring public historians to be more organic and flexible in their approaches to collecting, interpreting, and presenting the past.

Public history projects are full of complexities and dangers that are not faced in the classroom, balancing differing demands, interpretations and values in a way that requires listening and decision-making to produce a final story or stories of the past. It also requires and demands both an overarching and specialist knowledge of history, which is essential in order to provide an authentic, valid and publicly acceptable interpretation of the past, and to prevent manipulation, stereotyping, and dangerous abuses of history that can lead to conflict and social alienation. Public historians and historians have a moral and ethical obligation to provide a balanced portrayal of the multiple voices of the past. This portrayal requires combining traditional primary "tangible" source evidence with intangible stories of unrecorded pasts. Through maintaining professional standards and integrity of research and analysis, historians can construct a complex and multidimensional version of the past that is both professionally and publicly acceptable. Providing a "balanced" portrayal of the past requires collaboration with the public and consideration and critical analysis of new sources of historical research, knowledge and presentation.

Conclusion

Public history has developed based on an ethos of public communication, cooperation, and collaboration. Despite methodological developments, advances in digital technology and the incorporation of interdisciplinary

techniques of evaluation and pedagogical practices, the premise and key aims of public history have remained static.

Since public history's inception as a formally recognized sub-discipline of history in the 1970s and 1980s, its principles and practices have metamorphosed, moving from theory to actions and formal acceptance as performing a vital role in the practice of the subject.[14] The practice of public history has guided modern historical communication methods and influenced research practices of history.

Historians are now actively seeking to incorporate public history within their formal organizational research agendas and teaching practices. Historians are no longer regarded as those solely working in academic institutions, but are now seen as professionals, civil servants, government officials, and public practitioners. As such, history is not a career limited to academia and education; rather a historian can work in many guises, contexts and environments, ranging from government archives to community settings. Public history has led history as a discipline to diversify its methods and theories and it is playing a critical role in shaping history's futures and altering its practice. For example, community history is no longer overlooked as historical work undertaken by amateurs and non-academics; rather it plays an active role in shaping historical knowledge and research agendas, and has become a key component of public history. Similarly, media history is no longer shunned as inauthentic and unprofessional, but has been embraced by some historians for its ability to inform and enable public communication.

Since the nineteenth century and the beginning of professional history movements around the world, historians have fought to be heard in the social-political arena. They have developed a political voice and thus begun to be accepted as having public value. Public history has provided the platform to enable this acceptance and to formally prove its validity, giving history the diversity in practice to make it relevant to the public.

The community and the public are increasingly playing a role in shaping the practice of history and the production of historical knowledge. Public history as a discipline has helped shape the production and consumption of history. Public history has highlighted the complex nature of the relationships between academics, heritage professionals and the public and the multiple voices these disparate communities have, and considered how academics and professionals can work with communities to provide new knowledge through a range of techniques. This has enabled public history projects to have value to communities; values that go beyond simply the acquisition of knowledge.

This book has highlighted how public history projects in a range of settings are undertaken. As such, the nine chapters provide an oversight of public history in practice and seek not only what is required to work in different public history sectors, but to highlight overarching themes in methods and patterns in practice. This has illustrated how the practice of public history is not limited to "official" public history institutions, such as museums, but rather is practiced in a multitude of community and official contexts. This is particularly illustrated in Chapter 5 on community history and Chapter 7 on politics. These projects are delivered through various mechanisms, all of which indicate that it is critical that public history projects are developed to incorporate aspects of not only the visual and tangible past, but also the intangible past, i.e. that "lacking physical form and proof." It is this that requires heritage professionals, including historians, to tread the delicate minefield between various historical "truths" and often to challenge preconceived notions of fact and fiction.

This book has sought to provide the reader with an insight as to the multiple concepts of best practice in public history. It has illustrated that best practice within public history is not a consensus, but rather it is contextually specific and linked to wider professional debates pertaining to ownership, authenticity, validity, professional standards, co-production of knowledge, consumption and ethics and morals. The complex range of what is regarded as best practice is illustrated in the case studies presented; from community-led history such as Bellarine Bayside Project to larger, institutionally-established public history projects such as the United States Forest Service's "Passport in Time."[15]

This book has illustrated the diverse skill sets public historians require, which are adapted and developed based on contextual requirements and working environments. It has highlighted the diversity in the media of communication used by public historians in the field.

The future of public history requires current and future professionals to continue to evaluate, reassess, and critically review these methods and approaches, adapting both personal skills and overarching techniques to meet the public's, politicians' and professionals' changing demands. Providing a sustainable future for public history requires individuals working in the sector of history to continue to strive for wider relevancy while maintaining and advocating professional standards and integrity.

Glossary

Glossary words are shown in bold in the text.

Authentic (Authenticity) Perceived as real and genuine, regarded as historical truth.

Behaviorism Teaching-centered approach based on cause and effect. The teacher conditioned the learner often through repetition, for example, Pavlov's dog.

Blended learning Combines various pedagogical approaches to provide learning and teaching appropriate to diverse individuals.

Bottom-up approach See Grass-roots.

Cognitive learning A learning theory based on the idea that learning is an internal mental activity, influenced by previous knowledge and experience. Learning is developmental and changes internal cognitive structures.

Community history Public history projects, usually occurring in a specific geographical location, that are guided by the community.

Constructivism Learner-centered approach. Learning is influenced by experiences and personal interactions. This active approach is based on doing and reflection, such as "real-world problem solving."

Consumerism The promotion and production of history for the acquisition and use by consumers, i.e. the public.

Crowd-sourcing The securing of public funding, public support or public sourcing of information through the use of the internet.

Cybermuseology The creation of museum frameworks and external networks of interaction through the internet.

Desk-based assessment The production of a written document report that compiles historical archival records and archaeological evidence relating to a specific geographical locality/site to provide a comprehensive overview of the history of a site.

Digital media A technology that uses computers and related software to create, communicate and store data. This includes the use of the internet, and the creation of webpages, websites (see Social media) and databases.

Disneyfication The transformation of history for entertainment purposes. The sterilization, falsification and simplification of history for wider public consumption.

Experimental learning Learner-centered approach. This form of social learning is based on learning through experience and practical, hands-on learning, such as "placement learning."

Flexible This teaching and learning approach provides teaching based on learners' needs and usually is external to the classroom.

Genre A classification system for a specific type of medium and/or product, which can be used for the translation and communication of history.

Globalization A process by which different parts of the world come together, including economically, culturally, and ideologically.

Grass-roots Public history projects developed and managed by the public for the public (see Community history).

Heritage Management Plan A plan that outlines future strategic management, guidelines and policies for a historic site. This includes stakeholder values, financial investment, and project management strategy.

Historiography The writing of history and an understanding of its underlying links to broader theories and different approaches.

Listed buildings Historical buildings that due to their historical importance and architectural significance are protected by the UK government.

Material culture Physical evidence of the past, for example, artifacts.

Narrative A written or verbal account of an event, a story of history based on a specific perspective of the past.

Pedagogy Approaches and theories relating to teaching and learning.

Post-modern A historical approach and theory that dispels ideas of "truth" and "fact," but rather believes all historical interpretation is fluid. Belief that intangible pasts have equal value to the discipline and story of history as tangible pasts.

Primary school A school teaching children aged 5–11 in the UK (referred to as elementary school in North America).

Private institution Non-government-funded organization.

Private school Fee-paying schools that work independently from many government regulations and conditions, have more choice over curriculum and subjects (also known as Independent schools). Preparatory ("Prep") schools educate younger children.

Public history The process of communicating history within the public domain mechanisms that facilitate open access to and engagement of the public with history.

Public institution Government-funded organization.

Public school Two divisions: Outside the UK these are government-funded schools (state schools). In the UK public schools are established, expensive and exclusive schools, including boarding schools.

Qualitative Evaluation that involves the use of anthropological and psychological techniques of observation and conservation to provide "value"' and impacts evidence.

Quango Quasi-autonomous non-governmental organization. This refers to government-funded bodies that work semi-independently from government.

Quantitative Evaluation that involves the use of numerical and statistical surveys to provide demographic and statistical user evidence.

Reconstruction Re-created historical buildings and physical objects from the past. This often uses a mixture of historical and archaeological knowledge and creative interpretation.

Re-enactment Modern people re-create ideas and theories of past historical events and actions in the present.

Replicas Modern copies of original historical artifacts.

Secondary school A school teaching children aged 11–16 (referred to as high school in Australia and North America).

Self-reflection The action of personal evaluation, understanding what happened, why it happened and what worked and what didn't. A mechanism for understanding personal actions and reaction.

Social media The use of digital media and networks to support social interaction in the virtual world. This enables the public to share and exchange ideas, and create and communicate information to a broad audience.

Social networks Connections formed between different and diverse groups of people.

State school Government-funded and controlled "free" schools, working directly within government guidelines to deliver the UK National Curriculum.

Third sector funding Non-government, not-for-profit and charitable funding. Funding can be obtained through both public (civic) and private (social) sources for social benefit.

Top-down Public history projects developed and managed by professionals for the public, includes institutional and research projects.

Validity Credible and historically proven truth.

World Heritage Site A historical, archaeological, geographical or ecological place that has international cultural and physical significance.

Notes

Introduction: History beyond the Classroom

1 Davison, G., Public history, in G. Davison, J. Hirst and S. Macintyre (eds), *The Oxford Companion to Australian History* (Melbourne: Oxford University Press, 1998), pp. 532–3; Liddington, J., What is public history? Publics and their pasts, meanings and practices, *Oral History*, 3 (2002): 92–9; Wilmer, E. (2000) *What Is Public History?* See http://www.publichistory.org/ what_is/definition.html [accessed 10 Dec. 2013].
2 Jordanova, L., *History in Practice* (London: Bloomsbury Academic, 2010); Ashton, P. and Kean, H., *People and Their Pasts: Public History Today* (London: Palgrave Macmillan, 2009).
3 Grele, R., Whose public? Whose history? What is the goal of a public historian? *The Public Historian*, 3(1) (1989): 40–8; Samuel, R., *Theatres of Memory: Past and Present in Contemporary Culture* (London: Verso, 2012).
4 Kean, H. and Ashton, P., Introduction: people and their pasts and public history today, in H. Kean and P. Ashton (eds) *People and Their Pasts: Public History Today* (London: Palgrave Macmillan, 2009), pp. 1–20.
5 Kean and Ashton, Introduction, p. 1.
6 Hartley, L.P., *The Go-Between* (London: Penguin Modern Classics, 2004); Lowenthal, D., *The Past is a Foreign Country* (Cambridge: Cambridge University Press, 1990).
7 Jensen, B., Usable pasts: comparing approaches to popular and public history, in H. Kean and P. Ashton (eds) *People and Their Pasts: Public History Today* (London: Palgrave Macmillan, 2009), p. 43.
8 Franco, B., Public history and memory: a museum perspective, *The Public Historian*, 19(2) (1997): 65.
9 Claus, P. and Marriot, J., *History: An Introduction to Theory, Method and Practice* (Harlow: Pearson, 2012), p. 215.
10 Jensen, Usable pasts, p. 42.
11 Fredericksen, C., Caring for history: Tiwi and archaeological narratives of Fort Dundas/Punata, Melville Island, Australia, *World Archaeology*, 34(2) (2002): 299.

12 Holtorf, C., *From Stonehenge to Las Vegas: Archaeology as Popular Culture* (Oxford: Altamira Press, 2005).

13 Potter, P.B., *Public Archaeology in Annapolis: A Critical Approach to Maryland's Ancient City* (Washington, DC: Smithsonian Institute Press, 1994).

14 Anderson, B., *Imagined Communities: Reflection on the Origins and Spread of Nationalism* (London: Verso, 1983).

15 Suny, R.G., Provisional stabilities: the politics of identities in post-Soviet Eurasia, *International Security*, 24(3) (1999): 139–79.

16 Suny, Provisional stabilities, p. 148.

17 Suny, Provisional stabilities, p. 147.

18 Merriman, N., *Beyond the Glass Case: The Past, the Heritage and the Public in Britain* (Leicester: Leicester University Press, 1991).

19 Merriman, *Beyond the Glass Case*.

20 Bates, J., Introduction, in J. Bates (ed.) *The Public Value of the Humanities* (London: Bloomsbury Academic, 2012), p. 2.

21 Bates, Introduction, p. 6; Claus and Marriott, *History*.

22 Wilmer, E. (2000) *What Is Public History?* Available at: http://www.publichistory.org/what_is/definition.html [accessed 8 Oct. 2013].

23 Franco, Public history and memory, p. 66.

24 Green, J., *Taking History to Heart: The Power of the Past in Building Social Movements* (Amherst, MA: University of Massachusetts Press, 2000).

25 Jordanova, *History in Practice*.

26 Claus and Marriott, *History*, p. 217.

27 Green, *Taking History to Heart*, p. 2.

28 Twells, A. (2008) Community history, Institute of Historical Research. Available at: http://www.history.ac.uk/makinghistory/resources/articles/community_history.html [accessed 8 July 2014].

29 See http://www.historyworkshop.org.uk/about-us/; http://www.wea.org.uk/ [accessed 8 July 2014].

30 Scardaville, M., Looking backward toward the future: an assessment of the public history movement, *The Public Historian*, 9(4) (1987): 35–43.

31 Claus and Marriott, *History*, p. 219.

32 Jordanova, *History in Practice*; Ashton and Kean, *People and Their Pasts*.

33 Jordanova, *History in Practice*; Twells, Community history.

34 Howe, B., Reflections on an idea: NCPH's first decade, *The Public Historian*, 1(3) (1989): 69–85; Twells, Community history; Davison, Public history.

35 Kean and Ashton, Introduction.

36 Howe, Reflections on an idea.

37 Davison, Public history.

38 Liddle, P., Community archaeology in Leicestershire museums, in E. Southworth (ed.), *Public Service or Private Indulgence?* The Museum

Archaeologist 13 (Liverpool: Society of Museum Archaeologists, 1989), pp. 44–6.

39 Bates, Introduction.

40 Bates, Introduction.

41 Bates, Introduction, p. 5.

42 DCMS (2010) Public spending review. See http://www.official-documents. gov.uk [accessed 10 Dec. 2010].

43 Ashton and Kean, *People and Their Pasts*.

44 Kean and Ashton, Introduction.

45 Claus and Marriot, *History*, p. 219.

46 Jordanova, *History in Practice*, p. 92.

47 Jordanova, *History in Practice*, p. 93.

48 Classen, C. and Kansteiner, W., Truth and authenticity in contemporary historical culture: an introduction to historical representation and historical truth, *History and Theory*, 47(2) (2009): 4.

49 Classen and Kansteiner, Truth and authenticity, p. 4.

50 Classen and Kansteiner, Truth and authenticity, p. 3.

51 McKercher, B. and Du Cross, H., *Cultural Tourism: The Partnership between Tourism and Cultural Management* (New York: Haworth Hospitality Press, 2002).

52 Chhabra, D., Positioning museums on an authenticity continuum, *Annals of Tourism Research*, 35(2) (2007): 427–33.

53 Morris, W., At Henry Parks Motel, *Cultural Studies*, 2 (1988): 11.

54 See http://www.wwiilha.com [accessed 12 July 2014].

55 See www.tia.org [accessed June 2013]; Rosenzweig. R. and Thelen, D., *The Presence of the Past* (New York: Columbia University Press, 2000).

56 Slick, K., Archaeology and the tourist train, in B.J. Little (ed.) *Public Benefits of Archaeology* (Gainesville, FL: University Press of Florida, 2002), pp. 219–27.

57 Holtorf, *From Stonehenge to Las Vegas*, p. 5; Popcorn, F., *The Popcorn Report: Revolutionary Trend for Marketing in the 1990's* (London: Arrow, 1992).

58 Simpson, F., Community archaeology under scrutiny, *Journal of Conservation and Management of Archaeological Sites*, 10(1) (2009):16.

59 Ascherson, N., Why "heritage" is right-wing, *Observer*, November 8, 1987; Ashby, J., Beyond teaching: out of hours at the Grant Museum, *University Museums and Collections Journal*, 2 (2009): 43–6.

60 Smith, M. and Richards, G., *The Routledge Handbook of Cultural Tourism* (London: Routledge, 2012).

61 See http://www.tourismalliance.com/downloads/TA_327_353.pdf; Visit England 2011 [accessed March 2014].

62 Smith, L.J., *Archaeological Theory and the Politics of Cultural Heritage* (London: Routledge, 2004).

63 Smith, *Archaeological Theory*.
64 Carman, J., Towards an international comparative history of archaeological heritage management, in R. Skeates, C. McDavid, and J. Carman (eds) *The Oxford Handbook of Public Archaeology* (Oxford: Oxford University Press, 2012), pp. 13–35.
65 Twells, Community history.

2 Museums, Archives, and Heritage Centers

1 Jenkinson, H., *Manual of Archive Administration* (London: Percy Lund, Humphries and Co., 1937).
2 Bennett, T., *The Birth of the Museum: History, Theory, Politics* (London: Routledge, 1995).
3 Franco, B., Public history and memory: a museum perspective, *The Public Historian*, 19(2) (1997): 66.
4 Samuel, R., *Theatres of Memory: Past and Present in Contemporary Culture* (London: Verso, 2012).
5 Bennett, *Birth of the Museum*.
6 Samuel, *Theatres of Memory*, p. 214; ICOM (2007) Available at: http://icom.museum/the-vision/museum-definition/ [accessed 21 Aug. 2013].
7 Claus, P. and Marriot, J., *History: An Introduction to Theory, Method and Practice* (London: Pearson, 2012).
8 Wilton, J., Museums and memories: remembering the past in local community museums, *Public History Review*, 12 (2006): 58; Pearce, S., *Interpreting Objects and Collection* (New York: Routledge, 1994).
9 Samuel, *Theatres of Memory*.
10 Kavanagh, G., *Making Histories in Museums* (Leicester: Leicester University Press, 1996).
11 Kavanagh, *Making Histories*, p. 1; Gardner, J., Trust, risk and public history: a view from the United States, *Public History Review*, 17 (2010): 53.
12 Wilton, Museums and memories; Lewis, G., The role of museums and professional code of ethics, in P. Boylan (ed.) *Running a Museum: A Practical Handbook* (Paris: International Council of Museums, 2004), pp. 1–16.
13 Lewis, Role of museums.
14 Swain, H., *An Introduction to Museum Archaeology* (Cambridge: Cambridge University Press, 2007); Lewis, Role of museums.
15 Pickstone. J., *Ways of Knowing: A History of Science, Technology and Medicine* (Manchester: Manchester University Press, 2000).

16 Bennett, *Birth of the Museum*, p. 526; Pearce, *Interpreting Objects*.

17 Bennett, *Birth of the Museum*, p. 527.

18 Latour. B., *Pandora's Hope: Essays on the Reality of Science Studies* (Cambridge, MA: Harvard University Press, 1999).

19 Bennett, *Birth of the Museum*, p. 526; Latour, *Pandora's Hope*.

20 Lewis, Role of museums.

21 Bennett, *Birth of the Museum*, p. 521.

22 Glassberg, D., Review: Loving in the Past, *American Quarterly*, 38(2) (1986): 305.

23 Rentzhog, S., *Open Air Museums: The History and Future of a Visionary Idea*, trans. S.V. Airey (Stockholm: Carlssons and Jamtili, 2007), p. 19.

24 Rentzhog, *Open Air Museums*; Anderson, J., Simulating life in living museums, *American Quarterly*, 34(3) (1982): 291.

25 Rentzhog, *Open Air Museums*, p. 238.

26 See http://icom.museum/the-organisation/history/; http://www.ica. org/1832/about-ica/a-timeline-of-the-international-council-on-archives. html [accessed 10 Aug. 2013].

27 Merriman, N. and Poovaya-Smith, N., Making culturally diverse histories, in G. Kavanagh (ed.) *Making Histories in Museums* (Leicester: Leicester University Press, 1996); Claus and Marriot, *History*.

28 Bennett, *Birth of the Museum*; Samuel, *Theatres of Memory*.

29 Jordanova, L., *History in Practice* (London: Bloomsbury Academic, 2010).

30 See http://www.museumoflondon.org.uk/corporate/about-us/history-museum/ [accessed 2 Aug. 2013].

31 Merriman and Poovaya-Smith, Making culturally diverse histories; Sorensen, C., Theme parks and time machines, in P. Vergo (ed.) *The New Museology* (London: Reaktion Books, 2007).

32 Hooper Greenhill, E., *Museums and Shaping Knowledge* (London: Routledge; 1992); Robertshaw, A., Live interpretation, in A. Hems and M. Blockley (eds) *Heritage Interpretation* (London: Routledge, 2006).

33 Lewis, Role of museums.

34 Merriman, N., *Beyond the Glass Case: The Past, the Heritage and the Public in Britain* (Leicester: Leicester University Press, 1991).

35 Merriman, *Beyond the Glass Case*.

36 Bennett, *Birth of the Museum*.

37 Bennett, *Birth of the Museum*, p. 521.

38 MacDonald, S., *A Companion to Museum Studies* (London: Blackwell Publishing, 2009); Griffin, D. and Paroissien, L., *Understanding Museums: Australian Museums and Museology* (Sydney: National Museum Australia, 2011).

39 Bolton, L., The object in view: aborigines, Melanesians and museums, in
 L. Peers and A.K. Brown (eds) *Museums and Source Communities*
 (London: Routledge, 2003).
40 Lewis, Role of museums.
41 Lewis, Role of museums.
42 Lewis, Role of museums; Swain, H., *An Introduction to Museum
 Archaeology* (Cambridge: Cambridge University Press, 2007).
43 Swain, *Introduction to Museum Archaeology.*
44 Lewis, Role of museums.
45 Lewis, Role of museums, p. 4; Butler, T., "Memoryscape": integrating oral
 history, memory and landscape on the River Thames, in P. Ashton and
 H. Kean (eds) *People and Their Pasts: Public History Today* (London:
 Palgrave Macmillan, 2009), p. 223.
46 Lewis, Role of museums. Bennett, *Birth of the Museum.*
47 Butler, "Memoryscape."
48 Museum of the City of New York (2012), *Bicentennial Report: Museum of
 City of New York, 2011–2012.* Available at: http://www.mcny.org/sites/
 default/files/Biennial%20Report%202011–12.pdf, pp. 1–2. [accessed
 15 January 2014].
49 Chatterjee, H., Object-based learning in higher education: the pedagogical
 power of museums, *University Museums and Collections Journal*, 3 (2010):
 180.
50 Chatterjee, Object-based learning; MacDonald, *Companion to Museum
 Studies.*
51 MacDonald, *Companion to Museum Studies*, p. 8.
52 Jones, A., University museums and outreach: the Newcastle upon Tyne
 case study, *University Museums and Collections Journal*, 2 (2009): 27–32.
53 Chatterjee, Object-based learning, p. 179.
54 Chatterjee, Object-based learning, p. 179.
55 Rentzhog, S., *Open Air Museums: The History and Future of a Visionary
 Idea*, trans. S.V. Airey (Stockholm: Carlssons and Jamtili, 2007).
56 Merriman and Poovaya Smith, Making culturally diverse histories.
57 Wilton, Museums and memories.
58 See http://www.elizabethgaskellhouse.co.uk/the-house/ [accessed 10 Sept.
 2013].
59 See http://www.westchestergov.com/history/wash.htm [accessed 10 Sept.
 2013].
60 Merriman and Poovaya-Smith, Making culturally diverse histories.
61 Wilton, Museums and memories, p. 68.
62 Webber, K. Gillroy, L., Hyland, J., James, A., Miles, L., Tranter, D., and
 Walsh, K., Drawing people together: the local and regional museum
 movement in Australia, in D. Griffin and L Paroissien (eds) *Australian*

Museums and Museology (Sydney: National Museums of Australia, 2011). Available at: http://nma.gov.au/research/understanding-museums/index. htlm [accessed 5 Aug. 2013].

63 Webber et al., Drawing people together.
64 Jenkinson, *Manual of Archive Administration*.
65 See www.hha.co.uk [accessed 2 June 2013].
66 Samuel, *Theatres of Memory*; Pearce, *Interpreting Objects*.
67 Lewis, Role of museums.
68 See www.icom.org [accessed 10 Dec. 2013].
69 See www.museumassociation.org.uk [accessed 10 Nov. 2013].
70 Jenkinson, *Manual of Archive Administration*.
71 Claus and Marriot, *History*.
72 Miller, L., *Archives: Principles and Practices* (London: Facet Publishing, 2010).
73 Jenkinson, *Manual of Archive Administration*.
74 Miller, *Archives*.
75 Claus and Marriot, *History*.
76 Claus and Marriot, *History*.
77 See www.ica.org [accessed 10 June 2013].
78 See http://www2.archivists.org/about/introduction-to-saa [accessed 12 Dec. 2013].
79 Miller, *Archives*.
80 ICOM Code of Professional Ethics (1990), p. 31; CIDO Fact Sheet No. 2.
81 Jenkinson, *Manual of Archive Administration*.
82 Jenkinson, *Manual of Archive Administration*; Claus and Marriot, *History*.
83 Jenkinson, *Manual of Archive Administration*.
84 See http://www.ica.org/124/our-aims/mission-aim-and-objectives.html [accessed 10 Dec. 2013].
85 See http://www.ica.org/125/about-records-archives-and-the-profession/ discover-archives-and-our-profession.html [accessed 10 Dec. 2013].
86 Claus and Marriot, *History*.
87 Jenkinson, *Manual of Archive Administration*.
88 Jenkinson, *Manual of Archive Administration*.
89 See www.nationalarchives.org.uk [accessed 10 Dec.2013].
90 See www.ica.org [accessed 10 Dec. 2012].
91 See http://www.archives.org.uk/about/about.html [accessed 10 Dec. 2012].
92 See http://www.archivists.org.au/page/Learning_and_Publications/ ASA_Learning/ [accessed 10 Dec. 2013].
93 Robertshaw, Live interpretation.
94 Beech, Museums, visitors and heritage centres. Available at: https://www. waterways.org.uk/pdf/restoration/museum__visitor_and_heritage_centres [accessed 5 Oct. 2013].

95 See http://www.navy.gov.au/history/museums/ran-heritage-centre#desk
 [accessed 5 Oct. 2013].
96 Sorensen, Theme parks and time machines.
97 Jorvik Viking Centre is managed and owned by York Archaeological Trust.
 See http://jorvik-viking-centre.co.uk/about-jorvik/; http://www.history.
 org/Foundation/cwhistory.cfm [accessed 12 Dec. 2013].
98 See http://www.english-heritage.org.uk/support-us/members/magazine/
 oct–2013/new-beginnings-stonehenge/ [accessed 16 Dec. 2013].
99 See http://www.nps.gov/vafo/historyculture/welcome-center.htm
 [accessed 16 Dec. 2013].
100 See http://www.english-heritage.org.uk/support-us/members/magazine/
 oct-2013/new-beginnings-stonehenge/ [accessed 16 Dec. 2013].
101 See http://www.telegraph.co.uk/travel/travelnews/10568180/Stonehenge-
 visitors-attack-chaos-at-new–27m-centre.html. [accessed Feb. 2014]
102 Sorensen Theme parks and time machines; Parker Pearson, M., Visitors
 welcome, in J. Hunter and I. Ralston (eds) *Archaeological Resource
 Management in the UK: An Introduction* (Stroud: Sutton Publishing, 2001).
103 Glassberg, D., Review: Loving in the Past, *American Quarterly*, 38(2)
 (1986): 305–10; Robertshaw, Live interpretation.
104 Prospects website. Available at: http://www.prospects.ac.uk/museum_
 gallery_curator_entry_requirements.htm [accessed 12 Oct. 2013].
105 Prospects website. Available at: http://www.prospects.ac.uk/archivist_
 entry_requirements.htm [accessed 22 Oct. 2013].

3 Methods of Communication in Public History

1 Vygotsky, L. *Thought and Language* (Cambridge, MA: MIT Press, 1962).
2 Wallace, J, *Digging the Dirt: The Archaeological Imagination* (London:
 Gerald Duckworth & Co. Ltd, 2004), p.15; Vygotsky, *Thought and
 Language*.
3 Samuel, R., *Theatres of Memory: Past and Present in Contemporary Culture*
 (London: Verso, 2012).
4 Gardner, J., Trust, risk and public history: a view from the United States,
 Public History Review, 17 (2010): 53.
5 Gardner, Trust, risk and public history, p. 53; Wilton, J., Museums and
 memories: remembering the past in local community museums, *Public
 History Review*, 12(58) (2006): 224.
6 MacDonald, S., *A Companion to Museum Studies* (London: Blackwell
 Publishing, 2009); Samuel, *Theatres of Memory*.

7 Belcher, M., *Exhibitions in Museums* (Leicester: Leicester University Press, 1991).

8 Herreman, Y., Display, exhibits and exhibitions, in P. Boylan (ed.) *Running a Museum: A Practical Handbook* (Paris: International Council of Museums, 2004); Belcher, *Exhibitions in Museums*.

9 Belcher, *Exhibitions in Museums*.

10 Bennett, T., *The Birth of the Museum: History, Theory, Politics* (London: Routledge, 1995).

11 Kargar, M-R., Foreword, in J. Curtis and N. Tallis (eds) *Forgotten Empire: The World of Ancient Persia* (Berkeley, CA: University of California Press, 2005), pp. 7–8.

12 Bradburne, J., A new strategic approach to the museum and its relationship to society, *Journal of Museum Management and Curatorship*, 19 (2001): 75–85.

13 Herreman, Display, exhibits and exhibitions.

14 Bradburne, A new strategic approach.

15 See http://www.fraserrandall.co.uk/projects/touring/iwm_their_past.html [accessed 10 Aug. 2013].

16 Bradburne, A new strategic approach.

17 British Museum, Life and death in Pompeii, *British Museum Magazine* (2013).

18 Bradburne, A new strategic approach, p. 77.

19 British Museum, Life and death in Pompeii.

20 See http://www.bbc.co.uk/news/entertainment-arts-23050586 [accessed 5 July 2014].

21 Parker Pearson, M., Visitors welcome, in J. Hunter and I. Ralston (eds) *Archaeological Resource Management in the UK: An Introduction* (Stroud: Sutton Publishing, 2001).

22 Bennett, *Birth of the Museum*, p. 529.

23 Bolton, L., The object in view: Aborigines, Melanesians and museums, in L. Peers and A.K. Brown (eds) *Museums and Source Communities* (London: Routledge, 2003).

24 Bennett, *Birth of the Museum*, p. 536.

25 Bolton, The object in view.

26 Herreman, Display, exhibits and exhibitions, p. 94.

27 Bennett, *Birth of the Museum*, p. 526.

28 Bradbourne (2001).

29 Jones, A., Integrating school visits, tourists and the community at the Archaeological Resource Centre, York, UK, in E. Hooper Greenhill (ed.) *Museum, Media, Message* (Leicester: Leicester University Press, 1995).

30 Ascherson, N., Why "heritage" is right-wing, *Observer*, November 8, 1987.

31 Robertshaw, A., Live interpretation, in A. Hems and M. Blockley (eds) *Heritage Interpretation* (London: Routledge, 2006).

32 Sorensen, C., Theme parks and time machines, in P. Vergo (ed.) *The New Museology* (London: Reaktion Books, 2007).

33 Robertshaw, Live interpretation.

34 See http://www.history.org/Almanack/places/index.cfm [accessed 10 Dec. 2013].

35 See www.history.org/history.index [accessed 10 Dec. 2013].

36 See http://research.history.org/Archaeological_Research.cfm [accessed 4 April 2014].

37 Jameson, J., Public archaeology in the United States, in N. Merriman (ed.) *Public Archaeology* (London: Routledge, 2004), pp. 21–58.

38 Hooper Greenhill, E., *Museums and Shaping Knowledge* (London: Routledge, 1992); Hooper Greenhill, E., *Inspiration, Identity, Learning: The Value of Museums: The Evaluation of the Impact of DfES Strategic Commissioning 2003–2004*, National/Regional Museums Education Partnerships (2004). Available at: http://www2.le.ac.uk/departments/museumstudies/rcmg/projects/inspiration-identity-learning-1/DCMS%20Final%20Report%20Part%201.pdf [accessed 5 Sept. 2013].

39 Stone, P., Introduction: education and the historic environment into the twenty-first century, in D. Henson, P. Stone, and M. Corbishley (eds) *Education and the Historic Environment* (London: Routledge, 2004), pp. 1–12; Hooper Greenhill, *Inspiration, Identity, Learning*.

40 Samuel, *Theatres of Memory*; Sorensen, Theme parks and time machines.

41 Ascherson, Why "heritage" is right-wing; Samuel, *Theatres of Memory*.

42 Ascherson, Why "heritage" is right-wing.

43 Ascherson, Why "heritage" is right-wing.

44 Kavanagh, *Making Histories*; Samuel, *Theatres of Memory*.

45 Ashby, J., Beyond teaching: out of hours at the Grant Museum, *University Museums and Collections Journal*, 2 (2009): 43–6.

46 See http://www.nhm.ac.uk/visit-us/galleries/green-zone/treasures/index.html [accessed 10 Dec. 2013].

47 Cohen, D., The future of preserving the past, in H. Kean and P. Martin (eds.) *The Public History Reader* (London: Routledge, 2013), p. 218; Hogsden, C. and Poulter, E., The other real? Museum objects in digital contact networks, *Journal of Material Culture*, 17 (2012): 265–86.

48 See http://www.jerseywartunnels.com/visit/ [accessed 2 Dec. 2013].

49 See http://www.jerseywartunnels.com [accessed 10 Aug. 2013].

50 Cohen, Future of preserving the past; Hogsden and Poulter, The other real?

51 Masse, A. and Masse, W., Online collaboration and knowledge dissemination for university collections, *University Museums and Collections Journal*, 3 (2010): 91–6.

52 Masse and Masse, Online collaboration.

53 See http://naturalhistory.si.edu/panoramas/ [accessed May 5, 2014].

54 Cohen, Future of preserving the past, p. 218.

55 Cohen, Future of preserving the past, p. 216.

56 Cohen, Future of preserving the past, p. 217; Kazin, M., 12/12 and 9/11: tales of power and tales of experience in contemporary history, *History News Network*, September 11, 2013. Available at: http://hnn.us/articles /1675.html [accessed 10 Dec. 2013].

57 Swain, H., *An Introduction to Museum Archaeology* (Cambridge: Cambridge University Press, 2007).

58 See www.museumoflondon.org.uk/collections-research/laarc/ [accessed 10 Dec.2013].

59 Jones, A., Using objects: The York Archaeological Trust approach, in D. Henson, P. Stone, and M. Corbishley (eds), *Education and the Historic Environment* (London: Routledge, 2004), pp. 173–84.

60 Laurence, R., *Roman Archaeology for Historians* (London: Routledge, 2012), p. 141.

61 Simpson, F. and Williams, H., Evaluating community archaeology in the UK, *Public Archaeology*, 7(2) (2008): 69–90.

62 Merriman, N., *Beyond the Glass Case: The Past, the Heritage and the Public in Britain* (Leicester: Leicester University Press, 1991); Belcher, M., *Exhibitions in Museums* (Leicester: Leicester University Press, 1991).

63 Woollard, V., Caring for the visitor, in P. Boylan (ed.) *Running a Museum: A Practical Handbook* (Paris: International Council of Museums, 2004).

64 Woollard, Caring for the visitor.

65 Merriman, *Beyond the Glass Case*.

66 Newman, W.L., *Social Research Methods: Qualitative and Quantitative Approach* (Boston: Allyn and Bacon, 1995), p. 321.

67 Hooper Greenhill, *Inspiration, Identity, Learning*.

68 Hooper Greenhill, *Inspiration, Identity, Learning*.

69 McClanahon, A., Histories, identity, and ownership: an ethnographic case study in archaeological heritage management in the Orkney Islands, in M. Edgeworth (ed.) *Ethnographies of Archaeological Practice: Cultural Encounters, Material Transformations* (Lanham, MD: Altamira Press, 2006), p. 127.

70 Emerson, R., Fretzm, R. and Shaw, L., *Writing Ethnographic Fieldnotes* (Chicago: The University of Chicago Press, 1995), p. 143; Bryon, A., *Social Research Methods* (Oxford: Oxford University Press, 2010).

71 Bryon, *Social Research Methods*.

72 Falk, J. and Dierking, L., *Museums Experience Revisited* (Florida: Left Coast Press, 1992).

73 Falk and Dierking, *Museums Experience Revisited*; see www.inspiringlearningforall.gov.uk/toolstemplates/genericlearning/ [accessed 22 Dec. 2013].

74 Thomson, L., Ander, E., Menon, U., Lanceley, A., and Chatterjee, H., Evaluating the therapeutic effects of museum objects with hospital patients: a review and initial trial of wellbeing measures, *Journal of Applied Arts and Health*, 2(1) (2011): 37–56.

75 Thompson, S., Aked, A., McKenzie, B., Wood. C., Davies, M., and Butler, T. (2011) *The Happy Museum: A Tale of How It Could Turn Out All Right*. Available at: http://www.happymuseumproject.org/wp-content/uploads/2011/03/The_Happy_Museum_report_web.pdf [accessed 2 Dec. 2013].

4 Teaching History

1 Bates, J., Introduction, in J. Bates (ed.) *The Public Value of the Humanities* (London: Bloomsbury Academic, 2012), pp. 1–14; Jordanova, L., *History in Practice* (London: Bloomsbury Academic, 2010).

2 Booth, A. and Booth, J., Passion, purpose and value, in L. Lavender (ed.), *History Graduates with Impact* (Higher Education Academy, 2011), pp. 9–25; Nicholls, D., The employment of history graduates, in L. Lavender (ed.) *History Graduates with Impact* (The Higher Education Academy, 2010), pp. 49–58; Moussouri, T. (2002), A context for the development of learning outcomes in museums, libraries and archives. Available at: http://www2.le.ac.uk/departments/museumstudies/rcmg/projects/lirp-1-2/LIRP%20analysis%20paper%202.pdf [accessed 5 Oct. 2013]; Hooper Greenhill, E., *Inspiration, Identity, Learning: The Value of Museums: The Evaluation of the Impact of DfES Strategic Commissioning 2003–2004*, National/Regional Museums Education Partnerships (2004). Available at: http://www2.le.ac.uk/departments/museumstudies/rcmg/projects/inspiration-identity-learning-1/DCMS%20Final%20Report%20Part%201.pdf [accessed 5 Sept. 2013].

3 Hooper Greenhill, *Inspiration, Identity, Learning*.

4 Whitaker, P., *Managing to Learn* (London: Cassell, 1995), p. 7.

5 Stone, P., Introduction: education and the historic environment into the twenty-first century, in D. Henson, P. Stone, and M. Corbishley (eds) *Education and the Historic Environment* (London: Routledge, 2004), p. 8; Holtorf, C., *Archaeology is a Brand! The Meaning of Archaeology in Contemporary Popular Culture* (Oxford: Archaeopress, 2006).

6 Stone, Introduction, p. 7.
7 Henry, P., The Young Archaeologists' Club: its role within informal learning, in D. Henson, P. Stone, and M. Corbishley (eds) *Education and the Historic Environment* (London: Routledge, 2004), p. 99.
8 Moussouri, T. (2002) A context for the development of learning outcomes in museums, libraries and archives. Available at: http://www2.le.ac.uk/departments/museumstudies/rcmg/projects/lirp-1-2/LIRP%20analysis%20paper%202.pdf [accessed 5 Oct. 2013], p. 4; Kolb, D.A., *The Learning Style Inventory: Technical Manual* (Boston: McBer, 1976).
9 Watson, J.B., *Behaviorism* (Chicago: University of Chicago Press, 1930).
10 Pavlov, I.P., *The Work of the Digestive Glands* (London: Griffin, 1897).
11 Skinner, B.F., *Beyond Freedom and Dignity* (New York: Knopf, 1971).
12 Piaget, J., *The Origins of Intelligence in the Child* (London: Routledge and Kegan Paul, 1936).
13 Piaget, *Origins of Intelligence.*
14 Bloom, B., *Taxonomy of Educational Objects: The Classification of Educational Goals*, Handbook I: *Cognitive Domain* (New York: McKay, 1956).
15 Bruner, J., *The Culture of Education* (Cambridge, MA: Harvard University Press, 1966).
16 Wenger, E., *Communities of Practice: Learning, Meaning, and Identity* (Cambridge: Cambridge University Press, 1998).
17 Bruner, *Culture of Education.*
18 Kohl, H., *Growing Minds: On Becoming a History Teacher* (New York: Harper and Row, 1989).
19 Race, P., *The Lecturer's Toolkit: A Practical Guide to Assessment, Learning and Teaching* (London: Routledge, 2006).
20 Race, *The Lecturer's Toolkit.*
21 Rogers, C.R., *Freedom to Learn* (Columbus, OH: Merrill, 1969).
22 Kohl, *Growing Minds.*
23 See http://www.museumoflondon.org.uk/schools/classroom-homework-resources/sen-resources/ [accessed 10 Nov. 2013].
24 Americans with Disabilities Act (1990). Available at: http://www.ada.gov/pubs/adastatute08.htm [accessed 12 Dec. 2013]; Disability Discrimination Act (2005). Available at: http://www.legislation.gov.uk/ukpga/2005/13/pdfs/ukpga_20050013_en.pdf [accessed 12 Dec. 2013].
25 Hooper Greenhill, E., *Museums and Education: Purpose, Pedagogy, Performance* (London: Routledge, 2007).
26 Sternberg, R.J., Concept of intelligence and its role in lifelong learning and success, *American Psychologist*, 52(10) (1997): 1030–7.
27 Moussouri, Context, p. 6.
28 Moussouri, Context, p. 7.

29 Gibbs, K., Sani, M. and Thompson, J. (2007), *Lifelong Learning in Museums: A European Handbook*. Available at; http://www.ne-mo.org/fileadmin/ Dateien/public/service/Handbook-en.pdf [accessed 10 Dec. 2013], p. 14

30 Moussouri, Context; Hooper Greenhill, *Inspiration, Identity, Learning*.

31 See http://www.inspiringlearningforall.gov.uk [accessed 10 Dec.2013].

32 Hooper Greenhill, *Inspiration, Identity, Learning*.

33 James, A. and Boyd, N., *Fact Sheet: Understanding Audiences: Skills Development and Mentoring Programme for Museums* (London: Museum of London, 2007).

34 www.inspiringlearing.gov.uk [accessed 10 Dec. 2013].

35 Hooper Greenhill, *Inspiration, Identity, Learning*; Bloom, *Taxonomy*.

36 See http://www.smithsonianeducation.org/educators/lesson_plans/lincoln/ smithsonian_siyc_spring09.pdf; http://www.microsoft.com/education/ en-us/teachers/plans/Pages/legislative_bill.aspx[accessed 10 July 2014].

37 See http://www.boneswithoutbarriers.org [accessed 23 July 2014].

38 Moussouri, Context, p. 42.

39 Jordanova, L., *History in Practice* (London: Bloomsbury Academic, 2010); De Groot, J., *Consuming History: Historians and Heritage in Contemporary Culture* (London: Routledge, 2009).

40 Nicholls, Employment of history graduates; Archer, W. and Davison, J., *Graduate Employability: What Do Employers Think and Want?* (London: The Council for Industry and Higher Education, 2010); Booth and Booth, Passion, purpose and value.

41 Booth and Booth, Passion, purpose and value.

42 Archer and Davison, *Graduate Employability*; Booth and Booth, Passion, purpose and value.

43 Orrill, R. and Shapiro, L., From bold beginnings to an uncertain future: the discipline of history and history education, *The American History Review*, 110(3) (2005): 728.

44 Orrill and Shapiro, Bold beginnings.

45 Orrill and Shapiro, Bold beginnings, p. 731; Wallace, M., Integrating United States and world history in the high school curriculum: the trials and tribulations of a good idea, *The History Teacher*, 33(4) (2000).

46 Orrill and Shapiro, Bold beginnings, p. 731.

47 Yarema, A., A decade of debate: improving content and interest in history education, *The History Teacher*, 35(3) (2002): 389–98.

48 Orrill and Shapiro, Bold beginnings.

49 Skolnik, M.L., Diversity in higher education: a Canadian case, *Higher Education in Europe*, 11 (1986): 19–32.

50 Hawkey, K. and Prior, J., History, memory cultures and meaning in the classroom, *Journal of Curriculum Studies*, 43(2) (2010): 231–47.

51 Hawkey and Prior, History, memory cultures, p. 231.

52 Shackel, P. A., Public memory and the search for power in American historical archaeology, in L.J. Smith (ed.) *Cultural Heritage*, Vol. II (London: Routledge, 2007), p. 307.

53 Swansinger, J., Preparing student teachers for a world history curriculum in New York, *The History Teacher*, 43(1) (2009): 95–6.

54 Jeppson, P.L., Doing our homework: rethinking the goals and responsibilities of archaeology outreach to schools, in J. Stottman (ed.) *Changing the World with Archaeology: Activist Archaeology* (Greenville, FL: University of Florida Press, 2008), p. 28.

55 Metcalf, F., Myths, lies, and videotapes: information as antidote to social studies classrooms and pop culture, in B.J. Little (ed.) *Public Benefits of Archaeology* (Gainesville, FL: University Press of Florida, 2002), p. 170.

56 Simpson, F., *The Values of Community Archaeology: A Comparative Assessment between the UK and USA*, British Archaeological Reports (Oxford: Oxbow, 2010).

57 Loewenberg Ball, D. and McDiarmid. G., *The Subject Matter Preparation of Teachers* (Michigan: National Center for Research on Teacher Education. 1989).

58 Swansinger, Preparing student teachers, p. 94.

59 Dewey, J., *Experience and Education* (New York: Simon & Schuster Touchstone, 1997); Piaget, P.H., *Museums in Australia: Report of the Committee of Inquiry on Museums and National Collections* (Canberra: Australian Government Publishing Service, 1975); Lewin, K., *Resolving Social Conflicts; Selected Papers on Group Dynamics* (New York: Harper & Row, 1948); Kohl, *Growing Minds*.

60 Vygotsky, *Mind and Society*.

61 Bruner, *Culture of Education*.

62 Kohl, *Growing Minds*; Honey, P. and Mumford, A., *The Learning Styles Questionnaire, 80-Item Version* (Maidenhead: Peter Honey Publications, 2006).

63 Yarema, A., A decade of debate: improving content and interest in history education, *The History Teacher*, 35(3) (2002): 389–98; Seixas, P., Beyond "content" and "pedagogy": in search of a way to talk about history education, *Journal of Curriculum Studies*, 31(3) (2010): 317–37.

64 Yarema, Decade of debate, p. 299.

65 The Bradley Commission in Schools, *Building a History Curriculum: Guidelines for Teaching History in Schools* (Washington, DC: Educational Excellence Network, 1988); Swansinger, Preparing student teachers, p. 90.

66 Counsell, C., Disciplinary knowledge for all, the secondary history curriculum and history teachers' achievement, *The Curriculum Journal*, 22(2) (2011): 201–25; Wallace, Integrating.

67 Swansinger, Preparing student teachers; Loewenberg Ball and McDiarmid, *Subject Matter Preparation*, p. 5.

68 Loewenberg Ball and McDiarmid, *Subject Matter Preparation*.
69 Counsell, Disciplinary knowledge for all.
70 Yarema, Decade of debate.
71 Counsell, Disciplinary knowledge for all.
72 Skolnik, Diversity in higher education, p. 391.
73 Counsell, Disciplinary knowledge for all, p. 204; Wallace, Integrating, p. 491.
74 Smith, N., *History Teacher's Handbook* (London: Continuum, 2010).
75 Rogers, C.R. (1969) *Freedom to Learn* (Columbus, OH: Merrill).
76 Lave, J. and Wenger, E., *Situated Learning: Legitimate Peripheral Participation* (Cambridge: Cambridge University Press, 1990).
77 Yarema, Decade of debate.
78 Yarema, Decade of debate, p. 392.
79 Hawkey, K. and Prior, J., History, memory cultures and meaning in the classroom, *Journal of Curriculum Studies*, 43(2) (2010): 231, 244.
80 Hawkey and Prior, History, memory cultures, p. 231; Rosenzweig, R. and Thelen, D., *The Presence of the Past* (New York: Columbia University Press, 2000).
81 See http://www.brightoncollege.org.uk/prep-school/curriculum/history/ [accessed 2 Aug. 2013].
82 Jeppson, P.L. and Brauer, G., "Hey, did you hear about the teacher who took the class out to dig a Site?": Some common misconceptions about archaeology in schools, in L. Derry and M. Malloy (eds) *Archaeologists and Local Communities: Partners in Exploring the Past* (Washington, DC: Society for American Archaeology Press, 2003), p. 79.
83 Jeppson , P. L. (2012) 'Public Archaeology and the U.S. Culture Wars; in R. Skeates et.al (eds) *The Oxford Handbook of Public Archaeology*. (Oxford: Oxford University Press).
84 Jeppson and Brauer, Common misconceptions.
85 MacDonald, S., *A Companion to Museum Studies* (Oxford: Blackwell, 2009); Falk, J. and Dierking, L., *Museums Experience Revisited* (Florida: Left Coast Press, 1992).
86 See www.inspiringlearningforall.org [accessed 10 June 2014].
87 Gibbs, K., Sani, M., and Thompson, J. (2007) *Lifelong Learning in Museums: A European Handbook*. Available at: http://www.ne-mo.org/fileadmin/Dateien/public/service/Handbook-en.pdf [accessed 10 Dec. 2013].
88 Aston, M., Publicizing archaeology in Britain in the late twentieth century: a personal view, in R. Skeates et al. (eds) *The Oxford Handbook of Public Archaeology* (Oxford: Oxford University Press, 2012).
89 Gibbs, Sani and Thompson, *Lifelong Learning*, pp. 71–2.
90 Gibbs, Sani, and Thompson, *Lifelong Learning*, pp. 71–2.
91 http://www.nma.gov.au/education-kids [accessed 5 June 2014].
92 http://www.nma.gov.au/education-kids [accessed 5 June 2014].

93 http://www.nma.gov.au/education-kids [accessed 5 June 2014].

94 http://www.nba.fi/en/File/985/ole-winther-emac.pdf [accessed 5 June 2014].

95 http://www.chicagohistory.org/education/resources/index/#hands [accessed 7 June 2014].

96 http://www.chicagohistory.org/static_media/pdf/historyhands/chm-backtothefuture.pdf [accessed 7 June 2014].

97 Hooper Greenhill, *Inspiration, Identity, Learning*.

98 Hooper Greenhill, *Inspiration, Identity, Learning*, p. 47.

99 See www.finds.org.uk [accessed 8 Sept. 2013].

100 See www.bbc/historyforkids [accessed 8 Sept. 2013].

101 See www.mysticseaport.org [accessed 12 Sept. 2013].

102 See http://www.mysticseaport.org/learn/educators/ship-to-shore/ [accessed 12 Sept. 2013].

103 See http://www.mysticseaport.org/learn/educators [accessed 12 Sept. 2013].

104 See http://www.museumofvancouver.ca/family-education/educators/ night-mummy [accessed 10 Dec. 2013].

105 Cressey, P.J., Reeder, R., and Bryson, J., Held in trust: community archaeology in Alexandria, Virginia, in L. Derry and M. Malloy (eds) *Archaeologists and Local Communities: Partners in Exploring the Past* (Washington, DC: Society for American Archaeology, 2003); Potter, P.B., *Public Archaeology in Annapolis: A Critical Approach to Maryland's Ancient City* (Washington, DC: Smithsonian Institute Press, 1994).

106 Cressey et al., Held in trust.

107 Shackel, Public memory, p. 325.

108 Hensley, J., Museums and teaching history, *Teaching History: A Journal of Methods*, 13(2) (1988): 67–75.

109 Orrill and Shapiro, Bold beginnings, p. 732.

110 See http://oaeast.thehumanjourney.net/outreach/jigsaw [accessed 10 Oct. 2013].

111 See http://oaeast.thehumanjourney.net/outreach/jigsaw [accessed 10 Oct. 2013].

112 See http://www.chatsworth.org/schools/activities/house-activities [accessed 7 June 2014].

113 See http://www.chatsworth.org/schools/activities/house-activities

114 Bartoy, K., Teaching through rather than about, in R. Skeates, C. McDavid, and J. Carman (eds), *The Oxford Handbook of Public Archaeology* (Oxford: Oxford University Press, 2012), p. 559.

115 Bartoy, Teaching through rather than about, p. 560.

116 Jameson, J., Purveyors of the past: education and outreach as ethical imperatives in archaeology, in L.J. Zimmerman, K.D. Viteli, and J. Hollowell-Zimmer (eds) *Ethical Issues in Archaeology* (Oxford: Altamira Press, 2003), p. 156.

117 Bates, J., Introduction, in J. Bates (ed.) *The Public Value of the Humanities* (London: Bloomsbury Academic, 2012), pp. 1–14.

118 Bates, Introduction.

119 Post 1992 universities in the UK were polytechnics or higher educational colleges that were, through the 1992 Further and Higher Education Act, given university status. Prior to this, these organizations focused on training students through skill-based learning for future employment.

120 Booth, A., Developing history students' skills in the transition to university, *Teaching Higher Education*, 6(4) (2010): 487–503.

121 Booth, Developing, p. 490.

122 Stowe, N., Public history curriculum: illustrating reflective practice, *The Public Historian*, 28(1) (2006): 65.

123 Lewin, K., *Resolving Social Conflicts; Selected Papers on Group Dynamics* (New York: Harper & Row, 1948).

124 Smallbone, T. and Witney, D., Wiki work: can using wikis enhance student collaboration for group assignment tasks? *Innovations in Education and Teaching International*, 48(1) (2011):111; Booth, Developing.

125 See http://ncph.org/cms/education/graduate-and-undergraduate/guide-to-public-history-programs/ [accessed 12 Jan. 2014].

126 Stowe, N., Public history curriculum: illustrating reflective practice, *The Public Historian*, 28(1) (2006): 39–65.

127 Stowe, Public history curriculum, p. 39.

128 See http://www.heacademy.ac.uk/aimhigher [accessed 10 Dec. 2013].

129 Aston, Publicizing archaeology in Britain, p. 445

130 http://www.conted.ox.ac.uk/courses/index.php [accessed 10 Oct. 2013].

131 http://www.conted.ox.ac.uk/courses/index.php [accessed 10 Oct. 2013].

132 http://www.archaeologyuk.org/education/ehe [accessed 10 Oct. 2013].

133 Samuel, *Theatres of Memory*.

134 Gorman, J., Historians and their duties, *History and Theory*, 43(4), Theme Issue 43. *Historians and Ethics* (2004): 103–17.

135 Gorman, Historians and their duties.

136 See http://beyondacademe.com/faqs-history-jobs.html [accessed 6 June 2014].

5 Community History

1 Bates, J., Introduction, in J. Bates (ed.) *The Public Value of the Humanities* (London: Bloomsbury Academic, 2012), pp. 1–14.

2 De Groot, J., *Consuming History: Historians and Heritage in Contemporary Culture* (London: Routledge, 2009).

3 Cohen, A., *The Symbolic Construction of Community* (London: Routledge, 1985); Hoggett, P., *Contested Communities: Experiences, Struggles, Policies* (Bristol: Policy Press. 1979),

4 Cohen, *Symbolic Construction*, p. 5.

5 Hoggett, *Contested Communities*, p. 13.

6 Carman, J., Towards an international comparative history of archaeological heritage management, in R. Skeates, C. McDavid, and J. Carman (eds) *The Oxford Handbook of Public Archaeology* (Oxford: Oxford University Press, 2012), pp. 13–35.

7 See http://www.balh.co.uk/index.html [accessed 2 Dec. 2013].

8 Robertson, I., Heritage from below: class, social protest and resistance, in H. Kean and P. Martin (eds) *The Public History Reader* (London: Routledge, 2013), pp. 56–67; Sharpe, J., History from below, in P. Burke (ed.) *New Perspectives on Historical Writing* (London: Polity Press, 2001).

9 Robertson, Heritage from below; Martin, P., Introduction: the past in the present: who is making history? in H. Kean and P. Martin (eds) *The Public History Reader* (London: Routledge, 2013), p. 2.

10 Robertson, Heritage from below.

11 Merriman, N. and Poovaya-Smith, N., Making culturally diverse histories, in G. Kavanagh (ed.) *Making Histories in Museums* (Leicester: Leicester University Press, 1996), pp. 176–87.

12 Thompson, E.P., *The Making of the English Working Class.* (Harmondsworth: Penguin, 1963).

13 Eley, G., Marxist historiography, in S. Berger, H. Feldner, and K. Passmore (eds) *Writing History: Theory and Practice* (London: Hodder, 2003).

14 Eley, Marxist historiography, p. 63.

15 Sitzia, L., Telling people's histories: an exploration of community history making from 1970–2000. Unpublished PhD thesis, University of Sussex. Available at: http://sro.sussex.ac.uk/2488/1/Sitzia%2C_Lorraine.pdf [accessed 12 June 2014].

16 Davison, G., Use and abuse of Australian history, in H. Kean and P. Martin (eds) *The Public History Reader* (London: Routledge, 2013), pp. 68–82, Martin, Introduction, p. 3.

17 Davison, Use and abuse, p. 68.

18 Davison, Use and abuse, p. 69.

19 Twells, A. (2008) *Community History*. Institute of Historical Research. Available at: http://www.history.ac.uk/makinghistory/resources/articles/community_history.html [accessed 5 July 2013]; Thompson, *English Working Class*.

20 Start, D., Community archaeology; bringing it back to local communities, in G. Chitty and D. Baker (eds) *Managing Historic Sites and Buildings:*

Reconciling Presentation and Preservation (London: Routledge, 1999), pp. 49–59.

21 Parker Pearson, M., Visitors welcome, in J. Hunter and I. Ralston (eds) *Archaeological Resource Management in the UK: An Introduction* (Stroud: Sutton Publishing, 2001), pp. 225–31.

22 Thurley, S., *Men from the Ministry: How Britain Saved Its Heritage* (New Haven, CT: Yale University Press, 2013).

23 Thurley, *Men from the Ministry*; Lock, G., Rolling back the years: lifelong learning and archaeology in the United Kingdom, in M. Corbishley, D. Henson and P. Stone (eds) *Education and the Historic Environment* (London: Routledge, 2004), p. 56.

24 Bates, Introduction.

25 Twells, *Community History*.

26 See http://www.albertdock.com/history/regenerating-albert-dock/ [accessed 1 Jan. 2014].

27 See http://www.albertdock.com/history/regenerating-albert-dock/ [accessed 1 Jan. 2014].

28 See http://www.albertdock.com/history/regenerating-albert-dock/

29 Simpson, F., Birley Fields: exploring Victorian streetscapes in Manchester, *Current Archaeology*, 282 (2013): 28–33.

30 Watson, S., *Museums and their Communities* (New York: Routledge, 2007).

31 Jeppson, P.L. and Brauer, G., "Hey, did you hear about the teacher who took the class out to dig a site?": Some common misconceptions about archaeology in schools, in L. Derry and M. Malloy (eds) *Archaeologists and Local Communities: Partners in Exploring the Past* (Washington, DC: Society for American Archaeology Press, 2003), pp. 77–96.

32 Taksa, L., Hauling an infinite freight of mental imagery: finding labour's heritage at the Swindon Railway Workshops 'STEAM Museum', *Labour History Review*, 68 (2003): 394, 404.

33 Martin, Introduction, p. 3.

34 Volkert, J., Martin, L.R., and Pickworth, A., *National Museum of the American Indian: Smithsonian Institute, Washington, DC: Map and Guide* (Washington, DC: Scala Publishers, 2004).

35 Martin, Introduction, p. 6.

36 Martin, Introduction, pp. 7–8.

37 Jeppson (2012).

38 Jordanova, L., *History in Practice* (London: Bloomsbury Academic, 2010); Twells, *Community History*.

39 See www.muncyhistoricalsociety.org/dig /index.html

40 See www.muncyhistoricalsociety.org/dig /index.html

41 Butler, T., 'Memoryscape': integrating oral history, memory and landscape on the River Thames, in P. Ashton and H. Kean (eds) *People and Their*

Pasts: Public History Today (London: Palgrave Macmillan, 2009), pp. 223–39; Ritchie, D., *Doing Oral History: A Practical Guide* (New York: Oxford University Press, 2003).

42 Kier Reeves, E., Sanders, R., and Chisholm, G., Oral histories of a layered landscape: Rushworth oral history, *Public History Review*, 14 (2010): 116.

43 Reeve, J. and Wollard, V., *The Responsive Museum: Working with Audiences in the 21st Century* (Aldershot: Ashgate, 2007); Ritchie, D., *Doing Oral History*.

44 Reeve and Wollard, *The Responsive Museum*.

45 Liddington, J. and Smith, G., Crossing cultures: oral history and public history, *Oral History*, 33(1) (2005): 28–31.

46 See http://overcomingapartheid.msu.edu/index.php [accessed 5 Sept. 2013].

47 See http://wpsu.org/backfromiraq/ [accessed 5 Sept. 2013].

48 Reeve and Wollard, *The Responsive Museum*, p. 120.

49 See http://www.ohs.org.uk/ethics/ [accessed 9 Oct. 2013].

50 See http://ohda.matrix.msu.edu [accessed 12 Jan. 2014].

51 Bryon, A., *Social Research Methods* (Oxford: Oxford University Press, 2010).

52 See http://www.ohs.org.uk/advice/index.php [accessed 12 Dec. 2013].

53 Wilson, V., *Rich in All but Money: Life in Hungate 1900–1938* (York: York Archaeological Trust, 2007), Oral History Series 1.

54 English Heritage, *Understanding Historic Buildings: A Guide to Good Recording Practice* (London: English Heritage, 2006).

55 English Heritage, *Understanding Historic Buildings*.

56 See http://www.english-heritage.org.uk/caring/heritage-at-risk/ [accessed 10 Dec. 2013].

57 Eddisford, D. and Morgan, C., An archaeology of the contemporary: a standing buildings survey of "The Chicken Shed" at Çatalhöyük, in S. Farid (ed.) *Çatalhöyük 2011 Archive Report* (Çatalhöyük Research Project, 2011), pp. 137–49.

58 Eddisford and Morgan, The Chicken Shed, p. 137.

59 English Heritage, *Heritage Counts: The State of England's Historic Environment* (London: English Heritage, 2006).

60 See http://wearewhatwedo.org/portfolio/historypin/ [accessed 10 Oct. 2013].

61 See http://wearewhatwedo.org/portfolio/historypin/ [accessed 10 Oct. 2013].

62 See http://www.buildingtrustinternational.org/ [accessed 3 Nov. 2013].

63 Lowenthal, D., *The Heritage Crusade and the Spoils of History* (Cambridge: Cambridge University Press, 1989).

64 Parker Pearson, M., The value of archaeological research, in J. Bates (ed.) *The Public Value of the Humanities* (London: Bloomsbury Academic, 2012), pp. 30–43.

65 Bates, Introduction.

66 Holtorf, C., *From Stonehenge to Las Vegas: Archaeology as Popular Culture* (Oxford: Altamira Press, 2005); Samuel, *Theatres of Memory*.

67 Bartoy, K., Teaching through rather than about, in R. Skeates, C. McDavid, and J. Carman (eds) *The Oxford Handbook of Public Archaeology* (Oxford: Oxford University Press, 2012), p. 559.

68 Samuel, *Theatres of Memory*.

69 Potter, P.B., *Public Archaeology in Annapolis: A Critical Approach to Maryland's Ancient City* (Washington, DC: Smithsonian Institute Press, 1994); Blakey, M., Commentary: past is present: comments on "In the Realm of Politics: Prospects for Participation in African-American and Plantation Archaeology," in C. McDavid and D. Babson (eds) *The Realm of Politics: Prospects for Public Participation in African-American Archaeology* (The Society for Historical Archaeology,1997), pp. 140–5.

70 Moser, S., Glazier, D., Philips, J., El Nemer, L., Mousa, M., Richardson, S., Conner, A., and Seymour, M., Transforming archaeology through practice: strategies for collaborative archaeology and the Community Archaeology Project at Qusier, Egypt, *World Archaeology*, 34(2) (2002): 265–87.

71 Simpson, F., Shoreditch Park community archaeology excavation: a case study, in G. Moshenska and S. Dhanjal (eds) *Archaeology in the Community* (London: Heritage Publications, 2011), pp. 118–22.

72 Simpson, F. and Keily, J., Today's rubbish, tomorrow's archaeology: using nineteenth and twentieth century finds, *The Archaeologist*, 58 (2005): 26–7.

73 Simpson, Shoreditch Park, p. 121.

74 Holtorf, C. and Williams, H., Landscapes and memories, in D. Hicks and M.C. Beaudry (eds) *The Cambridge Companion to Historical Archaeology* (Cambridge: Cambridge University Press, 2006), pp. 235–54.

75 Moshenska, G., Oral history in historical archaeology: excavating sites of memory, *Oral History*, 35(1) (2007): 91–7.

76 Ford, A., *Bellarine Bayside Foreshore: Redevelopment, Cultural Heritage Management Plan* (Geelong: Dig International Pty Ltd, 2009).

77 Potter, *Public Archaeology in Annapolis*.

78 Gerrard, C. and Aston, M., *The Shapwick Project, Somerset: A Rural Landscape Explored* (Leeds: Society for Medieval Archaeology, 2007).

79 Aston, M., Coston, A., Gerrard, C., and Hall, T. (eds), *The Shapwick Project, Volumes 1–8* (Bristol: The University of Bristol Department for Continuing Education, 1997).

80 Moshenska, Oral history.

81 Ford, *Bellarine Bayside Foreshore*, p. 4.

82 Ford, *Bellarine Bayside Foreshore*, p. 4.

83 Aston et al., *The Shapwick Project*.

84 Aston et al., *The Shapwick Project*.

85 See http://muncyhistoricalsociety.org/archaeology-at-muncy [accessed 10 Jan. 2013].

86 See http://muncyhistoricalsociety.org/archaeology-at-muncy [accessed 10 Jan. 2013].

87 See http://www.archaeologyuk.org/community/ [accessed 3 Oct. 2013].

88 Simpson, F. Evaluating the value of community archaeology: the project, *Treball d'Arqueologia*, 15 (2009): 51–62.

89 Simpson, F., *The Values of Community Archaeology: A Comparative Assessment between the UK and USA*, British Archaeological Reports (Oxford: Oxbow, 2010).

90 Simpson, *Values of Community Archaeology*.

91 See http://www.nationaltrust.org.uk/visit/activities/walking/ [accessed 10 Sept. 2013].

92 Cressey, P.J., Reeder, R. and Bryson, J., Held in trust: community archaeology in Alexandria, Virginia, in L. Derry and M. Malloy (eds) *Archaeologists and Local Communities: Partners in Exploring the Past* (Washington, DC: Society for American Archaeology, 2003), pp. 1–18.

93 See http://www.bbc.co.uk/coast/audio-walks/ [accessed 12 Dec. 2013].

94 Kiddey, R and Schofield, J., Embrace the margins: adventures in archaeology and homelessness, *Public Archaeology*, 10(1) (2011): 4–22.

95 Kiddey and Schofield, Embrace the margins.

96 Butler, "Memoryscape."

97 See http://www.familylearningforum.org/engaging-text/writing-for-families/writing-for-families.htm [accessed 12 Oct. 2013].

98 De Groot, *Consuming History*.

99 De Groot, *Consuming History*.

100 See http://www.wickfordhistory.org.uk [accessed 2 Oct. 2013].

101 See http://www.manchesterhistoriesfestival.org.uk [accessed 12 Dec. 2013].

102 Cressey et al., Held in trust; Frisch, M., *A Shared Authority: Essays on the Craft and Meaning of Oral and Public History* (Albany, NY: University of New York Press, 1990).

103 Jordanova, *History in Practice*.

6 Media History

1 Hunt, T., How does television enhance history? in D. Cannadine (ed.) *History and the Media* (New York: Palgrave Macmillan, 2004), pp. 88–102.

2 Hunt, How does television enhance history? p. 88.

3 Downing, T., Bringing in the past to the small screen, in D. Cannadine
 (ed.) *History and the Media* (New York: Palgrave Macmillan, 2004), p. 12.

4 Hunt, How does television enhance history? p. 89.

5 De Groot, J., *Consuming History: Historians and Heritage in Contemporary
 Culture* (London: Routledge, 2009).

6 Jordanova, L., *History in Practice* (London: Bloomsbury Academic, 2010);
 De Groot, *Consuming History*; Rosenstone, R., *Visions of the Past: The
 Challenge of Film to Our Idea of History* (Cambridge, MA: Harvard
 University Press, 1995).

7 De Groot, *Consuming History*, p. 2.

8 De Groot, *Consuming History*, p. 2.

9 See http://www.theguardian.com/media/2005/sep/14/broadcasting.bbc
 [accessed 12 June 2014]; http://www.theguardian.com/media/2005/
 nov/03/overnights [accessed 12 June 2014].

10 See http://www.theguardian.com/artanddesign/artblog/2008/jul/11/
 bonekickersishilariousyoud [accessed 22 July 2014].

11 See http://www.bbc.co.uk/bonekickers/clipit_ep1.shtml [accessed 22 July
 2014].

12 Ascherson, N., Why "heritage" is right-wing, *Observer*, November 8, 1987.

13 Jordanova, *History in Practice*.

14 Gombrich, E., *A Little History of the World* (New Haven, CT: Yale
 University Press, 1936).

15 Gombrich, *A Little History of the World*.

16 See www.historytoday.com [accessed 6 April 2014].

17 See www.historytoday.com [accessed 6 April 2014].

18 See http://www.pressgazette.co.uk/node/47723 [accessed 10 Aug. 2013].

19 Rosenstone, R., *History on Film, Film on History* (Harlow: Pearson, 2012),
 p. 3.

20 Hughes-Warrington, M., *History Goes to the Movies: Studying History on
 Film* (London: Routledge, 2006).

21 White, H., *Tropics of Discourse: Essays in Cultural Criticism* (Baltimore,
 MD: Johns Hopkins University Press, 1978), p. 43.

22 Rosenstone, R., Introduction to experiments in narrative, *Rethinking
 History: The Journal of Theory and Practice*, 5 (2001): 411–16.

23 Schama, S., *A History of Britain* (London: Bodley Head, 2007).

24 De Groot, *Consuming History*, p. 44.

25 De Groot, *Consuming History*, p. 45; Kershaw, I., The Hitler myth. *BBC
 History Magazine*, April 2014.

26 See http://www.historyandpolicy.org/ [accessed 12 April 2014].

27 Steele, J., Doing media history research, *Film and History: An
 Interdisciplinary Journal of Film and Television Studies*, 21(2/3) (1991): 83–7.

28 Steele, Doing media history research.

29 De Groot, *Consuming History*, p. 33.

30 Gregory, P., *The Other Boleyn Girl* (London: HarperCollins, 2007).

31 De Groot, *Consuming History*, p. 33.

32 Blair, T., *A Journey* (London: Arrow, 2011).

33 Hosseini, K., *The Kite Runner* (New York: Riverhead Books, 2003).

34 See http://www.iwm.org.uk/exhibitions/iwm-london/horrible-histories-spies [accessed 12 Oct. 2013].

35 Deary, T., *The Vicious Vikings: Horrible Histories* (Danbury: Scholastic Press, 2007).

36 Schama, *A History of Britain*.

37 Tusa, J., A deep and continuing use of history, in D. Cannadine (ed.), *History and the Media* (New York: Palgrave Macmillan, 2004), pp. 123–40.

38 Tusa, Deep and continuing use of history, p. 134.

39 Bragg, M., The adventure of making *The Adventure of English*, in D. Cannadine (ed.), *History and the Media* (New York: Palgrave Macmillan, 2004), pp. 67–87.

40 Bragg, The adventure.

41 See http://www.bbc.co.uk/programmes/b03gg7nk [accessed 6 June 2014].

42 See http://www.bbc.co.uk/ahistoryoftheworld/ [accessed 12 Oct. 2013].

43 See http://www.bbc.co.uk/programmes/b00sl6dt [accessed 12 Oct. 2013].

44 See http://www.wikihow.com/Write-a-Radio-Play [accessed 8 Aug. 2013]; http://www.bbc.co.uk/worldservice/arts/features/howtowrite/radio.shtml [accessed 10 Oct. 2013].

45 Rosenstone, *History on Film*, p. 2.

46 Windschuttle, K., *The Killing of History: How a Discipline is Being Murdered by Literary Critics and Social Theorists* (Paddington: Macleay Press, 1996).

47 Hughes-Warrington, *History Goes to the Movies*.

48 Warren-Findley, J., History in new worlds: surveys and results in the United States and Australia, *American Studies International*, XLII (2 and 3) (2004).

49 Warren-Findley, History in new worlds.

50 Hughes-Warrington, *History Goes to the Movies*.

51 Jarvie, I., *Philosophy of the Film: Epistemology, Ontology, Aesthetics* (London: Routledge, 1987).

52 Ascherson, Why "heritage" is right-wing.

53 Rosenstone, *History on Film*.

54 Barrett J., *Shooting the Civil War: Cinema, History and American National Identity, National Television and Civil War* (New York: I.B. Tauris, 2009).

55 Rosenstone, *History on Film*, p. 4.

56 Ferro, M., Does a filmic writing of history exist? *Film and History: An Interdisciplinary Journal of Film and Television*, 17(4) (1987): 81–9; Sorlin, P., The night of the shooting stars: fascism, resistance and the liberation of Italy, in R. Rosenstone (ed.), *Revisioning History: Film and the Construction of a New Past* (Princeton, NJ: Princeton University Press, 1995), pp. 77–87.

57 Rosenstone, *History on Film*.

58 Crofts, S., Not a window on the past: how films and television construct history, *Film and History: An Interdisciplinary Journal of Film and Television*, 17(4) (1987): 90–5.

59 Crofts, Not a window.

60 Rosenstone, *History on Film*, p. 6.

61 Sorro, P., Historical films as tools for historians, *History and Film: An International Journal of Film and Media Studies*, 18(1) (1988): 2–15.

62 Rosenstone, *History on Film*, p. 149.

63 Croft, Not a window.

64 Barrett, *Shooting the Civil War*, p. 5; Crofts, Not a window, p. 93

65 Barrett, *Shooting the Civil War*, p. 5.

66 Crofts, Not a window, p. 93

67 Sorlin, Night of the shooting stars, p. 12.

68 Davis, N.Z., *Slaves on Screen: Film and Historical Vision* (Cambridge, MA: Harvard University Press, 2000).

69 Hughes-Warrington, *History Goes to the Movies*, p. 17; Rosenstone *History on Film*, Davis, *Slaves on Screen*.

70 Hughes-Warrington, *History Goes to the Movies*, p. 17.

71 Sorro, Historical films as tools, p. 15.

72 Rosenstone, *History on Film*.

73 O'Connor, J., Special report: the moving-image media in the history classroom, *Film and History: An Interdisciplinary Journal of Film and Television*, 16(3) (1986): 49–54.

74 Barrett, J., *Shooting the Civil War: Cinema, History and American National Identity, National Television and Civil War* (New York: I.B. Tauris, 2009), p. 5.

75 Barrett, *Shooting the Civil War*, p. 5.

76 Clack, T. and Brittain, T., *Archaeology and the Media* (London: University College London, 2007).

77 See http://www.dadsarmy.co.uk/whatisdad'sarmy.html [accessed 10 Sept. 2013].

78 See http://www.bbc.co.uk/archive/churchill/11001.shtml [accessed 6 June 2014].

79 See http://www.theguardian.com/culture/2013/oct/28/how-we-made-world-at-war [accessed 10 Sept. 2013].

80 Piccini, A. and Henson, D., *Survey of Heritage Television Viewing 2005–2006* (London: English Heritage, 2006); De Groot, *Consuming History*.

81 Piccini and Henson, *Survey of Heritage Television Viewing*; Ascherson, Why "heritage" is right-wing; De Groot, *Consuming History*.

82 De Groot, *Consuming History*.

83 Simpson, F., Community archaeology under scrutiny. *Journal of Conservation and Management of Archaeological Sites*, 10(1) (2009): 3–16.

84 Jordon, P., Archaeology and television, in H. Cleere (ed.) *Approaches to Archaeological Heritage.* Cambridge: Cambridge University Press,1984), pp. 207–14; Silberman, N. A., Is archaeology ready for prime time? *Archaeology Magazine* (May/June 1999): 79–82; Clack and Brittain, *Archaeology and the Media*.

85 Samuel, *Theatres of Memory*.

86 De Groot, *Consuming History*.

87 Clark and Britain, *Archaeology and the Media*; Gathercole, P., Stanely, J., and Thomas, N., Archaeology and the media: Cornwall Archaeology Society—Devon Archaeological Society Joint Symposium, *Cornish Archaeology*, 41–2 (2002), 149–60.

88 Lucas, G., Modern disturbances: on the ambiguities of archaeology, *Modernism/Modernity* 11 (2004): 109–20. Available at: http://muse.jhu.edu/journals/modernity/v001/11.lucas.pda [accessed 5 June 2013]; Merriman, N., *Beyond the Glass Case: The Past, the Heritage and the Public in Britain* (Leicester: Leicester University Press, 1991).

89 Clack and Britain, *Archaeology and the Media*.

90 Piccini and Henson, *Survey of Heritage Television Viewing*.

91 De Groot, *Consuming History*, p. 147.

92 De Groot, *Consuming History*, p. 147.

93 Downing, T., Bringing in the past to the small screen, in D. Cannadine (ed.) *History and the Media* (New York: Palgrave Macmillan, 2004), p. 10.

94 Downing, Bringing in the past, p. 10.

95 Downing, Bringing in the past.

96 See http://www.abc.net.au/tv/whosbeensleeping/[accessed 5 July 2014].

97 See http://www.abc.net.au/tv/whosbeensleeping/[accessed 5 July 2014].

98 De Groot, *Consuming History*, p. 184.

99 Downing, Bringing in the past, p. 7.

100 De Groot, *Consuming History*, p. 199.

101 Downing, Bringing in the past, p. 12.

102 Hunt, T., How does television enhance history? in D. Cannadine (ed.) *History and the Media* (New York: Palgrave Macmillan, 2004), p. 88.

103 Hunt, How does television enhance history?; De Groot, *Consuming History*.

104 Downing, Bringing in the past, p. 13.

105 Taylor, T., *Behind the Scenes at Time Team* (London: Channel Four Books, 2000).
106 Clack and Brittain, *Archaeology and the Media*; Gathercole et al., Archaeology and the media.
107 De Groot, *Consuming History*, p. 201.
108 Downing, Bringing in the past.
109 Downing, Bringing in the past, p.18.
110 De Groot, *Consuming History*; Downing, Bringing in the past, p.18.
111 Bates, Introduction.
112 Downing, Bringing in the past.
113 Bates, Introduction; Parker Pearson, Visitors welcome.
114 See http://iamhist.org [accessed 12 Jan. 2014].
115 See www.pastpreservers.com [accessed 12 Jan. 2014].
116 Smethhurst, W., *How to Write for Television* (Oxford: How To Books, 2009).
117 Lees, N., *Developing Factual TV Ideas from Concept to Pitch: The Professional Guide to Pitching Factual Shows* (London: Methuen Drama, 2010), p. 36.
118 Lees, *Developing Factual TV Ideas*.
119 Samuel, *Theatres of Memory*.

7 Policy, Politics, and History

1 Samuel, R., *Theatres of Memory: Past and Present in Contemporary Culture* (London: Verso, 2012; Bates, J., Introduction, in J. Bates (ed.) *The Public Value of the Humanities* (London: Bloomsbury Academic, 2012), pp. 1–14.
2 Fredericksen, C., Caring for history: Tiwi and archaeological narratives of Fort Dundas/Punata, Melville Island, Australia, *World Archaeology*, 34(2) (2002): 288–302; Greer, S., Harrison, R., and McIntyre-Tamwoy, S., Community based archaeology in Australia, *World Archaeology*, 34(2) (2002): 265–87; Meskell. L., *The Nature of Heritage: The New South Africa* (Maldon, MA: Wiley-Blackwell, 2012).
3 Greer et al., Community based archaeology in Australia.
4 Layton, R., *Who Needs the Past? Indigenous Values and Archaeology* (London: Unwin Hyman, 1989).
5 McGimsey, C., *Public Archaeology* (New York: McGraw-Hill, 1972).
6 See www.nps.gov/history/sec/protecting/html/201-neumann.htm [accessed 5 July 2013].
7 See www.nps.gov/history/sec/protecting/html/201-neumann.htm [accessed 3 Dec. 2013].
8 Jeppson, P.L., Doing our homework: rethinking the goals and responsibilities of archaeology outreach to schools, in J. Stottman (ed.)

Changing the World with Archaeology: Activist Archaeology (Greenville, FL: University of Florida Press, 2008), pp. 1–58; Jeppson, P.L. and Brauer, G., "Hey, did you hear about the teacher who took the class out to dig a site?": Some common misconceptions about archaeology in schools, in L. Derry and M. Malloy (eds) *Archaeologists and Local Communities: Partners in Exploring the Past* (Washington, DC: Society for American Archaeology Press, 2003), pp. 231–2.

9 Copper, D., Truthfulness and "inclusion" in archaeology, in C. Scarre and G. Scarre (eds), *The Ethics of Archaeology: Philosophical Perspectives on Archaeological Practice* (Cambridge: Cambridge University Press, 2006), pp. 131–47.

10 The Burra Charter (1999), *The Australian ICOMOS Charter for Places of Cultural Significance; Native American Graves Protection and Repatriation Act* (25 U.S. Code 3001 et seq.), statute text. See http://www.cr.nps.gov/local-law/FHPL_NAGPRA.pdf [accessed 10 Nov. 2013]; Australian Heritage Commission *Ask First: A Guide to Respecting Heritage Places and Values* (Australian Heritage Commission, 2002).

11 Valletta Convention (1992) *European Convention on the Protection of Archaeological Heritage* (revised) Valletta, 16.1.1992, Strasbourg: Council of Europe, 9, ii.

12 Valletta Convention.

13 See http://www.unesco.org/webworld/taskforce21/documents/holmstrom_en.htm [accessed 10 Dec. 2013].

14 See http://whc.unesco.org/en/funding/[accessed 10 Dec. 2013].

15 UNESCO, *World Commission on Culture and Development, Our Creative Diversity* (Paris: UNESCO, 1995).

16 Cleere, H., *Archaeological Heritage Management in the Modern World* (London: Unwin Hyman, 1989).

17 Rodwell, D., The UNESCO World Heritage Convention, 1972–2012: reflections and directions, *The Historic Environment*, 3(1) (2012): 64–85.

18 Rodwell, UNESCO World Heritage Convention; UNESCO, *Linking Universal and Local Values: Managing a Sustainable Future for World Heritage*. World Heritage Series 13 (UNESCO: World Heritage Centres, 2004).

19 Rodwell, UNESCO World Heritage Convention.

20 See http://whc.unesco.org/en/criteria/ [accessed 10 Dec. 2013].

21 ICOMOS, *Charter for the Protection and Management of the Archaeological Heritage* (International Council on Monuments and Sites, 1990).

22 See http://www.icomos.org/en/about-icomos/mission-and-vision/mission-and-vision [accessed 5 Sept. 2013].

23 Skeates, R., *Debating the Archaeological Heritage* (London: Gerald Duckworth & Co. Ltd, 2000), p. 63.

24 The Burra Charter, The Australian ICOMOS Charter for Places of Cultural Significance, p. 1.
25 The Burra Charter, The Australian ICOMOS Charter for Places of Cultural Significance, p. 1.
26 The Burra Charter, The Australian ICOMOS Charter for Places of Cultural Significance, p. 10.
27 See http://www.wmf.org.uk/projects/ [accessed 3 April 2014].
28 See http://www.wmf.org.uk/projects/ [accessed 3 April 2014].
29 See http://www.landmarktrust.org.uk/ [accessed 3 April 2014].
30 See http://www.landmarktrust.org.uk/search-and-book/properties/astley-castle-4806 [accessed 4 Jan. 2014].
31 See http://www.spab.org.uk/what-is-spab/ [accessed 4 Jan. 2014].
32 See http://www.spab.org.uk/what-is-spab/ [accessed 4 Jan. 2014].
33 See www.hlf.org.uk/English/AboutUs [accessed 4 Jan. 2014].
34 See www.hlf.org.uk/English/AboutUs [accessed 4 Jan. 2014].
35 Bickley, P., The National Lottery: Is It Progressive? (London: Theos, 2009). Available at: http://www.theosthinktank.co.uk/files/files/Reports/NationalLotteryreport.pdf [accessed 7 July 2014].
36 English Heritage, Power of Place: The Future of the Historic Environment (London: English Heritage for the Historic Environment Steering Group, 2000); English Heritage, Heritage Counts: The State of England's Historic Environment 2006 (London: English Heritage, 2006).
37 See http://www.english-heritage.org.uk/caring/listing/listed-buildings [accessed 10 Sept. 2013].
38 See http://www.english-heritage.org.uk/caring/listing/listed-buildings
39 Jameson, J., Public archaeology in the United States, in N. Merriman (ed.), Public Archaeology (London: Routledge, 2004), pp. 21–58; Advisory Council on Historic Preservation (2006), National Historic Preservation Act of 1966, as amended through 2006. Available at: http://www.achp.gov/docs/nhpa%202008.final.pdf [accessed 3 Dec. 2014].
40 See http://www.nps.gov/moru/index.htm [accessed 3 Dec. 2014].
41 See http://www.cr.nps.gov [accessed 5 Sept. 2013].
42 See http://www.fs.fed.us [accessed 5 Sept. 2013].
43 See http://www.passportintime.com [accessed 5 Sept. 2013].
44 See www.passportintime.com, USDA-USFS, Passport in Time Accomplishments, Region 6, United States Department of Agriculture (Tucson, AZ: United States Forest Service, 1995).
45 See www.passportintime.com [accessed 5 Sept. 2013].
46 See http://www.heritagegateway.org.uk/Gateway/CHR [accessed 9 Oct. 2013].
47 English Heritage, Understanding Historic Buildings: A Guide to Good Recording Practice (London: English Heritage, 2006); Faulkner, N.,

Flagship national archaeology scheme faces crippling cuts, *Current Archaeology*, 215 (2008): 49.

48 Scardaville, M., Looking backward toward the future: an assessment of the public history movement, *The Public Historian*, 9(4) (1987): 35–43.

49 Bland, R., Treasure Trove and the case for reform, *Art, Antiquities and Law*, 11 (1996): 11–12.

50 Bland, Treasure Trove.

51 Skeates, R., *Debating the Archaeological Heritage* (London: Gerald Duckworth & Co. Ltd, 2000), p. 43.

52 See http://finds.org.uk [accessed 8 Sept. 2013].

53 Bennett, T., *The Birth of the Museum: History, Theory, Politics* (London: Routledge, 1995).

54 Proff, L. and O'Keefe, P., *Law and Cultural Heritage*, vol. 3, *Movement* (London: Butterworth, 1989).

55 Prott and O'Keefe, *Law and Cultural Heritage*.

56 ICOM Code of Professional Ethics (1990).

57 Renfrew, C., *Loot, Legitimacy and Ownership* (London: Duckworth, 2000).

58 See http://news.bbc.co.uk/1/hi/england/london/6157572.stm [accessed 12 April 2014].

59 Kier, B. and Bell, C. (2004) *Canadian Legislation Relating to First Nation Cultural Heritage*. Available at: http://www.law.ualberta.ca/research/ aboriginalculturalheritage/ CanadianLegislation.pdf [accessed 10 Nov. 2013].

60 Volkert, J., Martin, L.R., and Pickworth, A., *National Museum of the American Indian: Smithsonian Institution, Washington, DC: Map and Guide* (Washington, DC: Scala Publishers, 2004), p. 2.

61 Crosby, A., Archaeology and Vanua development in Fiji, *World Archaeology*, 34(2) (2002): 363–78.

62 Crosby, Archaeology and Vanua development, p. 375.

63 Crosby, Archaeology and Vanua development, p. 376.

64 Volkert et al., *National Museum of the American Indian*, p. 2.

65 *Native American Graves Protection and Repatriation Act* (25 U.S. Code 3001 et seq.), statute text. See http://www.cr.nps.gov/local-law/FHPL_ NAGPRA.pdf [accessed 10 Nov. 2013].

66 McManamon, P.F., Heritage, history and archaeological educators, in B.J. Little (ed.), *Public Benefits of Archaeology* (Gainesville, FL: University Press of Florida, 2002), pp. 31–45.

67 McManamon, Heritage, history and archaeological educators.

68 *Native American Graves Protection and Repatriation Act*.

69 See http://www.nma.gov.au/collections/repatriation [accessed 6 June 2014].

70 See http://www.dpc.vic.gov.au/index.php/aboriginal-affairs/aboriginal-cultural-heritage/review-of-the-aboriginal-heritage-act-2006 [accessed 5 Sept. 2013].

71 Ford, A. (2009) *Bellarine Bayside Foreshore: Redevelopment, Cultural Heritage Management Plan*, Geelong: Dig International Pty Ltd. Available at: http://diginternational.com.au/page3.htm [accessed 5 Sept. 2013].

72 See http://www.latrobe.edu.au/humanities/study/pathways/certificate-iv-in-aboriginal-cultural-heritage-management [accessed 5 Sept. 2013].

73 See http://www.latrobe.edu.au/humanities/study/pathways/certificate-iv-in-aboriginal-cultural-heritage-management [accessed 5 Sept. 2013].

74 English Heritage, *Understanding Historic Buildings: A Guide to Good Recording Practice* (London: English Heritage, 2006).

75 Boniface, P., *Managing Quality Tourism* (London: Routledge, 1995).

76 Boniface, P. and Fowler, P., *Heritage and Tourism in "The Global Village"* (London: Routledge, 1993).

77 UNESCO, *Linking Universal and Local Values: Managing a Sustainable Future for World Heritage*, World Heritage Series 13 (UNESCO: World Heritage Centres, 2004).

78 Heritage Lottery Fund (2012), *Conservation Plan Guidance*. Available at: http://www.hlf.org.uk/HowToApply/goodpractice/Documents/Conservation_plan_guidance.pdf [accessed 10 Oct. 2013].

79 Natural England, *Preparing a Heritage Management Plan* (Natural England, 2008), 63.

80 Boniface, *Managing Quality Tourism*, p. 108.

81 Natural England, *Preparing a Heritage Management Plan*.

82 Parker Pearson, Visitors welcome.

83 Department for Culture, Media and Sport, *Planning Policy Statement 5. Planning for the Historic Environment* (PPS5) (London: Department of Culture and Local Government, 2010); English Heritage and DCMS; Department for Communities and Local Government, *National Planning Framework* (London: Department for Communities and Local Government, 2012).

84 Planning Policy Statement 5, section HE 9.3.

85 Planning Policy Statement 5, section HE 7.3; *National Planning Framework*, section 12, p. 126.

86 Simpson, F., Birley Fields: exploring Victorian streetscapes in Manchester, *Current Archaeology*, 282 (2013): 28–33.

87 Simpson, Birley Fields, p. 33.

88 See http://www.salford.ac.uk/cst/research/applied-archaeology/community-engagement/dig-greater-manchester [accessed 9 Dec. 2013].

89 Jameson, J., Public archaeology in the United States, in N. Merriman (ed.) *Public Archaeology* (London: Routledge, 2004), p. 29.

90 Jameson, Public archaeology, p. 29; Snead, J., Science, commerce and control: patronage and the development of anthropological archaeology in the Americas, *American Anthropology*, 10(2) (1999): 256–71.

91 Jameson, Public archaeology, p. 30.

92 Jameson Public archaeology, p. 30.

93 Cressey, P.J., Reeder, R., and Bryson, J., Held in trust: community archaeology in Alexandria, Virginia, in L. Derry and M. Malloy (eds) *Archaeologists and Local Communities: Partners in Exploring the Past* (Washington, DC: Society for American Archaeology, 2003), p. 2.

94 See http://bpc.iserver.net/codes/annapolis/ [accessed 2 Aug. 2013].

95 See www.marlandhistorictrust.net/aboutmht.html [accessed 2 Aug. 2013].

96 See http://www.historicinnsofannapolis.com/governor-calvert-house.aspx [accessed 10 Dec. 2013].

97 Jordanova, L., *History in Practice* (London: Bloomsbury Academic, 2010).

98 Bogdanos, M., *Thieves of Baghdad* (New York: Bloomsbury Publishing, 2005).

99 Zeidler, J. and Rush, L., In-theatre training through cultural heritage playing cards: A US Department of Defense example, in L. Rush (ed.) *Archaeology, Cultural Property, and the Military* (Woodbridge: Boydell Press, 2010), pp. 73–85.

100 Zeidler and Rush, In-theatre training; Siebrandt, D., US Military support of cultural heritage awareness and preservation in post-conflict Iraq. In L. Rush (ed.) *Archaeology, Cultural Property, and the Military* (Woodbridge: Boydell Press, 2010), pp. 126–37; Schlesinger, V., Desert solitaire, *Archaeology* 60(4) (2007). Available at: http://www.archaeology.org/0707/trenches/solitaire.html [accessed 10 Nov. 2013].

101 Siebrandt, US military support, p. 127.

102 Brown, M., Good training and good practice: protection of cultural heritage on the UK defence training estate, in L. Rush (ed.) *Archaeology, Cultural Property, and the Military* (Woodbridge: Boydell Press, 2010), pp. 60–72.

103 Porter, M. and Reid, A. (2010) Today's toughest policy problems: how history can help. Available at: http://www.historyandpolicy.org/papers/policy-paper-100.html [accessed 5 Oct. 2013].

104 See www.historyandpolicy.org

105 Szreter, S., History and public policy, in J. Bates (ed.) *The Public Value of the Humanities* (London: Bloomsbury Academic, 2012), pp. 219–31.

106 Porter and Reid, Today's toughest policy problems.

107 Blair, T. (2003), Prime Minister's speech to the United States Congress. Available at: http://number10.gov.uk/Page4220 [accessed 5 Oct. 2013].

108 Tosh, J., *Why History Matters* (London: Palgrave Macmillan, 2008).

109 Berridge, V. (2006), *Smoking and the Sea Change in Public Health, 1945–2007*. Available at: http://www.historyandpolicy.org/papers/policy-paper-59.html [accessed 5 Oct. 2013]; Andrew, C. (2004) Intelligence analysis needs to look backwards before looking forwards. Available at: http://www.historyandpolicy.org/papers/policy-paper-23.html [accessed 5 Oct. 2013].

110 Rogers, E. (2007), Hitting Northern Rock bottom: lessons from nineteenth-century British banking. Available at: http://www.historyandpolicy.org/papers/policy-paper-64.html [accessed 5 Oct. 2013].

111 Rogers, Hitting Northern Rock bottom.

112 Szreter, History and public policy, p. 219.

8 Digital Media

1 Favero, P., Getting our hands dirty (again): interactive documentaries and the meaning of images in the digital age, *Journal of Material Culture*, 18 (2013): 259–77.

2 See web.archive.org/web/1997060610526/www.ucmp.berkeley.edu_ [accessed 9 April 2014].

3 Bowen, J., A brief history of early museums online. Available at: http://www.rutherfordjournal.org/article030103.html [accessed 12 June 2014]; Bowen, J.P., The World Wide Web and the Virtual Library Museums pages, *Interdisciplinary Journal of the Academia Europaea*, 5(1)(1997): 89–104.

4 Bowen, J., A brief history of early museums online.

5 See web.archive.org/web/1997060610526/www.ucmp.berkeley.edu_ [accessed 9 April 2014].

6 De Groot, J., *Consuming History: Historians and Heritage in Contemporary Culture* (London: Routledge, 2009).

7 Hogsden, C. and Poulter, E., The real other? Museum objects in digital contact networks, *Journal of Material Culture*, 17 (2012): 265–86.

8 De Groot, *Consuming History*, p. 189; Jordanova, L., *History in Practice* (London: Bloomsbury Academic, 2010).

9 See http://www.ancestry.com [accessed 12 March 2014].

10 Jordanova, *History in Practice*.

11 See http://www.ataleofonecity.portsmouth.gov.uk [accessed 5 June 2014].

12 See http://www.google.co.uk/earth/explore/showcase/historical.html [accessed 22 July 2014].

13 Jordanova, *History in Practice*, p. 20.

14 De Groot, *Consuming History*, p. 90.

15 De Groot, *Consuming History*, p. 92.

16 See http://www.stroudlocalhistorysociety.org.uk [accessed 14 June 2014].

17 Muller, K., Museums and virtuality, *Curator*, 45(1) (2002): 21–33;
 Cameron, F., Digital futures I: Museum collections, digital technologies,
 and the cultural construction of knowledge, *Curator*, 46 (2003): 325–40;
 Lynch, C., Digital collections, digital libraries, and the digitization of
 cultural heritage information, *First Monday*, 7(5) (2002).
18 Sayre, S, Sharing the experience: the building of a successful online/on-site
 exhibition, in D. Bearnman and J. Trant (eds), *Museums and the Web 2000*
 (Pittsburg, PA: Archives and Museum Informatics, 2000), pp. 13–20; see
 http://www.metmuseum.org/about-the-museum/now-at-the-met/2014/
 making-a-scene-in-paris?utm_source=Facebook&utm_medium=
 statusupdate&utm_content=20140716&utm_campaign=nowatthemet
 [accessed 15 July 2014].
19 See https://www.edx.org/course/columbiax/columbiax-hist1-1x-civil-
 war-2241#.U8vIo1a3cdt [accessed 20 July 2014].
20 See https://www.edx.org [accessed 20 July 2014].
21 See http://www.theguardian.com/higher-education-network/blog/2012/
 aug/08/mooc-coursera-higher-education-investment [accessed 27 July
 2014].
22 See https://novoed.com/Global-History-Lab [accessed 27 July 2014];
 http://www.mooc-list.com/course/global-history-lab-part-1-novoed
 [accessed 27 July 2014].
23 See http://www.timeshighereducation.co.uk/comment/opinion/five-
 myths-about-moocs/2010480.article [accessed 27 July 2014].
24 See http://www.timeshighereducation.co.uk/comment/opinion/five-
 myths-about-moocs/2010480.article [accessed 28 July 2014].
25 Hogsden, C. and Poulter, E., The real other? Museum objects in digital
 contact networks, *Journal of Material Culture*, 17 (2012): 265–86.
26 Hogsden and Poulter, The real other?
27 De Groot, *Consuming History*.
28 See http://www.bbc.co.uk/videonation/ [accessed 2 July 2014].
29 Favero, Getting our hands dirty (again).
30 Favero, Getting our hands dirty (again).
31 See http://i-docs.org/2014/06/10/the-quipu-project-a-framework-for-
 participatory-interactive-documentary/ [accessed 12 June 2014].
32 See http://911digitalarchive.org/index.php [accessed 2 June 2014].
33 See http://911digitalarchive.org/about/partners.php [accessed 2 June 2014].
34 Cohen, D., The future of preserving the past, in H. Kean and P. Martin
 (eds) *The Public History Reader* (London: Routledge, 2013), p. 216.
35 Cohen, The future of preserving the past, p. 216.
36 See http://www.911memorial.org [accessed 2 June 2014].
37 See http://911digitalarchive.org/index.php [accessed 2 June 2014].
38 Cohen, The future of preserving the past, p. 216.

39 See https://www.facebook.com/FacebookUK/info [accessed 6 July 2014].

40 See http://www.theguardian.com/technology/2007/jul/25/media. newmedia [accessed 6 July 2014].

41 TripAdvisor is a website providing travel information and reviews, including user-generated reviews of public history facilities from heritage tourists that are shared with the wider public. Yelp is an open access website providing user reviews and guides of public places, including museums and heritage centers. Both are consumer-focused websites, initially based on restaurant or hotel reviews, but have expanded to encompass wider public facilities such as museums.

42 See https://www.facebook.com/britishmuseum [accessed 20 July 2014].

43 See https://www.facebook.com/metmuseum [accessed 18 July 2014].

44 See https://www.facebook.com/NationalMuseumoftheAmericanIndianin DC?sk=likes [accessed 20 July 2014].

45 See https://twitter.com/amhistorymuseum/with_replies [accessed 20 July 2014].

46 See http://www.boneswithoutbarriers.org [accessed 21 July 2014].

47 See http://www.tweetstats.com [accessed 24 July 2014]; http://www. twitonomy.com; http://www.socialbro.com [accessed 24 July 2014].

48 See http://histagrams.com [accessed 20 July 2014].

49 See http://pinterest.com/diefenbunker/ http://pinterest.com/ chicagomuseum/ [accessed 20 July 2014].

50 See http://blog.americanhistory.si.edu/ [accessed 20 July 2014].

51 See http://bloggingforhistorians.wordpress.com/guide-to-blogging-main-index/uses-of-blogs-for-historians/ [accessed 22 July 2014].

52 See http://historyonics.blogspot.co.uk [accessed 22 July 2014].

53 See http://timesonline.typepad.com [accessed 22 July 2014].

54 See http://blog.americanhistory.si.edu/ [accessed 22 July 2014].

55 See http://www.historymatters.group.shef.ac.uk [accessed 22 July 2014].

56 See http://winterconference.history.ac.uk/blog/ [accessed 23 July 2014].

57 See http://www.boneswithoutbarriers.org/blog [accessed 23 July 2014].

58 See http://bloggingforhistorians.wordpress.com [accessed 23 July 2014].

59 See http://bloggingforhistorians.wordpress.com/2014/04/03/social-scholar-seminar-academic-guide-to-social-media-and-blogging/ [accessed 23 July 2014].

60 See http://wordpress.com [accessed 22 July 2014].

61 See http://bloggingforhistorians.wordpress.com/guide-to-blogging-main-index/setting-up-a-blog/ [accessed 22 July 2014].

62 See http://www.historymatters.group.shef.ac.uk [accessed 22 July 2014].

63 See http://www.historymatters.group.shef.ac.uk/cultural-authenticity-consumerism-hipster/ [accessed 22 July 2014].
64 Booth, A., Developing history students' skills in the transition to university, *Teaching Higher Education*, 6(4) (2010): 487–503; Falk, J. and Dierking, L., *Museums Experience Revisited* (Florida: Left Coast Press, 1992).

9 Conclusion

1 Jordanova, L., *History in Practice* (London: Bloomsbury Academic, 2010); De Groot, J,. *Consuming History: Historians and Heritage in Contemporary Culture* (London: Routledge, 2009).
2 Hawkins, R. and Woolf, H., The assessment of work place learning in the UK undergraduate history programmes, in L. Lavender (ed.), *History Graduates with Impact* (Higher Education Academy, 2011), pp. 37–42.
3 See http://www.civilservice.gov.uk/wp-content/uploads/2011/05/Civil-Service-Competency-Framework-Jan2013.pdf
4 Nicholls, D., The employment of history graduates, in L. Lavender (ed.). *History Graduates with Impact* (Coventry: Higher Education Academy, 2010), pp. 45–57.
5 Archer, W. and Davison, J., *Graduate Employability: What Do Employers Think and Want?* (Coventry: The Council for Industry and Higher Education, 2010).
6 Booth, A. and Booth, J., Passion, purpose and value, in L. Lavender (ed.) *History Graduates with Impact* (Higher Education Academy, 2011), pp. 9–25.
7 Booth and Booth, Passion, purpose and value.
8 Booth and Booth, Passion, purpose and value.
9 Archer and Davison, *Graduate Employability*; Booth and Booth, Passion, purpose and value.
10 Jordanova, *History in Practice*.
11 Hawkins and Woolf, Assessment of work place learning.
12 Hawkins and Woolf, Assessment of work place learning.
13 Brookfield, S. *Becoming a Critically Reflective Teacher* (San Francisco: Jossey-Bass, 1995).
14 Scardaville, M., Looking backward toward the future: an assessment of the public history movement, *The Public Historian*, 9(4) (1987): 35.
15 See www.passportintime.com [accessed 5 Sept. 2013].

Bibliography

Advisory Council on Historic Preservation (2006) *National Historic Preservation Act of 1966*, as amended through 2006. Available at: http://www.achp.gov/docs/nhpa%202008-final.pdf [accessed 3 Dec. 2014].

Anderson, B. (1983) *Imagined Communities: Reflection on the Origins and Spread of Nationalism*, London: Verso.

Anderson, J. (1982) Simulating life in living museums, *American Quarterly*, 34(3): 290–306.

Andrew, C. (2004) Intelligence analysis needs to look backwards before looking forwards. Available at: http://www.historyandpolicy.org/papers/policy-paper-23.html [accessed 5 Oct. 2013].

Archer, W. and Davison, J. (2010) *Graduate Employability: What Do Employers Think and Want?* London: The Council for Industry and Higher Education.

Ascherson, N. (1987) Why "heritage" is right-wing, *Observer*, November 8.

Ashby, J. (2009) Beyond teaching: out of hours at the Grant Museum, *University Museums and Collections Journal*, 2: 43–6.

Ashton, P. and Hamilton, P. (2009) Connecting with history: Australians and their pasts, in P. Ashton and H. Kean (eds) *People and their Pasts: Public History Today*, Basingstoke: Palgrave, pp. 23–41.

Ashton, P. and Kean, H. (2009) Introduction: people and their pasts and public history, in P. Ashton and H. Kean (eds) *People and their Pasts: Public History Today*, Basingstoke: Palgrave, pp. 1–20.

Aston, M. (2012) Publicizing archaeology in Britain in the late twentieth century: a personal view, in R. Skeates, C. McDavid and J. Carman (eds) *The Oxford Handbook of Public Archaeology*, Oxford: Oxford University Press, pp. 443–60.

Aston, M., Coston, A., Gerrard, C. and Hall, T. (eds) (1997) *The Shapwick Project, Vols 1–8*, Bristol: The University of Bristol Department for Continuing Education.

Australian Heritage Commission (2002) *Ask First: A Guide to Respecting Heritage Places and Values*, Canberra: Australian Heritage Commission.

Barrett, J. (2009) *Shooting the Civil War: Cinema, History and American National Identity, National Television and Civil War*, New York: I.B. Tauris.

Bartoy, K. (2012) Teaching through rather than about, in R. Skeates, C. McDavid and J. Carman (eds) *The Oxford Handbook of Public Archaeology*, Oxford: Oxford University Press, pp. 552–65.

Bates, J. (2012) Introduction, in J. Bates (ed.) *The Public Value of the Humanities*, London: Bloomsbury Academic, pp. 1–14.

Beech, M. (n.d.) Museum, Visitor and Heritage Centres. Available at: https://www.waterways.org.uk/pdf/restoration/museum__visitor_and_heritage_centres [accessed 10 Oct. 2013].

Belcher, M. (1991) *Exhibitions in Museums*, Leicester: Leicester University Press.

Bennett, T. (1995) *The Birth of the Museum: History, Theory, Politics*, London: Routledge.

Berridge, V. (2006) Smoking and the sea change in public health, 1945–2007. Available at: http://www.historyandpolicy.org/papers/policy-paper-59.html [accessed 5 Oct. 2013].

Besterman, T. (2014) Stonehenge Visitor Center, *Museums Journal*, 114(5): 42–5.

Bickley, P. (2009) *The National Lottery: Is It Progressive?* London: Theos. Available at: http://www.theosthinktank.co.uk/files/files/Reports/NationalLotteryreport.pdf

Blair, T. (2003) Prime Minister's speech to the United States Congress, 18 July. Available at: http://www.number10.gov.uk/Page4220 [accessed 10 Dec. 2013].

Blair, T. (2011) *A Journey*, London: Arrow.

Blakey, M. (1997) Commentary: past is present: comments on "In the Realm of Politics: Prospects for Participation in African-American and Plantation Archaeology", in C. McDavid and D. Babson (eds) *The Realm of Politics: Prospects for Public Participation in African-American Archaeology*, California, Pennsylvania, The Society for Historical Archaeology, Vol 31(3), pp. 140–5.

Bland, R. (1996) Treasure Trove and the case for reform, *Art, Antiquity and Law*, 11: 11–12.

Bloom, B. (1956) *Taxonomy of Educational Objects: The Classification of Educational Goals, Handbook I: Cognitive Domain*, New York: McKay.

Bogdanos, M. (2005) *Thieves of Baghdad*, New York: Bloomsbury Publishing.

Bolton, L. (2003) The object in view: Aborigines, Melanesians and Museums, in L. Peers and A.K. Brown (eds) *Museums and Source Communities*, London: Routledge, pp. 42–54.

Boniface, P. (1995) *Managing Quality Tourism*, London: Routledge.

Boniface, P. and Fowler, P. (1993) *Heritage and Tourism in "The Global Village,"* London: Routledge.

Booth, A. (2010) Developing History students' skills in the transition to university, *Teaching Higher Education*, 6(4): 487–503.

Booth, A. and Booth, J. (2011) Passion, purpose and value, in L. Lavender (ed.) *History Graduates with Impact*, Higher Education Academy, pp. 9–25.

Bowen, J. (n.d.) A brief history of early museums online. Available at: http://www.rutherfordjournal.org/article030103.html [accessed 12 June 2014].

Bowen, J.P. (1997). The World Wide Web and the Virtual Library Museums pages, *European Review: Interdisciplinary Journal of the Academia Europaea*, 5(1): 89–104.

Bradburne, J. (2001) A new strategic approach to the museum and its relationship to society, *Journal of Museum Management and Curatorship*, 19: 75–85.

Bradley Commission in Schools, The (1988) *Building a History Curriculum: Guidelines for Teaching History in Schools*, Washington, DC: Educational Excellence Network.Bragg, M. (2004) The adventure of making *The Adventure of English*, in D. Cannadine (ed.) *History and the Media*, New York: Palgrave Macmillan, pp. 67–87.

Brookfield, S. (1995) *Becoming a Critically Reflective Teacher*, San Francisco: Jossey-Bass.

Brown, M. (2010) Good training and good practice: protection of cultural heritage on the UK defence training estate, in L. Rush (ed.) *Archaeology, Cultural Property, and the Military*, Woodbridge: Boydell Press, pp. 60–72.

Bruner, J. (1966) *The Culture of Education*, Cambridge, MA: Harvard University Press.

Bryon, A. (2010) *Social Research Methods*, Oxford: Oxford University Press.

Burra Charter, The (1999) *The Australian ICOMOS Charter for Places of Cultural Significance*. Charenton-le-Pont: International Council on Monuments and Sites.Butler, T. (2009) "Memoryscape": integrating oral history, memory and landscape on the River Thames, in P. Ashton and H. Kean (eds) *People and Their Pasts: Public History Today*, London: Palgrave Macmillan, pp. 223–39.

Cameron, F. (2003) Digital Futures I: Museum collections, digital technologies, and the cultural construction of knowledge, *Curator*, 46: 325–40.

Carman, J. (2012) Towards an international comparative history of archaeological heritage management, in R. Skeates, C. McDavid, and J. Carman (eds) *The Oxford Handbook of Public Archaeology*, Oxford: Oxford University Press, pp 13–35.

Chatterjee, H. (2010) Object-based learning in higher education: the pedagogical power of museums, *University Museums and Collections Journal*, 3: 179–82.

Chhabra, D. (2007) Positioning museums on an authenticity continuum, *Annals of Tourism Research*, 35(2): 427–33.

CIDOC Fact Sheet No. 1: Registration step by step: when an object enters the museum. Available at: http://icom.museum/fileadmin/user_upload/pdf/Guidelines/CIDOC%20Fact%20Sheet%20N1.pdf [accessed 8 March 2013].

CIDOC Fact Sheet No. 2: Labeling and marking objects. Available at: http://cidoc.mediahost.org/FactSheet2(en)(E1).xml [accessed 8 March 2013].

Clack, T. and Brittain, T. (2007) *Archaeology and the Media*, London: University College London.

Classen, C. and Kansteiner, W. (2009) Truth and authenticity in contemporary historical culture: an introduction to historical representation and historical truth, *History and Theory*, 47(2): 1–4.

Claus, P. and Marriot, J. (2012) *History: An Introduction to Theory, Method and Practice*, Harlow: Pearson.

Cleere, H. (1989) *Archaeological Heritage Management in the Modern World*, London: Unwin Hyman.

Cohen, A. (1985) *The Symbolic Construction of Community*, London: Routledge.

Cohen, D. (2013) The future of preserving the past, in H. Kean and P. Martin (eds) *The Public History Reader*. London: Routledge, pp. 214–23.

Copper, D. (2006) Truthfulness and "inclusion" in archaeology, in C. Scarre and G. Scarre (eds) *The Ethics of Archaeology: Philosophical Perspectives on Archaeological Practice*, Cambridge: Cambridge University Press, pp. 131–47.

Counsell, C. (2011) Disciplinary knowledge for all, the secondary history curriculum and history teachers' achievement, *The Curriculum Journal*, 22(2): 201–25.

Cressey, P.J., Reeder, R., and Bryson, J. (2003) Held in trust: community archaeology in Alexandria, Virginia, in L. Derry and M. Malloy (eds) *Archaeologists and Local Communities: Partners in Exploring the Past*, Washington, DC: Society for American Archaeology, pp. 1–18.

Crofts, S. (1987) Not a window on the past: how films and television construct history, *Film and History: An Interdisciplinary Journal of Film and Television*, 17(4): 90–5.

Crosby, A. (2002) Archaeology and Vanua development in Fiji, *World Archaeology*, 34(2): 363–78.

Davis, N.Z. (2000) *Slaves on Screen: Film and Historical Vision*, Cambridge, MA: Harvard University Press.

Davison, G. (1998) Public history, in G. Davison, J. Hirst, and S. Macintyre (eds) *The Oxford Companion to Australian History*, Melbourne: Oxford University Press, pp. 532–3.

Davison, G. (2013) Use and abuse of Australian history, in H. Kean and P. Martin (eds) *The Public History Reader*, London: Routledge, pp. 68–82.

Deary, T. (2007) *The Vicious Vikings: Horrible Histories*. Danbury: Scholastic Press.

De Groot, J. (2009) *Consuming History: Historians and Heritage in Contemporary Culture*, London: Routledge.

Department for Communities and Local Government (2012) *National Planning Framework*, London: Department for Communities and Local Government.

Department for Culture, Media and Sport (2010a) *Planning Policy Statement 5: Planning for the Historic Environment (PPS5)*, London: Department of Culture and Local Government, English Heritage and DCMS.

Department for Culture, Media and Sport (2010b) *Public Spending Review*. Available at: http://www.official-documents.gov.uk [accessed 10 Dec. 2010].

Dewey, J. (1997) *Experience and Education*, New York: Simon & Schuster Touchstone.

Downing, T. (2004) Bringing in the past to the small screen, in D. Cannadine (ed.) *History and the Media*, New York: Palgrave Macmillan, pp. 7–19.

Eddisford, D. and Morgan, C. (2011) An archaeology of the contemporary: a standing buildings survey of "The Chicken Shed" at Çatalhöyük, in S. Farid (ed.) *Çatalhöyük Archive Report 2011*, pp. 137–49.

Eley, G. (2003) Marxist historiography, in S. Berger, H. Feldner, and K. Passmore (eds) *Writing History: Theory and Practice*, London: Hodder.

Emerson, R., Fretzm, R. and Shaw, L. (1995) *Writing Ethnographic Fieldnotes*, Chicago: University of Chicago Press.

English Heritage (2000) *Power of Place: The Future of the Historic Environment*, London: English Heritage for the Historic Environment Steering Group.

English Heritage (2006a) *Heritage Counts: The State of England's Historic Environment 2006*, London: English Heritage.

English Heritage (2006b) *Understanding Historic Buildings: A Guide to Good Recording Practice*, London: English Heritage.

Falk, J. and Dierking, L. (1992) *Museums Experience Revisited*, Walnut Creek, Florida: Left Coast Press.

Favero, P. (2013) Getting our hands dirty (again): interactive documentaries and the meaning of images in the digital age, *Journal of Material Culture*, 18: 259–77.

Feilden, B.M. and Jokilehto, J. (1993) *Management Guidelines for World Cultural Heritage Sites*, Rome: ICCROM.

Ferro, M. (1987) Does a filmic writing of history exist? *Film and History: An Interdisciplinary Journal of Film and Television*, 17(4): 81–9.

Ford, A. (2009) *Bellarine Bayside Foreshore: Redevelopment, Cultural Heritage Management Plan*, Geelong: Dig International Pty Ltd.

Franco, B. (1997) Public history and memory: a museum perspective, *The Public Historian*, 19(2): 65–7.

Fredericksen, C. (2002) Caring for history: Tiwi and archaeological narratives of Fort Dundas/Punata, Melville Island, Australia, *World Archaeology*, 34(2): 288–302.

Frisch, M. (1990) *A Shared Authority: Essays on the Craft and Meaning of Oral and Public History*, Albany, NY: University of New York Press.

Gardner, H. (1991) *The Unschooled Mind: How Children Think and How Schools Should Teach*, New York: Basic Books.

Gardner, J. (1999) *Public History: Essays from the Field*, Malabar: Kreiger Publishing Company.

Gardner, J. (2010) Trust, risk and public history: a view from the United States, *Public History Review*, 17: 52–61.

Gathercole, P., Stanely, J., and Thomas, N. (2002) Archaeology and the media: Cornwall Archaeology Society – Devon Archaeological Society joint symposium, *Cornish Archaeology*, 41–42: 149–60.

Gerrard, C.M. and Aston, M.A. (2007) *The Shapwick Project, Somerset: A Rural Landscape Explored*, Leeds: Society for Medieval Archaeology.

Gibbs, K., Sani, M., and Thompson, J. (2007) *Lifelong Learning in Museums: A European Handbook*. Available at: http://www.ne-mo.org/fileadmin/Dateien/public/service/Handbook-en.pdf [accessed 10 Dec. 2013].

Glassberg, D. (1986) Review: Loving in the Past, *American Quarterly*, 38(2): 305–10.

Gombrich, E. (1936) *A Little History of the World*, New Haven, CT: Yale University Press (republished 2008).

Gorman, J. (2004) Historians and their duties, *History and Theory*, 43(4): 103–17, Theme Issue, Historians and Ethics.

Green, J. (2000) *Taking History to Heart: The Power of the Past in Building Social Movements*, Amherst, MA: University of Massachusetts Press.

Greer, S., Harrison, R., and McIntyre-Tamwoy, S. (2002) Community based archaeology in Australia, *World Archaeology*, 34(2): 265–87.

Gregory, P. (2007) *The Other Boleyn Girl*, London: HarperCollins.

Grele, R. (1989) Whose public? Whose history? What is the goal of a public historian? *The Public Historian*, 3(1): 40–8.

Griffin, D. and Paroissien, L. (2011) *Understanding Museums: Australian Museums and Museology*, Sydney: National Museum Australia.

Hartley, L.P. (2004) *The Go-Between*, London: Penguin Modern Classics.

Hawkey, K. and Prior, J. (2010) History, memory cultures and meaning in the classroom, *Journal of Curriculum Studies*, 43(2): 231–47.

Hawkins, R. and Woolf, H. (2011) The assessment of work place learning in the UK undergraduate history programmes, in L. Lavender (ed.) *History Graduates with Impact*, Coventry: Higher Education Academy, pp. 37–42.

Heal, S. (2005) Living with the enemy, *Museums Journal*, 105(8): 40–1.

Henry, P. (2004) The Young Archaeologists' Club: its role within informal learning, in D. Henson, P. Stone, and M. Corbishley (eds) *Education and the Historic Environment*, London: Routledge, pp. 89–100.

Hensley, J. (1988) Museums and teaching history, *Teaching History: A Journal of Methods*, 13(2): 67–75.

Heritage Lottery Fund (2012) *Conservation Plan Guidance*. Available at: http://www.hlf.org.uk/HowToApply/goodpractice/Documents/Conservation_plan_guidance.pdf [accessed 10 Oct. 2013].

Herreman, Y. (2004) Display, exhibits and exhibitions, in P. Boylan (ed.) *Running a Museum: A Practical Handbook*, Paris: International Council of Museums, pp. 91–104.

Hoggett, P. (1979) *Contested Communities: Experiences, Struggles, Policies*, Bristol: Policy Press.

Hogsden, C. and Poulter, E. (2012) The other real? Museum objects in digital contact networks, *Journal of Material Culture*, 17: 265–86.

Holtorf, C. (2005) *From Stonehenge to Las Vegas: Archaeology as Popular Culture*, Oxford: Altamira Press.

Holtorf, C. (2006) *Archaeology Is a Brand! The Meaning of Archaeology in Contemporary Popular Culture*, Oxford: Archaeopress.

Holtorf, C. and Williams, H. (2006) Landscapes and memories, in D. Hicks and M.C. Beaudry (eds) *The Cambridge Companion to Historical Archaeology*, Cambridge: Cambridge University Press, pp. 235–54.

Honey, P. and Mumford, A. (2006) *The Learning Styles Questionnaire: 80-Item Version*, Maidenhead: Peter Honey Publications.

Hooper Greenhill, E. (1992) *Museums and Shaping Knowledge*, London: Routledge.

Hooper Greenhill, E. (2004) *Inspiration, Identity, Learning: The Value of Museums: The Evaluation of the Impact of DfES Strategic Commissioning 2003–2004*, National/Regional Museums Education Partnerships. Available at: http://www2.le.ac.uk/departments/museumstudies/rcmg/projects/inspiration-identity-learning-1/DCMS%20Final%20Report%20Part%201.pdf [accessed 5 Sept. 2013].

Hooper Greenhill. E. (2007) *Museums and Education: Purpose, Pedagogy, Performance*, London: Routledge.

Hosseini, K. (2003) *The Kite Runner*, New York: Riverhead Books.

Howe, B. (1989) Reflections on an idea: NCPH's first decade, *The Public Historian*, 11(3): 69–85.

Hughes-Warrington, M. (2006) *History Goes to the Movies: Studying History on Film*, London: Routledge.

Hunt, T. (2004) How does television enhance history? in D. Cannadine (ed.) *History and the Media*, New York: Palgrave Macmillan, pp. 88–102.

ICOM (2010) Code of Professional Ethics for Museums. Available at: http://icom.museum/fileadmin/user_upload/pdf/Codes/code_ethics2013_eng.pdf [accessed 6 Sept. 2013].

ICOMOS (1990) *Charter for the Protection and Management of the Archaeological Heritage*, Charenton-le-Pont: International Council on Monuments and Sites.

Isaacs, J. (2008) Television history, *History Today*, 58(9): 17.

James, A. and Boyd, N. (2007) *Fact Sheet: Understanding Audiences: Skills Development and Mentoring Programme for Museums*, London: Museum of London.

Jameson, J. (2003) Purveyors of the past: education and outreach as ethical imperatives in archaeology, in L.J. Zimmerman, K.D. Viteli, and J. Hollowell-Zimmer (eds) *Ethical Issues in Archaeology*, Oxford: Altamira Press, pp. 153–62.

Jameson, J. (2004) Public archaeology in the United States, in N. Merriman (ed.) *Public Archaeology*, London: Routledge, pp. 21–58.

Jarvie, I. (1987) *Philosophy of the Film: Epistemology, Ontology, Aesthetics*, London: Routledge.

Jenkinson, H. (1937) *Manual of Archive Administration*, London: Percy Lund, Humphries and Co.

Jensen, B. (2009) Usable pasts: comparing approaches to popular and public history, in H. Kean and P. Ashton (eds) *People and Their Pasts: Public History Today*, London: Palgrave Macmillan, pp. 42–56.

Jeppson, P.L. (2008) Doing our homework: rethinking the goals and responsibilities of archaeology outreach to schools, in J. Stottman (ed.) *Changing the World with Archaeology: Activist Archaeology*, Greenville, FL: University of Florida Press, pp. 1–58.

Jeppson, P.L. (2012) Public Archaeology and the US Culture Wars, in R. Skeates, C. McDavid, and J. Carman (eds) *The Oxford Handbook of Public Archaeology*, Oxford: Oxford University Press, pp. 581–603.

Jeppson, P.L. and Brauer, G. (2003) "Hey, did you hear about the teacher who took the class out to dig a site?": Some common misconceptions about archaeology in schools, in L. Derry and M. Malloy (eds) *Archaeologists and Local Communities: Partners in Exploring the Past*, Washington, DC: Society for American Archaeology Press, pp. 77–96.

Jones, A. (1995) Integrating school visits, tourists and the community at the Archaeological Resource Centre, York, UK, in E. Hooper Greenhill (ed.) *Museum, Media, Message*, Leicester: Leicester University Press, pp. 156–64.

Jones, A. (2004) Using objects: the York Archaeological Trust approach, in D. Henson, P. Stone and M. Corbishley (eds) *Education and the Historic Environment*, London: Routledge, pp. 173–84.

Jones, L.A. (2009) University museums and outreach: the Newcastle upon Tyne case study, *University Museums and Collections Journal*, 2: 27–32.

Jordanova, L. (2010) *History in Practice*, London: Bloomsbury Academic.

Jordon, P. (1984) Archaeology and television, in H. Cleere (ed.) *Approaches to Archaeological Heritage*, Cambridge: Cambridge University Press, pp. 207–14.

Kargar, M. R. (2005) Foreword, in J. Curtis and N. Tallis (eds) *Forgotten Empire: The World of Ancient Persia*, Berkeley: University of California Press, pp. 7–8.

Kavanagh, G. (1996) *Making Histories in Museums*, Leicester: Leicester University Press.

Kazin, M. (2013) 12/12 and 9/11: tales of power and tales of experience in contemporary history, *History News Network*, 11 September. Available at: http://hnn.us/articles /1675.html. [accessed 10 Dec. 2013].

Kean, H. and Ashton, P. (2009) Introduction: people and their pasts and public history today, in H. Kean and P. Ashton (eds) *People and Their Pasts: Public History Today*. London: Palgrave Macmillan, pp. 1–20.

Kenshaw, I. (2014) The Hitler myth, *BBC History Magazine*, April.

Kiddey, R. and Schofield, J. (2011) Embrace the margins: adventures in archaeology and homelessness, *Public Archaeology*, 10(1): 4–22.

Kier, B. and Bell, C. (2004) *Canadian Legislation Relating to First Nation Cultural Heritage*. Available at: http://www.law.ualberta.ca/research/aboriginalculturalheritage/ CanadianLegislation.pdf [accessed 10 Nov. 2013].

Kier Reeves, E., Sanders, R., and Chisholm, G. (2010) Oral histories of a layered landscape: Rushworth oral history, *Public History Review*, 14: 114–27.

Kohl, H. (1989) *Growing Minds: On Becoming a History Teacher*, New York: Harper and Row.

Kolb, D.A. (1976) *The Learning Style Inventory: Technical Manual*, Boston: McBer.

Latour, B. (1999) *Pandora's Hope: Essays on the Reality of Science Studies*, Cambridge, MA: Harvard University Press.

Laurence, R. (2012) *Roman Archaeology for Historians*, London: Routledge.

Lave, J. and Wenger, E. (1990) *Situated Learning: Legitimate Peripheral Participation*, Cambridge: Cambridge University Press.

Layton, R. (1989) *Who Needs the Past? Indigenous Values and Archaeology*, London: Unwin Hyman.

Lees, N. (2010) *Developing Factual TV Ideas from Concept to Pitch: The Professional Guide to Pitching Factual Shows*, London: Methuen Drama.

Lewin, K. (1948) *Resolving Social Conflicts; Selected Papers on Group Dynamics*, New York: Harper & Row.

Lewis, G. (2004) The role of museums and professional code of ethics, in P. Boylan (ed.) *Running a Museum: A Practical Handbook*, Paris: International Council of Museums, pp. 1–16.

Liddington, J. (2002) What is public history? Publics and their pasts, meanings and practices, *Oral History*, 3: 99–92.

Liddington, J. and Smith, G. (2005) Crossing cultures: oral history and public history, *Oral History*, 33(1): 28–31.

Liddle, P. (1989) Community archaeology in Leicestershire museums, in E. Southworth (ed.) *Public Service or Private Indulgence? The Museum Archaeologist*, 13, Liverpool: Society of Museum Archaeologists, pp. 44–6.

Lock, G. (2004) Rolling back the years: lifelong learning and archaeology in the United Kingdom, in M. Corbishley, D. Henson, and P. Stone (eds) *Education and the Historic Environment*, London: Routledge, pp. 55–66.

Loewenberg Ball, D. and McDiarmid, G. (1989) *The Subject Matter Preparation of Teachers*, Michigan: National Center for Research on Teacher Education.

Lowenthal, D. (1989) *The Heritage Crusade and the Spoils of History*, Cambridge: Cambridge University Press.

Lowenthal, D. (1990) *The Past Is a Foreign Country*, Cambridge: Cambridge University Press.

Lucas, G. (2004) Modern disturbances: on the ambiguities of archaeology, *Modernism/Modernity*, 11: 109–20.

Lynch, C. (2002) Digital collections, digital libraries, and the digitization of cultural heritage information, *First Monday*, 7(5). Available at: http://firstmonday.org/issue7_5/lynch/index.html [accessed 23 July 2014].

MacDonald, S. (2009) *A Companion to Museum Studies*, Oxford: Blackwell Publishing.

Macintyre, S. and Clark, A. (2003) *The History Wars*, Melbourne: Melbourne University Press.

Martin, P. (2013) Introduction: the past in the present: who is making history? in H. Kean and P. Martin (eds) *The Public History Reader*, London: Routledge, pp. 1–10.

Masse, A. and Masse, W. (2010) Online collaboration and knowledge dissemination for university collections, *University Museums and Collections Journal*, 3: 91–6.

McClanahon, A. (2006) Histories, identity, and ownership: an ethnographic case study in archaeological heritage management in the Orkney Islands, in M. Edgeworth (ed.) *Ethnographies of Archaeological Practice: Cultural Encounters, Material Transformations*. Lanham, MD: Altamira Press, pp. 126–36.

McGimsey, C. (1972) *Public Archaeology*, New York: McGraw-Hill.

McKercher, B. and Du Cross, H. (2002) *Cultural Tourism: The Partnership between Tourism and Cultural Management*, New York: Haworth Hospitality Press.

McManamon, P.F. (2002) Heritage, history and archaeological educators, in B.J. Little (ed.) *Public Benefits of Archaeology*, Gainesville, FL: University Press of Florida, pp. 31–45.

Merriman, N. (1991) *Beyond the Glass Case: The Past, the Heritage and the Public in Britain*, Leicester: Leicester University Press.

Merriman, N. and Poovaya-Smith, N. (1996) Making culturally diverse histories, in G. Kavanagh (ed.) *Making Histories in Museums*, Leicester: Leicester University Press, pp. 176–87.

Meskell, L. (2012) *The Nature of Heritage: The New South Africa*, Malden, MA: Wiley-Blackwell.

Metcalf, F. (2002) Myths, lies, and videotapes: information as antidote to social studies classrooms and pop culture, in B.J. Little (ed.) *Public Benefits of Archaeology*. Gainesville, FL: University Press of Florida, pp. 167–75.

Miller, L. (2010) *Archives: Principles and Practices*, London: Facet Publishing.

Morris, W. (1988) At Henry Parks Motel, *Cultural Studies*, 2: 1–16.

Moshenska, G. (2007) Oral history in historical archaeology: excavating sites of memory, *Oral History*, 35(1): 91–7.

Moussouri, T. (2002) A context for the development of learning outcomes in museums, libraries and archives. Available at: http://www2.le.ac.uk/departments/museumstudies/rcmg/projects/lirp-1-2/LIRP%20analysis%20paper%202.pdf [accessed 5 Oct. 2013].

Muller, K. (2002) Museums and virtuality, *Curator*, 45(1): 21–33.

Museum of the City of New York (2012) *Bicentennial Report: Museum of City of New York 2011–2012*. Available at: http://www.mcny.org/sites/ default/files/Biennial%20Report%202011-12.pdf [accessed 10 Dec. 2013].

Native American Graves Protection and Repatriation Act (25 U.S. Code 3001 et seq.) statute text. Available at: http://www.cr.nps.gov/local-law/FHPL_NAGPRA.pdf [accessed 10 Nov. 2013].

Natural England (2008) *Preparing a Heritage Management Plan (NE63)*, Whitchurch: Natural England.

Neumann, L. (n.d.) The politics of archaeology and historic preservation: how our laws really are made. Available at: www.nps.gov/history/sec/protecting/html/201-neumann.htm [accessed 10 Jan. 2013].

Newman, W. L. (1995) *Social Research Methods: Qualitative and Quantitative Approach*, Boston: Allyn and Bacon.

Nicholls, D. (2010) The employment of history graduates, in L. Lavender (ed.) *History Graduates with Impact*, Coventry: The Higher Education Academy, pp. 49–58.

O'Connor, J. (1986) Special report: the moving-image media in the history classroom, *Film and History: An Interdisciplinary Journal of Film and Television*, 16(3): 49–54.

Orrill, R. and Shapiro, L. (2005) From bold beginnings to an uncertain future: the discipline of History and History education, *The American History Review*, 110(3): 727–51.

Parker Pearson, M. (2001) Visitors welcome, in J. Hunter and I. Ralston (eds) *Archaeological Resource Management in the UK: An Introduction*, Stroud: Sutton Publishing, pp. 225–31.

Parker Pearson, M. (2012) The value of archaeological research, in J. Bates (ed.) *The Public Value of the Humanities*, London: Bloomsbury Academic, pp. 30–43.

Pavlov, I.P. (1897) *The Work of the Digestive Glands*, London: Griffin.

Pearce, S. (1994) *Interpreting Objects and Collections*, New York: Routledge.

Piaget, J. (1936) *The Origins of Intelligence in the Child*, London: Routledge and Kegan Paul.

Piaget, P.H. (1975) *Museums in Australia: Report of the Committee of Inquiry on Museums and National Collections*, Canberra: Australian Government Publishing Service.

Piccini, A. and Henson, D. (2006) *Survey of Heritage Television Viewing, 2005–2006*, London: English Heritage.

Pickstone, J. (2000) *Ways of Knowing: A History of Science, Technology and Medicine*, Manchester: Manchester University Press.

Popcorn, F. (1992) *The Popcorn Report: Revolutionary Trend for Marketing in the 1990's*, London: Arrow.

Porter, M. and Reid, A. (2010) Today's toughest policy problems: how history can help. Available at: http://www.historyandpolicy.org/papers/policy-paper-100.html [accessed 5 Oct.2013].

Potter, P.B. (1994) *Public Archaeology in Annapolis: A Critical Approach to Maryland's Ancient City*, Washington, DC: Smithsonian Institute Press.

Prott, L. and O'Keefe, P. (1989) *Law and Cultural Heritage*, Vol. 3: *Movement*, London: Butterworth.

Race, P. (2006) *The Lecturer's Toolkit: A Practical Guide to Assessment, Learning and Teaching*, London: Routledge.

Reeve, J. and Woollard, V. (2007) *The Responsive Museum: Working with Audiences in the 21st Century*, Aldershot: Ashgate.

Renfrew, C. (2000) *Loot, Legitimacy and Ownership*, London: Duckworth.

Rentzhog, S. (2007) *Open Air Museums: The History and Future of a Visionary Idea*, trans. S.V. Airey, Stockholm: Carlssons and Jamtili.

Ritchie, D. (2003) *Doing Oral History: A Practical Guide*, New York: Oxford University Press.

Robertshaw, A. (2006) Live interpretation, in A. Hems and M. Blockley (eds) *Heritage Interpretation*, London: Routledge, pp. 41–54.

Robertson, I. (2013) Heritage from below: class, social protest and resistance, in H. Kean and P. Martin (eds) *The Public History Reader*, London: Routledge, pp. 56–67.

Rodwell, D. (2012) The UNESCO World Heritage Convention, 1972–2012: reflections and directions, *The Historic Environment*, 3(1): 64–85.

Rogers, C.R. (1969) *Freedom to Learn*, Columbus, OH: Merrill.

Rogers, E. (2007) *Hitting Northern Rock Bottom: Lessons from Nineteenth-century British Banking*. Available at: http://www.historyandpolicy.org/papers/policy-paper-64.html [accessed 5 Oct. 2013].

Rosenstone, R. (1995) *Visions of the Past: The Challenge of Film to Our Idea of History*, Cambridge, MA: Harvard University Press.

Rosenstone, R. (2001) Introduction to experiments in narrative, *Rethinking History: The Journal of Theory and Practice*, 5: 411–16.

Rosenstone, R. (2012) *History on Film, Film on History*, Harlow: Pearson.

Rosenzweig, R. and Thelen, D. (2000) *The Presence of the Past*, New York: Columbia University Press.

Samuel, R. (2012) *Theatres of Memory: Past and Present in Contemporary Culture*, London: Verso.

Sayre, S. (2000) Sharing the experience: the building of a successful online/on-site exhibition, in D. Bearnman and J. Trant (eds) *Museums and the Web 2000*, Pittsburg, PA: Archives and Museum informatics, pp. 13–20.

Scardaville, M. (1987) Looking backward toward the future: an assessment of the public history movement, *The Public Historian*, 9(4): 35–43.

Schama, S. (2007) *A History of Britain*, London: Bodley Head.

Schlesinger, V. (2007) Desert solitaire, *Archaeology*, 60 (4). Available at: http://www.archaeology.org/0707/trenches/solitaire. html [accessed 10 Nov. 2013].

Seixas, P. (2010) Beyond "content" and "pedagogy": in search of a way to talk about history education, *Journal of Curriculum Studies*, 31(3): 317–37.

Shackel, P.A. (2007) Public memory and the search for power in American historical archaeology, in L.J. Smith (ed.) *Cultural Heritage*, vol. II, London: Routledge, pp. 307–30.

Siebrandt, D. (2010) US military support of cultural heritage awareness and preservation in post-conflict Iraq, in L. Rush (ed.) *Archaeology, Cultural Property, and the Military*, Woodbridge: Boydell Press, pp. 126–37.

Silberman, N.A. (1999) Is archaeology ready for prime time? *Archaeology Magazine*, (May/June): 79–82.

Simpson, F. (2009) Community archaeology under scrutiny, *Journal of Conservation and Management of Archaeological Sites*, 10(1): 3–16.

Simpson, F. (2010) *The Values of Community Archaeology: A Comparative Assessment between the UK and USA*, British Archaeological Reports. Oxford: Oxbow.

Simpson, F. (2011) Shoreditch Park Community Archaeology Excavation: a case study, in G. Moshenska and S. Dhanjal (eds) *Archaeology in the Community*, London: Heritage Publications, pp. 118–22.

Simpson, F. (2013) Birley Fields: exploring Victorian streetscapes in Manchester, *Current Archaeology*, 282: 28–33.

Simpson, F. and Keily, J. (2005) Today's rubbish, tomorrow's archaeology: using nineteenth and twentieth century finds, *The Archaeologist*, 58: 26–7.

Simpson, F. and Williams, H. (2008) Evaluating community archaeology in the UK, *Public Archaeology*, 7(2): 69–90.

Simpson, R. (1998) Multimedia special: effective audio-visual, *Museums Practice*, 9: 44–6.

Sitzia, L. (2010) Telling people's histories: an exploration of community history making from 1970–2000, unpublished PhD thesis, University of Sussex. Available at: http://sro.sussex.ac.uk/2488/1/Sitzia%2C_Lorraine.pdf [accessed 12 June 2014].

Skeates, R. (2000) *Debating the Archaeological Heritage*, London: Gerald Duckworth & Co. Ltd.

Skinner, B.F. (1971) *Beyond Freedom and Dignity*, New York: Knopf.

Skolnik, M. L. (1986) Diversity in higher education: a Canadian case, *Higher Education in Europe*, 11: 19–32.

Slick, K. (2002) Archaeology and the tourist train, in B.J. Little (ed.) *Public Benefits of Archaeology*, Gainesville, FL: University Press of Florida, pp. 219–27.

Smallbone, T. and Witney, D. (2011) Wiki work: can using wikis enhance student collaboration for group assignment tasks? *Innovations in Education and Teaching International*, 48(1):101–10.

Smethhurst, W. (2009) *How to Write for Television*, Oxford: How To Books.

Smith, L.J. (2006) *The Uses of Heritage*, London: Routledge.

Smith, M. and Richards, G. (2012) *The Routledge Handbook of Cultural Tourism*, London: Routledge.

Smith, N. (2010) *History Teacher's Handbook*, London: Continuum.

Snead, J. (1999) Science, commerce and control: patronage and the development of anthropological archaeology in the Americas, *American Anthropology*, 101(2): 256–71.

Sorensen, C. (2007) Theme parks and time machines, in P. Vergo (ed.) *The New Museology*, London: Reaktion Books, pp. 60–73.

Sorlin, P. (1995) The night of the shooting stars: Fascism, resistance and the liberation of Italy, in R. Rosenstone (ed.) *Revisioning History: Film and the Construction of a New Past*, Princeton, NJ: Princeton University Press, pp. 77–87.

Sorro, P. (1988) Historical films as tools for historians, *History and Film: An International Journal of Film and Media Studies*, 18(1): 2–15.

Start, D. (1999) Community archaeology; bringing it back to local communities, in G. Chitty and D. Baker (eds) *Managing Historic Sites and Buildings; Reconciling Presentation and Preservation*, London: Routledge, pp. 49–59.

Steele, J. (1991) Doing media history research, *Film and History: An Interdisciplinary Journal of Film and Television Studies*, 21(2/3): 83–7.

Stephens, S. (2013) English Heritage unveils Stonehenge Visitor Centre, *Museums Journal*. Available at: http://www.museumsassociation.org/museums -journal/news/02102013-english-heritage-unveils-stonehenge-visitor-centre#. U8YyOFa3cds [accessed 1 March 2014].

Sternberg, R.J. (1997) Concept of intelligence and its role in lifelong learning and success, *American Psychologist*, 52(10): 1030–7.

Stone, P. (2004) Introduction: education and the historic environment into the twenty-first century, in D. Henson, P. Stone, and M. Corbishley (eds) *Education and the Historic Environment*, London: Routledge, pp. 1–12.

Stowe, N. (2006) Public history curriculum, illustrating reflective practice, *The Public Historian*, 28(1): 39–65.

Swain, H. (2007) *An Introduction to Museum Archaeology*, Cambridge: Cambridge University Press.

Swansinger, J. (2009) Preparing student teachers for a world history curriculum in New York, *The History Teacher*, 43(1): 87–96.

Szreter, S. (2012) History and public policy, in J. Bates (ed.) *The Public Value of the Humanities*, London: Bloomsbury Academic, pp. 219–231.

Taksa, L. (2003) Hauling an infinite freight of mental imagery: finding labour's heritage at the Swindon Railway Workshops' STEAM Museum, *Labour History Review*, 68: 394–404.

Taylor, T. (2000) *Behind the Scenes at Time Team*, London: Channel Four Books.

Thompson, E.P. (1963) *The Making of the English Working Class*, Harmondsworth: Penguin.

Thompson, S., Aked, A., McKenzie, B., Wood. C., Davies, M., and Butler, T. (2011) The Happy Museum: a tale of how it could turn out all right. Available at: http://www.happymuseumproject.org/wp-content/uploads/2011/03/The_Happy_Museum_report_web.pdf [accessed 2 Oct. 2013].

Thomson, L., Ander, E., Menon, U., Lanceley, A., and Chatterjee, H. (2011) Evaluating the therapeutic effects of museum objects with hospital patients: a review and initial trial of wellbeing measures. *Journal of Applied Arts and Health*, 2(1): 37–56.

Thurley, S. (2013) *Men from the Ministry: How Britain Saved Its Heritage*, New Haven, CT: Yale University Press.

Tosh, J. (2008) *Why History Matters*, London: Palgrave Macmillan.

Tusa, J. (2004) A deep and continuing use of history, in D. Cannadine (ed.) *History and the Media*, New York: Palgrave Macmillan, pp. 123–40.

Twells, A. (2008) *Community History*. Institute of Historical Research. Available at: http://www.history.ac.uk/makinghistory/resources/articles/community_history.html [accessed 5 July 2013].

UNESCO (1995) *World Commission on Culture and Development: Our Creative Diversity*, Paris: UNESCO.

UNESCO (2003) *Convention for the Safeguarding of the Intangible Cultural Heritage*, Paris: UNESCO.

UNESCO (2004) *Linking Universal and Local Values: Managing a Sustainable Future for World Heritage*, World Heritage Series 13. UNESCO: World Heritage Centres.

USDA-USFS (1995) *Passport in Time Accomplishments, Region 6*, Tucson: United States Department of Agriculture and United States Forest Service.

Valletta Convention (1992) *European Convention on the Protection of Archaeological Heritage* (revised) Valletta, 16.1.1992, Strasbourg: Council of Europe.

Volkert, J., Martin, L.R., and Pickworth, A. (2004) *National Museum of the American Indian: Smithsonian Institute, Washington, DC: Map and Guide*, Washington, DC: Scala Publishers.

Vygotsky, L. (1962) *Thought and Language*, Cambridge, MA: The MIT Press.

Vygotsky, L. (1978) *Mind and Society*, Cambridge, MA: Harvard University Press.

Wallace, J. (2004) *Digging the Dirt: The Archaeological Imagination*, London: Gerald Duckworth & Co. Ltd.

Wallace, M. (2000) Integrating United States and world history in the high school curriculum: the trials and tribulations of a good idea, *The History Teacher*, 33(4): 483–94.

Watson, J.B. (1930) *Behaviorism*, Chicago: University of Chicago Press.

Watson, S. (2007) *Museums and Their Communities*, New York: Routledge.

Webber, K., Gillroy, L., Hyland, J., James, A., Miles, L., Tranter, D., and Walsh, K. (2011) Drawing people together: the local and regional museum movement in Australia, in D. Griffin and L. Paroissien (eds) *Australian Museums and Museology*, National Museums of Australia. Available at: http://nma.gov.au/research/understanding-museums/index.htlm. [accessed 5 Aug. 2013].

Wenger, E. (1998) *Communities of Practice: Learning, Meaning, and Identity*, Cambridge: Cambridge University Press.

Whitaker, P. (1995) *Managing to Learn*, London: Cassell.

White, H. (1978) *Tropics of Discourse: Essays in Cultural Criticism*, Baltimore, MD: Johns Hopkins University Press.

Whittenbenburg, J.P. (2002) On the power of historical archaeology to change historians' minds about the past, in B. Little (ed.) *The Public Benefits of Archaeology*, Gainesville, FL: University Press of Florida, pp. 74–84.

Wilmer, E. (2000) *What Is Public History?* Available at: http://www.publichistory.org/ what_is/definition.html [accessed 10 Dec. 2013].

Wilson, V. (2007) *Rich in All but Money: Life in Hungate, 1900–1938*, Oral History Series 1, York: York Archaeological Trust.

Wilton, J. (2006) Museums and memories: remembering the past in local community museums, *Public History Review*, 12: 58–79.

Windschuttle, K. (1996) *The Killing of History: How a Discipline Is Being Murdered by Literary Critics and Social Theorists*, Paddington: Macleay Press.

Woollard, V. (2004) Caring for the visitor, in P. Boylan (ed.) *Running a Museum: A Practical Handbook*, Paris: International Council of Museums, pp. 105–18.

Worthington, C. (2005) A lost battle, *Museums Journal*, 105(10): 38–9.

Yarema, A. (2002) A decade of debate: improving content and interest in history education, *The History Teacher*, 35(3): 389–98.

Zeidler, J. and Rush, L. (2010) In-theatre training through cultural heritage playing cards: a US Department of Defense example, in L. Rush (ed.) *Archaeology, Cultural Property, and the Military*, Woodbridge: Boydell Press, pp. 73–85.

Websites

http://www2.archivists.org/about/introduction-to-saa [accessed 12 Dec. 2013].

http://911digitalarchive.org/index.php [accessed 2 June 2014].

http://bloggingforhistorians.wordpress.com [accessed 23 Jul. 2014].

http://boneswithoutbarriers.org [accessed 23 July 2014].

http://diginternational.com.au/page3.htm [accessed 5 Sept. 2013].

http://jorvik-viking-centre.co.uk/about-jorvik/[accessed 5 May 2014].

http://whc.unesco.org/en/criteria/ [accessed 10 Dec. 2013].

http://whc.unesco.org/en/funding/ [accessed 5 Dec. 2013].

http://www.abc.net.au/tv/whosbeensleeping/ [accessed 5 May 2014].

http:www.albertdock.com/history/regenerating-albert-dock/ [accessed 1 Jan. 2014].

http:www.archaeologyuk.org.education/ehe [accessed 10 Oct. 2013].

http://www.archives.org.uk/about/about.html [accessed 10 Dec. 2012].

http://www.archivists.org.au/page/Learning_and_Publications/ASA_Learning/ [accessed 10 Dec. 2013].

http://www.bbc.co.uk/worldservice/arts/features/howtowrite/radio.shtml [accessed 4 Jan. 2013].

http:// www.bcc/historyforkids [accessed 8 Sept. 2013].

http://www.catalhoyuk.com/downloads/Archive_Report_2011.pdf [accessed 10 June 2013].

http://www.conted.ox.ac.uk/courses/index.php [accessed 10 Oct. 2013].

http://www.cr.nps.gov [accessed 5 Sept. 2013].

http://www.dpc.vic.gov.au/index.php/aboriginal-cultural-heritage/review-of-the-aboriginal-heritage-act-2006 [accessed 5 Sept. 2013].

http://www.english-heritage.org.uk/caring/listing/listed-buildings [accessed 10 Sept. 2013].

http://www.english-heritage.org.uk/support-us/members/magazine/oct-2013/new-beginnings-stonehenge/ [accessed 16 Dec. 2013].

http:// www.finds.org.uk [accessed 8 Sept. 2013].

http://www.fraserrandall.co.uk/projects/touring/iwm_their_past. html [accessed 10 Aug. 2013].

http://www.fs.fed.us [accessed 5 Sept. 2013].

http://www.heritagegateway.org.uk/Gateway/CHR [accessed 10 Sept. 2013].

http://www.historicinnsofannapolis.com/governor-calvert-house.aspx
[accessed 10 Dec. 2013].

http://historymatters.group.shef.ac.uk [accessed 22 July 2014].

http://www.history.org/Almanack/places/index.cfm [accessed 10 Dec. 2013].

http://www.history.org/Foundation/cwhistory.cfm [accessed 12 Dec. 2013].

http://www.history.org/history.index [accessed 10 Dec. 2013].

http://www.hlf.org.uk/English/AboutUs [accessed 5 Sept. 2013].

http://www.ica.org [accessed 10 June 2013].

http://www.ica.org/124/our-aims/mission-aim-and-objectives.html [accessed
10 Dec. 2013].

http://www.ica.org/125/about-records-archives-and-the-profession/discover-
archives-and-our-profession.html [accessed 10 Dec. 2013].

http://www.icomos.org/en/about-icomos/mission-and-vision/mission-and-
vision [accessed 5 Dec. 2013].

http://www.inspiringleainingforall.org [accessed 10 Dec. 2013].

http://www.iwm.org.uk/exhibitions/iwm-london-histories-spies [accessed
12 Oct. 2013].

http://www.landmarktrust.org.uk/ [accessed 9 Oct. 2013].

http://www.landmarktrust.org.uk/search-and-book/properties/astley-
castle-4806 [accessed 9 Oct. 2013].

http://www.latrobe.edu.au/humanities/study/pathways/certificate-iv-in-
aboriginal-cultural-heritage-management [accessed 5 Sept. 2013].

http://www.microsoft.com/education/en-us/teachers/plans/Pages/legislative_
bill.aspx. [accessed 10 Jul. 2014].

http://muncyhistoricalsociety.org/archaeology-at-muncy [accessed 10 Jan.
2013].

http://www.museumassociation.org.uk [accessed 10 Nov. 2013].

http://www.museumoflondon.org.uk/collections-research/laarc/ [accessed 10
Dec. 2013].

http://www.museumoflondon.org.uk/schools/classroom-homework-resources/
sen-resources/ [accessed 10 Nov. 2013].

http://www.museumofvancouver.ca/about/exhibitionproposals [accessed 10
Dec. 2013].

http://www.navy.gov.au/history/museums/ran-heritage-centre#desk [accessed
5 Oct. 2013].

http://www.nationalarchvies.org.uk [accessed 10 Dec. 2013].

http://www.nba.fi.en/File/985/ole-winther-emac.pdf [accessed 5 June 2014].

http://www.nhm.ac.uk/visit-us/galleries/green-zone/treasures/index.html
[accessed 10 Dec. 2013].

http://www.nma.gov.au/education-kids [accessed 10 Oct. 2013].

http://www.nps.gov/moru/idex.htm [accessed 3 Dec. 2014].

http://www. nps. gov/history/sec/protecting/html/201-neumann.htm [accessed 3 Dec. 2013].

http://www.nps.gov/vafo/historyculture/welcome-center.htm [accessed 16 Dec. 2013].

http://www.oaeast.thehumanjourney.net/outreach/jigsaw [accessed 10 Oct. 2013].

http://www.passportintime.com [accessed 5 Sept. 2013].

http://www.pastpreservers.com [accessed 12 Jan. 2014].

http://www.prospects.ac.uk/archivist_entry_requirements.htm [accessed 22 Oct. 2013].

http://www.prospects.ac.uk/museum_gallery_curator_entry_requirements. htm [accessed 12 Oct. 2013].

http://www.salford.ac.uk/cst/research/applied-archaeology/community-engagement/dig-greater-manchester [accessed 9 Dec. 2013].

http://www.smithsonianeducation.org/educators/lesson_plans/lincoln/ smithsonian_siyc_spring09.pdf [accessed 10 July 2014].

http://www.tvmole.com/2009/01/how-write-proposal-tv-commissioner-will-read/ Greenlit [accessed 10 Oct. 2013].

http://www.unesco.org/webworld/taskforce21/documents/holmstrom_en.htm [accessed 10 Dec. 2013].

http://www.wikihow.com/Write-a-Radio-Play [accessed 5 Jan. 2013].

http://www.wmf.org.uk/projects/ [accessed 9 Oct. 2013].

https://www.waterways.org.uk/pdf/restoration/museum__visitor_and_ heritage_centres [accessed 5 Dec. 2013].

Index